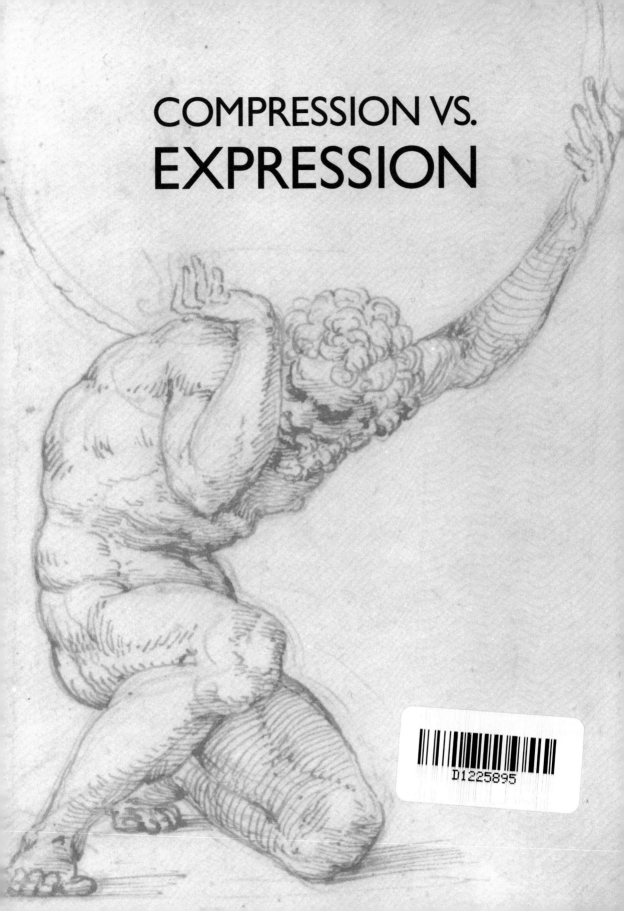

COMPRESSION VS.
EXPRESSION

COMPRESSION VS. EXPRESSION

Containing and Explaining the World's Art

Edited by John Onians

Sterling and Francine Clark Art Institute
Williamstown, Massachusetts

Distributed by Yale University Press, New Haven and London

This publication is based on the proceedings of the Clark Conference
"Compression vs. Expression: Containing and Explaining the World's Art,"
held 6–8 April 2000 at the Sterling and Francine Clark Art Institute, Williamstown,
Massachusetts. For information on programs and publications at the Clark,
visit *www.clarkart.edu.*

Curtis R. Scott, *Director of Publications*
David Edge, *Graphic Design and Production Manager*
Katherine Pasco, *Production Editor*
Diane Gottardi, *Layout*

Printed by the Studley Press, Dalton, Massachusetts
Distributed by Yale University Press, New Haven and London

ISBN (Clark) 0-931102-67-7
ISBN (Yale) 0-300-09790-5

Printed and bound in the United States of America
10 9 8 7 6 5 4 3 2 1

Title page and divider page illustration: Baldassare Peruzzi, *Atlas* (detail), c. 1525–27.
Pen and brown ink, over black chalk. The Metropolitan Museum of Art, New York.
Harry F. Sperling Fund, 1992 (1992.304)

Library of Congress Cataloging-in-Publication Data

Clark Conference (2000 : Sterling and Francine Clark Art Institute)
 Compression vs. expression : containing and explaining the world's art / edited by John Onians.
 p. cm. — (Clark studies in the visual arts)
 Based on the proceedings of the Clark Conference "Compression vs. expression : containing and
explaining the world's art," held 6–8 April 2000 at the Sterling and Francine Clark Art Institute,
Williamstown, Mass.
 Includes bibliographical references.
 ISBN 0-931102-67-7 (Clark : pbk. : alk. paper) — ISBN 0-300-09790-5 (Yale)
 1. Art—Historiography—Congresses. 2. Art criticism—Congresses. 3. Art and globalization—
Congresses. I. Title: Compression versus expression. II. Onians, John, 1942– III. Sterling and Francine
Clark Art Institute. IV. Title. V. Series.

N7480.C63 2006
701'.1—dc22
 2006042302

Contents

Introduction

John Onians

World and *art* are terms that have not always gone easily together. For many, they still do not. *World* can suggest the entire surface of the planet and a length of time that is astronomical, while *art* still readily evokes a particular elite taste associated with a few places and periods, especially Europe from ancient Greece to the present and the modern United States. The persistence of this disjunction is encouraged by collections such as the national galleries of art in London and Washington, which are dominated by the European Old Masters, and by the content of art history courses in universities, the majority of which, especially in Europe, deal only with this tradition. *Art* has too often been an exclusive term only grudgingly linked with the inclusive concept of the *world,* and this was still very much the case in 2000 when the conference "Compression vs. Expression: Containing and Explaining the World's Art" took place.

It was not always so. When Franz Kugler published his *Handbuch der Kunstgeschichte* in 1842, he covered prehistoric, ancient Near Eastern, Pre-Columbian, Indian, and Islamic art, as well as European art, and although the growth of art history as a discipline led to a strengthening focus on Europe, significant scholars continued to adopt a broader view, as did Heinrich Wölfflin with his *Prolegomena zu einer Psychologie der Architektur* (1886). Still, it was only in Vienna, with its close connections to territories to the east, and under the leadership of Alois Riegl and others around 1900 that the university's art history department briefly institutionalized such a wide perspective. This was then forgotten as the twentieth century advanced and Europe's relationship with the rest of the world became more and more fraught, though E. H. Gombrich still revealed his Viennese training in his late work *The Sense of Order* (1979), a largely psychological study of ornament worldwide. Few of his contemporaries, except for George Kubler, whose *The Shape of Time: Remarks on the History of Things* appeared in 1962, had similar ambitions, and in the next generation David Freedberg's *The Power of Images: Studies in the History and Theory of Response* (1989) was equally alone in its engagement with the imagery of many cultures. The only attempt to emulate late Kugler was Hugh Honour and John Fleming's *A World History of Art* (1984). Otherwise, when the arts of different areas of the globe were studied in the twentieth century, they were typically treated in isolation from each other, as in the *Propyläen Kunstgeschichte* and its English language descendant, the *Pelican History of Art,* or in

Thames and Hudson's "World of Art" series. The discrete nature of the volumes in these series, each the product of a relatively narrow "area studies" tradition, was, sadly, not conducive to the formation of a global overview, and the same was true of the otherwise admirable *Enciclopedia universale dell'arte* (1958), its expanded English edition, *Encyclopedia of World Art* (1960), and *The Dictionary of Art* (1996).

These volumes did, however, find a growing market in North American universities where, largely in response to the demands of students of different ethnic origin—especially Asian, African, and Native American—art history courses expanded their range to embrace the arts of these and other communities, and this created a new dynamic in the field. Soon there were yet more reasons for taking a broader view of art. When, in 1986, Irving Lavin organized the XXVth International Comité International de l'Histoire de l'Art (CIHA) Congress, he broke a century-old tradition of concentrating on Europe and chose as its title "World Art: Themes of Unity and Diversity." One factor that formed the background of his choice of designation was the changing character of the courses at major departments in the United States; another was CIHA's need to respond to political pressures from its umbrella organization, the United Nations Educational Scientific and Cultural Organization (UNESCO); and another was the increasing prominence in CIHA—and in the discipline as a whole—of countries outside Europe, the United States, and Canada, most prominently Japan, Mexico, and Australia. Then, in 1992, the School of Art History at the University of East Anglia in the United Kingdom, in an isolated response to a local pressure—that is, the need to engage with the worldwide range of the Robert and Lisa Sainsbury art collection with which it shared a home—changed its name to the School of World Art Studies.

All of this affected me personally. From 1983 I was an occasional visiting professor at the University of California, Los Angeles, where the art department was one of the leaders in the teaching of non-European art. Soon afterward I was appointed as a session organizer at the CIHA conference in Washington, D.C. But most profound was the impact of my involvement in the establishment of world art studies at the University of East Anglia. This required me to become more aware of the enormous scale of world art studies in comparison to the discipline of art history in which I had been educated. Once art was redefined, not in terms of the few works of painting, sculpture, and architecture valued by Europeans but of all the artifacts that any human beings anywhere had ever thought to be of overriding visual interest, it was clear that its study needed to be rethought entirely. It was also clear that for that rethinking to take place, a more profound reassessment needed to be made.

The present state of the field, the constraints that inhibited it, and the resources that empowered it needed to be analyzed. In addition, it became more and more apparent that the tensions between the entropy of the status quo and the energies liberated by the emerging situation were also of great interest in their own right. It was this realization of the complexity and interest of these issues that led me to make them the theme of the second Clark Conference.

The problems that I hoped the conference would address were all ones that related to the new challenge offered by world art as suggested by the conference's title. The terms *containing* and *explaining* were chosen to draw attention to two distinct, though related, problems. First, what is "the world's art," how is it to be defined, and how is knowledge of it to be brought together? And second, how is it to be studied and understood? Since it quickly became clear that our ability to engage with these problems was limited by current institutional and intellectual frameworks, I decided that it would be helpful to explore these challenges as well. That meant looking at the roles of museums, universities, and international organizations, the traditions of certain countries and regions, and the contents of bibliographies and libraries, books and theories. Finally, I chose the core concept of the title, "Compression vs. Expression," in order to confront directly one of the issues most likely to inhibit change: How is it possible to rise to the new challenge of embracing a vastly greater field of knowledge than that accepted by traditional art history without losing the depth of presentation and intellectual reflection with which the discipline is associated?

The essays published here, which necessarily reflect the level of debate at the time of the conference in 2000, advance this agenda. They do not exhaust it. Part One deals with two types of containing institutions that are most important for art's presentation: the museum and the university. Edmund Pillsbury, Yves Le Fur, and Jyotindra Jain present distinct brief museological case studies from the United States, France, and India, while Cecelia Klein and Anitra Nettleton offer analyses of the sharply contrasting and rapidly changing contexts for art history in the very different social environments of California and South Africa. Part Two offers a looser set of global and regional perspectives. The first two relate to the literature of art, presenting two very different research tools, one traditional, one new. Michael Rinehart discusses the Bibliography of the History of Art, a highly structured and authoritative bibliography of mostly European art; Dominic Marner focuses on the World Art Library at the University of East Anglia, a miscellaneous collection of publications on art from many places around the world that is deliberately random and unpredictable. The middle three papers in Part Two present reflections on international institutional frame-

works of different kinds. Derek Gillman considers the legal issues raised by heritage, its preservation, and exploitation, while Georges Zouain and Arlene Fleming look, rather, from different points of view at the intersection of the artistic and the economic. Rita Eder and Cao Yiqiang then offer insights into past and present views of art and its history in Mexico and China. Part Three provides reflections on the ultimate compression of world art into a book or a theory. Wilfried van Damme uses the book of his dissertation as the springboard for a review of different approaches to world aesthetics. James Elkins makes a critical assessment of the problems involved in writing histories of the art of non-Western cultures. David Summers, in implicit contradiction to Elkins, reflects on his own substantial attempt to write a world art history with robust terms of reference of its own. I also provide a preview of my planned world art history rooted in neuroscience. At the conference itself this range of views was further extended by the contributions of Fred Wilson on the ways established museum and gallery collections can be redisplayed in critical and creative ways; Whitney Davis on the teaching of prehistoric art as a worldwide phenomenon; T. A. Heslop on the tensions between theories of diffusion and independent origin; Renata Holod on the history of the treatment of non-European art in United States universities; Djon Mundine on the assumptions constraining the freedom of aboriginal Australian artists; Kapila Vatsyayana on the essence of Indian art; and David Freedberg on the psychology of violence in, and in relation to, art. The study of art worldwide also raises concerns about colonialism and post-colonialism, racism and feminism, fairness and exploitation, and these surfaced strongly in the open forum with which the conference ended. As the conference showed, it is in the nature of discussions of world art that larger issues than those typically associated with art history emerge.

The conference affected those who participated in it. It also affected the field, and in the six years since it was held, world art has become a topic of increasing importance. In terms of museology, five great museums or museum complexes—the Berlin museums, the British Museum, the Hermitage, the Louvre, and the Metropolitan Museum of Art—have formed an elite group, presenting themselves as uniquely capable of doing what the British Museum has called "illuminating world cultures." A new world art museum housed in the Millennium Art Museum in Beijing, the first to have that as an explicit goal from its foundation, aspires to join them in 2006. In higher education the trend has been equally apparent. More and more art history departments teach art outside Europe and, in 2004, the need to develop a new discipline explicitly designed to deal with art worldwide has been acknowledged by the appointment of Wilfried van Damme to a *lektoraat* in world

art studies at the University of Leiden and of John Mack, for some years head of re-
search at the British Museum, to the first-ever chair in world art studies at the
University of East Anglia. Disciplines need bibliographies, and publications are be-
ginning to emerge to sustain this development. In 2003 David Summers fulfilled
the plan he outlines here by publishing *Real Spaces: World Art and the Rise of Western
Modernism,* the first attempt by a single author to develop and apply a theoretical
framework for studying art worldwide. In 2004 Thomas DaCosta Kaufmann pub-
lished his *Toward a Geography of Art,* a review of the topic with coverage extending
beyond Europe to include South America and Japan, and in 2005 with co-editor
Elizabeth Pilliod offered *Time and Place: The Geohistory of Art,* a collection of essays
by different authors. Another contribution to the geography of art in 2004 was the
Atlas of World Art (John Onians, editor), built around the contributions of sixty-
eight specialists. This work, the first attempt to systematically document the art of
all regions of the globe from prehistory to the present, has found an international
resonance, with German, Italian, and Spanish editions having appeared already, to
be soon followed by Chinese, French, and Japanese. World art has a worldwide ap-
peal and has attracted the interest of foundations. In 2000 the Getty Grant Program
funded a month-long Summer Institute in World Art Studies at the University of
East Anglia, which was attended by thirty participants from twenty countries.
Conference sessions also increasingly address the issues discussed here. At the College
Art Association's annual conference in New York in 2003, I organized a session on
"Mapping the World's Art," and at the 101st annual conference of the American
Anthropological Association in New Orleans in 2002, dedicated to the discipline's
"(Un)imaginable futures," Eric Venbrux and Pamela Rosi organized a session on
"World Art Worlds," which resulted in the publication of a collection of papers in
a special issue of the *International Journal of Anthropology,* with an introduction by
Venbrux and Rosi called "Conceptualizing World Art Studies."

 The study of world art is of compelling intellectual interest when it relates
to those areas in which art history has long been strong. Outside those areas it is a
compelling necessity. Increasingly, around the globe communities regard art as an im-
portant expression of their history and look for appropriate frameworks for the
institutions in which it is preserved and explained. Art history, with its freight of as-
sumptions deriving from European roots, provides an inadequate paradigm. The
concepts of world art and world art studies, with their inherently greater flexibility
and openness, empower people anywhere, whether in major cities or on remote is-
lands, to develop approaches that suit their own needs.

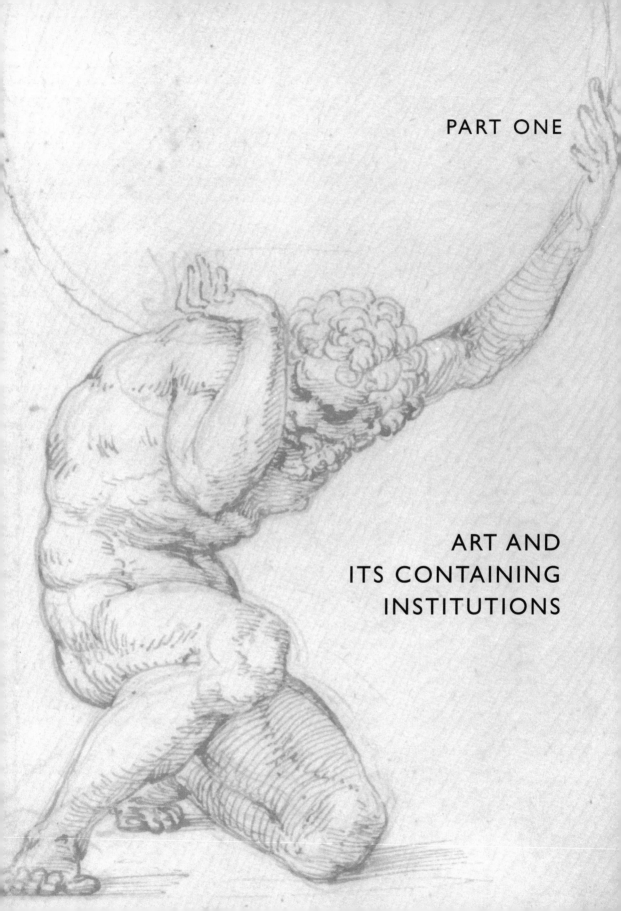

PART ONE

ART AND
ITS CONTAINING
INSTITUTIONS

The Museum Dilemma: Conservation vs. Interpretation

Edmund P. Pillsbury

I believe that all of us who attended the "Compression vs. Expression" conference would agree that the primary responsibility of an art museum is to acquire works of quality and, of course, preserve those fine works for the appreciation of future generations of a growing audience of visually literate museum-goers. We would probably also agree that museums must spare no effort to educate the public at large about the importance and meaning of art through every available means: labels, catalogues, exhibits of all types, lectures, workshops, tours, symposia, and films. Yet the two functions of the museum—collecting and interpretation—rarely exist in harmony.

The question arises as to which is more important: an acquisition or major loan exhibition; a new climate control system or an interactive website; a new curator with specialized knowledge or a prized teacher with exceptional communication skills; another wing to house the growing permanent collection or space to provide visitor services and generate retail or other sales; an increase in endowment to support collection development or exhibition sponsorship, either corporate or public?

An example is the National Gallery of Art in Washington, the nation's premier collection of master paintings and sculpture. Over the past thirty years—a period in which this institution launched ambitious and costly loan exhibitions ranging from ancient China to modern Africa, many totally unrelated to its collections—one questions whether it has competed successfully for the greatest acquisition opportunities in the international market. Except for bequests and a few gifts, the results are mixed. Has the Metropolitan Museum of Art in New York, arguably the nation's only claim to an encyclopedic collection of world-class status, devoted sufficient energy to the nurture of its holdings in deference to the expansion of its programs and services or, conversely, has it used the latter, its popular shows especially, to sustain its efforts in collecting and research? Or, finally, has the J. Paul Getty Museum in Los Angeles, with its enormous financial resources, succeeded in creating a major collection of art based on the highest level of connoisseurship and the most progressive and informed view of world culture, or could one argue that it has squandered an opportunity by launching a range of educational and other initiatives that has sapped its financial resources? Moreover, what did the Getty

gain by limiting its collecting to the very conservative tastes of its founder: Greek and Roman art, European furniture, painting and sculpture? The collection lacks twentieth-century art (except photographs), Egyptian or African art, Asian art, and Native American art. The Getty's acquisition policies perpetuate a Eurocentric set of values that is at odds even with its own educational initiatives.

Of course, there is no right course. Every institution has a different set of issues—economic, social, political, and historical—and a different set of problems and challenges. What may work in one venue at one time may be inappropriate in another at the same or a different moment. The 1960s called for social justification and gave birth to projects such as the Metropolitan's infamous *Harlem on My Mind* exhibit. The 1970s was the period of access. With the funds from the newly created National Endowments for the Arts and Humanities, the goal was to take art to every remote place in the country. In the 1980s, with the resurgence of private philanthropy, both corporate and individual, aesthetic quality reigned—core values and the supremacy of the object. In the 1990s, there has been what I call the birth of context and the demise or death of beauty as a normative concept.

Today, museum directors, as well as their boards, no longer enjoy the luxury of being passive custodians. They must generate resources to heat, light, and maintain the facilities and keep them open to the public on a regular basis. Museum officials must be astute in their knowledge and keen collectors, but more is expected. Even at the Frick Collection, the traditional house museum, it is no longer adequate to open the doors to the public in the morning and see that they are safely closed at the end of the day, occasionally dusting the frames and sweeping the floors. Lectures, symposia, publications, and even exhibitions are necessary to keep the public interested in the collection and to attract new audiences. On the other hand, should museums surrender to the economic and social pressures to provide entertainment—or even worse, "edutainment"—for culture-hungry citizens? A lot of money can be earned and great efficiencies achieved by maximizing attendance through programs like motorcycles at the Guggenheim, rock-and-roll fashion at the Met, or even Norman Rockwell paintings in Atlanta and elsewhere. Do these activities take precedence over collection care and development, or do they help to support them?

For some eighteen years at the Kimbell Art Museum, I strove to find a proper balance between collecting and interpretation. Among my proudest achievements was the success that I had in making accessible to regional audiences relatively serious subjects like Georges de la Tour, Giuseppe Maria Crespi, French mythological painting of the eighteenth century, and even Mayan epigraphy, while seeking

every opportunity to add to the collection works of the highest intrinsic merit, both historic and aesthetic. The Kimbell was never restricted to any medium or period except by choice and built its collection on the principle that the work of surpassing quality possessed the greatest permanent, educational value. Only time will tell if the acquisitions in which I was involved between 1980 and 1998 were wise and correct. There is always a degree of chance in the acquisition process, and one never has the funds to buy all the best works available. With every passing day I am more aware of the opportunities I missed and of my enthusiasms and those of my colleagues that may have been misplaced. All the same, collecting, conservation, documentation, and scientific research were always paramount in our endeavors, while programs to interpret art—exhibitions in particular, lectures, workshops, and symposia—were secondary. Still, these programs made it possible to create and nurture an audience for art, increasing our regional membership to more than thirty-thousand households in fifteen short years. Without them we could not have achieved the enviable position in 1997 (our twenty-fifth anniversary) of being so efficient, so businesslike, that nearly the museum's entire operating budget was supported by the earnings from sales of exhibition tickets, memberships, and merchandise—a feat that had been unthinkable only a decade or two ago.

As much as I lament the imbalance I see in many institutions, I am aware that historical forces pose great challenges to museums today. The consensus about the importance and quality of one artist's work over that of another, so essential to the psyche of the serious collector, no longer holds its own in museum boardrooms around the country and even abroad. There are regional demands, ethnic priorities, gender preferences, and other factors that influence decisions about what art to buy and what art to show. The commitment to uniform standards of excellence has been undermined by new ways of understanding art and of interpreting and communicating its meaning. Without an agreement about the intrinsic worth of the definitive object—a Darwinian belief in the survival of the fittest, rather than a concession to the notion that value resides exclusively in the eye of the beholder, however biased or uninformed—there is little hope that collecting will ever be restored to its former preeminence as the museum's primary responsibility. May a new generation of museum leaders rise to meet the challenge that this situation poses. An outsider now, I live in hope, cautious but optimistic.

Displaced Objects on Display

Yves Le Fur

I never understand it when people say that objects in museum galleries or collections are dead because they no longer exist in their original context. I rather feel that every piece or fragment has its own sight and voice, history and future. The opening of a museum storage area, for example, always disturbs me for a few seconds. I realize this whisper of little voices is not very scientific, but it attracts me. Objects in the museum do not seem to me as though they were in a cemetery, even the most abandoned and dusty ones. They always seem ready to suggest different relations, express new messages, and take on appearances we have not yet imagined, further expanding their expression.

Changing an object from one category to another (natural history, tribal arts, fine arts) creates new meanings and openings in our symbolic construction. For example, I once studied wax anatomical models from medical collections, from the points of view of the history of art, the field of sacred items, and the popular appeal of wax collections. The aesthetic shift is emblematic of these transfers, which are not always definitive.[1] In 1990, in the elegant Dapper Museum in Paris, which is usually dedicated to African art, I exhibited "savage" pieces of wood and stones collected in nature.[2] My intentions were not to suggest a relation between the natural and the primitive, but to explore the meanings of the same kind of pieces from different cultures (Africa, Europe, China). The public appreciated these intimately artistic works, which had no "authors," as well as the attitude toward collecting that anyone might be able to try. Ten years later, I was asked to prepare an installation for the international art exhibition *La Beauté* in Avignon.[3] Seeking to explore the concepts of beauty and nature by using exceptional natural samples together with contemporary art, I gathered pieces from very different collections—the botanical museum of Harvard University, the Museo Civico Correr in Venice, and nature. Because natural objects are easily displaced and seen in a different context, they are also very subject to ideological manipulations. In preparing the exhibition, it seemed necessary to challenge the clichés about romantic nature and ecological innocence by inoculating the audience with a dose of ambiguity, showing, for example, astonishing forms produced by accident, disease, or violence. We also tried to make discreet connections between artificial and real objects, so that

the public would become aware of the virtuality of beauty. In that sense it was also important to present natural objects that were appropriated by different cultures or philosophical purposes (Oceania, Africa, China), less to demonstrate a universal concept than to stress the different contexts in which the natural forms were manipulated to express ideas, beliefs, and emotions.

By approaching a distant culture we may consider in new ways our own categories and knowledge. In France, this is particularly true for the pieces from Oceania. Coming from the other side of the world, these objects are poorly known, often considered "exotic," and are less linked to the French colonial history than those from Africa, for example. As a result, they have a powerful effect on the imagination.

The exhibition *"La mort n'en saura rien": Reliques d'Europe et d'Océanie* [4] proposed to appreciate the sacred nature of works from South Seas Islands by exhibiting them together with European sacred works. To create a double gaze and continuous placements and displacements, I chose to present this common and vague notion of "the sacred" through a phantasmagoric medium of highly charged symbols in the two cultures: the human skull and its postmortem adornments.

Universally, the skull has a special status, being no longer a person yet never definitively an object. It is always an "other" and at the same time a part of our self. Both intimate and a stranger, the skull has an extraordinary agency to identify exchanges, to make rich connections between time and place. In this exhibition, skulls were the opposite of dead objects, "speaking" across cultures and centuries. Thus the dialogue was established between us—living human beings—and prestigious, deceased ancestors and saints. Europeans were confronted with their own cults of relics, rediscovering a practice that lasted from the Middle Ages to the twentieth century, or learning about popular rituals of painted skulls that are still done in Austria today. People from the South Pacific nation of Vanuatu, for example, found that their "custom" of placing the skull of a deceased tribal leader on top of a funeral effigy—a practice forbidden by missionaries—was not so far from the Catholic cult of skulls. (During the nineteenth century, Catholics exported relics from Roman catacombs to different parts of the world, including Oceania, sending ships that probably met other ships bringing back head trophies to ethnographic or missionary museums.) This comparison forces one to move away from the colonial-era evolutionist concept, when these skulls were exhibited as evidence of the "savagery" and "barbarity" of "primitive" people, a concept still attendant in the primitivist reaction of modernist artists as well as dealers, private collectors, or curators.

The location, the contiguity, and the position of the pieces in the space were carefully chosen. The exhibition space, inherited from the former colonial museum architecture,[5] is a long corridor (roughly 30 by 160 feet) with a series of domed skylights. This structure, normally covered with awnings, was exposed and used to create a series of alternate loggias, connected to "chapels," made with special light gold screens. The spaces gave the feeling of an ambulatory, where transparencies and opacities produced apparitions, moving shadows, and spectral impressions, connecting and integrating the faces and the bodies of the visitors to the relics. Each chapel had its own theme, introduced by a short text that linked the two cultures to reveal similarities and differences. The exhibition moved from simple painted marks on a skull to progressively more elaborate and large reliquaries, culminating in two entire shrines shown back to back. One, "Paradise Garden" of 1499, was from an abbey in north Germany, and the other, a twenty-foot painting to hang head-trophies, originated from the Sepik River region of Papua New Guinea and was collected in the mid-twentieth century. The show ended with a single skull from Easter Island, engraved simply with a stylized bird.

This progression would have logically extended to include a reliquary that the museum could no longer contain, such as a church or ceremonial house. The idea was also to express physically the limit or non-limit of the exhibition's capacity to be at once a laical and sacred space. In fact, the comments of the visitors revealed that they were less touched by the theme of the sacred than the feeling of respect between cultures, which also outweighed the great aesthetic qualities of the pieces.[6] Visitors were less concerned about the violent presence of skulls than by the individual reflections about themselves and about death that they experienced during their visits. They were more affected by the feeling of distance created by the Western reliquaries (the accumulation of gold and precious material around the bones, the silver armor of a sainted knight) and claimed to feel closer to the Oceanic reliquaries made with natural elements such as earth, feathers, pig tusks, and pigments. They felt that these materials were simpler, even if they had been chosen in the original culture because they were exceptional and the funerary effigies in question dealt with great chiefs and warriors. The public discovered and unconsciously refused the representations of death of their own culture and religion, but above all felt uneasy in realizing the lost link between the living and the deceased, a concept that is retained by people still considered to be cannibals and savages. Could we consider this ambiguous attitude from the visitors of an exhibition to be a deep desire of symbolic interpretation, to go beyond information

and delectation? This seems to be possible by displacing pieces from their original locations (church, abbey, ethnographical or natural history museum) so that people can encounter them in a place—the art museum—whose status and function are changing at the beginning of the twenty-first century.

This may show that we should move away from the individual concept of the "musée imaginaire" of André Malraux, as well as from primitivism, where non-Western art is judged according to the standard of modern art. How can one talk about an African cubist sculpture or an Oceanic surrealist mask? We also have to distance ourselves from exoticism appearing in fashionable presentation of global contemporary world art, which exports Western standards everywhere, even the concept of the museum. How can we move toward thematic interrogations and attitudes of reflexivity for the public?

The difficulty of naming the expressions of non-Western cultures "*art nègre*," "primitive art," or "art of people without history or without writing," which has known more success among the journalists than the specialists, is symptomatic. In April 2000, the Pavillon des Sessions in the Musée du Louvre was opened to a selection of masterpieces from four continents, on loan from the Musée de l'Homme and the Musée National des Arts d'Afrique et d'Océanie (natural history or ethnographic museums in France), and bought on the market. This installation was dedicated by French president Jacques Chirac as a political signal of recognition for non-Western cultures. The motto of the curator, the private collector Jacques Kerchache—"All masterpieces are born free and equal"—justified the presence of Kongo, Inca, or Kanak works of art in the Louvre sanctuary. The selection of pieces was based only on aesthetic criteria, demonstrating the excellence of anonymous artists in the ancient non-Western world. This exhibition, declared as permanent, represents the advanced unit of the future Musée Quai Branly being built by the architect Jean Nouvel and scheduled to open in 2006. This new museum, compressing two collections (that of the Musée de l'Homme and the Musée National des Arts d'Afrique et d'Océanie), will contain nearly 280,000 items from non-European cultures. Both a research center and a museum, it will present to the public a vast amount of information using new technologies. The project is co-managed by the renowned anthropologist Maurice Godelier (for the scientific portions) and Germain Viatte, former director of the Musée National d'Art Moderne, Centre Georges Pompidou (for the museography). The fusion and compression of the two collections, combined with the collaboration (once difficult) between anthropologist, ethnologist, curator, and historian, may be considered in an optimistic

perspective from which to find new relations between scientific fields and experience cross-cultural relations, rather than extending universally a Western conception of world art. The goals are not only to further research on various cultures and their history and to foster exploration of values of identity in collaboration with people of the five continents, but also to displace existing categories in order to offer elements for reflexive attitudes to all the various publics and to create a dynamic place that is always open to questioning.

1. Yves Le Fur, "Esthétique des cires anatomiques de Gaetano Zumbo (1656–1701) à Pierre Spitzner (1834–1896)" (Ph.D. diss., Panthéon-Sorbonne, 1989). Collections of pathological waxes stolen from medical collections in Paris were exhibited by the "Doctor" Spitzner and his wife from the middle of the nineteenth century until the 1950s in Paris and Belgium. This fascinating collection of transformations of the body inspired a famous painting by the Belgian artist Paul Delvaux, *Le musée Spitzner*. At auction, a pharmaceutical laboratory bought the collection on a French government initiative, thereby saving this fairground art heritage. The collection was then stored in a number of different locations until it was placed again in the anatomical university museum Orfila-Rouvière in Paris, where it is once again in danger of being dispersed.

2. Yves Le Fur, *Résonances: Musée Dapper* (Paris: Editions Dapper, 1990).

3. *La Beauté*, Avignon, 27 May–1 October 2000. Cf. Yves Le Fur, "La Nature à l'œuvre," in *La Beauté* (Paris: Flammarion, 2000).

4. The exhibition was on view at the Musée National des Arts d'Afrique et d'Océanie, October 1999–February 2000. Yves Le Fur, *"La mort n'en saura rien": Reliques d'Europe et d'Océanie* (Paris: Réunion des Musées Nationaux, 1999). The title has been taken from the last verse of a poem of Guillaume Apollinaire, "Funérailles," collected in *Le guetteur mélancolique (Poèmes divers, 1900–1917)* (Paris: Gallimard, 1970).

5. The museum was built in 1931 during the famous Colonial Exhibition in the Vincennes wood and created as the "Palais Permanent des Colonies." It became the "Musée de la France d'Outre Mer," and André Malraux transformed it into the Musée National des Arts d'Afrique et d'Océanie.

6. The Centre National de la Recherche Scientifique conducted 165 interviews with visitors to the exhibition.

Objects and Exhibits—Mutating Identities: The Case of India

Jyotindra Jain

> Objects were not what they were made to be but what they have become. This is to contradict the pervasive identification in Museum research and material culture studies which stabilizes the identity of a thing in its fixed and founded material form.
>
> —Nicholas Thomas

Collecting India: Tradition, Authenticity, and the Evolving Context

The institution of the museum in India, aimed at housing objects of antiquity and curiosity, is a colonial and Orientalist project. Indians themselves did not have a tradition of setting up museums of fragmented sculptures, rusted swords, and out-of-context paintings. Broken images were immersed in water, worn out metal objects were melted down to cast new ones, and terracotta votive objects were left to decay and merge with the very earth from which they were created. The West possessed the power to represent the Orient. "Classificatory mechanisms, systematizing languages, religions, peoples, and so on, were employed to continue and reinforce the indelible otherness of the Orient."[1] The Orient was depicted as a timeless space, without history, unaffected by industrialization and modernity, and thereby represented as "traditional space." In the colonial Indian context, tradition represented an amorphous, passive collectivity; its authenticity rooted in the past and its merit in anonymity, not having a contemporary face.

Collecting Indian art in museums or writing its histories in the nineteenth century had, as its primary purpose, probing the "fine" and "classical" elements in Indian sculpture, painting, and architecture seen through the prism of Sanskrit texts that were deemed to be the equivalents of European classics. For them, the text-based and therefore the fixed and founded forms of art and architecture set the essentialist criteria for originality and authenticity and as such for classicism in Indian culture. The ever-mutating, regional, living beliefs and practices, having no textual pedigree to claim, were reduced to the status of the vernacular and therefore derivative and degenerate. With the rise of anthropology the West did develop an interest in tribal artifacts, but here, too, authenticity was seen as rooted in the past and therefore in ultimate primitivism.

The Western practice of museum collecting in the colonies, right at its inception, attached much value to rarity and exoticism (*Wunderkammer*/curiosity cabinet ideology), which formed the criteria of quality and in turn determined the art market. These objects were glorified as fully formed, one-time masterpieces, isolated from their "evolving context."[2] All evolving context was considered a departure from tradition and therefore its dissipation. Most Western metropolitan ethnographic museums consciously isolate their objects from the context of processual change of the given culture to keep intact their "masterpiece" status. Here tradition did not have a contemporary face.

If one were to sketch a picture of the indigenous owners of the colonial ethnography as they are represented in museums, they would appear to be a single, timeless community whose women always go bare-breasted; whose men smoke tobacco pipes and roam around in ceremonial attire; who are extremely fond of tattoos and ornaments; who possess a tremendous urge for age-old artistic expression; whose arts, crafts, manners, and customs invariably have a magico-religious content; and whose homes, like their women, are always beautiful (a photographer's delight). They would not just "come" from somewhere but always "stem" or "hail" from it; their contact with their neighbors would be described as "exposure to the outside world"; their objects of everyday life would be classified as "utilitarian," "decorative," or "ritualistic"; everything they did in the past would be described as "authentic." Today, they would be seen in the midst of an identity crisis, their way of life "disintegrating with the inroads of modern, materialistic culture." Our job, of course, would be to protect them from this "menace." If a tribal artist would be seen responding to his contemporary environment in his art, to that extent it would be seen as a departure from tradition and therefore from authenticity.

Both in their vision and their practice, the so-called traditional craftsmen and folk artists have been open to adaptation of new materials and aesthetic norms: the nineteenth-century bazaar painters of Calcutta resorting to lithography against pencil drawing, exploring the possibilities of the newly introduced watercolor or probing photographic imagery; the hereditary metalworkers of Bengal absorbing the new technique of engraving to produce book illustrations; rural women painters of Bihar evolving new vocabulary to articulate their impressions of a visit to the United States (fig. 1); farmer women of Central India dressing their gods in the "United Colors of Benetton"; or a slum dweller of Delhi constructing from discarded plastic bottles of mineral water toy helicopters that carry prime ministers of India as passengers—each of these amply illustrates that tradition is not a static

Fig. I. Gange Devi, a village artist from the Indian state of Bihar, visited the United States in 1985, where she participated in an exhibition on Indian culture. On her return, she did a series of paintings based on her impressions of the U.S., of which this one depicts her experience of a ride on a roller coaster. Crafts Museum, New Delhi

entity. The bazaars of India are busy producing imagery for trucks and taxis, calendars and cinema billboards, casting in plaster and plastic images of film stars and deities with a sense of ease and humor. Perhaps to the distress of many protagonists of an imaginary pristine tradition, these popular images of deities command the same reverence as once did the celebrated Hindu sculptures of ancient India.

Tradition cannot be devoid of its contemporary manifestation. It cannot be conceived as somthing unalloyed, sterile, monolithic, or unilinear. Any museum concerning itself with Asian cultures cannot confine itself to ceaselessly reconstructing its imaginary "golden ages" in different permutations and combinations. It must take into account their evolving contexts and metaphors, their changing visual vocabulary that echoes their struggles and conflicts, their market-driven and politically oriented means of expression, their crumbling notions of aesthetics being replaced by new ones, filled with ironies—often accentuated by the very act of their being displayed in glass cases.

Colonial Aesthetics and the Transformation of Indian Objects

For George Birdwood, a bureaucrat-scholar in the India Office of the British Empire at the turn of the nineteenth century, "painting and sculpture as fine art did not exist in India."[3] However, he believed that the spirit of fine art was indeed latent everywhere in India, and it could be quickened through the art schools. The aim was to develop "applied" art and to improve artisanship with a view to encouraging trade in Indian handicrafts. In the British Indian context, all those working in the fields of painting, sculpting, wood-carving, weaving, or goldsmithing were dubbed as artisans or craftsmen, and since "fine art did not exist in India," they were all seen as people in need of scientific training in drawing, geometry, perspective, chiaroscuro, anatomy, ornamentation, etc. This brand of "scientific" approach, among other things, encouraged the production of colonial novelties—to scale miniature models

Fig. 2. Model of the Mangesh Temple, Goa, India, early twentieth century. Crafts Museum, New Delhi. This miniature ivory model is a typical example of an "Oriental" object inspired by the aesthetics of the colonial art schools in India, which emphasized high finish, labored detail, and "scientific" use of geometry and perspective.

of monuments carved in wood or ivory (fig. 2), latticework screens, ivory replicas of ceremonial boats, paisley shawls, decorative shields, and sheaths for swords and daggers. With this development, a sterile culture of tabletop decoration and glass-case display, hitherto unknown in India, was introduced, which was to have far-reaching consequences for the establishment of aesthetic norms of what were to become handicrafts, to be celebrated as exhibits and souvenirs and mass-produced and marketed in the whole of the twentieth century, before and after Indian independence. Smoking pipes, nutcrackers, lamps, incense burners, pots and pans of everyday Indian life, having an inherent specificity of materials, techniques, functions, beliefs, and practices, now began to be freely circulated all over the Western world as "art," anthropological specimens, and collectibles—a sort of entangled objects.[4] Living culture and practices were "museumized," documented, and packaged as "art" or "craft," "classical" or "folk."

The new scientific training brought a sea change in the character of the products that was in line with the taste of their European clientele. Eventually, the artisans, who were used to working in their own family-bound, hereditary environment, could not cope with the economic and other stresses of urban life and shunned the art schools. "The classes were, therefore, attended principally by boys and young men who had taken advantage of the literary education supplied by the government."[5] In this scheme of things, the notion of art with the artist as hero became connected exclusively with the art-school–trained artists, whereas the hereditary practitioners of the "arts" dubbed as artisans or craftsmen were left out of this hallowed category. At policy level, in independent India, this divide bracketed "art" with "culture" and "craft" with "commerce."

Industrial Reproduction and the Shifting of the Hindu Image into Exhibitory Space

Walter Benjamin speaks of the "cult value" and "exhibition value" of art in relation to ceremonial objects and comments that "with the different methods of technical reproductions of a work of art, its fitness for exhibition increased," that

"mechanical reproduction emancipates a work of art from its parasitical dependence on ritual," and that "instead of being based on ritual, it begins to be based on another practice—politics."[6]

The new generation of printed pictures of Hindu deities and mythological characters saw a whole range of amalgamated pictorial elements in the second half of the nineteenth century, especially relating to natural scenery and architecture, conventionalized in the tradition of the so-called "calendar art" or popular art. These attributes brought on to the picture plane a new visual appeal, which positioned the pictures between the cultic and the exhibitory space. Often placed against the background of watered-down Dutch and British landscape, or that of colonial Indian bungalows and villas as painted by the Indian academic realists emerging from within and outside the colonial art schools, the deities and mythological characters also began to be conceptualized in the costumes of the colonial theater heroes and heroines, adopting theatrical postures and gestures and bathing in the stage lights resulting in the peculiar theatrical chiaroscuro (fig. 3). Undoubtedly, the popularity of these pictures was rooted in the ideal (divine) landscape studded with flowering trees

Fig. 3. A popular painting produced in Nathadwara Rajasthan, India, around 1930 assimilates theater backdrop-like landscape and theater-character-like figures; the latter, cut out from popular oleographs of the period, clearly imitates a scene from the West-inspired Indian theater. Here the Hindu deity Krishna and his consort are shown listening to a gramophone. Collection of Jyotindra Jain

Fig. 4. This label for a bale of cloth from a mill in Glasgow depicts the Hindu god Krishna falling at his beloved Radha's feet to apologize for his flirtations with other women. Oleographic labels of this kind became popular in India as objects of domestic worship among the Hindus at the turn of the nineteenth century. Collection of Jyotindra Jain

and creepers, mountains, lakes, waterfalls, gardens, fountains, swans, and even colonial villas, all in one frame. This new picturesqueness shifted the Hindu cultic and mythological imagery from the exclusively cultic space to the more public exhibitory space. The mass proliferation of the sacred Hindu imagery caused by the techniques of mechanical reproduction emancipated the image from the narrow precincts of its sacred space and turned it into an immensely malleable artifact. Ever since, it has continued to cross borders (both ways) between the sacred and the profane, the caste-bound and the casteless, the spiritual and the political, and the canonical and the invented, in terms of its materials of construction, its objects and methods of veneration, and the locations of its installations.

Eventually, the printed popular imagery became the vehicle for marketing British products, leading to complete commodification of the sacred Hindu imagery by the end of the nineteenth century. The charm of the shiny, multichrome religious pictures became so irresistible for Indians at the turn of the nineteenth century and during the first half of the twentieth that several British, German, Swedish, Austrian, Italian, and Japanese companies began to produce Hindu religious pictures in various forms for export to India. Several textile mills in Manchester and Glasgow began to supply oleographic pictures with religious themes on the bales of cloth exported to India. People often bought British mill cloth to obtain these pictures free of cost. They framed, displayed, and worshiped them all over India (fig. 4). Some of the early-twentieth-century British multinationals, such as Glaxo, Lever Brothers, and Woodward, reproduced Hindu cultic images on their annual calendars. So coveted were these that even some of the most aristocratic families displayed them in their homes and worshiped them. In the first quarter of the twentieth century, European product labels and calendars became Hindu altars. Considering the great Indian market potential, Germany and Italy also began to produce similar pictures, "suitable for framing," in large quantities to export to India. Sweden, Austria, and Japan took

the lead in multichrome reproduction of Hindu mythological pictures on matchbox labels in the first half of the twentieth century.

Mechanically reproduced cultic imagery, once freed from its exclusive ritual function, attained immense popularity all over India and in the process became vulnerable to politics. Benjamin's prognosis literally came true in India almost seven decades after it was made. Today, images of political leaders conceptualized as Hindu deities, used for political propaganda, are a common phenomenon in India.

The Layered Space of the Museum

In the context of containing and explaining the world's art in museums, I am reminded of a point made by Duncan Cameron that there are two distinct museum-related stances: the traditional one, of the museum as temple, and a newer one, of the museum as forum.[7] To India, a country of temples, converting the institution of museum into a temple came naturally. In 1982, a large number of wooden figures of the cult of the Bhuta (deities and spirits of the dead), which were discarded from a shrine in the Indian state of Karnataka, were brought to the Crafts Museum in New Delhi. As the objects were cultic figures connected with the spirit of dead persons, none of the museum staff would agree to document or restore them. Finally, one staffer accepted the job, under government pressure. When he died prematurely within a year of starting the work, his wife and several employees of the museum attributed his demise to the wrath of the Bhuta deities. When I became director of the Crafts Museum in 1984, I noticed offerings being made to these and other images displayed in the museum by several museum employees. Treating exhibits as objects of worship is quite a regular feature in Indian museums. The notion of a museum as a modern space displaying objects of art and culture hardly ever took root in India as it did in the West. The museum in India remains an unfinished project to date. Incidents of common people holding museumized objects in reverence in India and elsewhere open up the question of ownership and control of cultural objects in the possession of museums and other exhibitory spaces, representing a dominant class vis-à-vis the vulnerable "Other," whose objects of worship have been plundered and museumized by the former. Cameron could not have found a more literal example of the museum adopting the role of a temple than this one.

Examples of the museum acting as a temple of art (which was actually the point made by Cameron) are also not lacking. Until the advent of tabletop display

and museumization of objects of everyday life in India in the nineteenth century, the craftsmen were utilitarians imbibing the changing materials and needs of the time. With the rise of museums as temples of culture, ordinary objects of everyday life, isolated from their cultural context, began to be aestheticized as art. Looking at the increasing demand for museum-like objects, the Indian craftsman began to produce replicas of such objects—lacking in function but high in decorative value. Museums began to determine the canon of aesthetic values and act as temples of art. This part of the story is rather too familiar and does not need restating here.

Of late, the museum in India is increasingly becoming a layered space with resurgent political, social, and religious interventions. In 1990, the director general of the National Museum in New Delhi served alcohol on the museum premises to a delegation of visiting Western dignitaries, an act to which the government objected on account of a certain regulation. Amazingly, a group of the museum staff even claimed that serving alcohol in a space that displayed Hindu deities violated their religious sentiment. Similarly when the cafeteria of the same museum began to serve meat in July 2002, the conservative Hindu faction represented by the Akhil Bharatiya Hindu Mahasabha (the All India Hindu Council) organized a public protest and burnt effigies of the museum's director for hurting their religious feelings. The council also demanded ritual purification of all the sacred objects and manuscripts that, according to them, were defiled due to serving of non-vegetarian food on the museum premises. This was despite the fact that several Brahmanic and Hindu deities are described in the canonical literature and mythology of the Hindus as given to blood sacrifice and consumption of intoxicating drinks. At the village-level Hinduism, meat and intoxicants are regularly consumed during religious ceremonies. The Hindu sect of the Shaktas (worshipers of the goddess Shakti) does not conduct any major ritual without consuming and offering alcoholic drinks.

It should also be noted that the majority of Hindu images displayed in the National Museum belonged to the classical or the canonical tradition, which required that the cultic image be ritually consecrated by an invocation ceremony before installation in a temple and be de-consecrated by another ceremony when removed. A broken image may not be worshiped. An image removed from the place of its original installation and reinstalled elsewhere requires a fresh ritual of consecration. Under the circumstances, the Hindu images displayed in the National Museum were not "living images," but a type deserted by the invoked spirits and

therefore not worthy of worship. The museum staffers were in the regular habit of sitting next to these images and smoking. The staff members and the visiting public (irrespective of their caste or creed) frequently touched these images. These acts would be considered sacrilegious by the Hindu scriptures. Considering these facts, the National Museum's staff objecting to serving alcohol or non-vegetarian food in a space where images of Hindu deities were displayed appears to be colored with politically inspired, resurgent reconstruction of the Hindu ethical ideology, one of the fora for its expression being the museum.

Another contest over the space of art in India is between the modern artists and their contemporary folk and tribal counterparts. The spaces of modern art, such as the National Gallery of Modern Art and the Academies of Fine Arts, as well as international modern art sites where modern Indian art is shown, are fiercely guarded against the entry of the living folk and tribal artists. In 1978, the works of several contemporary Indian folk and tribal artists were debarred by the Indian moderns from entering the Fourth Triennial of International Art, which took place in Delhi, on the grounds that "such art did not have anything in common with *contemporary* art."[8] Here contemporary stood for the universal modernist art, as practiced by a large number of Indian academic artists working in a variety of genres of the universal modern art practices (including one-way appropriation of the folk imagery by them), wherein the folk and tribal artists, even though reflecting their contemporary visual culture in their work, were excluded, as this work was not informed of the universal modernist tradition. The various levels of understandings or misunderstandings of these very universal modern art practices by the Indian academic artists are notwithstanding.

In 1989, the Centre Georges Pompidou, Paris, mounted the controversial exhibition *Magiciens de la Terre,* which brought together, on one platform, the works of universal modernists with those of the contemporary folk artists from the Third World. Deploring the unholy juxtapositions of "modern" and "folk," an Asian critic of modern art argued that the "Third World modern" could not be validly separated from the "Western modern," because the Third World had already "entered into the citadel of modernism" and asked: "can we say that the Third World is not affected by modern development?"[9] But the same critic was vehemently opposed to the idea of the contemporary works of folk artists being shown together with those of modern artists. Hierarchies of economic and social classes of makers and patrons of art and of aesthetic norms, which went hand in hand in India, provided the nineteenth-century European

art historians with a basis by which to classify Indian objects into art and craft, folk and classical, fine and applied. These also formed the basis for classifying Indian museums into those of classical art and others of the anthropological type. The classification was artificial and untenable, and therefore a conflict in the space of exhibitions has arisen, especially with the complexly evolving context of Indian cultural production acquiring its own voice. The Asian critic of *Magiciens de la Terre* was overlooking the fact that, like the "Third World modern," the "Third World folk" also is influenced by the modern developments (which are reflected in its artworks and in its desire to show them in the modern exhibition spaces) and on that ground should be accepted in the same "citadel of modernism." It is interesting that in this hierarchical structure, the "Third World moderns" question the hegemony of the "Western modern," but resist the entry of the "Third World contemporary folk" into the hallowed space of modern art.

The epigraph is from Nicholas Thomas, *Entangled Objects* (Cambridge: Harvard University Press, 1991), 4.

1. Edward W. Said in *Orientalism* (New York: Pantheon Books, 1978) as summarized by Inge Boer, "Orientalism," in *Encyclopedia of Aesthetics,* ed. Michael Kelly, 4 vols. (New York: Oxford University Press, 1998), 3:406–7.

2. James Clifford, "Four Northwest Coast Museums: Travel Reflections," in *Exhibiting Cultures,* ed. Ivan Karp and Steven D. Lavine (Washington, D.C.: Smithsonian Institution Press, 1991), 215.

3. Sir Richard Temple, *Oriental Experience: A Selection of Essays and Addresses Delivered on Various Occasions by Sir Richard Temple* (London: J. Murray Publisher, 1883), 485.

4. The phrase was originally used in Nicholas Thomas, *Entangled Objects.*

5. Partha Mitter, *Art and Nationalism in Colonial India: Occidental Orientations* (Cambridge: Cambridge University Press, 1994), 55.

6. Walter Benjamin, "The Work of Art in the Age of Mechanical Reproduction," in *Illuminations* (London: PIMLICO, 1999), 218–19.

7. Duncan Cameron, "The Museum: A Temple or the Forum," *Journal of World History* 14, no. 1 (1972): 197, 201.

8. Geeti Sen, "Fourth Triennale: Trials and Tribulations," *The Times of India, New Delhi,* 19 January 1978.

9. Rasheed Araeen, "Our Bauhaus, Others' Mudhous," in "Magiciens de terre," special issue, *Third Text* 6 (Spring 1989): 3, 4.

Around the Fourth World in Seventy Days: Art History and the Colonized Other

Cecelia F. Klein

The title of this essay should really have been "Around the Fourth World in Twenty-Three Hours," since that is exactly how much time an art history professor at UCLA, confined to a ten-week quarter system, actually spends in the classroom teaching a lecture course. Although this may seem like an exceptionally short term to academics used to a semester system, even semester-long courses on the arts of the Fourth World allow for only the most superficial and selective coverage. This is as true of more specialized courses as it is of comprehensive survey courses on Fourth World art. The material to follow, which traces the evolution of Fourth World art history programs at four American universities at which I have either studied or taught, attempts to document some of the ways in which academics have addressed this problem. Although I will take up these schools in the order in which I became involved with them, it happens that the first two institutions to be discussed, Yale University and Columbia University, were the first in this country to establish doctoral programs in the art history of one or more of the Fourth World areas. They should therefore be fairly representative of chronological and programmatic developments that have taken place on other campuses across the nation. Despite the fact that there are significant differences among these four programs, certain patterns can be discerned that shed light on changes in academic coverage of Fourth World art over the past nine decades.

My use of the term "Fourth World" differs from that provided by Nelson Graburn in 1976. Graburn defined the Fourth World as "the collective name for all aboriginal or native peoples whose lands fall within the natural boundaries and technobureaucratic administrations of the countries of the First, Second, and Third Worlds."[1] In the years following the fall of the Berlin wall, rapid economic growth in many former "Third World" countries, as well as the increasing globalization of culture and the progressive integration of many indigenous peoples into national politics, have blurred, if not erased, the boundaries separating the so-called "Worlds." Moreover, the Eurocentrism inherent in the concept has been exposed and denounced.[2] Graburn's definition of the Fourth World therefore is not only no longer meaningful but actually obscures the contemporary realities of the people he assigned to it.

In this essay I use the term "Fourth World" in a much more limited sense. In what follows, Fourth World will refer specifically to those peoples of formerly colonized status and dark(er than mine) skin color whose history and material culture have been traditionally excluded from or downplayed in (most) art history curricula by white Euro-American academics.[3] The limiting factor here is art history, since anthropology, in contrast, has long made these same peoples its stock in trade. Nor do I include in this category the majority of Asians, however orientalized by Western scholars they may have been. From the beginning, Asian art has played a larger role in university curricula and has enjoyed considerably higher status within the art establishment than have the arts of the indigenous inhabitants of the Pacific islands, all of Africa excluding Egypt, and the Americas, both north and south.[4]

As the preceding indicates, I do include under the Fourth World rubric the subjects of my own research, the Pre-Columbian ancestors of today's Latin Americans. Although academe currently distinguishes Pre-Columbian peoples (another misnomer) from Native North Americans and other groups formerly labeled "primitive," and although it has long assigned their culture a comparatively higher status, Pre-Columbian art, as we will see, was originally covered within so-called "primitive art" courses at some colleges and universities. Certainly, Pre-Columbian art has seldom been accorded the same praise by aesthetes and connoisseurs as has Asian art. Many U.S. colleges and universities staffed courses in Chinese, Japanese, and/or Indian art well before they deigned to consider inserting Pre-Columbian art into their curricula, and some of the nation's top art history departments with strong Asian art programs still do not regularly, if at all, offer courses in the Pre-Columbian field.[5]

Yale

One of the earliest Pre-Columbian courses to be taught in a U.S. art history department was offered at Yale, where in 1964 I took a summer job while still a student in the master's program in art history at Oberlin College. I was hired to work in Yale's slide library, now called the Visual Resources Collection, then headed by Helen Chillman, to identify and label a large collection of slides bequeathed to Yale by the Iberianist Martin Soria. Although most of the images were of Spanish art, identified by labels written in Spanish, others were photographs of unidentified Pre-Columbian Mexican objects. Fascinated by the Pre-Columbian pieces, I decided, with Chillman's blessing, to focus on them and, for a period of almost three months, buried myself in the stacks of Sterling Memorial Library. It was in the course of this reclusive

reverie, during which I first learned about the Pre-Columbian world, that I decided to study Fourth World art after obtaining my master's degree.

Yale was one of only four (out of four hundred) U.S. colleges and universities identified by Elizabeth Wilder, drawing on statistics on record at the Hispanic Foundation and the Library of Congress, as having offered courses on Latin American art during the academic year 1939–40.[6] Unlike the University of Minnesota, which offered "Modern Mexican Art" that year, and the University of Texas, which offered "Latin American Art," Yale offered two courses, one titled "Latin American Art" and the other, "The Art of America." The following year the University of Southern California joined the group with a single course offering, "Spanish Colonial Architecture." To judge by their titles, none of these courses dealt with art produced before the Spanish conquest of Middle and South America. Yale, however, had offered a course as early as 1938 on the "Art of South and Central America," which included the Pre-Columbian period. It had been taught by George Kubler, still a doctoral student at Yale at the time, who soon emerged as the nation's leading figure in the field. Although his mentors were all Europeanists (and some, European émigrés), Kubler was to break the mold by writing his dissertation, deposited in 1940, on the sixteenth-century architecture of New Mexico. During 1936–37, while supported by a fellowship, he had been introduced to Pre-Columbian art in a course on Mayan art taught at New York University by the anthropologist and Mayanist Herbert Spinden. Although he also lectured frequently at the Institute of Fine Arts, Spinden's primary position at the time was that of a curator at the Brooklyn Museum. Prior to that, he had held curatorial positions at the American Museum of Natural History (1909–20), the Peabody Museum at Harvard (1920–26), and the Buffalo Museum of Science (1926–1929).[7] The genesis of Yale's very strong Pre-Columbian art program today can therefore be ultimately traced to the social sciences and the museum world—not an uncommon development, as we will see.

Since Kubler's course theoretically covered not only the entire Pre-Columbian spectrum but the Post-Conquest period as well, its temporal scope, like its geographic range, was simply immense.[8] Perhaps for that reason, Kubler never taught any of the other so-called "primitive" fields, preferring to concentrate on Latin America, both Pre-Columbian and colonial. His department later hired an African art specialist, Robert Thompson, who still teaches at Yale, and for a period had an African American specialist on board as well. To my knowledge, however, Yale has never demonstrated curricular interest in the art of either Native North America or the Pacific Islands.

Instead of spreading itself over the entire Fourth World, then, Yale from the beginning chose to focus exclusively on only two fields. Moreover, at an early date it divided those fields into smaller, wieldier segments. By 1943 Kubler had replaced his "Art of Central and South America" course with two new, more specialized courses: "The Art of Middle America" and "The Art of South America." A third course in the series, "The Colonial Art of Latin America," which focused solely on the four hundred years from the Conquest to Independence, had been on the books since 1940.[9] In other words, Yale from the beginning not only distinguished Pre-Columbian art from the various so-called "primitive" art fields, but separated it from colonial Latin American art as well.

Columbia

Yale was exceptional in this regard, but at the same time, it was prophetic of a later trend in American universities. During the 1960s and 1970s, many of the schools offering courses on Fourth World art attempted to solve the pedagogical problems posed by the large geographical areas and long time spans to be covered by adding faculty and more, and more tightly focused, courses. By 1965, when I entered the doctoral program in "primitive art" at Columbia University, this strategy had already prevailed. Columbia's department of archaeology and art history had two Fourth World specialists on board, Paul Wingert and his former student Douglas Fraser, who became my advisor. Both were offering a full complement of courses that ranged from African to Oceanic to Native American to Pre-Columbian art. The department had (and still has) no curricular interest in colonial or, for that matter, modern Latin American art.

As the preceding indicates, Columbia differed from Yale at the time in manifesting an interest in the art of all Fourth World fields. Like Yale, however, it owed much of that interest to developments and individuals teaching in the social sciences, specifically anthropology. Columbia's interest in Fourth World art, however, goes farther back in time. Although he appears never to have taught a course specifically devoted to Pre-Columbian art, Marshall Saville, who was Columbia's Loubat Professor of American Archaeology from 1903 to 1918, annually offered a course on the "Archaeology of Mexico and Central America" that undoubtedly included Pre-Columbian art. If so, it represents the separate treatment of Pre-Columbian art at a very early date. Saville was very interested in Mesoamerican art and wrote several major studies on specific aspects of Mixtec and Aztec art.[10] Like Spinden, an example of the close ties between the museum world and academic

anthropology at the time, Saville had been a curator at the American Museum of Natural History.

As early as the academic year 1914–15, the Columbia department of anthropology was offering a course titled "General Ethnology—Technology and Primitive Art."[11] This course apparently covered material drawn from a broad range of Fourth World cultures. That year it was taught by Alexander Goldenweiser, who had received his doctorate in anthropology from Columbia in 1910. Goldenweiser most likely had studied with Franz Boas, who had joined the anthropology faculty at Columbia in 1896, becoming a full professor in 1899. Boas's keen interest in "primitive" art is well documented; in 1927 he published a book with that title, one of the first books devoted exclusively to the subject.[12] Although the points argued in *Primitive Art* were theoretically applicable to the art of many Fourth World peoples, the book focuses on the art of the native peoples of the Northwest Coast and southeast Canada, where Boas had done fieldwork in the 1880s. For ten years, between 1895 and 1905, Boas also held the position of curator in the anthropology department of the American Museum of Natural History in New York, being yet another example of the early ties between academic anthropology and the world of museums and collections.[13]

Goldenweiser's commitment to teaching "Technology and Primitive Art" was apparently shared by other faculty in his department, for in the academic year 1916–17, the course was taken over by Pliny Goddard, another Columbia alumnus. Since Goddard had earned his doctorate in 1904 from the same department, he, too, may have been influenced by Boas. In any event, he continued to offer the course until his death in 1929.

In 1924–25, Goddard was joined in his attempts to cover Fourth World art by Gladys Reichard, who created a new course entitled "The Art of Primitive Man." This course, which was as broadly conceptualized as Goldenweiser and Goddard's course, was cross-listed with what was then called the department of fine arts. Reichard had recently become an assistant to Boas, who in 1926–27 taught the course himself.[14] Since the course returned the following year to Reichard, Boas may have stepped in just for that year because Reichard was on sabbatical or leave.

The Columbia anthropology department's offerings in "primitive" art became more specialized in the 1930s. In 1936–37, for example, Franz Olbrechts was brought in to teach a new course on African art. At the same time, what was by then called the Department of Fine Arts and Archaeology—to become the Department of Art History and Archaeology in 1960—began to offer its own courses on Fourth World

art.[15] For the summer session in academic year 1940–41, it imported George Kubler from Yale to teach two more specialized courses on Pre-Columbian art, one that dealt exclusively with "Central American Art Before the Spanish Conquest" and one that focused on the "Pre-Conquest Art of South America." During this same term, a course titled "Primitive Art and Its Contributions to Modern Art" was offered by Wingert, who, having received his master's and doctoral degrees from Columbia, was initially hired into the department in 1935 to serve as a curator.

Until the disruptions of World War II, which made fieldwork in France untenable, Paul Wingert had studied the art of the French Renaissance.[16] His interest in the influence of "primitive" art on modern art was paralleled by that of his young colleague at Columbia, the medievalist Meyer Schapiro, who was also an early champion of "primitive" art. Schapiro's interest in the formal similarities of Fourth World art and modern Euro-American art is documented in his classic 1952 essay on "Style."[17] Wingert must also have known his counterpart and rival at New York University, Robert Goldwater, whose NYU dissertation was first published in 1938 as *Primitivism in Modern Art* and who occasionally wrote on sub-Saharan African art.[18] Like Goldwater, Wingert was a connoisseur and collector of objects crafted in Africa. His scholarly work on Fourth World art ranged, however, from African art to the wooden figure sculptures and masks of the Northwest Coast Salish Indians, to the art of the Pacific Islands. Willing and able to work across disciplinary borders, he frequently collaborated with the archaeologist Ralph Linton, who had joined Columbia's department of anthropology in 1937. Together, Wingert and Linton strengthened the academic ties between their two departments and collaborated on a number of projects, including an important survey of art styles in the Pacific.[19]

Wingert, in some ways, became Boas's unofficial successor in promoting the art of Fourth World peoples, publishing in 1962 a book with the same title as Boas's, *Primitive Art*.[20] Like Boas, Wingert excluded Pre-Columbian art from his book, but, in addition to teaching courses on Oceanic art, American Indian art, and African art, he offered a course on Pre-Columbian art. His students, although they specialized in one of these four fields, were expected to take all of these courses, thereby establishing a precedent for the academic practice, common during the next two decades, of expecting "primitive" art historians to know and be able to teach Pre-Columbian art.

The problem of scale that Kubler had faced with his "Art of America" course was inherent in all of Wingert's courses as well. The Pre-Columbian course,

for example, theoretically covered all of Central and South America prior to European conquest, but of necessity could impart only a small sample of the appropriate material. Wingert, however, like many "primitivist" academics of his day, addressed the obstacles presented by the vast temporal and geographic range of his material not by splitting up his course, as Kubler had done, but by delimiting his subject matter and approach to the material. Not only did he choose to focus solely on the description and stylistic genealogy of objects rather than on their historical context and meanings, but he also presented students with only those objects that he regarded as aesthetic "masterpieces." In addition, as in all his other courses, Wingert a priori eliminated all artworks produced during and after European contact, especially those made for sale to Europeans. These objects, in Wingert's view, did not deserve to be considered as either "primitive" or "art" because they were, in his opinion, "contaminated."

By the time I arrived in 1965, Columbia had tenured Fraser. More courses were added and specialists in specific areas were brought in on an ad hoc basis. For example, the German ethnologist Hans Himmelheber arrived for a semester to teach a graduate course on the art of the Alaskan Inuit (Eskimos) and another course on the art of the Dan people of what was then Liberia. The Mesoamerican archaeologist Gordon Ekholm, who was curator of Central and Southern American culture at the American Museum of Natural History, was brought in one summer to teach the Pre-Columbian art course. Several years later, in 1971, Columbia hired my former Columbia classmate Esther Pasztory to set up a Pre-Columbian program; she now holds a chair at that institution. Like me, Pasztory still covers both Central and South America in her courses, but, unlike Kubler, she has never taught courses in colonial Latin American art, nor has Columbia ever hired a colonial Latin Americanist.[21]

Since Fraser's death in 1983, Columbia has focused its program even more sharply. Yet another of Fraser's former students, Suzanne Blier, was hired shortly after his death to cover Africa. Until her departure to teach at Harvard in 1993, Blier, like Pasztory, also advised graduate students working on Oceanic and American Indian art. Teaching the courses on these subjects, however, was left to specialists such as George Corbin, working on the Pacific Islands, and Aldona Jonaitis, a Native American art historian, who were brought in from time to time for just that purpose. This situation continued during the time that Zoe Strother, who had been trained at Yale by Robert Thompson, taught African art at Columbia as its replacement for Blier. Upon Strother's resignation to move to UCLA in 2000, Columbia readvertised its African art position with no mention of the other Fourth

World fields. Thus, Columbia, which originally diversified its Fourth World offerings in an attempt to cover all of the Fourth World's constituent fields, eventually moved away from attempting comprehensive coverage to concentrate, like Yale, on Africa and Pre-Columbian America.

Oakland

Upon receiving my doctorate from Columbia in 1972, I took an assistant professorship in the department of art and art history at Oakland University in Rochester, Michigan, which I held until I left to teach at UCLA in 1976.[22] Oakland already had a tradition of offering courses in Fourth World subjects, thanks to my predecessor there, John Galloway, who had died two years earlier. Galloway, although originally trained as an Americanist, had been a student of both Wingert and Schapiro at Columbia, where he wrote his dissertation on the "Stone Sculpture of the North American Indian.[23] He acquired further knowledge of both modern and "primitive" art while working in several European countries as a senior research scholar under the Fulbright Act. Thereafter, he taught at the American University, the University of Alabama, Indiana University, and Southern Illinois University. Like many "primitive" art historians of his day, Galloway collected art and was himself an artist, having received his B.A. in painting; he continued to paint throughout his life. His writings range widely over the art historical landscape, but his major contribution to Fourth World scholarship is the book coauthored with Luis Pericot-García and Andreas Lommel entitled *Prehistoric and Primitive Art,* which was published in 1968.[24] Although these two fields were frequently linked at the time, this is seldom the case today, the nineteenth- and early-twentieth-century view that all so-called "primitive" peoples are living remnants of the Paleolithic and Neolithic past having lost all credibility.

When Galloway arrived at the campus in 1960, the name of the university was Michigan State University Oakland, the school having been founded as a member of the Michigan State University system. During his first year there, Galloway taught a course entitled "The Art of Primitive Man," which he quickly changed to "Primitive Art" in the following year. Galloway offered that course almost every year thereafter until his death. His only other Fourth World offering during that period was "The Art of Negro Africa," a course that Galloway offered only once, during academic year 1968–69, four years after the university left the Michigan State University system and shortened its name to Oakland University.[25] Presumably, Galloway did not devote any additional teaching time to the Fourth

World because he was regularly offering courses in studio art including painting, as well as a number of art history seminars, the department's introductory art history course, and a course on twentieth-century art.[26] During the winter quarter of 1965, he offered a course on Greek and Roman art and a seminar on Classical art. The extraordinarily wide range of Galloway's interests and expertise is further reflected in the course description of his "Art of Primitive Man (Primitive Art)" course, which states not only that the course covered "the major artistic styles of Africa, Oceania, and the Americas," but that "influences of primitive art upon recent Western art" were also considered.

Shortly before Galloway's death, the department hired an Asianist, Ralph Glenn, who offered a course in "Oriental Art" almost every year thereafter until he left Oakland in 1975. Glenn added a course on "Chinese Art" in the winter of 1971, and one on "The Art of Japan" in the fall of the same year. Like Galloway and the other department faculty, he assisted with the introductory survey course and occasionally offered more specialized upper-level "problems" courses on topics not always in his field. While at Oakland, I shared some of this responsibility for the more general and required courses, regularly teaching a course in modern art and periodically offering the introductory survey. Nonetheless, like Glenn, I quickly developed new courses in my areas of expertise as well. I eliminated Galloway's "Primitive Art" course, breaking it up into five new lecture courses. The first of these, "African Art," which replaced Galloway's "The Art of Negro Africa," was first offered in the fall of 1972. "Pre-Columbian and American Indian Art" made its debut in the winter of 1973. This was followed, in the fall of that same year, by a lower-division survey of the art of Africa, Oceania, and the American Indian. "Oceanic Art" was first offered during the winter of 1974, while I did not teach my specialty, "Pre-Columbian Art," until the fall quarter of 1975. At some point I also agreed to supervise the research of a student interested in what was then referred to as Afro-American art. I left Oakland, exhausted, shortly after being asked to develop a course on "women's art," with the realization that I had come to be seen as the department's chief expert on the "Other," regardless of whether the "Other" was of the Fourth World or not.[27]

UCLA

When I arrived at UCLA in 1976, all of the Fourth World areas, as well as Islamic, Japanese, Indian, and Chinese art, had already been covered for some time. The earliest Fourth World courses appear in the 1957–58 general catalogue, which reveals

that a course on "The Art of Prehistoric and Primitive Cultures" was taught that year by the Japanese art historian John Rosenfield. A second course, "Art of the Americas I," was also on UCLA's books in 1957–58, although it was not offered that year and no instructor's name is listed. Presumably there was an "Art of the Americas II," as well. Thus, although it was already covering a large part of the world map, UCLA originally followed the trend of dealing with the Fourth World by offering a very small number of courses, each of which theoretically covered a vast amount of material.

The situation improved in 1956, when Ralph Altman was appointed lecturer-in-art at UCLA. By 1958–1959, Altman, an art collector, dealer, occasional exhibition curator, and self-trained specialist in "primitive," prehistoric, and "folk" art, was listed in the school's catalogue as the sole instructor of its Fourth World art history courses. By 1960–61, he had instituted two new courses, an undergraduate lecture course called "Pre-Columbian Art II" and a graduate course called "Primitive Art."[28] After 1963 Altman shared his time between teaching and serving as curator of UCLA's newly formed Museum and Laboratories of Ethnic Arts and Technology (now the UCLA Fowler Museum of Cultural History), where he labored successfully to expand the collection. Despite his heavy workload, having dropped the old "Prehistoric and Primitive Art" course in 1966, Altman had, by 1968, split "Primitive Art" into three new, more specialized courses, each given a separate course number within a series.[29] Altman, in other words, like his counterparts at Yale, Columbia, and Oakland, was trying to find better ways to cover the wide range of material for which he was responsible by creating ever more focused, more specialized courses.[30]

Altman died in 1967, at which time Arnold Rubin, trained as an African art historian by Roy Sieber at Indiana University, joined the UCLA faculty. Rubin took over all of the Fourth World courses in that department, including the Pre-Columbian courses, but immediately added a course on Oceanic art, a course on the "Arts of Native North America," and four new courses on the art of Africa. In 1976, he introduced yet another new "survey" course called "Africa, Oceania, and Native America." This was really the old "Primitive Art" course with a more politically correct name, and it therefore preserved many of the latter's colonialist flaws in conceptualization and structure. My department has since replaced it with a more focused "Introduction to African Art" course.

The proliferation of Fourth World courses during the 1970s was due in part to my arrival on the UCLA campus in 1976. I had been hired by UCLA with the understanding that I would not only take over and augment the Pre-Columbian

offerings, thereby relieving Rubin of the field he knew least well, but also share with him the responsibility for the Oceanic and Native American fields. I perceived the move as highly advantageous to me, not only because of the stellar reputation of and resources at UCLA, but also because it allowed me to shed all responsibility for teaching African and Euro-American art, thereby leaving me more time to concentrate on my other three fields.

After arriving at UCLA, I learned that the department's decision to add a Pre-Columbianist, as opposed to an expert in one of the other Fourth World areas, had been heavily influenced by the pedagogical vision of its intellectual and political leader, Otto Karl (O. K.) Werckmeister, who until recently held a chair at Northwestern University. Werckmeister is, as Schapiro had been at Columbia, a medievalist who also works in the modern period. Like the younger Schapiro, he was (and still is) a Marxist. Werckmeister and his students envisioned a progressive art history department that, unlike other university art history programs at that time, would fully recognize, on an equal basis, all of imperialist Euro-America's dispossessed "Others."[31] Werckmeister therefore falls into the category of academics who initially supported creating room for the Fourth World in their department's curriculum so it could serve as a moral foil or complement to Euro-American art, particularly that of the modern era. Although the so-called "non-Westerners" in my department did not always conform to Werckmeister's expectations, the fact that UCLA today has the largest "non-Western" art history program in the country can be credited in part to Werckmeister.

Upon my arrival at UCLA, I naturally increased the number of undergraduate and graduate courses in Pre-Columbian art, in addition to assuming partial responsibility for teaching Oceanic and Native American art. After Arnold Rubin's death in 1988, the remaining education of his students was taken over by Herbert Cole, Rubin's counterpart at our sister campus in Santa Barbara. My department continued to staff Rubin's courses with visiting African specialists, however, and in 1999 finally hired two Africanists to replace him: Zoe Strother, who had been teaching African art at Columbia following Blier's departure, and Steven Nelson, a former student of Blier who had been teaching at Tufts University. In the same year, we also hired our fifth Asian art historian and our third Latin Americanist.[32]

I took on full responsibility for the Oceanic and Native American fields after Rubin died because, until a few years ago, there were few places in this country where an interested student could acquire a doctorate in those fields. Since there are now quality graduate programs in these fields at other universities, however, I

have ceased accepting students who want to work in them. Thus, like Yale and Columbia, UCLA has opted to sacrifice some Fourth World art areas in favor of letting specialists concentrate exclusively on others. I now teach only courses on Pre-Columbian art, which are arranged in a series beginning with an introductory survey, "Introduction to Pre-Columbian Art," followed by three cross-listed upper-division courses, one on Mexico, one on the Maya, and one on the Andean region of South America. Yielding to the pressure to replace breadth with depth, several years ago I also introduced an advanced course on my research area, the art of the Aztec peoples of Central Mexico.

Although this constitutes the narrowest range of courses that I have ever offered, willingness to cover all of these areas is increasingly rare among Pre-Columbian art historians. Universities are now turning out Mayanists who know little about Mexico, Mexicanists and Mayanists who know nothing of South America, and Andeanists equally minimally informed about Mesoamerica. I have vowed never to constrict my own range in this manner, but it is getting harder to keep that vow, as the literature for each of those areas balloons exponentially.

Despite the trend toward multiple appointments in Fourth World subjects and the increasingly narrow scope of Fourth World courses, those subjects, together with Asian art, are still the least apt to receive adequate coverage at UCLA. This can be seen by taking a look at my department's course requirements for its under-graduate majors. At UCLA, which prides itself on its Fourth World and Asian art course offerings, all undergraduate art history majors are required to take at least five courses in a "non-Western" field. This occurs because undergraduate art history majors must take, in addition to five courses in what it calls "Group A" (which in-cludes the various countries and time periods usually referred to as "Western"), five additional courses from "Group B," a euphemism for "non-Western." Group B in-cludes courses on the art of Africa, Oceania, Native North America, Pre-Columbian America, and most of Asia, including China, India, Southeast Asia, Korea, and Japan. Students may count Islamic art, which knows few geographic boundaries, as either a "Western" or a "non-Western" field as they see fit.

In addition to these courses, a UCLA art history major must elect five other courses, which may be drawn from any field or fields, regardless of category. However, even if a student fulfills all five of his Group B requirements with Fourth World courses, eschewing Asia altogether, and takes all five of his elected courses in the same fields, he or she will have taken no more than ten Fourth World courses by the time of graduation. These ten courses will have equaled a grand total of no

more than 230 hours of class time spent in studying the art of the Fourth World. This, of course, applies for Group A as well. There is an enormous difference, however, between the number of broad geographic regions and highly distinctive cultures to which Group A courses expose the student—by definition, essentially one region and one culture—and the number encountered in Group B courses. Moreover, many of the courses in Group A focus on a single country or period in European or (North) American history, periods that at times are restricted to one hundred years or less. The obvious imbalance between Group A and Group B therefore necessitates a far more superficial coverage, or "compression," of the material in Group B courses than for courses in Group A. This imbalance is paralleled, if not greater, in virtually every college or university art history program listing Fourth World courses among its offerings.

At UCLA, at least, this imbalance has significant repercussions. My highly specialized course on Aztec art, for example, enrolled seventy students the last time I taught it, with at least a dozen more turned away due to lack of seating. My most recent Maya art course was closed, with students turned away, when undergraduate enrollment reached eighty, with eight graduate students signed up as well. For such highly specialized courses, this is a large enrollment at UCLA. It is typical, however, of the growing demand for all of our Latin American art courses.[33] Much of this popularity can be attributed to the relatively large number of Latino students who are enrolling here. During the academic year 1999–2000, Latinos constituted 13.6 percent of the student body, making them the third largest ethnic group on the campus (the largest being not whites, but Asian Americans).[34] Moreover, they represent the largest so-called "minority" in Los Angeles, one that within a few years will be larger than any other group, including whites.

Latinos, however, like Chicanos, come to the classroom with a quite different agenda than that of the mostly white students who took my courses in the 1970s and 1980s, and my course offerings and teaching goals have had to be modified accordingly. Latinos are often seeking a cultural identity and an in-depth knowledge of their heritage, in particular the history of their people and a better understanding of what their ancestors really did and did not do, and why. What they seek, in other words, is a valid, detailed accounting of large segments of the human story that are just now coming to be known and understood. Certainly, there is no way to satisfy these longings with a class that meets for two and a half hours a week for only ten weeks.

The full answers to these students' questions—where we know them, of course—depend on exactly where a student's ancestors lived and when. For example,

the history of the Pre-Columbian Maya tells a Peruvian virtually nothing about his own people's past, and to homogenize the art traditions of the two areas under the vague rubric of "Pre-Columbian art" simply carries into the present all the old, primitivist sins and misunderstandings of the past. An Italian or Italian American at UCLA who is interested in fifteenth-century Florence has the luxury of a course devoted exclusively to the art of fifteenth-century Italy, whereas a Peruvian interested in fifteenth-century Cuzco must persevere through six thousand years of Andean art spread over what are today four comparatively large South American countries. Thus, although we no longer pretend to cover the entire Fourth World in a single course, and our courses are increasingly focused, what we who teach in any of the Fourth World fields cannot do is justice to the "history" in "art history."

Conclusion

The biographical and historical approach I have taken in this essay is intended to illustrate my main point. It will have taken the average reader approximately twenty to thirty minutes to read this essay, and thus to grasp some sense of the sequence and significance of curricular developments in Fourth World art as taught at only four universities in the United States alone. These developments have occurred over the course of little more than sixty years. Yet what I have reported here is but a sound bite compared to all there is to know about the subject. Imagine, then, the difficulty faced in trying to attain comparable goals within only twenty-three hours in the classroom, when the subject is thousands of art objects produced over the course of thousands of years in large regions of the world. These artworks were or are produced by peoples speaking diverse, typically mutually unintelligible languages, and usually having very different beliefs, customs, and experiences.

I have tried to show in this article that, at all four of the universities where I have either studied or taught Fourth World art, there has been an attempt from the beginning to steadily "decompress" this vast body of material. This has been done by means of increasingly restricting the range of the subjects offered; emphasizing one aspect of the material, such as form or context, at the expense of others; hiring more faculty, often specialists in diverse fields; and offering more, and more specialized, courses. These efforts have been made toward the end of better "expressing," in the classroom, the complexity, historical depth, and cultural context of these diverse art traditions. Nonetheless, after six decades of curricular improvements, the problem is by no means even close to being solved. Even in those departments where the arts of the Fourth World have been accorded a compara-

tively large space in the curriculum, the manpower and class time available for teaching Fourth World art is still far less than that reserved for the arts of white Euro-America.

This paper could not have been written without the aid of my research assistant, Michelle Wang, who put in many hours locating, photocopying, and analyzing UCLA and Columbia University course catalogues. I am also grateful to my former Oakland University colleague John Cameron for supplying me with photocopies of relevant pages from old Oakland course catalogues. George Corbin, Eileen and Michael Tennor, and Jean Galloway graciously shared with me their memories of Oakland University.

1. Nelson H. H. Graburn, ed., *Ethnic and Tourist Arts: Cultural Expressions from the Fourth World* (Berkeley: University of California Press, 1976), 1.

2. On problems with concepts of the First, Second, and Third Worlds, see Ella Shohat and Robert Stam, *Rethinking Eurocentrism: Multiculturalism and the Media* (New York: Routledge, 1994), 13–55, and Vinay Bahl and Arif Dirlik, "Introduction," in *History after the Three Worlds: Post-Eurocentric Historiographies,* ed. Arif Dirlik, Vinay Bahl, and Peter Gran (New York: Rowman & Littlefield, 2000), 3–23.

3. By "white Euro-American academics," I mean white academics descended from European ancestors who have taught at European or North American colleges or universities.

4. For an excellent study of the museological and academic history of Asian art history, see Warren I. Cohen, "The East Asian Art Historians," in *East Asian Art and American Culture: A Study in International Relations* (New York: Columbia University Press, 1992), 155–252. Cohen does not state when or where Asian art was first taught in an American university art history program, but claims (p. 160) that the German émigré Ludwig Bachhofer, "the first major academic art historian in the United States to specialize in Asian art," arrived at the University of Chicago "even before the rise of Hitler." Since George Rowley "taught Chinese art and served as curator of the Far Eastern collection at Princeton from 1925 to 1960" (p. 167), Cohen must mean that Bachhofer was at Chicago before 1925. East Asian art studies, according to Cohen, "had advanced to the point where specialization seemed necessary" by the late 1950s (p. 181) and grew "exponentially" in the 1960s (p. 155). Both of these developments predate by approximately a decade their counterparts in Fourth World art studies.

5. The major universities still lacking a Pre-Columbianist on their art history ladder faculty are: Stanford University; University of California, Berkeley; Harvard University; University of Michigan; and Princeton University. All have ladder faculty teaching Asian art history, however. Harvard is currently trying to recruit a Latin Americanist to teach art history.

6. Elizabeth Wilder, "Call for Pioneers," *College Art Journal* 1, no. 1 (1941): 6–9.

7. Thomas Reese, "George A. Kubler: An Intellectual Biography," unpublished manuscript in the author's possession, 4–6; J. Eric S. Thompson, "H. J. Spinden (1879–1967)," in Herbert Spinden, *A Study of Maya Art: Its Subject Matter and Historical Development* (New York: Dover Publications, 1975), v–x [reprint of the 1913 original published by the Peabody Museum, Cambridge, Mass., as vol.

6 of the Memoirs of the Peabody Museum of American Archaeology and Ethnology, Harvard University].
Thompson wrote that Spinden was more of an art historian than an archaeologist, "having studied
the art of various early or primitive cultures long before public interest in that field was aroused."

8. Reese, "George A. Kubler," 5.

9. Ibid. The third course, "Problems in American Art," was apparently topical.

10. See the following by Marshall Saville: "An Onyx Jar from Mexico in the Process of Manufacture,"
Bulletin of the American Museum of Natural History 13 (1900): 105–7; "The Goldsmith's Art in Ancient
Mexico," in *Museum of the American Indian, Heye Foundation, Indian Notes and Monographs* 7 (1920);
"Turquoise Mosaic Art in Ancient Mexico," in *Contributions from the Museum of the American Indian,
Heye Foundation,* 6 (1922); and "The Wood-Carver's Art in Ancient Mexico," *Contributions to the
Museum of the American Indian, Heye Foundation* 9 (1925).

11. This and all following information on Columbia University course offerings in anthropology are
derived from university course catalogues.

12. The 1940 edition of Leonard Adams's *Primitive Art* was reprinted, revised, and enlarged in 1949
by the original publisher (Penguin Books, Harmondsworth, Middlesex, U.K.).

13. On Franz Boas as educator and museologist, see Aldona Jonaitis, "Introduction: The Development
of Franz Boas's Theories on Primitive Art," in *A Wealth of Thought: Franz Boas on Native American Art,*
ed. Aldona Jonaitis (Seattle: University of Washington Press, 1995), 3–37; Aldona Jonaitis, "Franz Boas,
John Swanton, and the New Haida Sculpture at the American Museum of Natural History," in *The
Early Years of Native American Art History: The Politics of Scholarship and Collecting,* ed. Janet Catherine
Berlo (Seattle: University of Washington Press, 1992), 22–61; and Ira Jacknis, "Franz Boas and Exhibits:
On the Limitations of the Museum Method in Anthropology," in *Objects and Others: Essays on Museums
and Material Culture,* ed. George W. Stocking (Madison: University of Wisconsin, 1985), 75–111.

14. Reichard became an assistant to Boas in late 1923.

15. The Department of Fine Arts changed its name to the Department of Fine Arts and Archaeology
in 1934. See Julius S. Held, "History of Art at Columbia University, in *The Early Years of Art History
in the United States,*" ed. Craig Hugh Smyth and Peter M. Lukehart (Princeton: Department of Art
and Archaeology, Princeton University, 1993), 81.

16. "Paul S. Wingert, Art Historian, 74" (obituary), *New York Times,* 14 Dec. 1974.

17. Meyer Schapiro, "Style," in *Anthropology Today: Selections,* ed. Sol Tax (Chicago: The University
of Chicago Press, 1962), 278–303 (first printed in 1952). For information on Schapiro's appointment
to Columbia's faculty, see Held, "History of Art," 80.

18. An enlarged edition of Goldwater's book was published in 1966 by the Belknap Press of Harvard
University Press (Cambridge). On the appointment of Robert Goldwater to NYU's faculty, see Craig
Hugh Smyth, "The Department of Fine Arts for Graduate Students at New York University," in *The
Early Years of Art History in the United States,*" ed. Craig Hugh Smyth and Peter M. Lukehart (Princeton:

Department of Art and Archaeology, Princeton University, 1993), 77.

19. Ralph S. Linton and Paul S. Wingert, in collaboration with René d'Harnoncourt, *Arts of the South Seas* (New York: The Museum of Modern Art, 1946).

20. Paul S. Wingert, *Primitive Art: Its Traditions and Styles* (Cleveland: Meridian Books/The World Publishing Co., 1962).

21. This is not to say that Pasztory has never trained a student whose dissertation research and/or subsequent work entailed the study of colonial art. Eloise Quiñones Keber, who studied under Pasztory, for example, wrote her dissertation on the early-sixteenth-century Central Mexican painted manuscript known as the Codex Telleriano-Remensis and has since published extensively on that and other colonial Mexican manuscripts. See Eloise Quiñones Keber, *Codex Telleriano-Remensis: Ritual, Divination, and History in a Pictorial Aztec Manuscript* (Austin: University of Texas Press, 1995).

22. The name of this department, when it was established in 1963, was the Department of Art; it was later changed to the Department of Art and Art History.

23. Galloway received his B.A. and M.A. from American University before going to Columbia for his doctorate. This and additional information comes from a promotional brochure for Galloway's book *Modern Art,* published by Wm. C. Brown Company, and Albert Elsen's essay "John Crozier Galloway, 1915–1970," in *John C. Galloway Retrospective Exhibition: Paintings, Drawings, and Collages* (Rochester, Mich.: The University Art Gallery, Department of Art, Oakland University, 1970), n.p.

24. Luis Pericot-García, John Galloway, and Andreas Lommel, *Prehistoric and Primitive Art* (New York: Harry N. Abrams, 1968).

25. All information on course offerings at Oakland University are derived from Oakland University records of the registrar and/or course catalogues. Galloway's "The Art of Negro Africa" course appears only in the Oakland University records of the registrar, having never made it into the general catalogue.

26. George Corbin, an Oceanic art specialist who later went on to Columbia to earn his doctorate under Wingert's tutelage, was Galloway's first student at Oakland (George Corbin, personal communication, 2000).

27. A course on "Women in Art" was eventually created and offered by Jan Schimmelman, an Americanist, in 1978. For the academic year 1975–76, with the departure of Ralph Glenn, the department hired another Asianist, Carla Zainie, who changed the title of "Oriental Art" to "Introduction to Asian Art" and created a new course on "Buddhist Art." "Japanese Art" became "Introduction to Japan." Zainie left Oakland the same year I did, whereupon Asian art went untaught there for several years. I was immediately "replaced," in 1977, by Charlotte Stokes, who continued to offer the "African, Oceanic, and American Indian Art" course but, to my knowledge, none of my more specialized Fourth World courses. She has since left Oakland as well.

28. Because the course numbers in the catalogues continually changed during these years, it is impossible to know exactly how many separate courses on Pre-Columbian art Altman was teaching,

but it appears that he initially split his material into at least two courses.

29. The first course in the "Primitive Art" series was Art History 118A. The second was given the number 118B, and the third, 118C.

30. Altman left medical school in Germany in 1937 in the face of Nazi threats and eventually opened a shop on La Cienega Boulevard in Los Angeles, where he sold eighteenth-century furniture and a few pieces of "primitive" and "folk" art. Before his death in 1967 he published a number of exhibition catalogues on topics ranging from African "Negro" art to Pre-Columbian goldwork, Mexican "Folk" art, and the history of puppetry. This breadth of interests paralleled his teaching, which, according to his biographer, "included the whole sweep of primitive art, folk art, and ancient art," as well as the art of the prehistoric period. See Jay D. Frierman, "Ralph C. Altman (1909–1967)," in *Ralph C. Altman Memorial Exhibition: The Museum and Laboratories of Ethnic Arts and Technology, UCLA* (Los Angeles: The Ethnic Art Galleries, University of California, 1968), 6–9. Like the other "primitivist-connoisseurs" of the time, Altman's approach was essentially descriptive and formalist. None of these men appears to have done any fieldwork outside the U.S. or Canada, nor did they do archival research, to my knowledge.

31. Shortly after I arrived in Los Angeles, UCLA added to its roster a Chinese art historian, Martin Powers, bringing the number of its Asianists to three. It also replaced its retired Islamicist, Katarina Otto Dorn, with a younger Islamicist, Irene Bierman, and its retired Indianist, LeRoy Davidson, with one of Davidson's former students, Robert Brown. Brown, although he knows and teaches Indian art, specializes in the art of Southeast Asia, so his arrival broadened the range of our offerings even further.

32. The Asian fields currently covered at UCLA are: India, Southeast Asia, China, Korea, and Japan. David Kunzle teaches a lecture course on (modern) political art in Latin America, as well as occasional seminars on revolutionary Latin art. Charlene Villaseñor Black, whose specialty is Spanish Baroque art, also shares with me the coverage of the colonial period.

33. This is an extreme case of what is becoming a national trend, as the job market for Pre-Columbianists and colonial and modern Latin Americanists has expanded dramatically. This year the College Art Association's October job listing, which in previous years has contained an average of three to four Latin American art history openings, advertised fourteen positions for Latin Americanists of one specialty or another.

34. Karen Matsuoka, "Race Relations Still Hot Topic on Campus," *Daily Bruin News,* 25–28 Sept. 2000, 12.

Shaking Off the Shackles: From Apartheid to African Renaissance in History of Art Syllabi

Anitra Nettleton

At a session of the British Art Historians' Association conference in November and December of 1990, a plan was mooted to establish a bursary to enable a black South African to study the history of art at the University of the Witwatersrand at the undergraduate level, with a view to the student then being able to proceed to postgraduate studies at a British institution.[1] During discussion of this proposal, a rather querulous question was raised: "Surely we need to know what kind of art history *they* teach?" I have never been sure what lay behind that question, but I suspect that it was based on two assumptions. The first possibility was, quite reasonably, that in apartheid institutions the division of students and staff along racial lines would affect the formations and boundaries of art historical practice in South African universities. The other and, I suspect, more probable assumption was undoubtedly that the standards of colonial institutions were not "up to scratch." A major irony underlying this was the fact that the host institution, the Courtauld Institute of Art, had recently designated Eric Fernie, himself a graduate of the University of the Witwatersrand, as its next director.

In fact the links between the Witwatersrand history of art department and the Courtauld Institute go back to the 1940s,[2] and it is not, therefore, surprising that the history of art syllabus at this university was very firmly set in the mode of the "British tradition." As befitted colonial institutions, most departments of fine arts at South African universities adopted the European traditions of the discipline wholesale, although it is important to stress that the apartheid government's imposition of separate education for different "race groups" impacted on the discipline in curious ways.[3] Following Mahmood Mamdani's rejection of the notion of South Africa as an exception among colonial states in Africa,[4] one might suggest that such racial divisions are a feature of colonial societies everywhere and that the introduction of academic disciplines such as art history at the educational institutions within the colonies would be part of a "civilizing" mission, aimed largely at settler communities but largely rejected for the "natives" under colonial rule. In light of this argument, it would be instructive to know whether, and for how long, other institutions in Africa taught art history, and whether their syllabi were as heavily Eurocentric in colonial times as were those in South African institutions.[5]

From their inception, the art departments at most South African institutions treated art history as an adjunct to the practical courses, which were, at the liberal English-language universities, open to all races until 1959, the year in which the Nationalist government denied black students access to real tertiary education. In the 1960s and 1970s some of these now-segregated South African universities increased the numbers of art history staff in their fine art departments, while some Afrikaans-language universities established specialist art history posts[6] and the historically black universities of Durban-Westville, Fort Hare, and the University of Bophutatswana (now North-West) instituted new fine arts departments offering some art history courses (see appendix A on page 54).[7] The newly established departments were part of a program instituted by the apartheid government to keep the educations of people of different skin pigmentation in South Africa distinct from one another, to entrench white superiority, and to challenge the cultural hegemony of English-speakers in the arena of "high art," all the while masking the separation behind the claim that all would be equal.

At the English-speaking universities, notably Cape Town, Rhodes, Natal, and Witwatersrand, the three-year major in art history opened with a survey course on European art and, in subsequent years, moved through a chronological sequence of European art from the Renaissance to Surrealism (see appendix B on page 56). The Afrikaans universities followed similar patterns of curriculum but their syllabi included a much larger component of South African "white" art history, a bias that was linked to attempts to build a supposedly "national" culture, with largely Calvinist values at its core. Not only did the art historians at English-language universities regard their chosen path of Euro-imitation, especially British, as superior to anything that the Afrikaans universities could produce, they also relegated the teaching of more contemporary developments in American and "white" South African art to fine arts, rather than incorporating them into mainstream art history syllabi. At the Afrikaans universities there has also been a tendency to work within a more specifically German Kunsthistorisches and philosophical tradition, whereas the English-language departments followed a more formalist tradition with less theoretical underpinning. Some of these oppositions manifested themselves in the early 1980s, when the South African Association of Art Historians was formed—against the background of the cultural boycott—with government funding, to launch an art history journal, over which there was a struggle for control. Subsequently some academics from the Afrikaans-language universities' history of art departments formed their own association, Die Kunshistoriese Werkgroep, with its own journal.

With very small staff numbers, generally ranging from two to, at most, six art historians in each of these university departments,[8] the possibilities for real specialist teaching were minimal. Further, very few staff managed to study overseas at the postgraduate level, and even fewer came to South Africa with overseas post-graduate specializations, and all of these were, sometimes by default, trained in the European tradition only. To my knowledge, art in China,[9] Japan, the historical societies of the Americas, Polynesia, or Asia outside India have never formed a significant part of art history syllabi in South Africa. Lack of expertise is continually compounded, however, by lack of resources—library holdings are severely curtailed by lack of funds, especially on the art of the rest of the world, as we have always had to prioritize spending on books and journals that were and are germane to the current syllabus.

But the limits of resources and trained personnel are only half the story. The almost exclusive focus on European art history in these institutions functioned, albeit unintentionally in the case of the liberal English-language universities, to entrench the racial superiority of whites not only in the apartheid system but in the colonial context that preceded it and in which its foundations were laid. Mamdani argues strongly for the characterization of political structures in South Africa as colonial. He suggests that apartheid in South Africa was an implementation of forms of indirect rule commonly used by European powers in late colonial Africa and goes further to suggest that in many contemporary African states this system has been perpetuated.[10] Such colonial structures were reflected in the attitude that European art, "the great tradition," to borrow a phrase from F. R. Leavis,[11] *was* art; everything else was ignored. Although it was acknowledged by some Western art cognoscenti in colonial times that West and Central African societies had strong "art" traditions, the majority of people in South Africa were denied their own heritage, denied artistic ability or opportunity, and placed at the very bottom of a supposed hierarchy of cultural development.[12] These denials were used as a justification for robbing African people of a real education, perpetuating the myth of white superiority, and entrenching European ideas about the nature of culture. The tendency for the schools of fine arts in South Africa to follow Europe's and America's every move, trying to keep up with the North's Joneses, both in the teaching of fine arts and in the modes of teaching and researching art history,[13] meant that we ignored local traditions, eschewed all forms of so-called folk art, popular art, and art from the cultures of Europe's declared "Others." Our invited guests were Clement Greenberg (late 1960s), Kenneth Clark (post *Civilization*), and

Anthony Caro (who defied the cultural boycott to invest his cultural capital in African "high art" development), and our art history simply mirrored that of Europe and America. It is important, however, to remember that African art was not widely integrated into art history syllabi in either the U.S. or Britain, both of which have large African diaspora populations, and, where such African material was introduced, it was in the form of electives and was not really included in the mainstream. Further, the canonical journals of art history, such as *Art Bulletin, Art Journal, Art History,* or the *Gazette des Beaux-Arts,* have, since the rise of African art studies in the 1960s, published only a handful of articles on African art among them.

The only department in which Indian art was taught was the fine arts department at the University of Durban-Westville, established for the Indian community in South Africa. An experiment in the early 1990s in the introduction of Indian art as an optional course within the course structure at Witswatersrand was hindered by the lack of competent staff to manage it and by the fact that the part-time post that we had used to fund it was withdrawn. Only two of the other historically black universities, Fort Hare and North-West, had fine arts departments, and in these students were enculturated into what Susan Vogel termed "international" art.[14] Vogel's categories for the division of contemporary art among Africans resonate with unfortunate echoes of the apartheid education system, especially as South Africa was excluded from this overview and because her distinctions between the modern and the traditional were based not on their relative chronological positions but on sociocultural divisions between the international community and the exotic "Other." Fine arts at such institutions as Fort Hare and North-West were established to show that "separate but equal" was a reality in South Africa, and black African students here were supposedly offered education at the same level as students at white institutions—hence they had to be "modern." African traditions were given only passing reference, and real research into African traditions was not encouraged.

The lack of African content in the syllabi of tertiary institutions for black South Africans seems surprising, given that the art syllabus for schools for black children, outlined by the apartheid regime's Department of Bantu Education in the 1980s, stipulated a strong emphasis on local African craft traditions as the core. This emphasis was linked to a fundamental tenet of apartheid ideology, according to which black people were to be confined to manual labor, but the new emphasis in the school syllabus lifted the training, such as woodworking, previously termed "vocational," to a slightly elevated plane. The existence of such a syllabus at all was an irony, in

that there were virtually no schools for black children at which art was taught, there being only two in the whole of Soweto, South Africa's largest black township.[15]

In a climate where an ideological war against Pan-Africanist and Black Consciousness philosophies was escalating, especially at the University of Fort Hare, the academic home of Steve Biko,[16] such elevation of African "craft" traditions to the level of "art" could have been threatening to the status quo, under which white people had "art," but black people did not. An interesting corollary to this was the way in which the fine arts collection at Fort Hare was put together. In charge of the collection, Professor E. J. de Jager, an anthropologist by training, concentrated almost exclusively on the art of contemporary black South African artists, which is now displayed in a postmodern building sponsored by the De Beers (diamond) corporation. Despite the fact that the University of Fort Hare had a fine collection of Eastern Cape beadwork, this was not considered an important part of the collection for fine arts students, and apartheid structures were thus reinforced and extended into the familiar and seemingly neutral art-craft divide. The presence on the staff of the Fort Hare fine arts department of graduates from Rhodes, one of the "liberal" English-language universities, does not seem to have influenced the bias of the history of art courses, nor to have deflected fine art practice away from the European canon.[17] A contrast can be drawn here between the formal state institutions on one hand and, on the other, mission training centers such as the Evangelical Lutheran Church Art Centre at Rorke's Drift (under Peder Gowenius) and Grace Dieu and the community centers such as Polly Street Art Centre in Johannesburg (under Cecil Skotnes). At both of these institutions, students were exposed to some aspects of African visual traditions, often through a filter of European modernism, and made use of them in their own works—examples are Sidney Kumalo, Esrom Legae, and Lucky Sibiya. But many artists initially trained at these institutions only came to terms with their African heritage when they went into exile in Europe—examples would be Azaria Mbatha (Rorke's Drift), Ernst Mancoba (Grace Dieu), and Selbourne Mvusi (Fort Hare). At the same time, little or no research or teaching on modern art developments on the African continent outside of "white" South Africa was done anywhere. Thus the state-controlled tertiary institutions for black South Africans avoided subjects that had the potential to undermine apartheid ideology, promoting instead approaches they considered "progressive" and that would therefore appeal to both the marketplace and the international art community.

Within this context, it is tempting to interpret the introduction in 1978 of African art into the courses taught by the history of art department at

Witswatersrand, and the simultaneous establishment of a collection of African art in the Witswatersrand art galleries, as subversive.[18] While the reasons for the shift from a purely Eurocentric focus were never fully articulated within the department, there can be little doubt that it was prompted by the student uprisings of 1976 against the apartheid education system and the increasing resistance among the black youth to apartheid ideology. Even though we were not allowed to admit black students to our courses at the time, it was assumed that the inclusion of African art would offer a means of challenging the dialectics of race and culture that underlay apartheid ideologies. But this subversive potential was diluted because African art was simply introduced as another content field within the overarching structure of a discipline framed around essentially Western historical cultural practices. While our lecture-based course on European art was remodeled to cover two years of study, and the third-year topics were remodeled to include Africa, it was not debated how African "art" studies fit into the discipline of history of art. In this system Europe was still privileged, but Africa had a foot in the door, and ours was the only art history department in South Africa that offered African art as an area for teaching and research throughout the 1980s. The methodological aspects of Africanist art history within which we framed our courses were to be fully debated only in the late 1980s: the special issue of *Art Journal* on African art studies, edited by Henry John Drewal,[19] which presented examples of methodologies used by Africanist art historians in interpreting African art, was severely criticized by Whitney Davis.[20] Like the Smithsonian publication that first came out a few years later,[21] it attempted an "assessment" of African art studies *as a discipline,* using art historical methodologies entirely based within Western practice and accepting the proposition that there is such a thing as African "art" that can be paralleled to European "art."

It soon became apparent that the simple insertion of African "art," defined almost exclusively as figurative sculpture, into the "high art" canon would not help to shift the balance of cultural capital, especially as many other, and often more visible, forms of African visual culture—especially those produced by women— were marginalized as "craft."[22] In order to shake off the shackles of Eurocentrism, it has been imperative that the exclusive boundaries of the discipline as it is constituted by the European tradition (and which we had inherited from a generation of Courtauld-trained scholars) be demolished.[23] The discipline of the history of art as it is practiced in the Western academy, notwithstanding a long tradition of writing art's histories in China, was, like anthropology and sociology, an invention

of colonial and imperial Europe, dividing the world of "art" studies into two distinct spheres, opposing the "high art" traditions of Europe's elite, and perhaps those of ancient civilizations such as that of China on one hand, with the "material culture" of Europe's "Others" on the other. This divide was straddled by archaeology, which, however, entered the fray only in relation to ancient and mostly dead cultures, which it unearthed and whose art it removed from original sites to museums. Therefore it is clear that removing objects made for a variety of functions from within diverse contexts and simply inserting them into a framework designed to enlighten students on the history of art, as though their metamorphosis into "artworks" was natural, does not solve the problem of representation, in which the discipline of history of art is deeply implicated. The much-discussed notion of "metamorphosis," introduced in André Malraux's *Voices of Silence* (1953) and furthered in Jacques P. Maquet's *The Aesthetic Experience* (1986),[24] has functioned to homogenize all responses to visual culture in relation to Western theories of "aesthetic" experience and thus to sanction the removal of objects from any contexts of signification other than the "aesthetic." The result has been to legitimize the theft of cultural artifacts from Europe's "Others," on the grounds that they cannot care for or, even worse, cannot appreciate the "pure" aesthetic importance of the objects they or their forebears produced.

The need to interact with other disciplines in the process of breaking down received notions of what the proper subjects of history of art might be is an essential ingredient in reconstituting the discipline. And this means that we have to step outside notions of "art," "craft," and "material culture," as defined by the art markets and academies of Europe and America, and start to immerse ourselves in issues that are current and relevant in "the practice of everyday life." I use this phrase, derived from Michel de Certeau,[25] to distinguish the practices of the discipline as institutional and indubitably ideological from the ways in which people deal with issues of visual culture "on the ground." To deal with art history only within the orthodoxies of the "high art" canon—for, even in its most contemporary manifestations, high art is removed from the ordinary people—is to privilege a small elite. We therefore have to find ways in which we can, without being reductive, establish that the multiple practices of visual production, in Africa, Europe, and elsewhere, have not only not been bound by the exclusivity that operates within the European canon of "high art," but that that canon is in itself an ideological construct.

The introduction of diverse subject matter requires some specialist knowledge, and simply expanding the canon to include, for example, art in China, India,

and the Americas is simply beyond the scope of most African universities. One can, however, start to loosen the shackles by using forms of dress, textiles, cartoons, advertising, paintings, photography, sculptures, and graphics from African and European traditions to draw students into debates about "art" versus "craft" and "high art" versus "popular art," to interrogate the aesthetic conventions and iconographic complexity of diverse visual forms. Having introduced students to traditionally key disciplinary concepts, from style to contextual studies, iconography, and semiotics, demonstrating their applicability to any form of visual culture, one can start debunking the regnant divisions between "high" art and the rest.[26] Issues raised by post-colonial theory, spatial histories, and the role of representation in identity formation are used to interrogate ideologically loaded state-sponsored art, a variety of forms of historically based visual culture from South Africa, and the history of South African high art as it has been constructed by the white academies. This is especially important as the denial of artistic traditions among black South Africans was not merely a domestic issue brought about by apartheid: it was reinforced by the total lack of reference to Southern Africa in most of the books on African "art" that were published from the 1960s to the 1980s.[27]

Of course an inclusive but critical approach also necessitates a recognition of the prior experience of our students: most of those from rural areas or from urban, working-class backgrounds come to university without ever having set foot in an art gallery, without ever having set eyes on an original painting. In many of these students' homes, works of art are neither collected nor displayed, and what art education they may have had, if any, simply reinforces the notion that "art" is painting, sculpture, or graphics. Even those from middle-class homes may conceive of "art" as paintings, sometimes those in a kind of romantic-realist style, often featuring thorn trees and African villages, which are sold as "original" by the dozen by the side of the road. But these latter students are initially unable to accept "traditional" African or "tourist" art as art in the same sense. There is no requirement that students should have studied art at school before coming to study it at university, and the post-apartheid national schools art syllabus, although it includes a small section on African art at junior levels, places most of its emphasis on "high art" in the Western canon.

At most South African universities, the teaching of art history has been contained within and defined by departments of fine arts and has been treated more as a resource than as a field for serious investigation.[28] Even where independent history of art departments did exist, these have had to adapt their course

offerings, largely because the fine arts departments seem, inevitably, to be caught up in current global definitions of what constitutes relevant high art practice, and this has always been Euro-American. The original British orientation of our history of art courses meant that throughout the period from 1950 to 1980, no "modern" art from North America was included in the syllabus. Art's history effectively ended with Surrealism and its European offshoots. The introduction of Abstract Expressionism into the syllabus in the late 1970s was followed a decade later by Pop Art in America, but it was only in the 1990s that the American avant-garde came to dominate our teaching at the third-year level, sometimes to the detriment of the European avant-garde, and certainly to the exclusion of both recent developments in fine arts practice elsewhere in the world and the historical arts of both Europe and elsewhere. For example, one of our third-year courses, "Art after 1945," deals largely with European and North American and South African artists, including only a few artists of darker skin pigmentation. While postmodern developments are considered by the fine arts department to be essential for anyone wanting to practice fine arts, the course functions to promote a European and American monopoly on the definition of the avant-garde and the relevant.

Despite the problematic Eurocentric/Western bias of the post-1945 course, we have nevertheless identified it and two others, "Art in Europe from 1850–1950" and "Constructs of the (Italian) Renaissance," both survivals of our links to the Courtauld, as areas key to understanding the emergence of art history as a discipline and of fine arts as a contemporary practice. If one accepts Donald Preziosi's summation of the politics of art history as "a site for the production and performance of regnant ideology, one of the workshops in which the idea of the folk and of the nation was manufactured," then a critical engagement with these Western historical areas is imperative.[29] To expand on these European horizons, however, we also use thematic modules such as "Art, Power, and Society," taught at the second-year level, and "Art in the Public Domain," at the third-year level, to introduce diverse material, from medieval Europe, historical and contemporary African societies, America and Europe, as well as, recently, computer art and art on the Internet.

The criterion of "relevance" is a major factor in decisions about content, as few art practitioners, art historians, or educators in contemporary South Africa would be able to argue for the relevance of art in China, Polynesia, South America, or Japan in the face of calls for "Africanization" of the curricula at South African universities, coincident with the call for an "African Renaissance." Yet, because "Africanization" of the syllabus is potentially just another site for the production

of a different regnant ideology, we have to mitigate its tendency to homogeniza-
tion. While one cannot simply accept the existence of an as-yet undefined pan-African
cultural unity, it is important to challenge the usual treatment of African art as
constituted by a progression of different "tribes," each with its own style defined
exclusively in terms of sculpture. That the "tribal structuring" of African society
rests on social/cultural anthropology, itself a segregated form of sociology applied
only to Europe's "Others," has been remarked on by a number of authors,[30] and
the linking of art styles to ethnicities or mega-linguistic units has often obscured
both the varieties of objects under their umbrellas, their histories, and thus the
constructed-ness of their "traditions."

By using a thematic approach based in social, religious, and political for-
mations, the use of materials, critical analyses of style and meaning, and the creation
of identity, one can create a space for comparative non-African material to be in-
troduced. By examining received notions of "authenticity" we can interrogate the
notion of the "African" as a separate category, both within art historical studies and
beyond, particularly with reference to contemporary "African" art. What does it
mean to be "African"? What does it mean to be a contemporary African artist? What
is an "African" Renaissance? These questions are perhaps fraught, but they lie at
the heart of South Africa's reinvention of itself as an African state with an African
culture, and are therefore important to our student constituency.[31]

There is still a critical need to break down stereotypes and deliberate mis-
representations of African cultures that are, for us, a legacy of apartheid, but which
are a colonial legacy evident in the rest of Africa, Asia, Europe, and the Americas
as well. Students, from whatever social constituency, come to the table to eat of
the fare offered by a discipline called "art" history, and we have to make them aware
that the menu is couched exclusively in European language and the ingredients of
the dishes are determined by European chefs. We have to establish that there are
equivalent aesthetic practices across many cultures, that African practices are no
more nor less "primitive" than practices elsewhere, and that African "art," like
European "art," falls into a much broader scheme of visual culture.

While recognizing the dangers of a superficial comparativism, it is never-
theless possible to use the traditional histories of Western art as a springboard to
understanding the workings of the discipline and its boundaries, allowing for a rela-
tively in-depth analysis of identified key areas and an interrogation of broader issues
with a use of more heterogeneous subject matter. Thus, the history of art taught
in universities outside "the West" has to accommodate both compression *and*

expression; while accepting that we cannot hope to teach students everything and making sure that specialization remains a possibility, we must avoid the kind of subject apartheid that still pertains at most South African and many European and American institutions. Perhaps, because we cannot have a range of specialists, we have less feuding over territory and have therefore managed some degree of integration between Africa, Europe, and contemporary North America, an integration that refuses hierarchies of visual culture. Refuting the assumption that art and its histories are the homogenized preserve of an educated connoisseur elite, which is now global, and accepting that all forms of visual culture are its proper subjects of study, we will be better placed to reposition and, hopefully, rename a discipline whose inherent cultural imperialism is both anachronistic and inappropriate in a post-colonial world. The African Renaissance, understood in terms of the resurgence of a diversity of cultural norms, might provide one avenue for those at the center of the post-colonial world to challenge the overweening cultural authority assumed by the discipline of history of art.

1. It was originally intended that a black South African student be awarded a bursary to study the history of art at the undergraduate level in Britain, but, after consultation with some South African academics, this was deemed unrealistic, as there were so few students in black schools at the time who had the necessary educational backgrounds to cope. Ultimately the plan was shelved, partly because of the turn that South African politics took in 1992.

2. Heather Martienssen, the first professor of fine arts at Witwatersrand, was the first person to graduate with a Ph.D. in the history of art from the Courtauld, which she did in 1947 with a thesis on the British architect William Chamberlain. She was followed by a number of others.

3. A table of some of the approximate dates of founding of the fine arts and art history departments at South African universities appears in appendix A.

4. Mahmood Mamdani, *Citizen and Subject: Contemporary Africa and the Legacy of Late Colonialism* (Princeton: Princeton University Press, 1996).

5. Elspeth Court, "Notes: Art Colleges, Universities and Schools," in *Seven Stories about Modern Art in Africa,* ed. Clémentine Deliss (London: Whitechapel, 1995), provides an extensive list of tertiary institutions that teach fine art in Africa and a brief overview of the kinds of teaching that takes (took) place in some of these, but does not mention history of art. Ironically the University of the Witwatersrand does not appear on the list.

6. Fine arts was first introduced at the University of the Orange Free State (Bloemfontein) in 1974

but had been preceded by a chair of art history in 1970, with one senior lecturer post (1971) and one lecturer (1974). Apart from a brief experiment in uniting the departments in 1977, they have been separate entities.

7. Much of the information contained in appendix A was provided very generously by my colleagues at the various art departments of the universities listed. I also consulted the relevant webpages for information, where these were up and running. My thanks particularly to Marion Arnold, Rayda Becker, Rory Doepel, Elizabeth Delmont, Greg Kerr, Terry King, Sandra Klopper, Elizabeth Rankin, Brenda Schmahmann, and Dirk van den Berg, whose collective memories have smoothed this process. Much of the information on this table has changed in the last five years, however, as most universities have had to cope with transformation agendas.

8. Although in its heyday the department at Witwatersrand had seven staff members, the full-time complement has shrunk to five and may yet shrink to four. Of these all had an undergraduate training in Western art history, and some have branched out into South African art, popular culture, and other less "canonical" areas in their research and publication.

9. I take my cue for the usage "art in China" from Craig Clunas, *Art in China* (Oxford: Oxford University Press, 1997), whose explanations for not using the term "Chinese art" resonate strongly with my doubts about including all culture's visual products into the category of "art." My usage, however, must not be confused with apparently similar usage such as Maria Kecskési's *Kunst aus Afrika* (Munich: Prestel, 1999), where the *aus* can be read as either "from" or "out of," underlining the fact that this catalogue deals with objects removed from Africa ending in Munich, where they have become works of art.

10. Mamdani, *Citizen and Subject*.

11. F. R. Leavis used this term for the "English" tradition of novel-writing from George Eliot to James Conrad, establishing a canon that still functions in many departments of English as a touchstone against which all other novelists are judged. It thus functions to distinguish "English" English literature from "Other" English literature, including "African" literature in English. In many South African universities, African literature (in English) has been taught in departments or courses separately from mainstream "English" English Literature. See F. R. Leavis, *Two Cultures?: The Significance of C. P. Snow* (London: Chatto and Windus, 1962).

12. See Anitra Nettleton and David Hammond-Tooke, eds., *African in Southern Africa: From Tradition to Township* (Johannesburg: Ad. Donker, 1989).

13. This tendency continues as more South African artists find their way onto a global art circuit, and teaching of fine arts is aimed at this kind of exposure. None of the schools or departments of fine arts at South African universities besides the University of the Witwatersrand was to include historical African art in their syllabi prior to the 1990s.

14. Susan Vogel, *Africa Explores: Twentieth Century African Art* (New York: Center for African Art, 1991).

15. In the 1980s a community college called Funda (which means "learn") was set up in Soweto, and fine arts was taught there. A teacher-upgrading program Khula Udweba was established to try to spread the teaching of art at these schools. The situation in schools in the black townships has remained substantially unchanged to this day.

16. Biko, whose death in detention on 12 September 1977 sparked further vigorous resistance from the black youth, became an icon of the struggle, closely associated with Fort Hare. Of all the historically disadvantaged (black) universities, Fort Hare has retained most credibility, largely because of its long history of resistance to discrimination.

17. The staff included Thomas Matthews, who had done extensive research on mural painting in South Africa, and Michael Hallier, who had an M.A. from Rhodes.

18. Funded from 1979 onward by a generous grant from the Standard Bank, this was the first "public" collection of African art in the country to include objects from West and Central Africa, as well as arts from Southern Africa. Large collections of South African aesthetic objects were included in ethnographic museums across the country, but none was considered "art." To some extent, the Standard Bank was interested in the project of building the collection because it gave them some ammunition to use against the disinvestment lobby, as the bank was still at that time linked to Standard Bank in England. The university also has a collection of contemporary South African art, which has hardly grown in the past ten years owing to a lack of funding.

19. *Art Journal* 47, no. 2 (Summer 1988).

20. Whitney Davis, review of *Object and Intellect: Interpretations of Meaning in African Art,* by H. J. Drewal, ed., *African Arts* 22, no. 4 (August 1989): 24–32.

21. *The Yoruba Artist: New Theoretical Perspectives on African Art,* ed. Rowland Abiodon, Henry J. Drewal, and John Pemberton III (Washington, D.C.: Smithsonian Institution Press, 1994).

22. Here I would include especially beadwork but also pottery—both female traditions in Southern Africa. In many parts of Africa needlework is done by men but is equally lacking in recognition. For example, in the Yoruba *Gelede* and *Egungun* masking traditions, costume is as important as the wooden mask, or is exclusive of wooden masks, yet practically nothing has been written on the forms of costume in African art historical literature (see Anitra Nettleton, "To Sit on a Cushion and Sew a Fine Seam: Gendering Embroidery and Appliqué in Africa," in *Material Matter: Appliqués by the Weya Women of Zimbabwe and Needlework by South African Collectives,* ed. Brenda Schmahmann (Johannesburg: University of the Witwatersrand Press, 2000). Recently some attention has been paid to Yoruba beadworking traditions, but these are also male dominated; see Henry John Drewal and John Mason, *Beads, Body, and Soul: Art and Light in the Yorùbá Universe* (Los Angeles: UCLA Fowler Museum of Cultural History, 1998). Fon appliqué is similarly under studied; Suzanne Preston Blier's *African Vodun: Art, Pyschology, and Power* (Chicago: University of Chicago Press, 1995) also focuses on the less-visible aspects of Fon visual culture.

23. For us the canon has burst and the "elastic continuum" that Vogel proposed for definition of the "traditional" has withered in the way that all elastic does. See Christopher Steiner, *Perspectives in Africa: A Reader in Culture, History, and Representation* (Oxford: Basil Blackwell, 1996), and Vogel, *Africa Explores.*

24. André Malraux, *The Voices of Silence,* trans. Stuart Gilbert (Garden City, N.Y.: Doubleday, 1953); Jacques P. Maquet, *Aesthetic Experience : An Anthropologist Looks at the Visual Arts,* (New Haven: Yale University Press, 1986).

25. Michel de Certeau, *The Practice of Everyday Life* (Berkeley: University of California Press, 1984).

26. At the University of Cape Town, although the history of art department is now a sub-section of the department of historical studies, a similar approach has been taken, but on a much more disciplinary level, with only three specifically art historical courses left. See the webpage for the department of historical studies at the University of Cape Town (http://www.uct.ac.za/depts/history/ugcourse.htm).

27. There had been reference to South African artistic traditions in some German literature on African art, notably that by Eckart von Sydow (*Afrikanische Plastiek* [Berlin: Gebr Mann, 1954]), but the kind of detailed research that went into the art of the Congo, from the early 1900s, or Nigeria, Mali, and Ghana was unheard of in Southern Africa until the late 1970s.

28. See the Stellenbosch University Creative Arts webpage: "'History' is recognized as a valuable resource from which students learn how to use visual languages and develop personal and social commentary through painting, sculpture, photography, design and jewellery" (http://www.sun.ac.za/internet/academic/arts/finearts/arthist.htm).

29. Donald Preziosi, *Rethinking Art History: Meditations on a Coy Science* (New Haven: Yale University Press, 1989), 33.

30. See, for example, Sidney Littlefield Kasfir, *West African Masks and Cultural Systems* (Tervuren: Musée Royal d'Afrique Centrale, 1988).

31. Throughout this essay I have had to distinguish between "black" and "white" South Africans, largely because these were the terms in which distinctions between people were made in the period in which art history became a serious field of inquiry in South Africa. In the period of reconstruction and reconciliation, such distinctions are still being made, but there is an increasing debate about the terminology being used. It seems that while the term "African" is now being used as the preferred term for those South Africans who have indigenous roots, the term "black" is a catchall for those with darker skin pigmentation, including those of Indian and mixed descent, while "white" is used for those of European descent. This raises a number of problems, as those who are now excluded from the category "African" include settlers whose ancestors arrived in Africa over four hundred years ago and who call themselves "Afrikaners," and this includes those of dark skin color who descended from Malay slaves. It also excludes those of us who wish to identify ourselves with Africa and the political issues that confront Africa in relation to the wider world. Thus, while I may be African-born and think of myself as African,

my skin color, my language, and my inherited culture prevent my inclusion in the category of African, and the term becomes simply another marker of physical (read racial) difference, as it has in relation to African Americans. In this it perpetuates the notion that differences in skin color and other physical markers coincide with differences in culture to such a degree that religious and linguistic affinities, actual cultural practices, and customs are swept under the carpet with a homogenizing brush and a pan—pan-African, pan-European, or pan-Indian. The recent upheavals in Nigeria between Christians and Muslims are testimony to the non-tenability of such equations, as have been the similarly religiously motivated atrocities in Serbia, the tensions between Protestants and Catholics in Ireland, and between Muslims and Hindus in the Indian subcontinent.

Appendix A: South African Universities Teaching History of Art, c. 2000

Institution	Department	Comments
University of the Witwatersrand (English medium)	Fine arts dept. established in the 1930s; chair filled 1957; art history dept. established 1974; chair filled 1983	History of art was introduced only in 1946 as an adjunct to the fine arts department, of which the chair was established in 1957, with only a few specialist art historians on the staff, Heather Martienssen and Maria Stein-Lessing, a graduate of Berlin University, being the only ones with doctorates. In this the discipline of art history was, however, better represented than at any other fine arts department in South Africa; although there were some which were considerably older; there were none with staff of the same caliber. In the period of Martienssen's occupation of the chair of fine art, the history of art component went from strength to strength, and in 1972 a second chair was established, opening the way for a separate and independent history of art department, one of the last two remaining at present, although our days are numbered. In fact, this chair was only finally filled in 1983, although the departments had been separated for almost ten years. African art had been taught since 1978, first as part of an honors program, but by the mid-1980s as part of the undergraduate courses as well.
Rhodes University, Grahamstown (English medium)	Fine arts dept. established in the 1920s, taking over from the Grahamstown School of Art, founded in 1881	At present there are two art historians' posts. No African art is taught.
University of Cape Town (English medium)	Chair of fine arts at Cape Town School of Art endowed by Max Michaelis in 1920; fine arts taken over by UCT in 1925; art history dept. established 1988, closed 1999	At the University of Cape Town, the Michaelis School of Art had a venerable history by these standards, but did not have the same strength in art history. Up to the 1950s, art history there was taught by the members of the fine arts staff with input from part-timers. In the early 1960s a full-time art historian's post was established, and this staffing complement remained stable until the end of the 1980s. A newly independent history of art department was established in 1988, after the demise of the department of cultural studies, with a larger staff complement, only to succumb to incorporation into a larger department of historical studies in 1999. Some African art is taught as part of integrated art history modules.
University of Natal, Pietermaritzburg (English medium)	Fine arts established in 1930s on the Pietermaritzburg campus; post of art historian established in 1971	At the University of Natal a fine arts department was formally established with a chair in the 1930s, but it was only in 1971 that a post specifically designated for an art historian was established. This person is assisted in teaching by lecturers, whose prime function is in the teaching of practical fine arts courses. The two incumbents of the art history post were Raymund van Niekerk, who had an M.A. from the Courtauld, and Juliette Leeb du Toit, who has an M.A. from the Sorbonne. Modules on African art are taught and some postgraduate research has been done on African traditions since the mid-1990s.
University of South Africa (distance learning; dual medium)	Fine arts dept. established in the 1930s; chair established 1965	At the distance-learning University of South Africa, there was a chair of fine arts, first filled by the artist Walter Battiss, who had graduated from the fine arts department at UNISA in 1941. In the 1970s it was occupied by art historian Karin Skawran, who had a Ph.D. in Byzantine art from Munich. During the 1960s, the art history staff was increased to five or six, and in the 1970s associate professorships were established for both fine arts and history of art, although numbers of staff have decreased over the years. Some African art has been taught from the late 1980s.

University	Establishment	Notes
University of the Orange Free State (Afrikaans medium)	Chair of art history established in 1970; fine arts established 1974	Almost from its inception, the department of art history has had three lecturing posts: professor (1974), senior lecturer (1971), and lecturer (1974), plus the curator of the Stegman Gallery (1980). No African art is taught, but there has been teaching and research on "white" and some contemporary black South African art.
University of Pretoria (Afrikaans medium)	Fine arts and art history depts.	At present one professor and one lecturer in art history. No African art taught, but research and teaching done on (some) contemporary black and (mostly) white South African art.
Rand Afrikaans University (Afrikaans medium)	Dept. of art history established 1969(?); no fine arts department	Chair of art history established in 1970, with two lecturers. The department closed in the late 1980s. South African white art a heavy emphasis, but no other African art was taught.
University of Stellenbosch (Afrikaans medium)	Fine arts dept. established 1963	Art history taught by fine arts staff for first thirty years. One specialist art historian/theorist post was established 1996, occupied by Dr. Marion Arnold, who has just resigned. No African art is taught outside of contemporary South African art.
University of Durban-Westville (originally University College for Indian students)	Dept. of fine arts originally established 1963; in the 1970s becomes fine arts and art history department of the University of Durban-Westville	No specialist art history/theory posts. Chair occupied initially by Thomas Matthews, who did most of the art history teaching. Only department in which Indian art was a substantive part of the syllabus. Some African art taught. Recently closed.
University of Fort Hare (historically black university)	Dept. of fine arts established 1974	No independent art historians. Art history taught by fine arts staff. Large collection of art by contemporary black South African artists put together earlier by Prof. E.J. de Jager, complementing the anthropology collection, which contains "traditional" artifacts. Little, if any, African art is taught.
University of Bophutatswana (historically black university)	Dept. of fine arts established in the late 1970s	No independent art historian's posts. No African art taught. Department closed in 1996.

Appendix B: Art History at the University of Witwatersrand, 1960–2000.

	FIRST YEAR	SECOND YEAR	THIRD YEAR	NEW
1960–75	Survey: Ancient Egypt to Cubism (Europe only)	Italian Renaissance, Baroque, Romanticism	19th-Century Realism, Impressionism to Surrealism	
1978	Ancient & Classical Europe, Medieval Europe, Italian Renaissance	Baroque to 19th- and 20th-Century Europe & U.S.A.	Seminar topics; European art history; African art	African art topics in third year and honors seminars
1986	Ancient & Classical Europe, Medieval Europe, Italian Renaissance	Baroque to 19th- and 20th-Century Europe & U.S.A.	Seminar topics; European, South African, and African art	Topics on local subjects at third-year level
1990	Ancient & Classical Europe, Medieval Europe, Italian Renaissance	Baroque to 19th- and 20th-Century Europe & U.S.A.	Lectures: African and European Seminars: Europe, Africa, India	Indian art in third-year seminars, 1992–94

	FIRST YEAR	SECOND YEAR	THIRD YEAR 1st semester	THIRD YEAR 2nd semester
1996	Art and Visual Culture; Art in Europe 1850–1960	Art in 19th- and 20th-Century Africa; Art, Power, and Society	Art in the Public Domain, Art since 1945, and U.S.A.	Constructs of the Renaissance; Constructs of Africa

Please note that changes have been made to the art history syllabus since the department's inclusion into the Wits School of Arts in 2000.

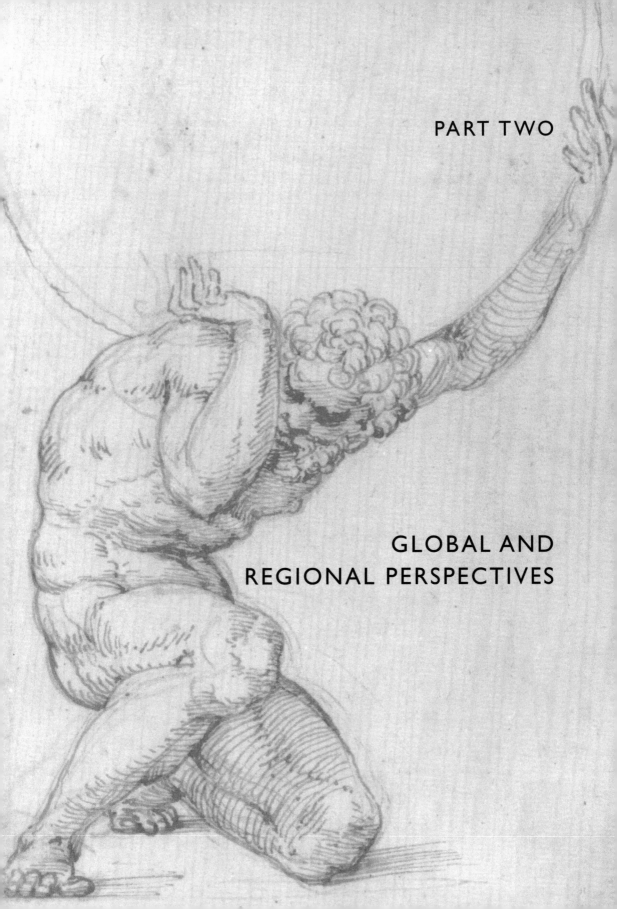

PART TWO

GLOBAL AND
REGIONAL PERSPECTIVES

Per non lasciar queste carte vote

Michael Rinehart

The first art bibliography is generally believed to be a list of thirty-five items interpolated on two pages between the introduction and the text of du Fresne's edition of Leonardo da Vinci's *Trattato della pittura* (1651) under the modest heading, *per non lasciar queste carte vote.*[1] This list contained most, if not quite all, of what could then be considered the literature of art. This first bibliographic "compression" of the still barely defined subject of art history consisted of theory, technique, biography, and topography about architecture, sculpture, and painting—the three arts first conceptually linked by Vasari as the *arti del disegno.* All but one entry (Albrecht Dürer) was Italian.

Du Fresne's list was a compilation of works known to him and for the most part in his possession. The same may be said of its much expanded eighteenth-century successor, Christoph Gottlieb von Murr's *Bibliothèque de peinture, de sculpture, et de gravure* (1770), and that still-valuable monument to the bibliography of art, Leopoldo Cicognara's *Catalogo ragionato dei libri d'arte e d'antichità posseduti dal conte Cicognara* (1821). Cicognara's annotated catalogue of his personal library contained 4,800 items classified by subject.

The origins of art bibliography therefore lay in the records or catalogues of particular collections, a practice that continued until late in the nineteenth century, culminating in the monumental *Universal Catalogue of Books on Art* published in 1870 for the British National Art Library. While primarily a record of the library's own holdings, the *Universal Catalogue* (as its name suggests) also included extensive contributions from other collections. It contained 67,000 notices contributed by some four hundred correspondents around the world. A first and final supplement of 655 pages was published seven years later, signaling perhaps the extent of the challenge in the face of an explosion of new publication. The aim and scope of this ambitious undertaking, as set forth in the introduction, makes impressive reading even today.[2]

Documenting the literature was now not so much a sideline of the librarian or a pastime of the *eruditi* as an exacting and potentially overwhelming task in itself. The museum as a public institution, advances in archaeological exploration, the growth of a general educated public as well as the gradual emergence of art

history as an academic discipline in the universities—all were reflected in the growth in the literature over the next century. Specialized art periodicals such as the *Gazette des Beaux-Arts* (1859–present) and the *Zeitschrift für Bildende Kunst* (1866–present) introduced a new form of serial bibliography that served a kind of "current awareness" purpose, informing the public about the "art world," exhibitions, the market, new scholarship, reviews, and new publication lists. Anticipating ten thousand subscribers, the *Gazette*'s inaugural issue went so far as to maintain that the public it addressed had not existed fifteen years earlier.[3]

Modern art bibliography began with the *Répertoire d'art et d'archéologie* (RAA), founded in 1910 by the Bibliothèque Doucet in Paris as an international index to art periodicals. Until 1925 the RAA listed periodical contents by country of publication, but for the first time an alphabetical subject index was added, thus allowing limited access by specific content. Coverage remained global (omitting only classical antiquity) until 1945. In that year aesthetics, folk art, and "primitive art" were dropped, on the convenient but unwarranted assumption that documentation in these fields was covered by other publications. The shift from a global to a strictly post-classical Western worldview had begun.

By this time the RAA had found an organizational niche within the newly established (1949) International Council for Philosophy and the Humanistic Sciences (ICPHS). A subsidiary of UNESCO, the ICPHS proposed "to coordinate international bibliographic work in the humanities, develop international cooperation, encourage the setting up of international organizations, and promote dissemination of information." This international superstructure was far removed from the routine concerns of bibliographic work, but it offered the only potential framework for coordinating resources for humanities documentation on a much-expanded scale. Thus was the RAA's place in the global scheme of things established, even as the scope of its content shrunk.

In 1965 management of the RAA was assumed by the Centre National de la Recherche Scientifique (CNRS). At the same time, Antiquity, Islam, India, and the Far East were dropped from its scope. Classification of the core Western medieval and Renaissance material was refined and elaborated, a reflection in part of the increasing quantity of publication in these fields, but also of the assumption that the discarded fields were both intellectually separable in terms of art historical practice and accounted for by other bibliographies, even though no coordinated effort was made to insure that this was actually the case. Whatever the practical considerations that led to the decision to retreat to an essentially Eurocentric

Christian and secular scope, it was clearly consistent with what in retrospect we can see as the broad westward-looking Atlantic orientation of the Cold War years.

———

This was the general picture in 1969, when the CNRS held a conference on art bibliography attended by art historians, librarians, and bibliographers from fourteen countries, representing the whole range of bibliographic activity in eastern and western Europe, Britain, and America—international, national, regional, and specialized bibliographies as well as library indexes. The papers of this conference remain the most complete snapshot of art historical bibliography at that time.[4]

The purpose of the conference was to identify and resolve issues common to all concerned. The principal issues quickly surfaced: tremendous growth in the amount of published work, increasing specialization (and therefore fragmentation) of the literature and readership, limited resources, and difficulty in maintaining coverage and currency in the face of such challenges. These problems were compounded by the redundant effort among overlapping and in some cases competing organizations. Recognition of this situation seemed in itself to hold out hope for a solution in cooperation. The underlying intent of the conference was to reinforce and strengthen the RAA through a collaborative effort among the participants. The promise held out by computer technology was already apparent, though it was just beginning to be understood. At that time computer processing was seen essentially as an aid to the management of the work and the creation of a print product. The prospect of electronic access to the cumulative data was foreseen but still seemed remote.

No initiative directly followed this meeting. It was not until three years later, in 1972, that the College Art Association held a second conference at the National Gallery in Washington that was attended by many of the same people. This sequel did lead to the launching of a new bibliography, based on a concept for the field of music developed under the auspices of the National Endowment for the Humanities and the American Council of Learned Societies as a model for all the humanities.

This new bibliography was the *International Repertory of the Literature of Art* (RILA, for the French name, Répertoire international de la littérature de l'art), produced at the Sterling and Francine Clark Art Institute from 1975 to 1989. The focus had shifted from the RAA to a new model, the essential features of which

included abstracts or brief summaries (preferably contributed by the original authors), supplied with detailed subject indexes, based on a controlled indexing vocabulary and relying on institutional collaboration for collection of the data and on computer-supported production. The objective was to create both a bibliography of record and a current awareness tool. The *éminence grise* of this project was H. W. Janson, at that time president of the College Art Association. The Eurocentric perspective of his general history of art, first published in 1962 and widely used at that time as a survey text in American college courses, reinforced the already established policies of the RAA and helped to determine the scope of RILA.

Initially the RAA participated in this collaboration, but it soon withdrew and developed its own computerized system, with the unintended consequence that RILA and the RAA became competitors, compounding the very problem they had set out to solve. Only in the 1980s after the College Art Association had transferred responsibility for RILA to the Getty Trust, were RILA and the RAA merged into a new bibliography, the first volume of which appeared in 1990 under the title *Bibliography of the History of Art* (BHA).

BHA is now in its tenth year and is producing twenty-four thousand bibliographic records annually.[5] An international collaboration supported by all that computer technology could offer was now in place, with editorial offices in Williamstown, New York, Paris, London, Rome, Groningen, Copenhagen, Göteborg, and Oslo, drawing on the holdings of numerous libraries in these and other locations. Though still confined to the traditional scope of post-classical Western fine and applied arts, BHA is the closest thing we have to a cumulative bibliography of record for art history today.

Among the many ways that computer technology has facilitated this work, there are two that have had particular consequences for scholarship. The capacity to provide uniform access to a cumulative backfile of data is perhaps the most significant contribution of the last thirty years. Past and present scholarship are integrated and equally accessible in a cumulative database. A second result of the move to an electronic medium is that the hierarchical classification characteristic of print (typically period, medium, country, artist) has been rendered superfluous. Direct access is possible from any perspective or point of view, no matter how idiosyncratic. The framework imposed by conventional classification ceased to be relevant—indeed, vanished—and the user could define his or her path of entry into the data. This feature is further enriched by the fact that the text of the abstracts and subject indexing are fully searchable. This can be especially valuable in

a novel, complex, or highly specialized search. When in due course these features are allied to the promise of links to other electronic resources, including full text and document delivery, the bibliographic database will become a still more powerful aid to research.

Nevertheless, despite these advances, the issues for art bibliography today are much the same as they were thirty years ago. Problems have kept pace with solutions. Whereas the technological issues are largely solved in principle if not yet in practice, logistical and editorial questions remain—questions about the collaborative application of resources, editorial responsibility, criteria for the collection and analyzing of data, and above all the definition of scope and content.

Growth in publication has certainly not abated. It continues to exceed the resources currently available to document it even within the area of Western art. BHA indexes more than fifteen hundred journals. In its first five years nearly twenty-three thousand articles in conference proceedings and Festschriften were cited, but many were left behind or overlooked. An extensive popular literature—exhibition catalogues, popular journals, commercial publications designed to be replaced in five years by the next generation of books on the same subject, the ephemeral publications we call "gray literature"—all this is constantly added to the ever-growing ranks of the scholarly literature. We have also seen an impressive growth and diversification in the range of subjects addressed by the scholarly literature itself, and its interpenetration with other disciplines. The greater proportion of journals and conference proceedings covered by BHA does not belong exclusively or even primarily to the field of art history per se.

As if the sheer volume of material were not enough, the perception of a "crisis" in the discipline appeared in the early 1980s. A whole new literature about the discipline itself, its historiography, theory, boundaries, and methods began to emerge. New perspectives under the rubric of the "new art history" (a term that also first appeared in the early 1980s), a growing involvement in the methods and content of other disciplines, and a new activism on the part of museums (with important consequences for public as well as professional interest) all contributed to the complexity of documenting the literature. Add to this the particular issues raised by the documentation of contemporary art and you have a daunting prospect.

Thus it is not surprising that bibliographic documentation has become a specialized activity in its own right, no longer a sideline of periodicals and libraries. There are now many library online public access catalogues (OPACs), some networked into powerful consortia, and therefore widely accessible but, despite this

technical advance, library cataloguing has become more and more superficial. Reliance on the minimal-level subject cataloguing provided by the Library of Congress is more and more the norm, facilitated by electronic data sharing—and not only in the United States.

A library catalogue is essentially a finding aid. It serves to locate (and col-locate) a book or periodical in a particular collection. Only secondarily does it provide subject access—and certainly not at a level of great detail. It does not individually analyze the contents of periodical issues, conference proceedings, and Festschriften. Within its usually limited means, a library collects the literature required by its immediate constituency or its stated subject area. Even a library as comprehensive as the Getty Research Library does not subscribe to nearly half the fifteen hundred periodicals indexed by BHA. A bibliographic database like BHA must draw on the resources of many libraries and serve a significantly larger com-munity than that served by any single collection.

I have suggested that the goal of bibliography should be to reflect art his-tory, not to define it. The reality, however—as we have seen—is inevitably quite different. Decisions about scope and coverage, the inevitable selection imposed by the abundance of material and other practical considerations, too often result in a bibliographic record that, however inadvertently, is skewed. Nevertheless, the need for an analytical bibliography is greater than ever, particularly *because* of the promise of a cumulative record, ready access, electronic publication, machine-readable text, and document delivery. The richer and more complex the resources, the more im-portant is an intermediary mechanism that gives access to them.

But if art history is to reflect the field, what exactly is the field it is to reflect? Is there a universal art history? Nearly twenty years ago Oleg Grabar addressed this question in an article in the *Art Journal*.[6] He foresaw two possible courses for art history: further fragmentation and specialization (comparable to the sciences), or the development of a new set of issues (perception, sign structure) that could be applied universally to all artistic phenomena. In a sense both have happened, and for analytical art bibliography it remains to find a way to "com-press," possibly even to "express," an ever broader and more diverse field of published scholarship without distorting it.

1. Leonardo da Vinci, *Trattato della pittura di Leonardo da Vinci, novamente dato in luce con la vita dell'istesso autore scritta da Rafaelle Du Fresne* (Paris: Appresso Giacomo Langlois, 1651). See also Kate Traumann Steinitz, *Leonardo da Vinci's "Trattato della pittura": A Bibliography of the Printed Editions, 1651–1956* (Copenhagen: Munksgaard, 1958).

2. National Art Library (Great Britain), *First Proofs of the Universal Catalogue of Books on Art, Compiled for the Use of the National Art Library and the Schools of Art in the United Kingdom* (London: Chapman and Hall, 1870).

3. The *Zeitschrift für Kunstgeschichte* continued to publish such an annual bibliography until 1983.

4. The papers of this conference were published as *Bibliographie d'histoire de l'art, Colloques Internationaux du Centre National de la Recherche Scientifique* (Paris: Éditions du Centre National de la Recherche Scientifique, 1969).

5. Until recently BHA was published in print and on CD-ROM, and distributed online by the Research Libraries Group and the Institut National d'Information Scientifique et Technique. The print and CD-ROM editions have been discontinued, and BHA is now distributed online by CSA, Dialog, NISC, Ovid Technologies, Inc., and RLG.

6. Oleg Grabar, "On the Universality of the History of Art," *Art Journal* 42 (1982): 281–83.

Museum Publications: History, Bibliography, Iconography

Dominic Marner

In 1997, as part of my responsibilities as a senior research associate and J. Paul Getty Library Fellow at the School of World Art Studies (University of East Anglia, Norwich, U.K.), I began what might be described as a twentieth-century version of the "Grand Tour." After having spent several years researching and contemplating the historical events and artistic production surrounding the confines of the beautiful Anglo-Norman Cathedral at Durham, in northern England, I undertook this project with both alarm and excitement. The thought of diving into the larger realm of "world art" sounded, quite frankly, both frightening and fantastic. It filled me with the anticipation one must have felt embarking on the Grand Tour in the eighteenth century, while at the same time I felt the uneasy sense of responsibility and doubt such a project has with its latent colonial associations. Such a "world tour" presented to me myriad practical problems: What was I looking for? Where might I find it? And how am I to understand it? Or, in other words, how can I "contain" and "explain" it?

The aim of my travels was to familiarize myself with the art of the world, as much as one could in such a short space of time, and to forge links with those who knew something about that art. This ambitious enterprise functioned as a prelude to creating and developing a "World Art Library."[1] Notions of containment, therefore, and the associated ideas of inclusion and exclusion weighed heavily on my mind. Since I was interested in the manner in which groups and communities were represented, I thought I would begin my journey looking at museums and, in conjunction with museums, museum publications such as catalogues and even ephemera.

Inevitably what follows are reflections by a white European male, and therefore an "outsider." I am conscious that this brief study is only the first step toward understanding museum publications. The primary source of this preliminary study was informal conversations with curators and directors and also analysis of the material published by the institutions themselves. Therefore, to a great extent what follows are my personal impressions of museums and exhibits.

The highly ordered and structured space of museums presents the public with a particular view of art.[2] As James Clifford has recently pointed out, museum exhibitions, whatever the subject, inevitably draw upon the cultural assumptions

and resources of the people who make them.[3] Decisions about what to display and what not to display reflect both institutional and individual concerns. The assumptions underlying these decisions vary according to place, time, museum, type of exhibit, and, of course, the intended target audience. Since people tend to visit exhibitions for both educational and entertainment purposes, there is often less critical assessment of the underlying assumptions contained in the display of objects. However, the assumptions become clearer when one contrasts particular exhibitions or museum displays with either older installations or those made in another cultural context. Therefore, the messages conveyed may in those cases seem either archaic or "foreign" to our own sensibilities.

A general trend that becomes apparent in almost every corner of the world is an interest in the idea of multiculturalism and interculturalism.[4] This is especially apparent in North America, Australia, New Zealand, and Africa, where groups attempt to establish and maintain a sense of community in order to assert their social, political, and economic claims in the larger cultural context. In doing so, they often have to challenge the right of established institutions to control the presentation of their own cultures.

The manner of challenge varies but can include a demand for some representation or power within an existing institution, on the one hand, and the establishment of alternative institutions, on the other.[5] Even if curators and museum directors are sympathetic, they often find themselves in very difficult territory, especially when issues are hotly contested. In addition, they may not be sufficiently aware of the assumptions that underlie their own exhibition. And even if they have a clear vision of what they want to engage in and an established set of aims, these can be blurred by the complex interaction of people involved in any one project: curators, designers, publishers, and artists.

Museums today also participate in a highly complex web of activity that includes shops, restaurants, galleries, lectures, and performances, all of which add pleasure to the experience of visiting the exhibitions or bring another layer of interpretation to the experience. The presentation of diverse cultural groups and the desire to represent them fairly and coherently have led to myriad explanatory texts, videos, and audio tours. Even so, museums attempting to act responsibly in complex, multicultural environments are bound to find themselves involved in controversy.

Museum publications play an equal part in this complex web of ancillary activity, acting as a bridge between two fundamental proponents of art history, the book and the museum. These publications are produced in a great variety of formats,

ranging from the comprehensive museum catalogue (potentially similar in scope to the survey texts) to ephemeral brochures, often presenting schematic plans, maps, or diagrams of the museum and its collections. Like public museums, these books are constructed in particular ways and with particular audiences in mind. They, therefore, provide fertile material for consideration. Books about museums and their collections, like the museums themselves, provide us with yet another filter, another layer, or another context with which the objects themselves have become integrated. Also, contemporary catalogues, rather than simply listing objects, attempt to integrate objects, labels, and ideas through their accompanying essays, essays that, of course, necessarily attach a particular narrative and order to the objects displayed. To what extent are these explanations of art tied to and therefore part of their inevitable containment?

Museum catalogues or gallery catalogues have a very specific origin. They developed in Europe in the late eighteenth and early nineteenth century in relation to a strong interest in the development of systems of classification.[6] The cataloguing system that prevailed in the eighteenth century was based upon a division by national schools and became so entrenched that even today we find it difficult to conceive of any other classificatory system. Australian art, American art, Italian art, or English art are clearly categories defined by "nation."

Classification of objects from the sixteenth to the mid-eighteenth century centered upon their being either products of nature or products of art.[7] The earliest catalogues of painting in Europe were generally straightforward inventories. Paintings and other works of art were listed according to the positions in which they were to be found in the collections, and the earliest and easiest classifications were through medium: drawings and prints being described apart from paintings.

During the eighteenth century, private art collections, like private scientific museums, became increasingly available to the public, even a limited aristocratic public, and this tendency stimulated the development of the art catalogue. These publications were encouraged by the growth of the art trade that, in Paris at least, was also engaged in the publication of elaborate sales lists. For private and semi-private collections, three principal types of publications emerged that could roughly be described as catalogues: the inventory catalogue, the expository guide, and the presentation volume, especially associated with royal or noble collections.[8] Although the trend toward national categories was prevalent by the end of the eighteenth century, there was some contemporary debate about other forms of classification, including chronology, provenance, physical setting, and artist. However, the

classification of national schools led the way, and Johann Joachim Winckelmann, among others, went one step further, and related the quality of a nation's painting to the political and intellectual vigor of its people.[9] It is perhaps surprising how little has changed in this regard.

I mention this only briefly by way of introduction. Even museum catalogues have a history, a history that has yet to be fully understood. Toward this end, I shall consider three types, or categories, of publications that one might associate with museums and galleries: the general book on the museum itself and its collection; the exhibition catalogue; and the brochure. My approach to these books is bibliographic, iconographic, and, to a certain extent, sociological.[10] Just like conventional textbooks on art history,[11] individual museum publications can be analyzed and dissected. However, less consideration has been afforded to the genre of museum publications. These are inherently more populist in nature, related to specific collections and the display of objects, and informed by institutional and/or other political agendas, as well as patronage issues, and, finally, driven by a sense of what the general public might desire. They are part of a particular genre of publication with their own characteristics, style, and, to a certain extent, layout. However, in their distinctive content, they represent both the compression of information about a particular collection and the expression of an institution's aims, objectives, and identity. My remarks are intended to provide a preliminary step into the world of museum publications and cannot be regarded as comprehensive. Further studies into specific institutional histories, and their earlier publication histories, are necessary to establish a better understanding of institutional aims and intentions over specific time periods and within specific historical and political contexts.

The publications under consideration are as follows: (1) *Honolulu Academy of Arts: Selected Works,* Honolulu, Hawaii, 1990; (2) *A Decade of Collecting: The Anglo American Johannesburg Centenary Trust 1986–1996,* 1997, the catalogue from an exhibition at the Johannesburg Art Gallery, South Africa; and (3) *Yiribana: Aboriginal and Torres Strait Island Gallery,* a brochure from the Art Gallery of New South Wales, Sydney, Australia.

The Honolulu Academy of Arts produced this handsome publication in 1990, intending, as we are told in the acknowledgments, to update the earlier 1968 publication, a catalogue which highlighted a limited number of the objects in the holdings of the academy (fig. 1). Further examples from the collection were added to this catalogue, many color photographs were introduced, and new catalogue entries were written by the curatorial staff at the academy to accompany each illustrated

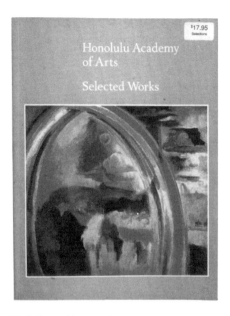

Fig. 1. *Cover of Honolulu Academy of Arts: Selected Works*

object. The 279 pages have been divided into regional sections: East Asian Art; Southeast Asian, South Asian, and Middle Eastern Art; Ancient Mediterranean Art; European Art; American Art; and, finally, Art of the Pacific, the Americas, and Africa. Within each section the objects are placed chronologically, and with few exceptions one page is dedicated to one object and its accompanying text. There are no introductory essays for each general section.

The introductory statement begins with a recitation of the history of the academy and in particular the role the founder, Anna Rice Cooke, played in the formation of the academy. The history of the institution is described as a "fascinating episode in museum history, one flavored by a strong humanitarian spirit and resolve."[12] In 1922 a charter of incorporation was issued and Cooke's family home became the first academy, later demolished, with the present building completed by 1927. The strong educational imperative of the academy, articulated by Cooke and her family in these early years, led to a change in name from the Honolulu Art Museum to the Honolulu Academy of Arts. In 1927 the academy was formally opened to the public, and Cooke articulated its aim in the opening speech:

> That our children of many nationalities and races, being far from the centres of art, may receive an intimation of their own cultural legacy and wake to the ideals embodied in the arts of their neighbors. . . . That Hawaiians, Americans, Chinese, Japanese, Koreans, Filipinos, Northern Europeans, and all other people living here, contacting through the channel of art those deep intuitions common to all, may perceive a foundation on which a new culture, enriched by the old strains, may be built in these islands.[13]

Today the academy has approximately 24,000 objects and is the only general art museum in Hawaii. Of course, more specialized museums exist, such as the nearby Bishop Museum, renowned for its collection of Pacific Island material cul-

Fig. 2. Page 25 of *Honolulu Academy of Arts: Selected Works,* showing Hawaiian bed covers

ture. Approximately half of the academy's catalogue is devoted to Western art, while Asian art makes up the other half. Of the Asian art, Chinese, Japanese, and Korean objects constitute the vast majority. In addition, we are told that "because of space limitations," aspects of the Western collection are not represented in the catalogue: approximately 10,000 prints, as well as photographs and a substantial assemblage of historical and contemporary works by artists of Hawaii. Only 5 of the 276 pages are dedicated to Hawaiian art (fig. 2). Such an omission is all the more curious when one considers that Anna Rice Cooke made express mention of Hawaiian traditions and art in her 1927 dedication speech. It is clear from her comments that she felt "far from the centres of art," and that, therefore, she must have perceived Hawaiian art as being something other than "art," at least in an academic sense. Perhaps this underlying attitude is still present and may go some way in explaining the virtual omission of historical and contemporary Hawaiian art from the catalogue.

Cooke also stated that it was her desire that the academy, in addition to displaying objects that she collected from around the world, showcase the islands' natural beauty and climate. This was accomplished by introducing interconnected court-

Fig. 3. Courtyard of Honolulu Academy of Arts

yards throughout the building (fig. 3). The correlation between the pleasure one derives from experiencing the natural beauty of the environment and that derived from aesthetically pleasing objects is also present in many other museums such as the University of British Columbia's Museum of Anthropology in Vancouver.[14] One might argue that it was taken to its logical conclusion in the recently built Getty Center, where framed vistas of the Los Angeles suburban hillsides are interspersed with the display of the collections.[15] In such museums, one might legitimately speculate upon what exactly is on display: nature or art?

The very colorful painting by Robert Delaunay entitled *Rainbow,* produced in 1913 and purchased in 1966 by the academy, is featured on the cover (fig. 1). Although depicting the urban setting of Paris, the profusion of color and the intervention of the rainbow connote a sense of the natural beauty of the landscape, a connotation that might be in keeping with that of the beauty of the Hawaiian Islands. Book covers and frontispieces provide the first visual clues about what might lie inside. Although the decision to put this or that graphic or picture on the cover is often the result of negotiation between authors, editors, and publishers (not to mention museum directors), there is considerable thought in the decision and therefore taking a closer look at this introductory material might shed light on the books themselves. Just as the choice to include or exclude illustrations of particular art objects in survey texts or to begin such narratives with the Egyptians, the Assyrians, or whomever reflects underlying assumptions about the history of art, so, too, does this matter play a part in museum catalogues.

From the Honolulu Academy's catalogue, we can take the metaphor of a rainbow one step further. The idea of a rainbow has particular resonance with Anna Rice Cooke's expressed intention to found a "multicultural" institution in which the "children of many nationalities and races," born far from the so-called centers of art, "may receive an intimation of their own cultural legacy and wake to the ideals embodied in the arts of their neighbors." The notion of integration implicit in such

Fig. 4. Roman pitcher, page 6, *Honolulu Academy of Arts: Selected Works*

a statement is today mirrored in the plan of the academy, in which the Western art sections are placed on the eastern side of the complex, as it were, facing East, while the Eastern art sections are placed at the western side, facing West.

The natural beauty of the environment is visually echoed in a curious way by the color plate of the magnificent large Roman pitcher prefacing the acknowledgments (fig. 4). Whether intended or not, its rounded form and blue and silvery patina have visual resonances of the Earth and its oceans. Likewise the pan-Pacific multicultural aspect of Hawaii and its natural and exotic beauty is reinforced (this time) by the introduction of Paul Gauguin's *Two Nudes on a Tahitian Beach* (1891–94), given to the academy by Mrs. Charles M. Cooke in 1933 (fig. 5).[16] This painting is, significantly, a Western representation of the native "other," a fetish of the primitive. Here the native is not allowed to speak but is framed and presented through the European male gaze.

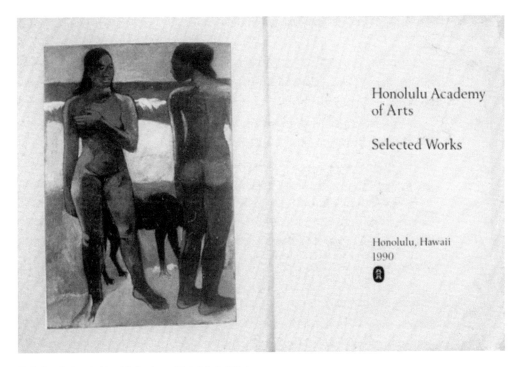

Fig. 5. Frontispiece to *Honolulu Academy of Arts: Selected Works*

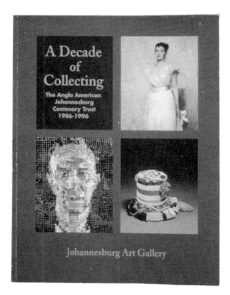

Fig. 6. Cover of *A Decade of Collecting: The Anglo American Johannesburg Centenary Trust, 1986–1996*

Patronage issues are at the core of the next publication under consideration: that of a specific exhibition catalogue published in 1997 to commemorate a decade of collecting in the Johannesburg Art Gallery in South Africa (fig. 6). It is seventy-four pages in length and consists of four main sections, a foreword, and a preface. The sections are entitled "Mining Patronage at the Johannesburg Art Gallery"; "The Anglo Trust and Traditional Southern African Art"; "The Anglo Trust and the Development of the Historic Collections"; and "The Anglo Trust and the Contemporary South African and International Collections." Each section consists of an introductory essay and a series of color plates illustrating objects and accompanying catalogue entries.

The whole point of this exhibition, which opened on 25 March 1997, was to display new acquisitions that were made possible by a generous donation from the Anglo American Corporation of South Africa Limited. In this sense it pays tribute to the mining company and its generosity. Despite the relationship between this company and the gallery, the structure of the catalogue, the objects acquired and displayed, and the introductory essays all revolve around the idea that the gallery itself has an independent acquisitions policy, independent at least of the Anglo American Corporation.

However, there is a deed of trust that outlines the purposes and powers of the trustees. And, in fact, this deed does suggest acquisition areas. All the suggestions would build upon the established strengths of the gallery, that is, primarily European art collected by Sir Hugh Lane. No new areas were suggested. As a document engaged in the effects of political patronage in a country with such a volatile racial history, the essays make fascinating reading.

The first acquisition made by the trust in 1987 was that of traditional South African art, a large collection of headrests, collected in the 1920s and 1930s by the Reverend A. P. Jaques. What we may find surprising is that, in its seventy-seven year history, this was the first time traditional African art had been introduced into the collection. Traditional South African art was therefore not one of the areas of acquisition that would build upon the strengths of the collection, as suggested in

the deed of trusts. Given this, throughout the catalogue we are assured, or perhaps the Anglo American Corporation of South Africa Limited is assured, that the "Trust has *not* been used only to forge *radical* new directions. It has also been used to enhance the existing collection."[17]

One is left with the impression that the catalogue itself, its structure and essays, were carefully considered in order both to appease the trust and to express a desire of the gallery and its staff to engage in the problem of how to update the collection by integrating African art into what was clearly a very Euro-centered and even Anglo-centered historical collection. The idea of acquiring African art in Johannesburg might seem quite sensible to an outsider like myself, but even in South Africa's post-apartheid era, the acquisition of traditional South African art by the Johannesburg Art Gallery was still viewed and described as "radical" in this 1997 publication.

Before moving on, I will offer some tentative suggestions about the cover. The cover is divided into four sections, three of which are images, the fourth being the title of the exhibition. Such a structure obviously denotes parity between the images and the title. How can these images and their relationships be read? Perhaps a simple and literal approach would be that the images themselves represent visually the trust's name: the Anglo American Johannesburg Centenary Trust.

The portrait of Hilda Orchardson, daughter of the artist Sir William Quiller Orchardson, was painted in 1894, just prior to her immigration with her husband to South Africa in 1904 to manage a farm. A portrait by Orchardson seems to be appropriate, given that the artist was from Scotland and the sitter had immigrated to South Africa. This portrait is traditional, classical, and European and denotes authority and origins.

The color wood-block print in the lower left by the American artist Chuck Close seems to have less of a connection with South Africa. One might surmise, however, that it represents the modern part of the collection, having the added bonus of being made by an American artist and depicting another American artist, Alex Katz. It connotes the "New World": abstraction, diffusion, and materialism.

And finally, at the bottom right is what looks at first glance to be a hat of some sort, but is really a Tsonga *nwana,* or child figure, associated with fertility and procreation. It also denotes the traditional, but this time African, primitive, organic, and even sexual. Hence the combination of images presented on the cover reinforces the notion that, with the trust, the established areas of the collection are being added to in the form of the portraits by Orchardson and Close and that the new acquisitions area of traditional South African art is being developed. The im-

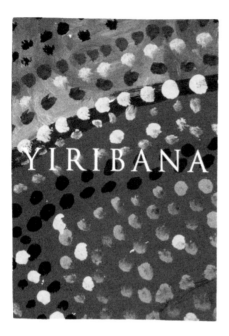

Fig. 7. Cover of *Yiribana*, a brochure from the Art Gallery of New South Wales

Fig. 8. Back cover of *Yiribana*

ages themselves denote South Africa's past, present, and future, of colonialism, capitalism, and modernity. All three are bodies: one a woman, one a man, and one a child.

The final "object" under discussion is the brochure. This brochure, from the Art Gallery of New South Wales, is not typical in that it has a small-book format and is therefore quite unusual for a brochure. However, as we are told on page one, this self-styled brochure celebrates the opening of the Yiribana gallery, and it contains excerpts from the book *Yiribana,* published by the gallery in 1994. It is eighteen pages in length, with two maps, twenty-two illustrations, and the corporate sponsorship logo for "Qantas" on page two. It also has a rather spectacular color front and back cover (figs. 7, 8).

The text consists of a short introduction, a section entitled "How We Look at Aboriginal Art," and then thematic sections entitled: "A Collection Begins"; "Land Before Time"; "Spirits of Place"; "Land Maps"; "Sorry Business"; "Shimmer"; and "Claiming a Space." These divisions were chosen in order to depart from the more traditional ways of articulating aboriginal art into geographical regions, different media, or chronological sequence. In addition a short bibliography and useful glossary accompany the text.

The front cover is illustrated by a rather colorful series of dots and lines commonly found in much aboriginal art and also used in the marking of bodies as illustrated on the back cover. Under the section "Shimmer," we are told that the technique of cross-hatching and dotting, illustrated in the brochure by an untitled work by Emily Kame Kngwarreye, is used to produce

Fig. 9. The section entitled "Shimmer" on pages 13–14 of *Yiribana*

a visually vibrating surface and to invest the work with spiritual presence (fig. 9). It also elevates the work from the ordinary to the extraordinary.

This discourse of spirituality is pervasive in the writings about aboriginal art and, whether intended or not, and despite a call for aesthetic appreciation in the opening remarks of the brochure, the shimmer of the cover places the brochure itself into the context of this spiritual discourse and, therefore, within the context of aboriginal beliefs and society. Even though the brochure does not make any overt statement characterizing the aboriginal people as the "spiritual native," it nevertheless subtly participates in this discursive process. The monumentalization of aboriginal and, indeed, any "exotic" or "foreign" culture, and the flattening effects of spiritualizing complex and irregular groups are still evident today, even in such a brochure.

Another related issue is that of corporate sponsorship, this time by the Australian airline Qantas. This issue involves the importance of copyright in dealing with aboriginal art, and the belief that certain patterns and "styles" are actually "owned" by certain aboriginal artists, with no other artists being allowed to incorporate them into their work.[18] Qantas has clearly decided that decorating their

Fig. 10. Pages 1–2 from *Yiribana*

planes with pseudo-aboriginal motifs and patterns is a good thing, providing them with both an exotic looking and easily recognizable fleet, and in doing so presenting the flying public with the tacit impression that they have sympathy with the aboriginal cause. Both presumably help profit margins, as politically correct and upwardly mobile Australians (and others) fly with Qantas. It is perhaps important to acknowledge that, on the opening page of the brochure, the Qantas logo itself and the "Y" of Yiribana, in the opposite corner, both share the same stark red color, making them visually and typographically associated (fig. 10). Such visual and typographical links should not be underestimated.[19]

I would like to be able to offer some grand concluding remarks, an overarching theory if you like, that might explain world art, at least from the perspective of museum display and museum publications, but this I am unable to do. A reductionist account would simplify the material greatly and prevent important differences between institutions and cultures from being properly recognized and articulated. Such an approach would also lead to a certain flattening effect of the more complicated relationships between museums, artists, groups, nations, pub-

lishers, and corporate or other sponsorship and patronage. However, conversely, concentrating upon the individual or particular at the expense of broader issues and themes does not necessarily lead to a clearer understanding of art in a global context. The end result, of course, is that a delicate balance must be drawn between the particular and the universal.

Analyzing museum displays and books about art, rather than the art itself, can provide us with insights into the management of historical and artistic information. Museums and books tell us something about their makers and the culture they inhabit. And museum displays and publications, whether large catalogues or ephemeral brochures, provide us with histories, narratives, and explanations of art for both public consumption, corporate profit, and scholarly reflection.

1. The World Art Library, based in the School of World Art Studies at the University of East Anglia, is a growing multimedia collection of publications on art available to students, scholars, and international visitors.

2. For critical assessments of museums see Carol Duncan, *Civilizing Rituals: Inside Public Art Museums* (New York: Routledge, 1995); Ivan Karp and Steven D. Lavine, eds., *Exhibiting Cultures. The Poetics and Politics of Museum Display* (Washington, D.C.: Smithsonian Institution Press, 1991); Eilean Hooper-Greenhill et al., eds., *Museums and the Shaping of Knowledge* (New York: Routledge, 1992); Stuart Hall, ed., *Representation: Cultural Representation and Signifying Practices* (London: Sage, in association with the Open University, 1997).

3. James Clifford, "Four Northwest Coast Museums: Travel Reflections," in *Exhibiting Cultures,* 212–54.

4. Ivan Karp and Steven D. Lavine, "Introduction: Museums and Multiculturalism," in *Exhibiting Cultures,* 1–10.

5. For instance, the placement of Djon Mundine's "Aboriginal Memorial" near the entrance to the National Gallery of Australia in Canberra is an example of how aboriginal art received serious attention and consideration by a national institution. Likewise, the District Six Museum, near the center of Capetown, presents the public with an alternative space with which to understand what was once a multicultural community that was virtually destroyed and dismantled under apartheid.

6. Giles Waterfield, "The Origins of the Early Picture Gallery Catalogue in Europe, and its Manifestation in Victorian Britain," in *Art in Museums,* ed. Susan Pearce (London: The Athlone Press, 1995), 42–73. For a discussion of classification see N. J. Williamson and M. Hudson, eds., *Classification Research for Knowledge Representation and Organization* (Amsterdam: Elsevier, 1992); H. van de Henri Waal et al., *Iconclass: An Iconographic Classification System* (Amsterdam: North-Holland Publishing Co.,

1973–); Brian Buchanan, *Theory of Library Classification* (London: Bingley, 1979); R. Howard Bloch and Carla Hesse, eds., *Future Libraries* (Berkeley: University of California Press, 1995); Rita Marcella and Arthur Maltby, eds., *The Future of Classification* (Aldershot, England: Gower, 2000). For a discussion of publishing and museums, see Benedict Anderson, *Imagined Communities: Reflections on the Origins and Spread of Nationalism*, rev. ed. (London: Verso, 1991), 37–46, 178–85.

7. Waterfield, "The Origins of the Early Picture Gallery," 43.

8. Ibid., 44–46.

9. Ibid., 49.

10. "The physical forms through which texts are transmitted to their readers (or their auditors) affect the process of the construction of meaning. Understanding the reasons and the effects of such physical devices (for the printed book) as format, page layout, the way in which the text is broken up, the conventions governing its typographical presentation, and so forth, necessarily refers back to the control that the authors but sometimes the publishers exercised over the forms charged with expressing intention, orienting reception, and constraining interpretation." Roger Chartier, *The Order of Books* (Cambridge: Cambridge University Press, 1994), 28. See also D. F. McKenzie, *Bibliography and the Sociology of Texts* (Cambridge: Cambridge University Press, 1999), esp. "The book as an expressive form," 9ff.

11. A type of publication that has recently received a great deal of attention has been the so-called survey texts of art history. The structure, content, and illustrations of these textbooks have been subjected to exhaustive comment and critical analysis, especially in the late 1980s and 1990s in the volumes of the *Art Bulletin*. As Robert Nelson has argued, the inherent structures and order of such books are seldom noticed, but, nevertheless, these structures and implicit agendas permeate the very teaching and understanding of art and its history in every undergraduate course in America. See Robert S. Nelson, "The Map of Art History," *Art Bulletin* 79, no. 1 (March 1997): 28–44. See also Chartier, *The Order of Books*.

12. *Honolulu Academy of Arts: Selected Works* (Honolulu: Honolulu Academy of Arts, 1990), 9.

13. Ibid., 10.

14. For a discussion of the relationship of nature and art in this context, see Clifford, "Four Northwest Coast Museums," 212ff.

15. Displaying both the natural and the artificial within a museum seems at first glance to be particularly unfashionable, especially if one considers the large, open-planned, and polished marble spaces of any picture gallery. If anything, juxtaposing the natural with the artificial brings to mind perhaps outdated and outmoded attempts to house and display the "wonders of the world" and, indeed, this desire to experience both was the impetus behind a very early form of the museum, that of John Tradescant's seventeenth-century *Musaem Tradescatianum*. His collection of rarities was classified into the *artificialia* and the *naturalia*, denoting, of course, those things found in nature and those things

derived from nature but transformed by human endeavor. See Henrietta Lidchi, "The Poetics and the Politics of Exhibiting other Cultures," in Hall, *Representation,* 156–60.

16. *Honolulu Academy of Arts,* 192.

17. *A Decade of Collecting: The Anglo American Johannesburg Centenary Trust, 1986–1996,* exh. cat. (Johannesburg: Johannesburg Art Gallery, 1997), 5.

18. The role of copyright is more difficult to disentangle, especially in relation to tourist arts, corporate sponsorship, and aboriginal notions of artistic ownership. I only mention it here and in passing as another facet of the commodification of art, apparent not only in Australia but in many other venues and cultures throughout the world.

19. For a discussion of the importance of the form and typography of a book, see D. F. McKenzie, *Bibliography.*

Legal Conventions and the Construction of Heritage

Derek Gillman

Merryman

The grandfather of cultural property cases remains the Parthenon marbles, a case that continues to test relations between Britain and Greece. This *cause celebre* is regarded by many museums as representing a battleground between the cosmopolitan and the particular, or the global and the regional. Others see it as a contest between colonizers and the colonized, or the art poor and the art rich. These two general approaches have been scrutinized during the past fifteen years by John Merryman, whose 1986 article "Two Ways of Thinking about Cultural Property" was a major contribution to an emerging area of legal discourse.

One of Merryman's central points is that two international conventions captured these broadly different approaches. One was the 1954 Hague Convention (for the Protection of Cultural Property in the Event of Armed Conflict), called by UNESCO, the other the 1970 UNESCO Convention (on the Means of Prohibiting and Preventing the Illicit Import, Export, and Transfer of Ownership of Cultural Property).

The Hague Convention grew out of a nineteenth-century code of conduct, the Lieber Code, devised for the behavior of military forces in a theater of war, which demanded that classical works of art, libraries, and scientific collections be secured against all avoidable injury, but also allowed them to be removed by the conquering state.[1] The Hague Convention provided for likely conflict between the value of human lives and the preservation of things embodying value, the yardstick being "military necessity." The primary difference between it and the Lieber Code, however, was that if the Convention was breached discipline was now to be a matter for other nations.

Merryman sees the language of the preamble to the Hague Convention as embodying a nobility of purpose, while also serving as a charter for internationalism. The second and third clauses are germane to his argument:

> Being convinced that damage to cultural property belonging to any people whatsoever means damage to *the cultural heritage of all mankind,* since each people makes its contribution to *the culture of the world;*

> Considering that the preservation of *the cultural heritage* is of great importance for all peoples of the world and that it is important that this heritage should receive international protection. [my italics][2]

The key phrases are "the cultural heritage of all mankind," "the culture of the world," and "the cultural heritage." In Merryman's opinion, the 1954 Hague Convention exerts an influence that extends beyond the obligations imposed on and accepted by its parties. It is a piece of international legislation that exemplifies "cultural internationalism," and expresses the cosmopolitan notion of a general interest in cultural property apart from any national interest. In support of this proposition, he cites Sir Harold Nicholson's comments, in the *Spectator* magazine, that he would be prepared to be shot if it meant preserving the Giotto frescoes and would not "hesitate for an instant . . . to save St. Mark's even if I were aware that by so doing I should bring death to my sons."[3]

Merryman wants to contrast the Hague Convention with the 1970 UNESCO Convention. If the agenda of internationalism supports an ambassadorial role for cultural objects, then the "other way" of thinking takes national cultural heritage as its principal subject. As with the Hague Convention, the governing thought on heritage is embedded in the preamble:

> Considering that cultural property constitutes one of the basic elements of civilization and *national culture,* and that its true value can be appreciated only in relation to the fullest possible information regarding its origin, history and traditional setting. [my italics][4]

Ways of addressing heritage can be quite different from those conventionally associated with property; indeed crucial to the debate over heritage is the language used in setting out a case.[5] Hence, within the preamble to the UNESCO "Convention Concerning the Protection of the World Cultural and Natural Heritage," 1972, we find the phrases "world heritage of mankind as a whole," "heritage of all the nations of the world," and "world's heritage" coupled with the observation that "this unique and irreplaceable property" nonetheless belongs to specific people ("to whatever people it may belong").[6]

Leaving Georges Zouain expertly to address UNESCO's approach to heritage, I now want to look in the most cursory way at the construction of the concept of heritage, with a particular focus on the English- and German-speaking worlds,

in order to show how the two positions are historically imbricated to a greater degree than we might imagine from the present passionate level of debate.

Customary Law

One of the most important elements of this construction is local custom, manifested not only as custom per se, but also as customary law. Both elements are found in Hugo Grotius's history of the ancient Batavian Republic, a work written in the tradition of Italian humanist city chronicles, which were themselves composed in imitation of the classical poets and orators, especially Cicero.[7]

This history offered an unbroken account from Roman times, to show how the Dutch had an enduring history of self-governance, local custom, and customary law. In creating a convincing record of the people and their state, Grotius was also attempting to hold back the theocratic tendencies of the Calvinist lobby.[8] Hence, the work was formally quite different from more urgent Puritan assertions of divine privilege, which, in their justification of ruling dynasties, echoed the medieval style of chronicle. Through legal precision and the rational analysis of cause and effect, Grotius and his humanist contemporaries sought to legitimate the foundation and continuance of the state.[9]

This constitutional concern was shared by lawyers and political actors of diverse shades. Against the divine right, custom was a powerful weapon—immemorial, sacred, and beyond the king's power to alter or annul. All such regional European movements, in France, England, Sicily, Sweden, and the Netherlands, associated longstanding custom and customary law with the freedom of the people, so that "by 1600 or thereabouts there was hardly any constitutional movement without its accompanying historical myth."[10]

In Stuart England, feudal and customary law were set against each other. Feudal law was established by a specific ruler (William the Conqueror) and was thus contingent on the present monarch's grace; customary law was a product of the ancient constitution and immemorial custom. Grotius and Sir Edmund Coke are early users as a political counter of this emerging concept of heritage. Yet for Coke, the beneficiary of the common inheritance was to be a relatively small group of people. His motives for supporting the common law included a concern to defend landed elites against the unchecked powers of the monarchy. Thus it was vital to the constitutionalist side that laws should be shown *not* to have been instituted under the Normans. In consequence, there was a desire to find recognizable elements of the law in ancient Saxon documents, but at the same time, there was a

somewhat cavalier, ahistorical attitude to laws that should reasonably be thought to have been of recent date.[11]

Opposed to the Grotian vision of a nation of free, contracting individuals, united by common history and enduring common tribulations, was Sir Robert Filmer's highly disciplinary idea, derived from Hadrian Saravia, of the world as a patriarchal commonwealth. Filmer offered a radically different version of heritage. People were descended from Adam and presided over by sovereigns whose authority was vouchsafed by God: they were not born free, but into families. Monarchy was absolute, and the family was subject to its head—the father.[12] God had given the world not to all men, but to Adam and his line by natural inheritance, of whom the Stuarts were descendants (a point ridiculed by Locke).[13] The sovereign authority of a state held fatherly power over the people, using it to limit the power of the subordinate fathers below him, and power was not derived from the consent of the subjects, but from God alone, who in His wisdom could transfer it to someone else, or even alter the form of government to aristocracy or democracy.[14]

At one level these debates between constitutionalists and monarchists were occupied with economic privilege and are thus still primarily concerned with familial inheritance. Yet, at another level, the question of who should inherit was understood in terms of the social fabric—the social fabric, but not yet the cultural fabric. Filmer articulated the view that great families should retain their wealth, which was legitimated in the contemporary practice of primogeniture. Administrators and lawyers argued that this was one means of keeping together the great families, and prevented the morcellation of property, a concern related to civic continuity. Hence within Thomas Starkey's *Dialogue between Cardinal Pole and Thomas Lupset* (1532–34), Lupset claims that:

> If the lands in every great family were distributed equally betwixt the brethren, in a small process of years the head families would decay and little by little vanish away. And so the people should be without rulers and heads … [whereby] you shall take away the foundation and ground of all our civility.[15]

Another dimension introduced into the consideration of primogeniture was the colonization first of Ireland and then of America, which was promoted, amongst other reasons, because the lands would accommodate many younger brothers. In Massachusetts the legislature eventually adopted partible inheritance,

but with the elder son given a double share—a biblical idea, showing yet again how most contemporary legislators and legal commentators on politically sensitive issues turned to the Old Testament for wisdom and guidance, and, of course, legitimacy.[16]

Hence, to rebut Filmer effectively, John Locke was required in the *First Treatise* to quote extensively from the Old Testament. In the *Second Treatise,* however, he grounds political institutions in the social compact. In this passage, we have the thought that law-making institutions have the capacity to unite individuals into a social body:

> 'Tis in their *Legislative,* that the Members of a Commonwealth are united, and combined together into one coherent living Body. This is the *Soul that gives Form, Life, and Unity* to the Commonwealth: From hence the several Members have their mutual Influence, Sympathy, and Connexion: And therefore, when the *Legislative* is broken, or *dissolved,* Dissolution and Death follows.[17]

Locke's image of the legislative as the soul of the living political body applies to a particular social moment. In contrast, Edmund Burke's vision of the people, which broadly holds to Locke's line, is trans-generational. Warning the "temporary possessors and life renters" in the commonwealth against committing waste on their inheritance, Burke argues that society is not a commercial contract:

> Society is indeed a contract . . . but the state ought not to be considered as nothing better than a partnership agreement in a trade of pepper and coffee, calico or tobacco, or some other such low concern, to be taken up for a little temporary interest, and to be dissolved by the fancy of the parties. It is to be looked on with other reverence; because it is not a partnership in things subservient only to the gross animal existence of a temporary and perishable nature. It is a partnership in all science; a partnership in all art; a partnership in every virtue and in all perfection. As the needs of such a partnership cannot be obtained in many generations, it becomes a partnership not only between those who are living, but between those who are living, those who are dead, and those who are to be born.[18]

The phrase "nothing better than a partnership agreement in a trade of . . . some . . . such low concern" speaks also to the primacy given in eighteenth-century English law to land over tangible property as the principal means by which wealth was transmitted. The estate was considered at length by Burke's contemporary William Blackstone, in contrast to the law of contract, which was briskly dispatched. Contract only acquired its present status during the next century, leaving the rural character of the English aristocracy embedded in the later rhetoric of heritage.[19]

Cosmopolitanism/Particularism

The writings of J. G. von Herder are a major source for much of the "cultural nationalism" that Merryman identifies with the 1970 UNESCO Convention. There is some irony in this, insofar as Herder's attitude to nationality and to the particular was firmly non-parochial. Moreover, his philological researches laid the foundation for the later idea of a universal cultural heritage.

In his dictum that "Human nature under diverse climates is never wholly the same," Herder moves away from the Kantian notion that human nature has an essential identity. Inspired by Justus Möser's homage to local cultures and traditions, he also departs from Voltaire in promoting cultural pluralism, as distinct from a monism where European culture is seen as the universal yardstick of human values.[20]

> Least of all must we think of European culture as a universal standard of human values. . . . For "European culture" is a mere abstraction, an empty concept. . . . Besides, it can scarcely pose as the most perfect manifestation of man's culture, having—who can deny it?—far too many deficiencies, weaknesses, perversions and abominations associated with it. Only a real misanthrope could regard European culture as the universal condition of our species. The culture of man is not the culture of the European; it manifests itself according to time and place in every people.[21]

Central to his thinking is the assertion that fundamental to the cohesiveness and coherence of the *Volk* is a common language, the bedrock of social life. Language is the living manifestation of a culture and cultural continuity—the matrix in which a person's awareness of her cultural heritage is aroused and deepened. This shift from contract to language is critical—the individual is no

longer paramount, but becomes embedded in a collectivity that has meaning through the language-culture relationship, an idea further developed by Hegel.

For Grotius and John Selden, Locke and Jean-Jacques Rousseau, natural law discourse both on the individual and the social contract was set against a Protestant foregrounding of the Old Testament and the Mosaic Covenant. Herder was firmly within this tradition. The combination of a powerful, universal drama and a national document (embedded in a "common language") gave flesh to Herder's thoughts on the proper relationship between the universal and the particular, between *Humanität* and *Volk*. Moses, the wisest legislator ever, could only accomplish the Exodus and the establishment of a Hebrew state by appeal to the divinity of the law, to something transcending the *Volk*. The Covenant interwove language, law, and the land with a fabric of religious, moral, and political sentiment.[22] As F. M. Barnard argues:

> Herder's interpretation of the Mosaic Constitution signals, therefore, an unmistakable shift from the prevailing individualism of the Enlightenment. The individual is now viewed as an integral part of associational units within the nation or as a member of the collective body of the nation as a whole.... A person is now seen as being able to find fulfillment only within a land and a people of his own, in which he can stand up and be counted. Indeed, a person can only be a person within a cultural and territorial context that is distinctly his own.[23]

If we are able to accept that the general sensitivity to local culture expressed within the 1970 UNESCO Convention is rooted in Herder and Hegel, then the strong cosmopolitan position underpinning the 1954 Convention should be sought in Immanuel Kant. Each individual (not just each state) should yield "generously to the cosmopolitan society as the destiny of the human race," directing their endeavors towards the "progressive organization of the citizens of the earth within and towards the species as a system which is united by cosmopolitical bonds."[24] Kant's citizens, crucially, were autonomous individuals, not members of particularized communities, which for Herder were the vital sociocultural media through which *Humanität* was realized. And Kant, unlike Herder, was not animated by a primitivist interest in the *geist*.

The idea of a universal cultural heritage, as captured in those two Hague Convention phrases, "cultural heritage of all mankind" and "culture of the world," has a cosmopolitan tenor. It also seems to me to have two further sources, both

related to Herder. One is primitivism itself. Here is Max Pechstein writing from the Melanesian island of Palau in 1914:

> Since I myself grew up among simple people amidst nature, I readily came to terms with the abundance of new impressions. I didn't have to change my attitude that much…Out of the deepest feeling of community I could approach the South Sea islanders as a brother.[25]

Pechstein embeds his thoughts in the axial relationship articulated, a century after Herder, by Ferdinand Tönnies, who made a distinction between *Gemeinschaft* (community) and *Gesellschaft* (society) in order to distinguish between natural communities, linked by kinship and local custom, and capitalist societies, regulated by individualism and contract.[26]

Indeed, the interest of Western painters and sculptors not only in the non-European "primitive" and exotic but also in folk art quickened from the mid-nineteenth century. Taking a variety of forms, it is seen, for example, in the Impressionist and Post-Impressionist fascination with Japanese woodblock prints; in the Pre-Raphaelites' turn to a romanticized version of the Middle Ages, the French Nabis living amongst indigenous "primitives" of Brittany, and Paul Gauguin's subsequent domicile in Tahiti; in Cubist images reflecting a knowledge of African masks and figures; in the German Expressionists' travels to Oceania; in the Freudian and quasi-anthropological ideas of the surrealists; and so on. Rousseau's charter for the Noble Savage legitimated a natural and—from Darwin on—competitive progression from savage/primitive to rational/civilized. The primitive was, of course, a trope of contest between apparent polarities, some stemming back to the *Querelle des Anciens et Modernes:* ancient and modern, artistic and scientific, proletariat and bourgeoisie, preindustrial and industrial. Those with no voice were, unsurprisingly, the unwitting subjects.

The second source of those universalizing phrases is the notion of world literature, *Weltliteratur,* a term that Goethe himself coined and which was increasingly used by him at the end of his life to signify literature that expressed *Humanität*—the expression of which was literature's ultimate purpose. Transcending national literatures without destroying their identities, and understood as a concert of works rather than a selective collection, it was influenced by the emerging tradition of German philology to which Herder had already contributed.[27] Reflecting on the romantic formation of the notion of *Weltliteratur,* Edward Said writes:

> Underlying their work [Vico, Herder, Rousseau, and the brothers Schlegel] was the belief that mankind formed a marvellous, almost symphonic whole whose progress and formations, again as a whole, could be studied exclusively as a concerted and secular historical experience, not as an exemplification of the divine. . . . Goethe's idea of *Weltliteratur*—a concept that waffled between the notion of "great books" and a vague synthesis of *all* the world's literatures—was very important to professional scholars of comparative literature in the early twentieth century.[28]

Said's comment here is a useful clue to what I see as the most recent component in the construction of heritage. In 1952, in his sixtieth year, the philologist Erich Auerbach sought to recover a Goethean and Herderan humanism founded on diversity: "The presupposition of *Weltliteratur* is a *felix culpa:* mankind's division into many cultures."[29] Profoundly affected by his experience of exile from Germany, Auerbach here attempts to reconcile the universal with the particular:

> The most priceless and indispensable part of a philologist's heritage is still his own nation's culture and language. Only when he is first separated from this heritage, however, and then transcends it does it become truly effective. We must return, in admittedly altered circumstances, to the knowledge that prenational medieval culture already possessed: the knowledge that the spirit [*Geist*] is not national.[30]

This Germanist idea of unity in diversity reaches its apogee in the writing of Leo Spitzer, Auerbach's fellow philologist in exile. In his contribution to George Boas's *Studies in Intellectual History,* published the year before the Hague Convention, we find Spitzer writing of "the general human mind," "a general human attitude," and our "general human experience,"[31] in, as Geoffrey Green puts it, "an effort to integrate his particular humanistic Spirit with the post-war idealistic yearning for world peace that helped create the United Nations."[32] On reflection, it is hardly surprising that humanist versions of the *Geist* should set themselves in opposition to the virulent National Socialist version and that such thinking should appear in an international convention of the early 1950s. Indeed, Timothy O'Hagan observes that documents like the French Declaration of the Rights of Man and the Citizen, the U.S. Declaration of Independence, and the European Convention for the Protection of Human Rights and Fundamental Freedoms were all forged

during or in the after-math of struggles against oppressive political forces or alien occupations.[33]

In summary, I looked first at two postwar international legal conventions that appear to support divergent approaches to cultural heritage. Then I noted the emergence of the idea of heritage in the late sixteenth and early seventeenth centuries, when customary law was championed as a defense against the divine right of kings. Then, passing quickly over the contribution of contractarians, like Locke, who saw society as a political bond between individuals, I moved to the late eighteenth century debate between Herder and Kant, in which local customs were set against cosmopolitical bonds. Broadly speaking, this is the division that John Merryman has made between the two international conventions.

For my part, I believe we should be clear that the approaches to heritage discussed by Merryman are both predicated on constructions—which is not to say that they are poor constructions—the histories of which are more deeply entwined than their respective proponents acknowledge.

1. In no case could they be privately appropriated. See the Instructions for the Governance of Armies of the United States in the Field, issued by the Union command as General Orders No. 100, 24 April 1863 in Richard Shelley Hartigan, *Lieber's Code and the Law of War* (Chicago: Precedent, 1983).

2. UNESCO, "Convention for the Protection of Cultural Property in the Event of Armed Conflict" (The Hague, 1954), preamble. In its 1939 study on the protection to be afforded monuments and works of art in times of war and civil strife, ICOM (the International Council of Museums) held that states that are rich artistically are only depositories of such works for the general benefit of all mankind. See Sharon A. Williams, *The International and National Protection of Movable Cultural Property: A Comparative Study* (Dobbs Ferry, N.Y.: Oceana Publications, 1978).

3. John Henry Merryman, "Two Ways of Thinking about Cultural Property," *American Journal of International Law* 80, no. 4 (1986): 840.

4. UNESCO, "Convention on the Means of Prohibiting and Preventing the Illicit Import, Export, and Transfer of Ownership of Cultural Property" (Paris, 1970), preamble.

5. Lyndel V. Prott, *Problems of Private International Law for the Protection of the Cultural Heritage,* Recueil des cours 217 (The Hague: Hague Academy of International Law, 1989).

6. UNESCO, "Convention Concerning the Protection of the World Cultural and Natural Heritage" (Paris, 1972), preamble.

7. *De Antiquitate Republicae Batavicae,* 1610. See also Quentin Skinner, *The Foundations of Modern*

Political Thought (Cambridge: Cambridge University Press, 1978), 1:28–41.

8. Simon Schama, *The Embarrassment of Riches: An Interpretation of Dutch Culture in the Golden Age* (London: Vintage Books, 1987), 78–79, 114–15.

9. Elisabeth de Bièvre, "The Art of History and the History of Art, Cause and Effect in Historiography and Art in the Commonwealth of the Low Countries around 1600," in *From Revolt to Riches, Culture and History of the Low Countries 1500–1700,* ed. Theo Hermans and Reinier Salverda (London: Centre for Low Countries Studies, University College London, 1993), 163–81.

10. In France, the Hugenot jurist François Hotman asserted the antiquity of the Assembly of the Nation (in the *Francogallia,* published 1573); in England, Coke promoted the antiquity of Parliament and the common law; in Sicily, Pietro de Gregorio that of baronial privilege and the *Parliamento;* François Vranck in the Netherlands that of the sovereign and independent Dutch towns; and Sparre in Sweden that of the nobles in their *Riksrad.* These constitutional stands (Protestant and Catholic), with their emphasis on the native and local and their accompanying construction of history, had some roots in the turn against Roman law. J. G. A. Pocock, *The Ancient Constitution and Feudal Law* (Cambridge: Cambridge University Press, 1987), 11, 15–17.

11. Coke was attacked on monopolies by Francis Bacon, who argued that, if the rule of common law stood consistently against all monopolies and sponsored freedom from restraint and control, the ancient law could not also justify the most rigorous kind of corporate monopoly privilege. David Little, *Religion, Order, and Law: A Study in Pre-Revolutionary England* (Oxford: Oxford University Press, 1970), 214–15.

12. Sir Robert Filmer, *Patriarcha and Other Writings,* ed. Johann P. Somerville (Cambridge: Cambridge University Press, 1991).

13. John Locke, "First Treatise," in *Two Treatises of Government,* ed. Peter Laslett (Cambridge: Cambridge University Press, 1988), ch. 6, 218ff.; see also Jeremy Waldron, *The Right to Private Property* (Oxford: Clarendon Press, 1988), 144.

14. Filmer, *Patriarcha and Other Writings,* xv–xxiv.

15. As quoted in Joan Thirsk, "The European Debate on Customs of Inheritance, 1500–1700," in *Family and Inheritance, Rural Society in Western Europe, 1200–1800,* ed. Jack Goody, Joan Thirsk, and E. P. Thompson (Cambridge: Cambridge University Press, 1976), 178–85.

16. Thirsk, "The European Debate," 188–89. Arguing from the Welsh experience, David Powell (in his translation of and commentary on the *History of Cambria,* 1584) saw partition being appropriate to the planting and settlement of places where land was plentiful and the population small (the notion here of course is of an "uninhabited" country, where indigenous peoples are "invisible"). However, in "a populous country already furnished with inhabitants it is the very decay of great families, and . . . the cause of strife and debate."

17. John Locke, "Second Treatise," in *Two Treatises of Government,* ch. 19, 407–8.

18. Edmund Burke, "Reflections on the Revolution in France" (1790), in *The Works of the Right Honourable Edmund Burke* (Oxford: Oxford University Press, 1907), 4:35, 105–6.

19. A. W. Brian Simpson, introduction in William Blackstone, *Commentaries on the Laws of England* (Chicago: University of Chicago Press, 1979), 2:xii–xiv, ch. 30.

20. M. H. Abrams, *The Mirror and the Lamp: Romantic Theory and the Critical Tradition* (Oxford: Oxford University Press, 1953), 204.

21. Cited in F. M. Barnard, *Herder's Social and Political Thought: From Enlightenment to Nationalism* (Oxford: Clarendon Press, 1965), 100.

22. Moses Mendelssohn was admiring of Herder's gift "to feel yourself, whenever you wish, into the situation and mentality of your fellow-beings." F. M. Barnard, *Self-Direction and Political Legitimacy: Rousseau and Herder* (Oxford: Clarendon Press, 1988), 259.

23. Barnard, *Self-Direction and Political Legitimacy,* 267.

24. Immanuel Kant, *Anthropology from a Pragmatic Point of View,* trans. Victor Lyle Dowdell (Carbondale: Southern Illinois University Press, 1978), 247–51.

25. Donald E. Gordon, "German Expressionism," in *"Primitivism" in 20th Century Art: Affinity of the Tribal and the Modern,* ed. William Rubin (New York: Museum of Modern Art, 1984), 2:391.

26. Ibid., 370.

27. "But still . . . its practical meaning and operating ideology were that, so far as literature and culture were concerned, Europe led the way and was the main subject of interest." Erich Auerbach, "Philology and *Weltliteratur,*" trans. and introduction by Edward Said and Marie Said, *Centennial Review* 13 (1969): 1.

28. Edward Said, *Culture and Imperialism* (London: Vintage Books, 1993), 50–53.

29. Auerbach, "Philology and *Weltliteratur,*" 2.

30. Ibid., 17.

31. Leo Spitzer, "Language: The Basis of Science, Philosophy and Poetry," in *Studies in Intellectual History,* Johns Hopkins History of Ideas Club (Baltimore: Johns Hopkins University, 1953), 79, 82. This was contemporary with the publication of André Malraux's *Musée imaginaire de la sculpture mondiale,* 1952–54.

32. Geoffrey Green, *Literary Criticism & the Structures of History: Erich Auerbach and Leo Spitzer* (Lincoln: University of Nebraska Press, 1982), 118, 145.

33. Timothy O'Hagan, "On Hegel's Critique of Kant's Moral and Political Philosophy," in *Hegel's Critique of Kant,* ed. Stephen Priest (Oxford: Clarendon Press, 1987), 157.

World Heritage, Art, and Economics:
The World Heritage Convention in the Light of Economic Theory

Georges S. Zouain

This essay is an attempt to show how heritage, art, and economics have been and remain very closely related throughout their history and how together, through this relationship, they have led to the making of the "International Convention for the Protection of the World Cultural and Natural Heritage."[1] It also tries to illustrate how heritage, and particularly world heritage, is looping the loop by returning to its origins—economics and economic rationality. For the sake of simplicity, I shall concentrate on the cultural immovable heritage, even if most of what follows applies equally to movable objects and to natural sites.

The Origins of the World Heritage Convention

It is often considered that the World Heritage Convention is rooted in the International Campaign for the Safeguarding of the Temples of Nubia in Egypt and, to illustrate the point, reference is made to the speech given by André Malraux at the launch of the campaign, when he said:

> Beauty has become one of the major enigmas of our times, that mysterious presence by which the monuments of Egypt unite with the statues of our cathedrals or of the Aztec Temples, those of the grottos of India and China—to the paintings of Cézanne and Van Gogh . . . in the treasure of the first world civilization . . . the first world civilization publicly claims world art as its indivisible heritage.[2]

The roots of a world heritage, which is unique and worthy of being protected by all, stretch far back in time. In 1931, the first International Conference for the Preservation of Historic Buildings was held in Athens, and although it brought together only Europeans, the second conference, held in 1964 in Venice, included representatives from Mexico, Peru, and Tunisia. Meanwhile, in 1937 under the auspices of the League of Nations, the Athens conference called for the safeguarding of the "world cultural heritage."

However, the need to protect unique monuments or representations of the genius of humankind started centuries before. When the emperor Charles V

(1500–1588) saw that the Mosque of Córdoba, built under the reign of Abd al-Rahman (r. 756–88) and completed by the great caliph al-Mansur in 987, was being destroyed by the priests in order to enlarge the chapel erected in its center, he ordered them to stop because "they were destroying what could be seen nowhere else, to build what exists everywhere."[3]

Whatever its origins, the World Heritage Convention is today the most successful international legal instrument for the protection of immovable heritage, be it cultural or natural. One hundred fifty-eight countries have ratified it and have placed more than 630 sites under its watch, protecting heritage under threat from war or as a result of deliberate destruction. Recent examples of its successes include the Cairo ring-road on the Giza plateau, the Galapagos Islands, Byblos in Lebanon, the Kakadu National Park in Australia, and the El Vizcaino whale sanctuary in Mexico.

The Convention has also been successful in raising awareness among decision-makers and society at large about the values and importance of heritage, universality, and the uniqueness of our world. Because of the prestige attached to the World Heritage List, the Convention is also attracting donors and investors— institutional and private—to invest in World Heritage sites. International and regional development funders, private companies such as hotels, travel agents, and even entrepreneurs from other sectors, are concentrating on World Heritage cultural sites, particularly cities.

However, the prestige attached to the Convention has its drawbacks. Registration on the World Heritage List is becoming an aim in and of itself: added prestige and heightened visibility are deemed to ensure guaranteed revenues from tourism, and states are becoming more interested in these revenues than in the virtues of universality and of protection of the site. This interest in the tourism market value of the inscription on the World Heritage List explains, to a certain extent, the competition taking place in the nomination process between the "haves" and the "have-nots": those countries with the administrative ability to understand and to manage a nomination process that involves technical, scientific, and political (lobbying) difficulties nominate and list more sites than others. More than 30 percent of the sites listed belong to five European countries, and this imbalance continues to grow. The link between tourism and the Convention is getting stronger. A simple reading of the list of nominations over the last few years shows that the countries where tourism is already strong nominate the most and that the universal exceptional value of the nominated sites tends increasingly to be forgotten in the process.

Hence, the economic worth of heritage remains very present in the minds of those who own it. If some countries keep submitting more and more sites, which evidently have less and less of a "universal exceptional value," and if there are more and more cultural sites nominated than natural ones, it is because of the economic returns expected. Are these returns limited to the direct impact of tourism, or is there more to it? Before addressing this question, I will further investigate the concept of heritage.

The Concept of Heritage and Its Origins

Birth of the Concept

From the outset, we must note the difference between the French word *patrimoine* and the English *heritage;* they bear different historical contents. Although the origin of the French word is the Latin *patrimonium* (that is, what belongs to the family), its origins can be traced back to ancient Greece, where it represented the land or the estate that produced the family's basic commodities. It could neither be traded nor sold; it was to be transmitted from one generation to the next.

It seems that the concept started under the economic regime of what has been called the *oikos,* a non-market economy[4] where, according to the nineteenth-century German economist Johann Karl Rodbertus,[5] it symbolized the family estate. This concept and the economic system built up around it met with some criticisms: the controversy was between the "modernists," who believed that Greece's economy was very advanced and structured, and the "primitivists," who considered it to be "archaic."

Because of historical confusion—there is no exact reference to a given period—and of the controversy surrounding it, the word *oikos* became an easy tool to explain the "natural economy" in which money, markets, and trade had little impact on the whole system of production. In such an economy, the family had to possess its means of production, since it was impossible to address its needs through emerging and little-monetarized markets that were functioning through a system of barter. Joseph Schumpeter further clarified the rationale of the Graeco-Roman economy:

> Their Oeconomicus (*oikos,* house, and *nomos,* law and rule) meant only the practical wisdom of household management; the Aristotelian *Chrematistics* (Possession of wealth), which comes nearest to being such a label, refers mainly to the pecuniary aspects of business activ-

ity.…Greek thought, even where most abstract, always revolved around
the concrete problems of human life.[6]

On this period of ancient Greece and on the importance of agriculture in its econ-
omy, Fernand Braudel wrote about "The Land or the Commodity," reminding us
that land is the true value. It is the major production factor with manpower.
Accumulation of wealth came through the accumulation of land and labor (for the
latter, the *hectémores* being the ideal example). This wealth—wheat, olive oil, etc.—
had to be traded and exchanged, and this could take place only in the presence of
markets and of specialized traders.[7]

Thus the *patrimoine*—heritage—gained the status of non-exchangeability.
It is in this context—which became the subject of lengthy debate among the econ-
omists of the late nineteenth and early twentieth centuries[8]—that the concept of
the *patrimoine,* which could neither be sold nor traded, emerged, a concept that
would gain weight and recognition throughout the twentieth century.

Here a word of caution is needed: the distinction between pre-market and
market economies (that between the modernists and the primitivists) serves us to
avoid an "inversion of perspective," which, as Karl Polanyi puts it, might lead to
read into antiquity "modern" phenomena, which in reality are archaic or primi-
tive.[9] The *patrimoine* of ancient Greece (i.e., the *oikos*) may be the father of our
patrimoine, but it is of a different ilk and serves different purposes. How, then, did
the *patrimoine* or heritage change through time until it became a mainly cultural
and aesthetical object?

"Heritage" As We Understand It

Roman law reinforced the notion of family heritage by introducing a quasi
identification between the *pater familias,* who is its protector and transmitter and
the *patrimonium.* The *pater familias* brings to the *patrimonium* his personal val-
ues—the intangibility of his social status, together with the personal obligation of
its transmission.

It is usually agreed that the institutionalization of the notion of "common
heritage" and the introduction of intangible values in the concept of "heritage"
were brought about by the French Revolution. In 1792, the revolutionaries began
destroying physical representations of the ancien régime: castles, palaces, private
domains, monasteries, churches, etc. The Convention, which headed the Revolution,
became alarmed by the loss of wealth caused by this destruction and decided to

protect the so-called "monuments."[10] It entrusted a special commission with this task. The purpose of such protection was twofold: (1) to protect the wealth of the country and put it at the service of the new regime; and (2) to give this new regime a historical dimension and root it in tradition, thus legitimizing it; from belonging to a family or a community, the monuments became the property of the state. It was then that the concept of "national heritage" was born. With this "national heritage" the French Revolution created the artistic memory, the notion of monuments, and the heritage of forests and estates.

This was followed by the listing of monuments and sites (in 1810 by the French minister of the interior Alexandre de Laborde). Once these lists were published, the bourgeoisie was keen to visit the sites, thereby starting the first tourism activity, then called *excursions*. From the listing of monuments, it became easy to move to the "classification" of these monuments according to their order of importance as done then by Prosper Mérimée in 1834.

With the Industrial Revolution, two important things occurred from the point of view of heritage. First, the bulk of production, of revenue generation, was no longer driven by agriculture. Industry took over, thus relieving the land and the estates of a large part of their economic function and widening the gap already opened by the French Revolution between the concept of heritage *(patrimoine)* as we know it now and the original meaning of the Greek *(oikos)*. Second, a large economic surplus was generated, thanks to the new production processes and the colonies. This surplus enabled the state to devote more of its resources to the protection and enhancement of its "national heritage," which was increasingly becoming a heritage of beauty, of aestheticism, and of picturesque sites. Romanticism prevailed.

Meanwhile, the results of discoveries and exploratory expeditions, which Europe was hearing about thanks to the emerging media, together with a new "universal thinking" were pointing to the notion of a single world—a single humanity. The search for universality was also challenged by the destruction taking place in European cities and in the colonies, owing to the pressures of economic growth and the needs of emerging industry.

The modern notion of *patrimoine*—which had already lost much of its economic value—was born under specific economic circumstances: those of the Industrial Revolution in Europe, once agriculture was replaced by industry as the main sector of production. The *patrimoine,* initially land-related, was no longer needed to produce the wealth of the nation.

Different Cultures, Different Contents

This is why the concept of heritage in the Western world is so different, for example, from the African concept of heritage, or from that of the Pacific Islands. In such places the spiritual value of a site, an object, or a monument remains the main reason for protecting it and ensuring its conservation as part of the *patrimoine*. These regions have not experienced the same economic and political processes as the Western world.

Moreover, the availability of materials has influenced the types of techniques used and of *patrimoine* built, while each type of material has determined the development of specific building techniques and of art. In the civilizations of stone constructions, for example, most of the monuments that have survived down through the centuries are cathedrals or places of worship or monuments erected for the dead (Egypt). The same applies to the prehistoric sites so far uncovered.

Yet creativity is the product of our environment as much as of our needs. The Danish economist Esther Boserup has explained the process of technological innovation, based on demographic pressures on arable land.[11] Similarly, the French anthropologist André Leroi-Gourhan has shown the impact of the environment and of the materials available on the techniques developed by humankind, that technological innovation is brought about by human needs, while the types of materials available determine technical innovation and the sorts of tools developed.[12] In Japan, temples are built of wood, and their builders have devised very specific techniques in order to withstand earthquakes—the balancing effect of the roof-supporting poles. In civilizations or cultures of "earth," builders have privileged form and elaborate façades. Where nomadism or pastoralism was the rule, places of worship and sacred places were natural (as opposed to man-made) areas.

Religious monuments of worship are as much the product of the architect who designed them as of the very many workers who built them. Although we assign to these monuments cultural (religious) functions, we should not lose sight of their social and economic functions, which can be compared to those of the modern, large-scale public works undertaken, for example, to revitalize the economy after the Great Depression. In limited monetarized markets or local markets, it was necessary at times to redistribute wealth from the landlord or the church and to provide food for the poor. Social cohesion in times of hunger or war could also be achieved by such large-scale, labor-intensive projects.

Here again, we run the risk of looking at things from the past through our modern eyes, ascribing them values of which their builders or owners had no notion. As Sir Alan Peacock, the British economist, reminds us:

> A large proportion of artefact are not produced with the idea of re-
> minding us of our past . . . they become identified as heritage goods
> usually by archaeologists and historians who have obtained some form
> of official recognition or public acceptance of their status as experts
> in determining their artistic or historical significance. These experts ex-
> ercise a pronounced effect on the accretion process which is reinforced
> by their influence as holders of senior positions in the heritage services
> which are provided by public institutions not normally subject to mar-
> ket forces.[13]

The difference between the economic role played by these monuments when they were being built and the economic function of infrastructure projects of modern times derives from the very limited "investment multiplier" effect these monuments could have. The goods created by the construction of these monuments had little impact on the rest of the economy.

The Introduction of Beauty and Aestheticism

Some words are necessary here on the concept of beauty since it has become a major reason for listing a site or a monument and the most powerful attraction for tourists of all races and nations. Again, we return to Greek civilization and particularly to Plato, whose reflections on beauty have influenced all Western thinking. In one of his discourses, "Hippias Major," Plato says of beauty that "there is a beauty in itself which ornates all other things and makes them appear beautiful when this form is added to them."[14] The word used by Plato for "form" is *eidos,* the idea—which, in this context, is nothing but beauty itself. Today, we list, protect, and classify "beautiful" places and monuments quite often for very personal, subjective, and psychological reasons.

During the Industrial Revolution, the memorial function of monuments gradually started to be replaced by art, a trend begun during the Renaissance. Previously, the function of a monument was to remind us of deity, of power, or of a victory. Perfection in construction as well as the ornamental aspect of the monument were sought, but not necessarily beauty.

Until the fifteenth century, "art" (from the Latin *ars*—activity or know-how) referred to a set of technical activities related to a trade. The idea of aestheticism, as we understand it, only appeared when art gained recognition, through its new acceptation, as an intellectual activity that could not be reduced to a single technical task.

This happened once again as a result of a change in the economic process. The transition from a small-scale, artisan-based production system to a capitalistic mode of production radically changed the status of the artist. This change released the artist from the domination of the guilds and their feudal structures. In the Middle Ages, the object of art had to conform to the requirements of the commissioner to meet its future functions (religious, ornamental, celebratory); this gradually changed, and more freedom was left to the creativity of the artist. At the same time, the price of works of art increased drastically. Prices no longer related to the materials used; instead they reflected the reputation of the artist, his market value.[15]

The intrusion of beauty, aestheticism, and the picturesque, which has developed a quasi-psychoanalytical bond between us and our cultural "heritage," has provoked an inflation of this heritage at all levels of social organization: local, regional, national, and international, even though the meanings of "heritage" or *patrimoine* are not shared by all cultures in the world. Sometimes the concept of heritage or *patrimoine* simply does not apply. Nevertheless, there is a growing "heritage" market in our world, and it has entered an inflationary spiral.[16] In a sector—that of heritage, where the supply of goods is limited by the sheer nature of these goods—you cannot produce archaeological sites or the Pyramids or a cathedral; their availability is finite. Our modern societies are creating more "heritage" by progressively enlarging the notion of "heritage," which includes more and more recent monuments; this reduces further the market value of such goods. To repeat the words of André Malraux, "Beauty has become one of the major enigmas of our times."

The Economic Values of Heritage

Must heritage have an economic value? If we were to follow John Maynard Keynes, then the answer is yes. It is not only a matter of intrinsic value, but rather, according to Keynes, a matter of use value. He once suggested that if artistic resources were not fully employed, then it would be worth knocking down the majority of buildings in South London next to the Thames and replacing them with the best of contemporary buildings and parks laid out like St. James's.[17]

The Different Types of Value

Tourism, which is becoming a major sector of the economy, is not the only source of economic value for heritage. In a recent publication, Ismaïl Serageldin provides us with a very clear list of the economic values of heritage. From the more tangible to the intangible values, Serageldin divides the total economic value of cultural

heritage assets into two major categories: the use value and the non-use value. Between these two categories lies the "option value." Serageldin explains these different values:

> Total economic value is usually decomposed into a number of categories of value. [It] generally includes the following:
>
> *Extractive use value.* Extractive use value derives from goods which can be extracted from the site.... In historic living cities, there are direct uses being made of the buildings, for living, trading, and renting or selling spaces.... Unlike a forest, the use of a historic city does not deplete it unless the use is inappropriate or excessive, denaturing the beauty of the site or the character of the place. At some level, a parallel exists to extractive use of a forest being kept at sustainable levels.
>
> *Non extractive use value.* Non-extractive use value derives from the services the site provides.... The parallel for historic cities is clear: some people just pass through the city and enjoy the scenery without spending money there, and their use of the place is not captured by an economic or financial transaction. Measuring non-extractive use value is considerably more difficult than measuring extractive use value.... those likely to have the most relevance to the valuation of cultural heritage are aesthetics and recreational value:
>
>> *Aesthetic value.* Aesthetic benefits are obtained when the fact of sensory experience is separate from material effect on the body or possessions. Aesthetic effects differ from the non-use value because they require a sensory experience, but aesthetic benefits are often closely linked to physical ones.
>>
>> *Recreational value.* Although the recreational benefits provided by a site are generally considered together as a single source of value, they are a result of different services which a site might provide.... A historic area could have rest stops, vistas, and attractive meditation spots, in addition to shopping bazaars and, of course, monuments....
>
> *Non-use value.* Non-use value tries to capture the enrichment derived from the continued existence of major parts of the world heritage. Even if not likely to visit these sites, one would feel impoverished if the

sites were destroyed. In many cases, this benefit is referred to as *exis-tence value* (the value that people derive from the knowledge that the site exists, even if they never plan to visit it) . . . Other aspects of non-use value include the *option value* (the value gained from detaining the option of taking advantage of a site's use value at a later date, akin to an insurance policy) . . . Non-use values are the most difficult types of values to estimate. Yet, this category of value has obvious relevance for the assessment of cultural heritage sites.[18]

The Economist's Perspective: Estimating Value

The most common method to estimate the economic value of heritage is that of contingency valuation. There is however, in my view, another approach worth en-visaging. Since at its beginnings, heritage was basically an economic factor, then one can consider heritage as an economic commodity and try to analyze its eco-nomic role and returns. In this framework, heritage becomes an economic "asset," since its protection and management represent "future economic benefits."[19]

The technique of contingency valuation is a direct product of welfare eco-nomics, a sector of economic theory dealing particularly with the provision of public services and the well-being of the community.[20] Contingency valuation is based on a survey conducted among representatives of the target population po-tentially interested in a heritage element. This sample is asked about its Maximum Willingness to Pay (MWP) to secure a public service or avoid its loss or deterio-ration. Applied to a heritage element, this technique enables the decision makers to estimate the economic value the society provides to a given heritage, thus pro-viding basic information for the cultural heritage policy to apply.

At its beginning, during the 1960s, contingency valuation was more a theo-retical tool, and its first applications were geared toward the valuation of protecting natural and recreational areas. Nowadays it has become used regularly by a variety of actors—from national decision makers to international organizations—and is used for all types of cultural goods, from museum collections to sites and historic cities.

In terms of heritage as a commodity, the total economic value of a site can be considered to be at least equal to the total revenues its various uses generate over time, its most intangible values being impossible to calculate.[21] Therefore, to maxi-mize its value as well as its return to the economy, the lifetime of a cultural site must be as long as possible, since, as opposed to other "commodities," a cultural site is unique and cannot be replaced. When a tool becomes obsolete, we can buy

a new one; there is no such thing in cultural heritage, since whatever the value of, say, a building by Sir Norman Foster or Frank Lloyd Wright, never, in our foreseeable future, can they replace a Roman amphitheater. They are simply different, and each one is unique. The fact that any heritage site is unique and cannot be replaced gives it a special economic value.

The second limitation to this economic perspective of heritage derives from that peculiar perception and personal relationship we have with cultural heritage. It is this perception and this relationship that tell us how much, in almost monetary terms, our heritage is worth. This imposes upon the custodians of the site the duty to ensure its full protection, so as to enable it to last as long as possible. The site must not be consumed rapidly; better still, it should not be consumed at all.

This extended protection has an economic return known as the "reward of waiting"[22] or the "reward of abstinence." Instead of spending, consuming, or simply destroying a heritage site, its owners—state, local community, or private owner—decide to keep it. This decision could well have been taken against a possibility of high returns from a touristic or construction operation. Since heritage sites are not abundant and will never meet the exceeding and ever-increasing demand, there should be property in them in order that they may be used in an effective manner. It is the scarcity of these capital goods that makes income from their property possible. How does this apply?

Let us now consider that heritage is a commodity and that, as such, it is a tool—or factor—of production. Here, Piero Sraffa, an Italian economist who taught at Trinity College and at Cambridge University, provides an important contribution to the estimation of the value of a commodity such as heritage. In his major work[23] Sraffa writes on fixed capital being a durable production tool and entering annually into a production process in the same way as, say, the raw materials that are regularly consumed in the production. In this perspective, a heritage site or a cultural monument will be considered as being (a) fixed capital and (b) a commodity that contributes to a production process. For the sake of this discussion, I use the text of Sraffa as a guide and refer to either the site or the monument as "heritage."

Heritage, therefore, is a durable production instrument, which is part of the means entering yearly in a production process like any other means of production consumed in the process. At the end of the period (say, a year), what remains of the heritage used in the process will be dealt with as a portion of the joint annual product of the branch, the main output of which being the negotiable commodity, which represents the main subject of the process. In our field of eco-

nomics of heritage and to simplify the explanation, we can suppose that the subject of the production branch is the returns from tourism.

Let us consider, for example, a knitting machine, which together with the thread, the energy, and so forth, contributes to the production process. At the end of the production period under consideration—any given year—the machine has aged by one year; it has been utilized, it has become older by one year, and it would then emerge at the end of the production period as a new commodity together with the socks it had produced. This implies that the same machine, at different ages, be treated as many different products, each having its own price, its own value.

Consequently, a branch that uses a durable production instrument must be looked at as being subdivided in as many separate processes as there are years in the total life of the instrument. Every one of these processes uses an instrument of a different age, and every one produces, jointly with other commodities, an instrument that is older by one year than the previous one used in the process.

In the case of heritage, sites and monuments can be assimilated to such commodities as Sraffa defines in his process, replacing the knitting machine with a heritage site. Surely enough, it produces goods, generates revenues, together with other commodities used in the process: hotels, restaurants, buildings, travel, etc.

In doing so, however, exactly like the knitting machine, the site is confronted with depreciation. In economic terms, its market price will therefore change, but we do not need to sell to know its market value. Here, we return to the notion of "option value," but with an economic, market-oriented bias. We can say that the value of a site or a monument is equivalent to the value of goods it produces. The value of heritage is therefore equal to the sum of all the revenues its existence generates, minus the costs of its management and of the maintenance of its heritage values.

If V_t = value of site at year (t)
 R_t = total revenues generated by the existence of the site (s) in year (t)
 C_t = management and maintenance costs of site (s) in year (t)
Then $V_t = R_t - C_t$
Where R_t is equal to the sum of all the direct and indirect revenues induced by the presence and utilization of the site, such as entrance fees (tickets) and related costs; sales of maps, guides, souvenirs, etc.;

restaurants, parking fees, hotels, and recreational activities; and trans-
portation to and from the site, taking into consideration the fact that
every one of these activities induces a variety of related economic ac-
tivities in the national context.

And where C_t is equal to the sum of all costs, ranging from the clean-
ing of the site, its presentation, scientific research, and publications, and,
depending on the fragility of the site, the direct and indirect costs of
its physical maintenance and continuous rehabilitation to match the
degradation caused by its utilization.

Theoretically, if we assume that a tool such as a heritage site produces revenues
with a constant, regular efficiency throughout its existence, the annual cost of its
maintenance and management to cover its depreciation must be constant if we
want the prices of all the units (different types of revenues) produced by this tool
(heritage) to remain equal through time. This annual cost will be equal to a fixed
annuity, the value of which—calculated on the basis of the general rate of return
(r)—is equal to the original price of the tool[24] (or economic value of heritage). If
this direct economic value is $V_{(0)}$ and the life of the site (n)—which in the case of
a physical cultural heritage should be as long as possible,[25] the annuity will become:

$$V_{(0)} \times [r(1+r)^n] / [(1+r)^n - 1]$$

However, we had considered that the annual processes of production differ one
from the other by the sheer fact that the production tool (heritage) produces at the
end of every process a new tool, a new commodity, older by one year from the pre-
vious one. Its value therefore varies with its age—or better, with the number of
years of its use. Therefore, year after year, more of the returns of heritage should
be devoted to its protection and presentation.

Thus, if
V_{t0} = direct use value of the site in year t_0
V_{t1} = direct use value of the site in year t_1
$dV_{t1,t0}$ = variation of the direct use value between t_1 and t_0 (which can
be negative)
and

TR_{t0} = total direct use revenues in year t_0

TR_{t1} = total direct use revenues in year t_1

TC_{t0} = total maintenance and presentation costs in year t_0

TC_{t1} = total maintenance and presentation costs in year t_1

Then,

$dV_{t1,t0}$ should be equal or higher than $[(TR_{t1} - TR_{t0}) - (TC_{t1} - TC_{t0})]$ if the site is to retain its values.

This relationship, however, depends also on the type of the site and on the amount of direct use it can absorb (among other uses, visits). A fragile site such as a prehistoric or a Phoenician archaeological site cannot receive the same numbers of visitors and accommodate the same types of uses as a Roman amphitheater or a historic building. Similarly, historic cities, as it is well known, cannot accommodate too many tourists if they are not to become mono-economies.

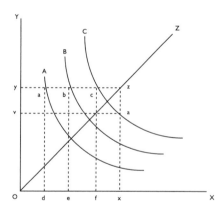

Fig. 1. Diagram showing the relation between the revenues generated by the heritage site (Y axis) and the life of the heritage site (X axis), where fragility of the site, measured along the diagonal (Z), increases as it approaches 0.

These relations can be best explained in a diagram (fig. 1). In the diagram, the vertical axis (oY) represents the revenues generated by the use of a heritage site and the horizontal axis (oX) the life of this site. The diagonal (oZ) represents the fragility of the site considered—fragility increases as it approaches (o). The isoquant curves A, B, and C represent the relationship between revenue and duration of heritage with sites of different fragility.

For a given level of revenue (oy), the less fragile site (curve C) will have a life duration of (of) and the most fragile a life duration of (od). For a revenue of (ov), lower than (oy), the life duration will increase to reach (ox) for the less fragile.

Conclusion

This discussion of the relationship between heritage, art, and economics is still at its preliminary stages and deserves to be further developed. From the point of view of conservation of the cultural heritage, it is evident that the increasing demand from society for more heritage and places of beauty reinforces an economic role of heritage that needs to be taken into account. Protectors and owners of heritage

now have to compete with an increased demand for a tourist use of heritage that does not always help in the conservation of this same heritage. It is therefore important that a revision of the economic reading of heritage and new management processes be developed.

1. Known as the World Heritage Convention and approved by the General Conference of UNESCO at its seventeenth session on 16 November 1972.

2. André Malraux, speech at the launching of the International Campaign for the Safeguarding of the Temples of Nubia (Egypt), 1962.

3. *Michelin Guide—España & Portugal,* 2005 (Paris: Michelin, 2005), 194.

4. This part is based on the works of Karl Polanyi, Conrad M. Arensberg, and Harry W. Pearson, eds., *Trade and Markets in the Early Empires: Economies in History and Theory* (Glencoe, Ill.: The Free Press, 1957).

5. See Johann Karl Rodbertus, "Economic Life in Classical Antiquity," published between 1864 and 1867 and cited in ibid.

6. Joseph Schumpeter, *History of Economic Analysis,* ed. from manuscript by Elizabeth Boody Schumpeter (New York: Oxford University Press, 1954).

7. Fernand Braudel, *Memory and the Mediterranean,* ed. Roselyne de Ayala and Paule Braudel, trans. Siân Reynolds (New York: Knopf, 2001), 216–18:

> Land was of course the basis of everything. At the time when its people began to spread far and wide, Greece was a rather poor agricultural country with an archaic economic system. There was little arable land, and even less of any real quality. As soon as the population grew, the need for internal colonization appeared, but there was little scope for expansion. The pick-axes of the pioneers had to cope with stony ground and knotty tree roots; it was hard to make much of a living out of this marginal land.... The difficulty can easily be restated in social terms. Excessive numbers of poor peasants competing for a meagre living made them easy prey for a few big landowners, turning them into *hectemores*—tenant farmers who had probably to hand over five-sixths of their crop every year—driving them into debt, and eventually making the whole territory 'slave land.' ... Everything thus conspired with the process of pauperization to drive men to distant shores.... [Once they had] exhausted the possibilities of *internal* colonization ... [they sought] to get hold of the grain of the sparsely populated lands.... This grain all had to be paid for, generally

with wine and oil—luxury agricultural products—or with manufactured goods. But such exchanges of grain, pottery vases or metals, once they attained a certain volume, could not take place without professional merchants....Almost from the very first wave of emigration then, one must suppose the existence of merchants, commercial calculations, and even colonization motivated by commercial imperatives.

8. Debate centered on whether the economy of classical Greece should be characterized as primitive or early modern.

9. Karl Polanyi, *Trade & Markets in the Early Empires: Economies in History & in Theory* (New York: The Free Press, 1957).

10. The origin of the word comes from the Latin *monumentum,* derived from the verb *monere,* to remind, to alert.

11. Esther Boserup, *The Conditions of Agricultural Growth: The Economics of Agarian Change under Population Pressure* (London: Allen and Unwin, 1965).

12. Andre Leroi-Gourhan, *Milieu et Techniques* (Paris: Albin Michel, 1945).

13. Alan Peacock, "A Future for the Past: The Political Economy of Heritage," The British Academy—Keynes Lectures in Economics; read 27 October 1994 at the British Academy and published in the *Proceedings of the British Academy,* vol. 87 (Edinburgh: The British Academy, 1995).

14. Plato, *Hippias Major,* in *Platon: Oeuvres Complètes,* vol. 1 (Paris: La Pléiade, 1950).

15. On art and aestheticism, see Marc Jimenez, *Qu'est-ce que l'esthétisme?* (Paris: Gallimard, 1997).

16. Remember Alan Peacock's words, cited above.

17. In Alan Peacock, "A Future for the Past."

18. Ismaïl Serageldin, *Very Special Places: The Architecture and Economics of Intervening in Historic Cities* (Washington, D.C.: The World Bank, 1999).

19. A very instructive study has been prepared by Helen Tyzack, "Recording the Value of Museum Collections in Financial Reports: Issues" (Queensland: Australian Key Centre for Cultural and Media Policy, University of Queensland, 1998).

20. For this technique, most recent studies among others are: Walter Santangata and Giovanni Signorello, "Contingent Valuation of a Cultural Public Good and Policy Design: the Case of 'Napoli Musei Aperti,' forthcoming in the *Journal of Cultural Economics,* and the studies of Professor Douglas Pearce and his colleagues of the Center for Cultural Economics and Management of the University College, London.

21. A great number of economic studies have been carried out on heritage sites or cities or monuments as being economic tools. See, among others: Bath City Council, "Economics of Tourism in Bath," Feb. 1987; New Zealand Historic Places Trust, "The Economics of Heritage Buildings: A Contribution to the Historic Heritage Management Review," 1998; Timothy Ambrose, ed., "Money,

Money, Money and Museums," Scottish Museums Council, 1991; "Economic Values of Protected Areas," ed. Adrian Phillips, in *Best Practice Protected Area Guidelines Series* (Cardiff, Wales: Cardiff University and IUCN, 1998).

22. Joan Robinson provides an interesting reading of this concept in her book *The Accumulation of Capital* (London: Macmillan St Martin's Press, 1956), 393, in a section entitled "Income from Property as the Reward of Waiting."

23. Piero Sraffa, *The Production of Commodities by Means of Commodities: Prelude to a Critique of Economic Theory* (Cambridge: Cambridge University Press, 1960).

24. In the case of heritage, this price can be the market value of a piece of art, or the social value of a site or monument, this being estimated, for example, through the contingency valuation method or even the market value of the monument, which would represent the pure economic direct value, excluding any patrimonial value.

25. For our case here, we should rather say that the life of the site is the expected number of years of its exploitation.

Cultural Perspectives in a Multicultural World: The World Bank Invests in Historic Urban Enclaves

Arlene K. Fleming

This essay presents the context for the World Bank's involvement in culture and development and describes two Bank-financed projects in historic urban areas. These projects illustrate some of the challenges encountered in *containing* and *explaining* valued historic art and architecture. The Fez Medina Rehabilitation Project in Morocco and the Pilot Cultural Heritage Project at Mostar, in Bosnia and Herzegovina, are investments in historic urban enclaves that are recognized as local, national, and international treasures. Both are also dynamic contemporary communities, characterized by a blend of tradition and modernity, and by interaction between their inhabitants and foreign observers.

A discussion of these two investment projects must consider how an ensemble of historic monuments and structures is *contained*: that is to say, how the heritage is used in the present while being conserved for the future. In historic enclaves, the cultural heritage exists, not *in*, or *as* a museum, but as the setting for homes, commercial establishments, public living space, and vistas for a contemporary population.

Attention also must be given to the optimal means of *explaining* and interpreting an urban heritage site, in order to foster among a broad range of groups an appreciation for its cultural and historical value. These groups may be considered as the site's stakeholders. They include: the residents themselves, who may be impoverished tenants; the property owners; the larger adjacent communities; local, provincial, and national governments; and a range of other interested parties at the municipal, regional, and national levels. Other stakeholders may include organizations and individuals outside the country, for example, heritage conservation advocates, religious groups, and the tourism, hospitality, and communications industries.

The World Bank's Approach to Culture and Sustainable Development

In the work of the World Bank as an international development organization, the importance of understanding diverse behavioral patterns, outlooks, values, traditions, and languages is a given. Any transaction between peoples and institutions of differing cultures requires interaction that affects and may have a cultural influence on all parties involved. The success of transactions between the Bank and its

borrowing countries depends heavily on the ability of all participants to understand and work effectively in a multicultural environment.

A second aspect of the World Bank's involvement with culture is more proactive. This is a willingness to lend for projects with explicit cultural objectives as one of numerous approaches to addressing the institutional mission of poverty reduction. The initiative stems from a recognition that a society's accomplishments, in the form of material and expressive culture, have social and economic value that can stimulate development. Material, or physical, culture is considered to include objects, sites, and structures. Expressive culture comprises artistic enterprises, music, oral and written history, language, literature, and traditional practices.

The World Bank's president, James D. Wolfensohn, recognized the cultural dimension of the institution's role when he said:

> As globalization draws us all into greater proximity, it is essential that we nurture, prize, and support the diverse cultures and historical experiences of the countries in which The World Bank Group operates. We simply cannot conceive of development without cultural continuity. It must be acknowledged and must form the basis for the future. Serious attention to culture is basic to improving development effectiveness—in education, health, the production of goods and services, the management of cities. . . . Integrating culture into the Bank's work will depend on successful partnerships. Partnerships that bring together international, regional, national, and local actors: that bridge formal and informal, private and public sectors. Partnerships that bring in foundations, civil society, and the communities themselves, as well as national governments and international agencies.[1]

In April 1999, the World Bank's executive directors gave provisional approval for a modest culture and sustainable development initiative, stipulating that lending, grant-making, and related activities should be focused on furthering the institution's core mission of poverty reduction, with attention to social cohesion, local empowerment, conflict and disaster mitigation, and reconstruction following financial, civil, or national disasters. The initiative has five components:

> 1. *Loans and grants.* Investments may involve projects where a cultural approach to social and economic development is predominant, or there

may be a cultural component in a project with other major objectives.

2. A *policy* exists for safeguarding significant physical cultural resources encountered in any project financed by the World Bank.[2] This policy is implemented through the environmental assessment process and may include capacity building for cultural resource management in borrowing countries.

3. *Research.* The purpose is to establish an economic rationale for investing in culture and development, especially as such investments assist in poverty reduction. This research has included competitive awards for activities that build on cultural assets of the poor, with provisions for documentation and evaluation.

4. *Partnerships.* Collaborative approaches involve a range of governmental, non-governmental, community, and private sector organizations in the implementation of culture and sustainable development projects. During 1998 and 1999, the World Bank, together with UNESCO, the government of Italy, and a host of other partners, convened three international conferences and two workshops to explore issues and initiatives in culture and development.

5. *Knowledge management and dissemination.* Using the World Bank's global electronic telecommunication capacity, it is possible to publicize best practices in culture and development initiatives, as well as to offer technical assistance and training.

The World Bank's portfolio of urban culture and development projects under implementation, or in preparation, is a response to requests for assistance from several countries and one territory: Eritrea, Ethiopia, and Mauritania in Africa; China and Indonesia in East Asia and the Pacific; Azerbaijan, Bosnia and Herzegovina, Georgia, Macedonia, Romania, and Russia in Europe and Central Asia; Jordan, Lebanon, Morocco, Tunisia, and the West Bank and Gaza in the Middle East and North Africa; and Honduras in Latin America and the Caribbean.

Standards and Issues in Heritage Conservation and Tourism

All of the above-mentioned investment projects seek to conserve valued historic structures, enclaves, or sites, while stimulating social and economic development in the local community. One of the two projects selected as examples, the Fez Medina in Morocco, has a high incidence of poverty and disintegrating infrastructure.

The other project is in the city of Mostar, in Bosnia and Herzegovina, a country emerging from years of civil strife and physical destruction, with a shattered sense of community and lingering animosity between Croat and Bosniac inhabitants. The objectives of both projects are consistent with the Bank's mission; each was designed to build on the relationship of cultural heritage conservation to poverty reduction and community development.

Within historic enclaves, three cultural elements exist in a dynamic environment. First, there is the urban fabric, consisting of monuments, public buildings, dwellings, streets or passageways, and the town plan. The structures and plan may have been created by a society distant from the contemporary population, not only in time but also in character.

The second cultural element is the social interaction among residents within the urban enclave and their relationship with groups in the surrounding urban area or countryside and with visitors, including tourists. Within a historic enclave or neighborhood, there may be conflict between ethnic, religious, or economic groups, between tenants and owners, or among other factions.

A third element is the interplay of multiple values and perspectives in relation to the historic urban setting. These include the characteristics that merit international recognition of an area's historical and cultural significance, which have placed Fez on UNESCO's World Heritage List. National recognition may be assigned by inclusion of a cultural site on a country's register of historic places. However, local residents, if poor or alienated from the majority population of the country, may be unaware of or disinterested in such designations of historical and cultural significance. The inhabitants tend to focus on day-to-day problems associated with livelihood, while tour operators and tourists from other cultures may be attracted by the unique, aesthetic, historic, or exotic nature of a heritage site. Not all communities are receptive to tourists, especially if they do not generate direct economic benefits or if their presence is considered disruptive. National governments and entrepreneurs may value historic urban enclaves as a source of status or income and be more receptive to tourism than are local communities.

The International Council on Monuments and Sites (ICOMOS) acknowledged the intricate relationships between material cultural heritage, the host community, and visitors in a Cultural Tourism Charter, ratified in 1999. The charter states that:

> Domestic and international tourism continue to be among the foremost vehicles for cultural exchange, providing a personal experience,

not only of that which has survived from the past, but of the contemporary life and society of others. . . . Tourism should bring benefits to host communities and provide an important means and motivation for them to care for and maintain their heritage and cultural practices. The involvement and cooperation of local and/or indigenous community representatives, conservationists, tourism operators, property owners, policy makers, those preparing national development plans . . . is necessary to achieve a sustainable tourism industry and enhance the protection of heritage resources for future generations. . . . A significant proportion of the revenue specifically derived from tourism programs to heritage places should be allotted to the protection, conservation, and presentation of those places. . . . Where possible, visitors should be advised of this revenue allocation . . . [and] the promotion, distribution and sale of local crafts and other products should provide a reasonable social and economic return to the host community, while ensuring that their cultural integrity is not degraded.[3]

The Approach in Morocco's Fez Medina

The principles of the ICOMOS Cultural Tourism Charter are inherent in the Fez Medina Rehabilitation Project. Preparation of the project began in 1993, when the government of Morocco appealed to the World Bank for assistance in combating the rapid deterioration of infrastructure and economic viability in the twelve-century-old city of Fez. This venerable medieval enclave holds outstanding examples of Islamic architecture, embedded in a dense assemblage of residential and commercial structures. Large ornate houses, once the pride of wealthy owners, are now crowded with impoverished migrants from the surrounding countryside. But even in its dilapidated state, Fez is evocative and memorable, attracting many Islamic scholars, architects, and foreign and Moroccan visitors.

Preparing the project was a learning experience for the Bank, as well as for the national and municipal governments of Morocco and for the residents and entrepreneurs of Fez. An early study recommended a capital development approach, calling for extensive demolition of structures to improve vehicular accessibility in the town, now a warren of narrow passageways. The plan would have entailed involuntary relocation of some six hundred households. Yet the World Bank, UNESCO, and the Fez community raised concerns about the impact of such a scheme on the fabric of the city and the morale of its inhabitants.

Consequently, the ambitious road proposal was modified significantly, and the resettlelment option eliminated.

During project preparation, the World Bank, together with its Moroccan and international partners, conducted a series of comprehensive socioeconomic, environmental, cost-recovery, and valuation analyses. These pivotal studies provide a model for those engaged in renewing urban areas with important historic buildings as part of their physical and cultural fabric.

The environmental assessment drew attention to the Fez Medina's antiquated system of waste management and lack of basic sanitation services. This study emphasized an urgent need to relocate two hundred heavily polluting industries, including traditional metalworking and leather tanning, to an area outside the Medina. Handicraft industries, on the other hand, would profit from new locations in closer proximity to upgraded tourist routes and facilities.

For all the international interest in the state of historic Fez, the community itself insists that it be viewed as a living city. The approximately 180,000 inhabitants are at least as, if not more, concerned with daily commerce and social interaction as they are with the bricks and mortar of ancient monuments and houses. A social analysis, conducted under World Bank auspices, revealed a certain tension between Medina residents who want an improved quality of life and the perceived preoccupation of heritage conservationists with "old stones." Thus, an important lesson for the World Bank, for urban planners, and others, relates to the necessary balance between historic conservation and the community's economic and social well-being. These relationships, including the direct economic benefits of cultural tourism, must be emphasized through community participation and intensive, well-structured public education.

In the Fez Medina, as in many urban renewal projects, the impact of real-estate upgrading on the hard-core urban poor is a persistent and vexing problem. Neighborhood gentrification and reversal of middle-class flight, together with improvements in infrastructure, undoubtedly would raise property values in Fez, but would make housing unaffordable for the 20 percent of the population characterized as poor. A comprehensive valuation analysis further probed the issue of housing affordability and project cost recovery. This study estimated that ameliorating constraints, such as the low rate of tax and fee collection, inheritance laws, administration of the property-owning religious trust, and other factors, would have a positive effect on real estate in Fez. The study also demonstrated that significant private sector upgrading of property will not occur unless infrastructure and basic services components are provided by local government.

Additional Bank-initiated studies concluded that the historic importance of Fez is cherished by foreign visitors. The majority of those surveyed expressed the willingness to pay a special hotel tax earmarked for historic conservation. Such a tax could theoretically return $11 million annually from the estimated 170,000 tourists who spend at least one night in a Fez hotel each year. Moreover, foreign visitors to other Moroccan cities and Europeans who have never visited Fez similarly endorse the concept of a special fee for historic conservation. If the cost of additional goods and services purchased by tourists in more commodious Medina facilities were factored in, the benefits of tourism to the Medina community would prove even more significant.

In summary, the preparation for a World Bank–financed project in Fez evolved during three years, from an ambitious effort requiring demolition of three hundred dwellings and dislocation of some six hundred families, to a plan far more sensitive to the social, environmental, and cultural needs of the Fez community. The various studies sponsored by the World Bank are rich in the dynamic interplay of residents, local and national politicians, urban planners, social anthropologists, and conservationists. Investigations and analysis provide clear evidence of the balance and foresight needed to undertake complex urban renewal activities where historic treasures are embedded in the physical environment.

Two positive conclusions from the preparatory studies suggest possibilities for longer-term maintenance and financing of Fez. First, all but the poorest residents are willing to invest in property renovation, provided they are assured of government-financed infrastructure and basic service improvements. And second, well-managed cultural tourism can return significantly higher benefits to the community through special fees for ongoing conservation and revenue from handicraft products and tourist services.

A Reconstruction Project in Mostar, Bosnia and Herzegovina

The World Bank–financed project for cultural heritage reconstruction and community rehabilitation in Mostar deals with markedly different conditions than those evident in Fez. When the government of Bosnia and Herzegovina requested a loan to rebuild the famous bridge, Stari Most, the World Bank had little difficulty attracting partners for the project. The elegant historic stone bridge, spanning the Neva River, had been deliberately destroyed by Croat forces in 1993, before the eyes of the world. A Bank-financed project provided the vehicle for participation by interested foreign governments and cultural organizations, including the Aga Khan Trust for Culture, the World Monuments Fund, and UNESCO.

Extensive intentional damage and destruction of cultural heritage during civil strife in the early 1990s, prior to obliteration of the bridge, attracted scant notice in the international press. It was the demise of the beautiful and symbolic Stari Most that captivated a global media audience, as it seemed to symbolize the tragedy of intense ethnic conflict in a region where Christianity (both Roman and Orthodox) and Islam had coexisted peacefully for centuries.

International attention focused on the bridge, with scant mention of the concurrent destruction and damage to Mostar's old town, located adjacent to Stari Most. An enclave of traditional wooden Ottoman-style architecture, the neighborhood had been renovated in the early 1980s to become a viable social and economic community and a popular tourist attraction. The sensitivity and success of this renovation resulted in an international prize from the Aga Khan architectural program in 1986.

In addition to reconstructing the bridge and its two adjacent towers, the World Bank–financed project will restore selected monuments in Old Mostar, attempting to preserve the historic character through neighborhood initiatives, following architectural guidelines. To assure sustainability of the endeavor and tap global interest in Mostar, an International Stari Mostar Foundation will be created.

The project is considered a pilot effort to assist in reconciling the Croats and Bosniacs who inhabit the sectors of the city on either side of the Stari Most—West and East Mostar, respectively. Findings from a social analysis conducted during project preparation indicate substantial challenges. The majority of Bosniacs favor reconstruction of the bridge and Old Mostar. Expressing deep emotional attachment, one prominent resident said: "I didn't cry when my father and mother died, but I did cry when the old bridge was destroyed." In general, the Croats are considerably less enthusiastic, and there has been a prevailing lack of trust between the two groups.

Information gathered from Mostar residents during the social assessment led to several recommendations. Public information on the project should be well designed and targeted, making clear that cultural heritage investments will not be made at the expense of basics such as education and health care. There must be a balance of leadership between foreign and local control. Particular attention should be paid to avoid politicizing the project, which should be highly participatory. The reconstruction and revitalization of Old Mostar should be in accordance with internationally recognized historic preservation standards and should be coordinated with an action plan for tourism generation.

Conclusion

Experience to date in both Fez and Mostar seems to validate investment in projects where reconstruction or rehabilitation of cultural heritage structures is an integral element in achieving social and economic well-being. In these cases, culture and development are intricately intertwined. There will be no lasting conservation of internationally treasured historic enclaves unless the people who inhabit them are willing custodians with a vested interest. The inhabitants must be motivated by an appreciation of their historic built environment, a will to maintain and enjoy it, and an interest in receiving visitors, from whom they should gain a fair return for goods and services.

1. The World Bank, *Culture and Sustainable Development: A Framework for Action* (Washington, D.C.: The World Bank, 1999), 6.

2. Operational Policy Note 11.03—Management of Cultural Property in Bank-financed Projects, under conversion in 2001–2 to Operational Policy and Bank Procedures 4.11—Physical Cultural Resources.

3. U.S. Committee, International Council on Monuments and Sites, ICOMOS Charters and Other Doctrinal Documents, in *U.S. ICOMOS Scientific Journal 1,* no. 1 (Washington, D.C.: U.S. National Committee of the International Council on Monuments and Sites, 1999), 99–102.

Eternal Mexico: Between Nationalism and Globalization

Rita Eder

The theme of this conference, "Compression vs. Expression," suggests a polarization of concepts that characterizes contemporary debate on cultural diversity.[1] The double perspective, which seems to dominate today's understanding of the world, is reflected in the simultaneous use of terms such as *integration/difference* or *globalization/localization.*[2] *Globalization* is a sign of social phenomena, as Frederic Jameson has noted,[3] resilient to a clear definition and characterized by the tensions of a new global economic geography, which is still tied to the structure of the state. *Integration/universalization,* in contemporary terms, can be thought of as an anxious hegemony challenged by difference and the specific, its other pole.

Mexican cultural history is founded on diversity, which is problematic for modernity and the need for articulating difference into the demands of the state. The term *mestizaje*[4] became, culturally and ethnically, a synonym for the specifically Mexican, as well as a political tool involved in the process of the erasure of difference and a strategy for the construction of a strong state. Serge Gruzinski in *La pensée métisse* has signaled the affinities between *mestizaje* and globalization and discussed how the global industry has assimilated this concept and flooded the market with *mestizo* objects, pretending that today everything is fusion.[5] In times of the redefinition of the nation-state and the rise of the Zapatista movement in Chiapas with strong claims on ethnic identity, *mestizaje* has been suspected of operating as a hegemonic concept, a symptom of the link between local crisis and globalization.

Liberalism, which tinted modern Mexican politics, makes constant reference to the ideal of a unified nation only possible through the integration of its different social and racial components. The desire to establish a modern nation and its politics was founded on eliminating the white *Criollo* and on the ambiguous recognition of the indigenous. *Mestizaje,*[6] based on a long intellectual debate, has its roots in the third part of the nineteenth century and culminated in the 1925 work of José Vasconcelos, *La raza cósmica.*[7] However, the issue is still alive. From the theoretical point of view, in the last two decades the discussion on *mestizaje* has been central to the debate on culture and has also been activated in the political scene.

The debate of mixture in racial and religious terms took a peculiar turn in the arts of Mexico. The first part of the following pages is dedicated to analyzing

through discourse and images the construction of *mestizaje* that ran parallel to the ideology of the nation-state. The aesthetic question of Pre-Columbian art inevitably emerges—and the anxiety it provokes—and yet that which seems so distant in terms of form and sensibility will constitute the terms of argumentation for modernity. The final part seeks the breaking point of a lasting artistic discourse under a changing conception of territory and new meanings of cultural diversity.

One Nation

Mexican art history has been engaged, since its first founding text of 1862,[8] in the task of constructing its own tradition. This meant, in the first instance, the valorization of colonial art and, a few decades later in 1893,[9] the integration of the Pre-Columbian past, its monuments, objects, and sculptures. Rupture and change, conflict and trauma were suppressed in favor of the ideal of one nation capable of embracing harmonically its different religions, races, and languages. The utopia of the unified nation was indeed the project of Porfirio Diaz, and his conception of a strong state. It is in the encyclopedic work by Vicente Riva Palacio, *México a través de los siglos,* that the reconciliation of the different past actually takes place.[10] The idea of a historical narrative, which suggested solidarity of all its pasts, including modernity, has been a strong basis of art-historical discourse and has a rich tradition in the visual arts.

Mestizaje and Classicism

Saturnino Herrán, born in 1881, only lived to be thirty-one. In 1918, a year before his death, he was working on a series of panels to decorate the Palace of Fine Arts with the theme of *Our Gods* (fig. 1), which remained unfinished. What we see is a

Fig. 1. Saturnino Herrán (Mexican, 1881–1919), *Adoración indígena (Indigenous Adoration),* from the series *Our Gods,* 1914–15. Crayon and watercolor on paper; 39 ¾ × 44 ⅛ in. (101 × 112 cm). Museo de Aguascalientes, Mexico

Fig. 2. Saturnino Herrán, *Coatlicue*, from the series *Our Gods,* 1918. Crayon and watercolor on paper, 34 ¾ × 24 ⅝ in. (88.5 × 62.5 cm). Museo de Aguascalientes, Mexico

classicized academic vision of the Pre-Columbian past embodied in a procession of youths in different positions that have come to venerate the sculpture *Coatlicue* (fig. 2), which, at the time of Herrán's painting, presided over the dark rooms of the National Museum of Anthropology. *Coatlicue* (fig. 3), a most complex work in formal and symbolic terms, became a key object for the debate on Pre-Columbian art in the first half of the twentieth century. In *Our Gods* Herrán has transfigured *Coatlicue* into an emblem of religious *mestizaje.* The head of Christ arises from the twin serpents that top *Coatlicue*'s massive presence, while the limbs and feet emerge from the lower part of her body. Herrán was able to construct into this image, almost literally, the strong claim for fusion that the new state, born out of the Revolution, wanted at all costs. The nude youths are somewhat constrained by the classic canon; however, sensuality as a strategy for racial differentiation brings an interesting tension into the image. Herrán is heir to the academic tradition in which Indians were portrayed through Western eyes, yet he takes a further step in the measure that the Pre-Columbian past is interpreted through the notion of Classical Antiquity and the cult of the body. The second *panneaux* or embodiment of Christianity presents dressed figures, men of the church, that visually hold a secondary interest. *Our Gods* projects, in the conception of the indigenous body, the aspiration of a solid antiquity but also the confusion of its place in the new society. Through the resource of ideal types, Herrán establishes the necessary distance between the founding myth of nationalism and the living Indian population. However, here *Coatlicue* is clearly

Fig. 3. *Coatlicue,* c. 1300–1500. 11 ft. 5 ¾ in. × 41 ³/₁₆ in. (350 × 130 cm). Museo Nacional de Antropología, Mexico

swallowing the hardly visible Christ, who seems to be melting into her powerful frame—a homage to the strength of Pre-Columbian form or perhaps fear of fusion with her symbolic complexity.

Anthropology: The Conflict of Otherness and *Mestizaje*

Manuel Gamio, a contemporary of Herrán, was most interested in the problem of *mestizaje* and was the first to delve into the question of the aesthetic value of Pre-Columbian objects versus the classical canons. Gamio, founder of modern Mexican anthropology, studied with Franz Boas at Columbia University between 1909 and 1911. Under the influence of Boas and the significant social changes brought about by the Revolution, Gamio founded the Mexican Department of Anthropology in 1917. The school functioned as a public organism and its program was centered in the integral study of what he called the regional population of his time and the in-

Fig. 4. *The Eagle Warrior,* c. 1500, Aztec. Museo Nacional de Antropología, Mexico

digenous cultures of the past. With these studies he intended to promote development in the communities and to encourage a coherent nationality. The "Indian problem," according to Gamio, was not due to ethnic incapacity and could not be solved by destroying a culture.

In 1916 Gamio had already written a first influential book, *Forjando Patria.*[11] Its main ideas were directed to the need for the unification of the nation and the defense of the indigenous as a component assimilated to the national utopia. The solution was the mixture of races or *mestizaje.* His writings carry to the logical end a paradox, on the one hand an open attitude for understanding and thorough study of indigenous cultures, and on the other assimilation. "European civilization," says Gamio, "has not been able to infiltrate the indigenous population due to natural resistance to change. Since we ignore the reasons for resistance, the only way out is to be able to understand and put our will to be understood by these cultures. We must build in ourselves an indigenous soul."[12]

Fig. 5. *Coyolxauhqui,* mid-14th century, Aztec. Museo Nacional de Antropología, Mexico

Aesthetic values were important for Gamio in his comparison and confrontation of canon. Guided by his criteria of fusion, it was important to familiarize the Indian with European art and promote the knowledge of Indian

art among the middle classes. He claims: "When the middle classes and the indigenous population reach the same criteria in art we shall culturally be redeemed, the Grand National will exist, an important foundation of nationalism."[13]

"There is no essential beauty," says Gamio, who thinks it is logically impossible for "one [to] experience artistic emotion in front of the Precolumbian whose manifestations appear before our eyes for the first time."[14] For Gamio, appreciation and emotion for art is the fruit of experience, not of spontaneity. To prove his point, Gamio, in what may be considered pioneering research on reception, made an experiment with observers knowledgeable in Western art but absolutely profane in Pre-Columbian. They were presented with some Aztec objects, among them *The Eagle Warrior* (fig. 4) and *Coyolxauhqui* (fig. 5). Gamio explained rejection of Pre-Columbian objects through the fact that they were made for a fanatically religious civilization prone to war and nomadism. *The Eagle Warrior* was the only sculpture that was well accepted; the anthropologist considered this a fraud, for its acceptance was based on the affinities with Western values:

> *The Eagle Warrior* was not sculpted under the sky of Argolida or in the Roman countryside, it was made in the high plateau of Mexico and was not inspired in the Greek or Roman soul but in the Aztec. The truthful point of view for this sculpture to awaken in us a profound, legitimate, unique aesthetic emotion, the beauty of the material must blend with the understanding of the idea it expresses. We must know how and when he lived and the how and when of his life. The Eagle Warrior is not a Discobolus or a Roman gladiator. He represents the hieratic quality, the fierceness and the serenity of the Aztec warrior of the noble classes. The sculptor that produced this work was identified with the time of his flourishment; a witness of his combats and all those epic visions arose in his mind. The beautified and palpitating type of his race, the immutability of his repose mirrors the pleasure and pain of indigenous faces ... only by the knowledge of its background can we feel Precolumbian art.[15]

This quote is key to the aesthetic debate on Pre-Columbian art. History and context are the clues for the making of a cultural analysis. Gamio's work is testimony to the tensions of the legitimization process of a new cultural identity and the manifest distance with that other half of the nation, which only history can redeem.

The founder of modern anthropology in Mexico is today under severe criticism, for his grand vision of the nation contains the extinction of the very differentiated ethnic groups present in today's Mexico.[16]

Coatlicue: Fear and the Aesthetic Quest

Gamio and others that came after him were involved in the problem of explaining aesthetic values that confronted the classical ideal of beauty. While artists were incorporating the indigenous as representation and artistic concept, anthropologists, literary critics, and historians were involved in the discussion of how to approach the Pre-Columbian as artistic. It was not until the early 1940s that the full discussion actually took place and Pre-Columbian art began to be valued as an artistic ideal of modernity and to displace the hegemony of colonial art as the root of Mexican art.

The consolidation of the unified nation was indeed a most important theme of Mexican art history. In his opus magnum *Estética del arte mexicano,* published in the early 1960s, Justino Fernández establishes the vision of a country rich in art through all its history: "a short walk through the Plaza de la Constitución and its near quarters is enough to find a good number of important works of all our historic periods. In one day, in a couple of hours, we can admire in our daily walk through the city, works that are testimonies of other worlds and this one."[17] Fernández formulates the foundation of Mexican art history in its historicity. He engages in the construction of another aesthetics, one he calls impure, historical, and particular, and contests the enduring values of classicism and the pure beauty of Kant. "What I consider to be beautiful," he says, "is not absolute beauty but historical beauty, the only possible absolutism."[18]

Cultural relativism and the foundation of an artistic expression dependent on its historical circumstances allowed Fernández the enterprise of an encyclopedic work that discusses Mexican art of all times through a double method. On the one hand he engages in the exhaustive revision of the reception process in an infinite array of texts, due to historians and art historians, chronicles, and literary criticism; on the other hand he chooses to analyze a paradigmatic work for each period.[19] I shall only recapitulate some of his thoughts on *Coatlicue,* his choice for the Pre-Columbian period, traditionally considered horrible and monstrous. For Fernández the sculpture is the very image of the mysterious Mexican world and emblematic of ancient indigenous beauty: "Coatlicue appears in our modern history and has conquered a place far from the first and long period which considered indigenous

art as the realm of monsters. In our time she has been praised as the key work of sculpture in the Americas, in her terribleness she has become a fountain of rare beauty."[20]

It is not inconceivable to think that when Fernández wrote on the Aztec sculpture, around 1954, he had in mind a response to his close friend, Edmundo O'Gorman, and O'Gorman's argumentation on *Coatlicue,* published in 1940 under the title *El arte o de la monstruosidad.*[21] In this essay the Mexican historian addresses the spiritual relationship between contemporary Western sensibilities and the artistic world of the ancient Mexicans. The problem, according to O'Gorman, is how we react when faced with a world that is historically foreign: "When in the first third of the 16th century Europeans could contemplate the monumental statues of the ancient Mexicans they could only be impressed by their ugliness; as men of the Renaissance were incapable of approaching this mythic world populated by monsters of stone."[22] The concept of the monstrous provides the fundamental key to ancient Mexican art and art in general—that is, to conceive something that is "outside the natural order." O'Gorman's dialogue focuses on classical Greece, with the Apollinian that corresponds to an ordered and rational vision of nature and where any interference introduced into the order means confronting the ominous and the alien. Most striking among these reflections is O'Gorman's encounter with *Coatlicue,* of which he says, "what first delights the mind with the impetus of the inevitable is its ominous monstrosity."[23]

The main debate on Mexican art in the first half of the twentieth century circled around new relationships with the Pre-Columbian objects and sculptures, a debate, as we have seen, marked by words like "ominous," "terrible," and "monstrous." It is impossible not to see in these concepts anxiety and estrangement of the indigenous, in spite of all the discourses of a unified nation.[24]

The complexity and meaning of this vision were interrupted by the founding document of Mexican Muralism in 1922: "Not only noble work, but the spiritual and physical expression of our race, springs from the native and particularly from the Indian. This extraordinary talent for the creation of beauty and the art of the Mexican people is the healthiest expression in the world and our tradition our greatest possession."[25] The hegemonic place of Muralism put forward a vision of acceptance and admiration of indigenous art and was adopted as an official discourse by the cultural bureaucracy, while the intellectual debate pointed to a theoretical tour de force engaged in enlarging its aesthetic appreciation.

Modernity

It was only later that the question of difference entered the debate of aesthetic modernity. While it was amply discussed in the field of literature, and the poet Octavio Paz had long been one of the leading figures of the subject at an international level,[26] modernity came to the discussion of the visual arts in Mexico in the 1980s, when it became a necessary theoretical debate.[27]

Paz related modernity and tradition: "I realized that modernity is not novelty, to be truly modern I had to return to the origin of the origin."[28] These thoughts became clear after his encounter with Rufino Tamayo, an artist who had asked himself the same questions (fig. 6). Modernity, according to the poet, is resolved in the exploration of Mexico, not in the narrative of the Muralists and realist writers but rather in its spiritual and psychological foundations: "Modernity is antiquity, not chronological antiquity, it resides not in time before but now, inside each of us."[29] Paz's appraisal of Tamayo's painting as truly modern is tied to the idea of a peculiar construction of Mexican antiquity. For Paz the question of Mexico and the visual arts needed the confrontation with the dominant position of the Muralists,

Fig. 6. Rufino Tamayo (Mexican, 1899–1991), *Las músicas dormidas (Sleeping Music)*, 1950. Oil on canvas, 51 3/16 × 77 3/16 in. (130 × 196 cm). Museo de Arte Moderno, Mexico City

specifically with David Alfaro Siqueiros and his radical position of an art with a narrative and an ideological content.[30]

Modernity was expressed in Tamayo but also in the generation that followed him and was involved in developing a new figuration and abstract art in defiance of the still-predominant position of Muralism as late as the mid-1960s. The battle of a "committed art" versus the group of *La Ruptura,* as well as the issue of Cold War politics, have been evaluated only in a partial way and still await a post–Berlin Wall assessment.[31]

The authority of Paz, however, for some time made his the uncontested version in the visual arts of modern Mexico. In the last decade, with the so-called reform of the state and the discussion of modernity in terms of change in the political and economic structure, the cultural institutions promoted through exhibitions a different look at the question of Mexican identity. Modernization and urban culture became a central topic, and two key works addressing these themes came out in the last decade: Fausto Ramírez's *Modernización y modernismo en el arte mexicano* and *Modernidad y modernización en el arte mexicano (1920–1960)* edited by Olivier Debroise.[32]

Ramírez has been long recognized for opening a new perspective on the arts under Porfirio Díaz (1877–1911), during a period traditionally considered the dark ages by the ideology of the Mexican Revolution. Ramírez's modernization is focused on an early modernity known in Spanish America as *modernism.* The originality of his work consists in opening the perspectives of urban life in the nineteenth century through a detailed analysis of the changes in the limits of the colonial city. Ramírez thinks in terms of two modernities: one is immersed in the logic of capitalism, scientific thought, technology, and the idea of progress; the other is the cultural answer to modernization in the guise of, first, a spiritual crisis and then in the search for a national soul. Although Ramírez manages to introduce a new paradigm, still, the question of a national soul in the midst of the fast growth of the city and new urban identities reminds us of the persistence of a loyalty to the question of identity.

The fall of the Soviet Union in 1989 caused quite an impact on the Mexican intellectual elite. Paz, as the author of *Los hijos del limo,* was enthusiastic about the death of the socialist world and the simultaneous entrance into the Mexican political scene of a modern president like Carlos Salinas de Gortari, who was engaged in the reform of the state and moved swiftly into globalization through NAFTA. The entrance to modernity, in the mind of Octavio Paz, had to be legitimized in relation to historical roots, and in his work he considered the compatibility of the principles of the Mexican Revolution with Salinas de Gortari's conception of the modern state.

Fig. 7. David Alfaro Siqueiros (Mexican, 1896–1974), *Collective Suicide,* 1936. Enamel on wood with applied sections, 49 × 72 in. (124 × 183 cm). The Museum of Modern Art, New York. Gift of Dr. Gregory Zilboorg

It was in this context that Olivier Debroise developed an exhibition and a catalogue on modernity and modernization. In the introduction he states that the exhibition was the first destined to deal with the concept of the avant-garde. However, given the fact that most Mexican artists were striving for difference from the European artistic movements and were "in search of different and even opposite ways of regionalism and nationalism," the question of an avant-garde that was late and harmless seemed a bit uncomfortable.[33] Modernity seemed a better possibility, and some of its thematic issues are articulated in Debroise's discourse, for example, the notion of lost paradises and dream cities, the possibility of change, and the relationship with the United States, in terms of the art market and the good reception of its painting. In the end Debroise strives, counter to Paz's support of Tamayo, for an alternative figure of modernity: David Alfaro Siqueiros, who experimented with all types of materials—industrial products, cement, acrylic, and cellulose—and was also trying to expand the national borders to a plastic universalism. However, what makes Siqueiros really modern, according to the postmodern view of Debroise, is his pessimistic vision of modernization as seen in

his images of the 1930s, among them *Collective Suicide* (fig. 7) and *Explosion in the City,* both of 1936.[34]

The discussion through the optics of modernity was indeed a big step to redefine the plurality and complexity beyond ethnic and historical notions of Mexican art from the late nineteenth century through the 1960s. The single most relevant theme became the city, the theater of modernization and change; the modernity of the state was a preamble for globalization and a plea for a flexible conception of identity.

Eternal Mexico: Two Steps Back

At the very end of 1999, only a few months before the crucial Mexican elections of 2000, an exhibit entitled *Eternal Mexico: Art and Permanence* was organized by the cultural authorities of the PRI, the ruling party since 1929. The exhibition consisted of four hundred objects that were, in the words of the chief museographer, "liberated from the tyranny of chronology and exposed thematically. The artistic gaze that supports the exhibit finds links of hundreds of years that are present in Mexican art of different times."[35] It does not seem implausible that the title of the exhibit and the thematic approach were a counterproposal to the mega-exhibitions that the Mexican state had organized in the last sixty years, among them *Twenty Centuries of Mexican Art* in 1940 at the Museum of Modern Art and *Splendors of Thirty Centuries* at the Metropolitan Museum of Art in 1990. As declared officially: "This exhibit will allow a reflection on Mexican art with a different attitude, mainly the absence of a chronological pattern. The idea is to present an axis of three fundamental themes: space, man and time."[36]

The idea of the panoramic exhibitions with strong chronological emphasis seemed to be related to the already-cited discourse of Vicente Riva Palacio's nineteenth-century encyclopedic work, *Mexico a través de los siglos*. The very title was related to its diverse and conflicting pasts, finally reunited in a harmonious present—a nation that had survived in spite of its complex history and had remained through the centuries.

Eternal Mexico has the same roots, for even if it disregards chronology, the sense of duration of its cultural essence coincides at some point with the nineteenth-century construction of the Mexican nation. It is rather obvious that the exhibition conveyed the illusion of eternalizing a vision of the nation and also of the political party that had been in power for so long. Although the exhibit covered all the artistic periods, the accent was placed on Pre-Columbian art, with intentions similar to Riva Palacio's work.

Mexico a través de los siglos had in its first edition a frontispiece with Pre-Columbian references, the Aztec calendar set on a stylized pyramid and flanked by two indigenous figures of high-ranking position, dressed accordingly. However, the nineteenth century in Mexico was also the age of indigenous rebellion; a war of extermination carefully hidden in official history was carried out against the Yaquis and the Maya, and these Casta wars, as they were called, were explained by the white population as racial and were brutally repressed. Racial hate is indeed the most outstanding element of these wars that lasted almost a hundred years.[37] *Eternal Mexico* opened at the Palace of Fine Arts in Mexico City at the highest point of the Chiapas conflict. The public was welcomed by an impressive Olmec sculpture. Without doubt, Pre-Columbian art was given the place of honor in this exhibition. As the philosopher Luis Villoro says in *Los grandes momentos del indigenismo,* there has been a schism between a glorified and dead past and the actual indigenous reality.[38]

The exhibition was unsuccessful in its grand plan to trace a common aesthetic in the visual arts of Mexico. In the end it was done with the criteria of choosing mostly monumental objects or certain established exoticisms such as death, so attractive to foreign eyes. The final destination of *Eternal Mexico* would be the Petit Palais in Paris, where its arrival coincided with the signing of an economic treaty with the European Common Market. The chaotic impression was perhaps in tune with the tension of a desired, open image of a modern nation whose government defended globalization while still holding to authoritarian structures.

Although *Eternal Mexico* was exhibited in the year 2000 and has some elements in common with the late-nineteenth-century discourse of unification, *mestizaje,* as conceived by Molina Enríquez, Manuel Gamio, and José Vasconcelos, reached its climax as an intellectual debate in the early 1930s and was substituted by a philosophy of psychological orientation. Samuel Ramos, with his book of 1934, *El perfil del hombre y la cultura en México,* opened a field of studies that allowed the possibility of overcoming ethnic obsession in favor of a cultural vision, as becomes evident in the writings of Edmundo O'Gorman and Justino Fernández. However, the concern for mixture or *mestizaje* or, better yet, hybrid has had a noticeable comeback. If *mestizaje,* as we have been aware, had the connotation of fusion, in the last decades it has been rescued beyond the racial to describe the juxtaposition of diversities caused by the pace of modernization. A new geographic imaginary seems to be settling in. Displacements and migrations have been the basis of the mixture discourse in contemporary art and a basis for breaking the limits of borders and limits between cultures.

The Breaking Point: *InSite*

In recent years contemporary art has reopened the question of national identity, something quite visible in *inSite,* an installation project that began in 1992 and conceived by its organizers as an exploration in public space with a binational character. Successive projects from 1997 have expanded to include the Americas. The interesting thing is that it has been done with institutional participation; the same authorities that supported *Eternal Mexico* did so for this project.

InSite is a border art proposal for Tijuana and San Diego, and the sculptures and installations run through these two most contradictory places. The public from both sides had to cross the border several times to be able to see these works, which are spread out through the large area that forms what some call the Tijuana-San Diego metropolis. The landscape changes dramatically from one side to the other. Tijuana, dry and dusty, with very scarce vegetation, is an example of fantastic urban disorganization and has cultivated an explosive bad taste in terms of billboards, environments, and decorations of shops and bars as a scenography for the tourists of the other side. A most disquieting visual presence are the men who stand near the steel wall that separates the limits of both countries and look silently, for hours, at the sea, thinking, dreaming, but studying how to reach the other side. The border and the way it functions is in itself an irony. A place for the rootless and the adventurous, a space where language and ways of life mix and where cultural identity is constantly questioned, this border becomes a laboratory for the impact of migrations and the challenge of radical difference in the grand plan of economic blocs.

As Sally Yard, one of the curators of *inSite*97, has said: "In this restlessly mobile place of exchanges, economies, and labor forces, political structures and urban fabrics, languages and mythologies abut. At the edge of their nations, the two cities are prone to fantasy-endpoints of succesive mythic journeys in pursuit of grail prosperity."[39]

In this territory artists were invited to make their installations and propositions of public sculpture. One of these projects was a two-headed Trojan horse by the artist Marcos Ramírez ERRE (fig. 8) just a few meters from the border, one head looking to the United States, the other toward Mexico. The fragile and ephemeral anti-monument is translucent, as noted by Néstor García Canclini, "because we can already see their intentions toward us and they see ours toward them."[40] ERRE does not choose a symbol of national affirmation, but rather a modified universal symbol, which perhaps signifies that national symbols are obsolete in terms of the mobility of territory and identity. The border reinforces thoughts of mixture and

Fig. 8. Marcos Ramírez ERRE (Mexican, born 1961), *Toy an Horse,* 1997. Puerta de Entrada San Ysidro, Tijuana. Commissioned by *inSite97*

cultural accumulation and of how we imagine and explain the others in us, but also it becomes a sensitive spot of potential conflict. The question of displacement and voyage is charged with hope, but also with repression.

Francis Alys, a Belgian artist who lives in Mexico City, presented *The Loop,* a project for a route between Tijuana and San Diego without crossing the Mexico/U.S. border. The conceptual piece is related to the wall and those who aspire to cross, spending many hours looking at the sea thinking of a strategy. Alys offers a route following the Pacific Rim. The artist's work in *inSite*97 has the memory of his actual trip that took place from 1 June to 5 July.

InSite is a territory for rethinking the different conceptualizations of mixture that have been so welcome in the last two decades. Although the complexity of the debate would be the subject of a more extended discussion, it is pertinent to say that intercultural mixtures have not only been recognized but have become emblematic of how the world is functioning in our time.

The notion of the hybrid to explain Latin American modernity and modernization gained momentum after the publication in 1989 of Néstor García Canclini's *Hybrid Cultures.*[41] The author carefully separated the use of hybridization to distinguish cultural mixture from *mestizaje* for its racial connotations and from syncretism and its religious referent. The appeal of the hybrid is that it accepts as reality the permanent interconnection of disciplines, lifestyles, commodities, materials and, most of all, the legitimization of diversity and equality in the process of appropriation. Canclini's notion of the hybrid also involved the critique of qualities of modernity: originality, style, novelty, and authenticity. At almost the same time Lucy Lippard's *Mixed Blessings*[42] defended mixing as the central metaphor of art in the 1980s and spoke about a new hybrid cultural identity in the United States, which she referred to as going through a process of accelerated *mestizaje*. Among the artists she comments on is Domingo Cisneros and his work *Chichimeca Resurrection* of 1984, part of a wider project, *Zone of Silence,* which he initiated with Canadian artists and installed in the middle of the Mexican desert in Durango. His work consists of creating from bones and other found materials mythical hybrids. Lippard's book is a celebration of the new condition, which, as the title suggests she is well aware, is also conflict.

If for some time mixture has been in the contemporary sense the basis for a new utopia, there seems to be, from the theoretical point of view, concern about how the terms have begun to lose their meaning. Serge Gruzinski has pointed out the problem of the banalization of *mestizaje* through the creation of a new planetary language directed to consumer society; the hybrid in this sense is close to dethroning the exotic.[43] Gruzinski argues for the precision of meaning for mixture and the danger of treating it as a monolithic concept. His book *La pensée métisse* is an impressive analysis of how particularities operate through images and the place of conflict and negotiation in the different *mestizajes*.

Epilogue

Marcos Ramírez ERRE participated in *inSite*94 with an installation of a Mexican shanty made out of wood and cheap materials. Placed in the midst of the official cultural center of Tijuana, the one-room installation contained the microcosmos of millions of urban poor with laundry on the line and bathed in light from television. Done at the height of discussion of NAFTA, the title of his installation, *Century 21,* is an anti-utopian vision of the future. Even if *Century 21* uses a tradition of radical

Fig. 9. Gustavo Artigas (Mexican, born 1970), *The Rules of the Game (Las Reglas del Juego).* Performance, 13 Oct. 2000, Lázaro Cárdenas High School, Tijuana. Commissioned by *inSite*2000. For the first part of the work, two Mexican soccer teams played soccer in a gymnasium in Tijuana at the same time and on the same court that two teams from San Diego played a game of basketball.

Fig. 10. Gustavo Artigas, *The Rules of the Game (Las Reglas del Juego)*, 2000. Colonia Libertad, Tijuana. Commissioned by *inSite*2000. The second part of the work featured a court constructed against the border fence in a poor neighborhood on the outskirts of Tijuana. Locals quickly adopted it as their own, adding a basketball hoop.

art that has no impact, it seems to remind one in the midst of the euphoric side of hybridization of the function of political reflection.

Cuauhtémoc Medina has written on the artist Gustavo Artigas and his project for *inSite*2000: *The Rules of the Game* (figs. 9 and 10). The work consists of a handball court where a double and simultaneous game of basketball and football takes place, built against the border fence in the midst of a shantytown, well-known as a crossing point to the other side. The work would seem to renovate political language in art through the metaphor of sports and, in the cool vocabulary of urban metaphor, questions not only coexistence but also mixture. For Medina, Artigas's work is an essay on post-hybrid cultural politics: "For in it we don't find mixture, incorporation, cultural borrowing, and travestism as strategies to bridge the cultural and economic divide between two distant neighbouring cities. The double game proposes a non-community distinction that overlaps without fusion. The political fantasy herein provoked might be articulated this way: the presence of the other is not an obstacle for the light speed of the one, provided operations which could deactivate the contradictions of two economic speeds."[44]

Artigas's *Rules of the Game* works as a counterproposal to *Eternal Mexico*, using, instead of permanence, the recourse of speed. Art as interruption and displacement[45] is perhaps of use in the redefiniton of territory and culture in times of globalization.

This paper was written at the beginning of the year 2000 for the Clark Conference "Compression vs. Expression." It seemed to me then that John Onians's intention in organizing this symposium was to examine art history's alliance with the constraining ideologies of the national state and perhaps unsettle the arrogance, as well as the fragility, of the so-called "world art histories." Perhaps he

was also interested in points of view for a new world art history, and he gave relevant and interesting space to the two upcoming world powers India and China.

My thoughts at that time were to examine—for the purpose of the conference—Mexican art history, its distortions in the name of the national state, and some changes visible in the post-NAFTA horizon. The events of 11 September 2001 and the harder and harsher control of the U.S.-Mexico border make one wonder if some of the illusions of art regarding multiculturality and a certain share of artistic power brought forth by some angles of globalization are still there. Some of my observations in this essay were related to the manipulations of art in Mexico by the PRI, the 70-year-old ruling party, and the possibility of the end (as it was) of a one-party dictatorship in the elections of 2000. In a way, it is still difficult to assess if much has changed. However, the debate on ideological constructions of art in Mexico and types of art historical narrations relative to ethnicity and gender have gone through significant changes in the last five years, and the ideas set forth here at some point have been surpassed, yet some of the debates remain of interest. Unless otherwise noted, all translations are my own.

1. Renato Ortiz, "Diversidad estatal y cosmopolitismo," in *Nuevas perspectivas desde/sobre América Latina. El desafío de los estudios culturales* (Santiago: Editorial Cuarto propio, 2000), 43.

2. Ortiz, "Diversidad estatal," 44.

3. Frederic Jameson and Masao Miyoshi, eds., *The Cultures of Globalization* (Durham: Duke University Press, 1998), xi.

4. *Mestizaje* refers to the mixture of races and has no adequate translation in English. Agustín Basave Benítez, *México mestizo. Análisis del nacionalismo mexicano, En torno a la mestizofilia de Andrés Molina Enríquez* (Mexico: Fondo de Cultura Económica, 1993). A thorough research of the origins of *mestizaje* emphasizes Darwinian thought in Andrés Molina Enríquez, the main theoretician of *mestizaje,* and his argumentation based on racial beliefs and theories.

5. Serge Gruzinski, *La pensée métisse* (Paris: Fayard, 1999), 8–10.

6. The idea of unification stemmed from the divided attitude of the nineteenth century vis-à-vis its colonial and indigenous past: "The hate for the colonial system didn't admit the necessary reflection of a past we need to understand. Despisement of preexisting civilizations of the New World has not allowed to go beyond the colonial system and penetrate that barbarian past. For as much as we despise it, it lives amongst us, and constitutes the most formidable obstacle for the establishment of peace and development of the positive elements." José Ma. Vigil, "Necesidad y conveniencia de estudiar la historia patria," in Juan Antonio Ortega y Medina, *Polémicas y ensayos mexicanos* (Mexico: UNAM-Instituto de Investigaciones Históricas, 1992), 268.

7. Benítez, *México mestizo,* 1930–36. In his chapter on Vasconcelos and *La raza cósmica,* Basave Benítez argues in spite of the obsolete thesis on race that Vasconcelos represented a most creative initiative for an original cultural tradition for Latin America. The *mestizo* is in this essay the mythical axis of

Latin American integration. In opposition to the United States, Latin America would not repeat the model of its *metropoli,* but create a new civilization based on fraternity and the genius and blood of all humanity of a tropical region, the great capital of this new zone of the world. "Universopolis" would be placed near the Amazon in the heart of the civilizations that began in the tropics, says Vasconcelos, and the final civilization will return to the tropics.

8. Bernardo Couto, *Diálogo sobre la historia de la pintura en México* (Mexico: Consejo Nacional para la Cultura y las Artes, 1995).

9. Manuel Revilla, *Arte en México* (Mexico: Imprenta Mundial, 1923).

10. Vicente Riva Palacio, *México a través de los siglo. Historia completa del desenvolvimiento social, político, religioso, militar, artístico, científico y literario de México, desde la antigüedad más remota hasta la época actual,* 5 vols. (Mexico: Ballescá y Cía, Editores, 1884–89).

11. Manuel Gamio, *Forjando Patria* (Mexico: Editorial Porrúa, 1960).

12. Gamio, *Forjando Patria,* 9.

13. Ibid., 39–40.

14. Ibid., 42.

15. Ibid., 45–46.

16. Marie-Areti Hers, "Manuel Gamio y los estudios de arte prehispánico :contradicciones nacionalistas," in *El arte en México: autores, temas y problemas,* ed. Rita Eder (Mexico: Fondo de Cultura Económica, 2001).

17. Justino Fernández, *Estética del arte mexicano. Coatlicue, El Retablo de los Reyes, El Hombre* (Mexico City: UNAM-Instituto de Investigaciones Estéticas, 1990), 7.

18. Fernández, *Estética del arte mexicano,* 8.

19. *Coatlicue* for the Pre-Columbian, the *Altar of Kings* in the Cathedral of Mexico for the colonial period, and José Clemente Orozco's *Man in Flames* at the Hospicio Cabañas for the modern era.

20. Fernández, *Estética del arte mexicano,* 10.

21. Edmundo O'Gorman, "El arte o de la monstruosidad," in *Estudios sobre arte. 60 Años del Instituto de Investigaciones Estéticas,* ed. Martha Fernández and Louise Noelle Grass (Mexico City: UNAM-Instituto de Investigaciones Estéticas, 1998), 471–76.

22. O'Gorman, "El arte o de la monstruosidad," 474.

23. Ibid., 475.

24. Cuauhtémoc Medina, "Gerzso y el gótico indoamericano:Del surrealismo excéntrico al modernismo paralelo," in *El Riesgo De Lo Abstracto: El Modernismo Mexicano Y El Arto De Gunther Gerzso* (Santa Barbara: Santa Barbara Museum of Art, 2003), 195–213.

25. Cited in Justino Fernández, *El hombre, estética del arte moderno y contemporáneo* (Mexico City: UNAM-Instituto de Investigaciones Estéticas, 1962), 215.

26. Octavio Paz, *Los hijos del limo,* 2nd ed. (Barcelona: Seix Barral, 1984). This work by Paz is a ref-

erence for authors such as Mathei Calinescu, *Five Faces of Modernity* (Durham: Duke University Press, 1996); Marshall Berman, *All That Is Solid Melts into Air* (London: Verso Editions, 1983); Jurgen Habermas, *El discurso filosófico de la modernidad* (Madrid: Taurus, 1986).

27. Octavio Paz, *Pequeña crónica de grandes días* (Mexico: Fondo de Cultura Económica, 1990).

28. Octavio Paz, *México en la obra de Octavio Paz,* vol. 3, *Los privilegios de la vista* (Mexico City: Fondo de Cultura Económica, 1987), 29.

29. Ibid.

30. Rita Eder, "Modernidad y modernización: piezas para armar una historia del nacionalismo cultural," in *El arte en México: autores, temas y problemas,* ed. Rita Eder (Mexico: Fondo de Cultura Económica, 2001).

31. Shifra Goldman, *Mexican Painting in a Time of Change* (Austin: University of Texas Press, 1980); Raquel Tibol, *Confrontaciones, crónica y recuento* (Mexico: Editorial Samara, 1992); Rita Eder, "La joven escuela de pintura mexicana: eclecticismo y modernidad," in *Ruptura 1952–1965* (Mexico: Museo de Arte Contemporáneo Alvar y Carmen T. de Carrillo Gil, 1988), 44–78.

32. Fausto Ramírez, *Modernización y modernismo en el arte mexicano,* is the compilation of Ramírez's essays of two decades. This work is forthcoming and will be published by the Instituto de Investigaciones Estéticas, UNAM; Olivier Debroise, ed., *Modernidad y modernización en el arte mexicano (1920–1960),* (Mexico: INBA/Conaculta, 1991).

33. Debroise, *Modernidad y modernización,* 19.

34. Ibid., 42.

35. Virginia Bautista, "Revisarán tres mil años de arte mexicano," *Reforma,* 17 November 1999.

36. Monica Mateos, "México eterno:arte y permanencia," *La Jornada,* 17 November 1999.

37. Enrique Florescano, *Etnia, Estado y Nación* (Mexico City: Aguilar, 1997), 405–18.

38. Luis Villoro, *Los grandes momentos del indigenismo* (Mexico City: Ediciones la Casa Chata, 1979).

39. Sally Yard, "Editor's Note," in *InSITE97: Private Time in Public Space: San Diego, Tijuana* (San Diego: Installation Gallery, 1998), 1.

40. Néstor García Canclini, "Arte desurbanizado, desinstalaciones fronterizas," in Yard, *InSite97,* 46.

41. Néstor García Canclini, *Hybrid Cultures: Strategies for Entering and Leaving Modernity,* trans. Chrisopher L. Chiappari and Silvia L. López (Minneapolis: University of Minnesota Press, 1995).

42. Lucy Lippard, *Mixed Blessings: New Art in Multicultural America* (New York: Pantheon Books, 1990).

43. Serge Gruzinski, *La pensée métisse,* 36.

44. Cuauhtémoc Medina, "Chasing a Ball in the Political Field," forthcoming in *La imagen política: XXV Coloquio Internacional de Historia del arte* (México: Instituto de Investigaciones Estéticas, UNAM, 2006).

45. Susan Buck-Morss, "What is Political Art?" in Yard, *inSite97,* 22.

Anxiety and Expedience: Chinese Art History Seen in the Context of World Art

Cao Yiqiang

The wisdom of the "Compression vs. Expression" conference is embodied in a famous line by Shu Dongpo, the great Chinese poet and painter of the Song Dynasty, that "one cannot understand the true features of Mount Lu when one is in it."[1] No regional perspectives can be clearly perceived unless they are viewed from a distance. Following this insight, I shall approach my topic first by "estranging" myself, to use a Nietzschean concept, from our local situation. The effective way of doing so is to borrow a pair of spectacles from our Euro-American sinologists. Through these foreign lenses I see two prominent views about the history of Chinese art: the one claims that the Chinese before the nineteenth century had always declined to accept "Western art," denying its values and the techniques of perspective and chiaroscuro; the other emphasizes European influence on Chinese art and tends to claim that everything unexpected to be found in Chinese painting—such as "emotional expression," "sculptural masses" or "tactile masses," "a zigzag recession," "a bird's-eye view," and "visionary scenes"—is the result of this influence.[2] Opposite as they may be at first sight, these two prevailing theories are all based on the stereotyped formula: dynamic, creative, and individualistic "Western art" versus static, conventional, and unimaginative Chinese art. The first concludes that, because the Chinese reject the Western discovery of representational skills, a source of life-enhancement, their art becomes stagnant. While this view has increasingly come under criticism as one begins to realize that the history of Chinese art has in fact undergone no less dramatic changes than its European counterparts, the second theory swiftly comes to its aid by claiming that then it must be due to their influences.

Rather than repeat my critique of these theories in detail, as I have done in *Some Hidden Links in the Dialogues between Chinese and European Art,* I will give one quick example. There exists a book on European perspective written by a Chinese author at the beginning of the eighteenth century,[3] a work which, according to the first Western theory mentioned above, could not have existed. Because of that, it was neglected until the 1970s, when the fashion for looking for Western influences began to prevail. The first more than casual mention of the book is found in a study by two French writers of the Italian Jesuit painter Giuseppe Castiglione. Yet their doubts about the Chinese capacity for understanding the science of perspective are

so deeply embedded that they do not hesitate to write the following caption for an illustration: "Page of a treatise on perspective, after Andrea Pozzo, written by Castiglione and Nien Hsi-yao. Bibliothèque Nationale, Paris."[4]

Nothing in this statement, except the reference to the location of the copy used here, is correct. If it is not too surprising that they should have mistaken the Italian painter Castiglione as the first author, it is, on the other hand, remarkable that they failed to recognize that the illustration they selected is not after Pozzo's *Perspectiva Pictorum et Architectorum* (1693–1700) at all, but has been adapted from a French source, probably Jean Cousin's *Books on Perspective* of 1560. Anyone who has bothered to take a glance at the first paragraph of the Chinese author's preface would not fail to notice that, while acknowledging his debts to Castiglione, the Chinese writer made it clear that he had begun the work independently ten years before Castiglione's arrival in China in 1715. What is more important is that the Chinese writer explained the reasons why he finally realized, after years of painstaking study, that the fixed-point perspective was not suitable for Chinese painting. His explanation shows that the adoption of perspective is merely a matter of choice, not of mentality.

I must admit that Western writers are not alone in holding these stereotyped views. In fact, their views are partly derived from our scholars in China, yet it must be noted at once that they are used for different purposes.

In a lecture I gave at the Clark in June 1999, I tried to demonstrate how, for the sake of his political reform, Kang Youwei conceived an expedient scheme to sacrifice his beloved traditional art during his visit to Italy in 1904.[5] I would like to add now that, like him, many Chinese thinkers of the time were so confident in the strength of our artistic tradition and in the capacity of the Chinese to absorb foreign influences and still remain Chinese that there was little reason for them to fear that this expedient policy might lead to an end of the Chinese tradition. History provided ample evidence to sustain confidence of this kind: the natural assimilation of Indian, Persian, and other foreign elements into our ancient art is one example, and the other is that, even when the Chinese Empire was conquered by other nations like the Mongol, its artistic tradition still retained its vigor to develop along its own course and finally convert the conquerors. But this time our Chinese thinkers were just as wrong as our Western sinologists: while the latter tended to take their intention at face value, the former failed to realize that the circumstances had so completely changed as to make their expedience go out of control and end up with the irretrievable destruction of traditional values, despite some attempts that were immediately made by such figures as Cheng Shizheng to redeem them. It was too

late. European realism, first imported into China via Japan, then through the Soviet Union, occupied the empire of Chinese art. Naturally, this defeat gave rise to their anxieties about the historiography of Chinese art.

It seems to me that the year 1929 was a turning point in this respect. In this year, three attempts were made to improve the situation: Zheng Wuchang, the eminent painter and publisher, published his *Comprehensive History of Chinese Painting and Theories;* Teng Gu, the first German-trained Chinese art historian, began to write a concise *History of T'ang and Song Paintings;* and Lu Xun, the giant of Chinese thinking, published his translation of a Japanese book on *Modern Movements in European Art History.* Despite their difference in form as well as the degree of their influence, these three endeavors expressed a common desire and a common hope. The desire was for a "scientific method," and the hope was that such a method would enable the Chinese historian to reassert the absolute supremacy of Chinese painting in the realm of world art.

Zheng Wuchang launched a severe attack on our traditional patterns of writing art history, as he believed that they were largely responsible for the decline of Chinese art. He argued that the weakness inherent in them was the neglect of synthesis and a narrow concentration on isolated points, which made it impossible for the art historian to produce a coherent narrative of Chinese art that could embrace every stage of its historical development and show the world its splendor in its complete form. Thus, he attempted to write just such a coherent history by dividing the whole history of Chinese art into four stages: the "utilitarian period," the "ritual period," "the age of religion," and "the era of literature."

It is clear that in Zheng's mind what constitutes a "scientific method" is a new system of periodization. This is even more true of Teng Gu. In his *History of T'ang and Song Paintings,* he first discussed this problem in connection with the theories of his contemporary German, French, and Japanese sinologists, and then he redefined his own periodization put forward a year earlier in his brief survey of Chinese art history. He, too, divided it into four periods. He called the era before the coming of Buddhism a period of growth; the period after the coming of Buddhism an age of infusion; the time of the T'ang and Song dynasties a most flourishing period of Chinese art history; and the period from the Yuan Dynasty to the present day an age of stagnation. He was confident that his periodization was more workable than what his foreign colleagues proposed, because, he said, "it not only breaks completely with the concept of dynasty . . . but also shows clearly the development of each age and its style."[6] Thus he claimed that his definition was based on "a history

of style whose development is determined by the forces that underline itself." The old method of "differentiating periods by dynasties," he went on, "cannot define this stylistic development, because it is classified according to genres, which in turn isolates itself." Before elaborating his theory, Teng Gu criticized the traditional Chinese historiography in the same spirit as Zheng Wuchang. He called the previous writings "random notes," meaning a lack of synthesis. Therefore, he emphasized from the first that "the only legitimate thing for an art historian to do is to deduce a conclusion from the works of all ages, no matter what viewpoint he may adopt."

One may surmise that by his German training Teng Gu must have made some unique contribution to Chinese art history. Unfortunately, it is not true, because he died shortly after his return to China from Germany. He is little known even in Chinese academic circles. By contrast, Zheng Wuchang's book once and for all set the authoritative tone of recent Chinese art history. For it provided the first framework for a general survey of Chinese art from its beginning to the present time, as opposed to a conventional periodical narrative. Above all, it created a mania for completeness that has culminated in our own times.

However, the momentum of his impact comes from his patriotic attempt to reestablish Chinese painting as one of the two fountains of world art. As he proclaimed, "in this world there only exist two systems of painting; one is the Eastern, the other the Western. . . . The Eastern system originated in the mainland China . . . then . . . spread to Japan. While the motherland of Western painting is Italy, the fatherland of Eastern painting is China. This is the place that our painting occupies in the world history of art!"[7] That too many a grandiose project of the general survey has been undertaken under the auspices of governmental organizations is intended to prove this nationalist claim. Yet, it must be said that if Zheng's own work has been surpassed by later generations, it is only in size rather than in substance.

As you will remember, in the same year as Zheng Wuchang and Teng Gu launched their attack on our traditional modes of art history, the third path to a "scientific method" was paved by Lu Xun. Through his translation of the *Modern Movements in European Art History*, Lu Xun introduced into China for the first time the mainstream of European art history represented by Riegl, Worringer, Wölfflin, and Panofsky, together with the idea of nationalism as reflected in art. A phrase, "mainly on the basis of the national colours," was carefully prefixed to the title of the book. Yet his path was hardly followed until 1980, when Fan Jingzhong launched a systematic introduction into China of the work of Western art historians. The reason for this can be explained by Lu Xun's own expedient scheme that we should

take from the West what we think useful to us. However, Lu Xun had a single yet most powerful follower, Zhong Bai Hua, who sought to establish Chinese art as one of the two systems of world art in terms of stylistic categories, or, to be more precise, on the basis of Riegl's "will-to-form."

Zhong studied during the 1920s in Europe and, after his return to China, was professor of aesthetics at Beijing University. His great influence rests on three or four small articles that appeared between 1936 and 1943. What makes these little articles so powerful is the fact that he described the antithesis between the Eastern system and the Western system through a comparison between their treatment of what he called "pictorial space": Chinese art belongs to "a musically linear system," whereas Western art belongs to an "architecturally massive system." This opposition, he argues, springs from a different attitude to the cosmos and the world that artists undertake to represent. Chinese painters seek to commune with nature, to convey a spiritual reality beyond its visual space, a sense of fleeting infinity, and therefore they do not adopt such artificial devices as perspective. As opposed to Chinese painters, Western artists set themselves the task of confronting the external world, face to face, in order to transcribe it onto their canvases. In so doing, they are forced to resort to the aid of perspective and other scientific means. Their works thus produced are admirable, but only insofar as they faithfully represent a reflex of actual appearance and reach a balanced formal harmony, for in comparison to Chinese painting they are limited and trapped in a finite world. The different outlooks of the cosmos give birth to different ways of picturing the world. Whereas Western artists seek to emphasize a feeling for mass in their architecture, sculpture, and painting, Chinese artists endow their palaces, gardens, sculpture, and painting with a rhythmic line of their traditional calligraphy and make them flow into infinity.[8]

Thanks to Zhong's influence, aesthetics has become a dominant force in Chinese art history, because this accords with the desire for a system of the arts. This has also affected the institutionalization of art history in China. Since it is regarded as an aesthetic or theoretical guide for art practice, art history is only taught at the academies of art, which, while allowing us to establish a close tie with artists, completely separates us from other disciplines that are equally important for us. As a matter of fact, some great Chinese scholars realized the importance of teaching art history at the universities. For example, in 1925 Cheng Yinke pointed out that the progress of Chinese historical studies was hampered by the neglect of art history. After 1949, Jia Bozai called for setting up a department of art history at Beijing University. Despite their efforts, decisions from above finally forced them to dis-

continue their push in the academies as an "expedient measure," to use the words of the first dean of our academy. The situation has not changed since. Therefore, I am sometimes inclined to ask myself whether it is our art historians or the system under which they have to work that should be blamed for the unsatisfactory state of our discipline that I have been describing.

One may then wonder what has come of the recent introduction of Western art history mentioned above. I think we have every reason to congratulate ourselves for making available to the Chinese readers a number of the unabridged works of Western art historians. Some attempts have already been made to apply their ideas to the study of Chinese art. One of the most ambitious undertakings is a book called *The Taste, Schema, and Value of Literati Painting.* As the title manifests itself, it is an attempt to adopt E. H. Gombrich's theories. It is an excellent book in many respects, but there are problems that have arisen from its application of Gombrich's ideas. In his *Art and Illusion,* Gombrich has referred several times to Chinese art pattern books in support of his emphasis on the role of convention and even stereotype in image-making. It seems to me that his theories about schemata can be best used to study the relation between individual Chinese artists and the models from which their personal style is derived, but the Chinese authors wish to go beyond these limits. They have tried to use Gombrich's schema-correction formula to explain the transformation of Chinese landscape painting. They argue that by the late Song period, literati painters "chose" the two Song period landscapists Dong Yuan and Ju Ran as an "initial schema" and "corrected and adapted them" by abstracting from them the lyrical elements and free effects of brush ink–work to constitute their own new orthodox tradition. We can fully subscribe to their conclusion about the link between the development of literati landscape painting with the style of Dong Yuan and Ju Ran, but to say that this whole development is a result of the process of Gombrichian schema and correction will inevitably cause confusion. Gombrich's formula gains its imposing force in the study of the psychology of pictorial representation—in plain words, of the tricks for creating illusion. Within this context, the direction of the process of correcting the schema moves steadily toward an approximation to the visual truth, which is to be reproduced, rather than toward abstraction and simplification. Although Chinese literati painters, like any painters in the world, depend on schemata, by and large they do not aim to represent visual truth but to move away from it, that is, to "simplify" it.[9]

This essay opened with an attack on some Western views, and it concludes by censuring those of my fellow art historians in China. Indeed, to do so requires a bit of nerve in a region where criticism is hardly allowed. I stand up to criticize

them because at the basis of their approach lies an old belief: that a civilization, like the Chinese, that dies out slowly must be stagnant and must therefore be censured on that account.

It is said that we historians belong to the more timid in the human race, as we are afraid of our secretaries but find consolation in censuring the dead generals. Let me therefore retreat into the past, where I find it more comfortable to dally with the great dead, as I have been doing with Kang Youwei, Lu Xun, Zheng Wuchang, Teng Gu, and Zhong Bai Hua. I have tried to describe their anxieties about the state of Chinese art and their expedient policies reasserting the place of Chinese art in world art. In doing so they all began an assault on our traditional historiography that failed to "produce a coherent history of Chinese art."

The target at which they had all aimed is the prototype of traditional Chinese writings on art, *Famous Painters of Successive Dynasties* by Zhang Yanyuan of the ninth century. Yet a brief comparison of the content of their target with that of their own works, which were supposed to replace it, reveals that not only were they blindly fighting against an imaginary enemy, but in the end they had also to fall back on what they were so anxious to destroy.

Zhang Yanyuan's *Famous Painters* appeared seven centuries earlier than Vasari's *Lives of the Artists,* yet his was much closer to the history of art as we understand it today than was Vasari's. It combines into one system such varied aspects as an exposition of the principles of art; of its relationship with other arts; of its techniques; and of their political, social, religious, and cultural functions; as well as an account of the biographical facts of individual artists and their personal contributions to the evolution of Chinese art up to his own time. It also incorporates a history of collecting that reflects these changes.

Nothing can be more coherent and comprehensive. Such is the "old mode" our exponents of the "scientific method" were so eager to eliminate. It is no more than natural that, despite their rhetoric, they could not escape the overwhelming shadow of the old. Apart from what is generally said in their opening words, in the main body of their work neither Zheng Wuchang nor Teng Gu could significantly dispense with that personification of the unscientific art history: Zhang Yanyuan's *Famous Painters.* What really makes the former different from the latter is the narrowing scope of their discussion, as is manifest in the titles of their books discussed above. It is somewhat shocking to note how the only two German-trained art scholars in China had, for different reasons, abused Zhang Yanyuan's *Famous Painters;* they had to draw on it because it is the only surving source on the history of ancient Chinese art. Teng Gu's

references to it were astonishingly inaccurate, while Zhong Bai Hua simply put in the mouth of Zhang Yanyuan his own phrases in order to legitimize his theories about Chinese art as a linear system, as distinct from Western art.

I think we could and should forgive our grandfathers and even fathers for all this, because they had lived in an age of anxiety, caused by wars, social and political instabilities, and a long, dark period of cultural isolation. Yet we must not forget the lessons we have learned from them. We are fortunate to live in a great age of cultural exchange between all the nations under the sun, to which this publication is a witness. The anxiety and expedience of the past must pass. It must give way to reason, to critical openness, and to sincere efforts to acknowledge, understand, and hence protect and develop the singularity and uniqueness of not only the tradition of today, but of yesterday; of the culture and the arts of not only "ours" but of "others." This seems to be the most obvious yet difficult goal of world art studies. The mystery of Mount Lu is a metaphor particularly relevant to this theme. When we travel a certain distance in order to gain a clearer view of its features, we must always keep in perspective what distinguishes *the* Mount Lu from all other mountains in the world, or to be more precise, that exactly what constitutes its own uniqueness is the very mystery about it, its elusiveness, which has made it so difficult to grasp its nature. We should not try to avoid it simply by "demystifying it."

1. See *Selected Poems of Su Tung-Po,* trans. Burton Watson (Port Townsend, Wash.: Copper Canyon Press, 1994).

2. This view is strongly asserted in James Cahill's *The Compelling Image* (Cambridge: Harvard University Press, 1982), 1–35, 70–103.

3. Nian Xiyao, *Shi xue* [The Theory of Vision], rev. ed., vol. 1067, *Xu xiu Si ku quan shu* [Complete Collection in Four Repositories II] (1735; Shanghai: Shanghai gu ji chu ban she, 2002).

4. Cécile Beurdeley and Michel Beurdeley, *Giuseppe Castiglione* (Boston: Charles E. Tuttle Company, 1971), 137.

5. Cao Yiqiang, "Unintended Consequences of Tourism: Kang Youwei's Italian Journey (1904) and Sterling Clark's Chinese Exploration (1908)," lecture, Sterling and Francine Clark Art Institute, Williamstown, Massachusetts, 15 June 1999.

6. This and the following quotations are from Teng Gu's preface to *History of T'ang and Song Paintings*, 2nd ed. (Beijing: Ren min mei shu chu ban she, 1962).

7. Zheng Wuchang, *Zhongguo hua xue quan shi* [Comprehensive History of Chinese Painting and

Theories] (1929; repr., Shanghai: Shanghai shu hua chu ban she, 1985), 1.

8. Zhong Bai Hua's articles are collected in a volume, *Mei xue san bu* [Aesthetic Strolls] (Shanghai: Shanghai rem min chu ban she, 1981).

9. For fuller critique of the book, see my dissertation "Avenues of Art History: Recent Developments in English Art History, with Special Reference to the Works of Francis Haskell and Their Possible Application to the Study of Chinese Art History" (Ph.D. diss., Oxford University, 1995), 147–53.

PART THREE

THE ULTIMATE
COMPRESSION

World Aesthetics: Biology, Culture, and Reflection

Wilfried van Damme

The neurologist Oliver Sacks named one of his books *An Anthropologist on Mars.*[1] After my first encounter with this book's title, however, I misremembered it as "An Anthropologist from Mars." The idea of a "Martian anthropologist" appealed to me, as it tellingly evokes the humanity-centered approach I try to develop for the study of aesthetics. This approach finds its initial inspiration in a simple yet comprehensive question: What about *Homo aestheticus?* That is, what do we actually know, and what might we hope to learn, about "beauty" and other aesthetic phenomena in the lives of human beings? Addressing these queries requires adopting an equally simple and comprehensive perspective, one that is both global in time and space and multidisciplinary, from biology to philosophy. The project I envision thus invites scholars from various fields of study to join forces in elucidating the place of the aesthetic in human existence.

By way of introduction, one may then indeed imagine an extraterrestrial scholar, implausibly humanlike, who is examining the most prominent species on the planet Earth today—a species known to some of its members as *Homo sapiens.* Imagine, furthermore, that this scholar is taking a special interest in a rather elusive phenomenon it observes to be panhuman. English-speakers in the West, and far beyond, refer to it as *beauty,* the Yoruba in Nigeria and elsewhere call it *èwa,* in China one uses the term *měi,* and so on. Indeed, an extraterrestrial scholar will soon notice that "beauty"—and I will restrict myself largely to visual beauty—features quite prominently in the lives of human beings. People evaluate other people, and themselves, in terms of beauty. Indeed, humans often go to great lengths to enhance their physical appearance. Beauty is also considered a quality of a whole range of human-made objects and events that are carefully conceived and produced, and used in a variety of sociocultural contexts. Beauty is talked about and discussed, generally referring to a property that enables a stimulus to induce a pleasurable or gratifying experience in the perceiver, varying from day-to-day and rather fleeting experiences to more intense and rarefied ones. Beauty features in proverbs, stories, poems, and songs worldwide, pertaining not only to humans and their products but also to animals, flowers, and other aspects of nature. Terms for beauty are also frequently used—metaphorically—to express appreciation or satisfaction in various other contexts.

The multifaceted phenomenon of beauty would thus seem a significant feature in human existence, and hence warrant a more thorough study in an attempt to understand the life-form that has attracted the interest of our visiting scholar. While focusing on human beings as a species (also paying attention to non-human parallels and antecedents), this scholar will at the same time not fail to observe the diversity of ways of life and outlook that *Homo sapiens* has developed. Having established the importance of beauty in human existence, it may then pose several fundamental questions against the background of humanity and its cultural diversity.

For example, which visual stimuli or stimulus features actually do elicit a gratifying experience in human beings (morphochromatically, but also beyond, into signification)? Are there perhaps stimuli that in fact do so panhumanly (or "universally," although this would seem a rather awkward term from an extraterrestrial perspective)? And if so, which stimuli or features, and why do they have this panhuman pleasurable effect? Are there perhaps stimuli that are considered visually pleasing in a given range of cultures but not all cultures? If so, which stimuli in what cultures, and why? Do stimuli exist whose attractiveness seems limited to one particular culture? In either case of aesthetic relativism, can we identify environmental factors—sociocultural or physical—that have a bearing on the formation of aesthetic preference? How and why do these factors exercise their influence? Are the processes at work unique to a given culture, or can we discern various cross-cultural patterns or indeed worldwide regularities in the way in which environments influence people's view of visual attractiveness? And how may one account for any such recurring processes in shaping aesthetic preference?

Moreover, what is the place and role of beauty in human cultures? For example, in which sociocultural contexts do visually appealing objects tend to feature prominently, and why is this so? What purposes does beauty fulfill, and how is it perhaps manipulated? What part does it play in nonverbal and verbal communication? From a global perspective, one may expect that, while keeping an eye on cases of cultural uniqueness, attempts to answer these questions will focus on discerning pancultural regularities in the functioning of beauty in its sociocultural context.

Following from the above queries, one may also become interested in the question of how people in various cultures themselves reflect upon and analyze aesthetic phenomena. How do the world's cultural traditions conceive of the nature of beauty? Which views have been developed as to where it originates, how it manifests itself, or what is needed to produce it? How is beauty seen to be related to

other qualities? Which opinions have been formulated as to what its effects are and how they may be accounted for?

Now imagine that an extraterrestrial scholar, as part of its investigation, would display an interest in what its human colleagues have produced in view of such questions. What have they achieved in establishing, analyzing, and comparing data from a variety of cultures? Also, how have they gone about attempting to explain both diversity and any regularities? Had our scholar called upon Earth some fifteen years ago, he or she would have found very little in the way of studies that set out to answer any of the questions that pertain to aesthetic phenomena worldwide.[2] All this seems to be changing rather rapidly, especially in the last decade or so. Indeed, for someone interested in aesthetics from a humanity-centered perspective, these are quite exciting times.

In this essay I would like to share some of this excitement by briefly introducing three types of contemporary investigation that address varying aspects of aesthetics in panhuman terms, ranging from humanity's evolutionary history to the various cultural traditions it has developed. Indeed, it would now finally seem feasible to start methodically addressing questions on the aesthetic dimension of "human nature" and its varying manifestations in differing contexts. Having made the case for a global study of "beauty," I will first discuss research that considers aesthetic phenomena as socioculturally integrated, in whatever culture worldwide. Beauty as a sociocultural phenomenon is the domain of particularly anthropologists and other scholars interested in sociocultural contextualization. Cross-cultural commonalities arising out of anthropological research will lead us to consider investigations that deal with the bio-evolutionary origin of human aesthetic preferences. Beauty as an experience of the human organism is nowadays studied rather intensively by evolutionary scholars as well as, increasingly, by neuroscientists. A third contemporary development in studying aesthetics worldwide concerns the examination of the various systems of thought that different cultures have developed with regard to aesthetic phenomena. Beauty as an object of reflection in the world's diverse cultural traditions is now receiving attention from philosophers and other humanistic scholars representing different cultural backgrounds. While portraying these emerging lines of research, I will attempt to suggest how they may be fruitfully integrated into a larger scholarly framework that would enable one systematically to study aesthetic phenomena in human existence.

Before proceeding, I would like to say a few words on the relationship of my topic to the theme of this volume, a volume that I consider to be dealing with

exploring the possibilities of studying the visual arts worldwide. In my experience art and aesthetics are often bracketed together. As will already be apparent from what I have said so far, however, I would insist on considering art and aesthetics as overlapping but distinct subject matters or fields of study. In brief, art is more than aesthetics, and aesthetics is more than art. Although I will be dealing with aesthetics as a rather autonomous field of inquiry, I assume that the relevance of this field for the study of art will be clear. In effect, I hope that the type of approach outlined in this essay will turn out to be inspiring to the development of the global study of the visual arts as well. In keeping with the tenor of my introduction, the notion of the visual arts should thereby be broadly conceived and by no means be limited to the so-called "high" or "fine" arts, in whatever culture in time and space.

Also, in addition to "beauty," the study of aesthetics from a global perspective should deal with other "aesthetic" qualities or categories, including at least the reverse of beauty—namely, "ugliness."[3] There are of course still other categories to be considered. One may think here of the various concepts that denote qualitative experiences that particular cultural traditions have come to discern as significant within or outside the context of the arts. As examples, I mention here only such relatively well-known and various cases as *yūgen* in Japan, the *sublime* in the West, and the different *rasas* or "emotional flavors" of aesthetic experience as conceived in Indian tradition. Indeed, studies of aesthetic vocabularies throughout the world will undoubtedly increase our insights, nuance our views, and sharpen our questions.

Beauty as a Topic of Research

One may dismiss on several grounds a large-scale approach that suggests we study aesthetics in relation to humans as bio-evolutionary, sociocultural, and reflective beings. Problems already begin, in effect, with what is proposed here as the initial focus or subject matter of this approach—namely, "beauty." Two objections immediately come to mind from a contemporary Western academic perspective. According to a first objection, now on the wane, beauty is simply not an acceptable topic of research in any sense, for reasons more ideological or political than scholarly.[4] More seriously, one may object that, as a notion or analytic concept, "beauty" is so intimately tied to the Western tradition of thought as to make it a questionable conceptual tool in any global investigation. Worse, after some 2,500 years of reflection in the West, we still do not seem to have any satisfactory solution to the problem of what we actually mean by "beauty"—philosophers still speak of "the murky waters of beauty"—a most vague and uncertain notion.[5] As a result,

we would not even have a firm conceptual basis on which to consider the funda-
mental epistemological question of whether it would be feasible to study this
phenomenon from a global perspective. [6]

Although we may be at a loss when it comes to characterizing the notion
of beauty in any sound scholarly sense, whoever is familiar with the term does have
some idea of that to which it refers. Indeed, this observation forms the starting
point of many analyses of beauty.[7] Especially in the present global context, how-
ever, a merely intuitive conception of beauty does not suffice. The brief preceding
outline of a worldwide and multidisciplinary approach to aesthetics makes it clear
that it is best here if we start by conceiving of the idea of beauty in a very broad
or liberal sense; nuances may follow later.

We may begin by thinking of beauty as a term used by English-speakers
in connection with pleasurable or gratifying responses to particular properties of
such varying stimuli as the human face and body, the representation of these and
other subject matters in a visual medium, a landscape or a flower, a poem or a piece
of music, but also behavior, traits, and ideas. This characterization of the term
beauty, as used to refer to whatever "delights the senses and the mind"—in vary-
ing manifestations and degrees of intensity—does indeed correspond to what we
find if we look up the word in various dictionaries of the English language. In light
of this broad conception, one may observe that many other present-day European
languages employ similar terms, and that analogous concepts have been in use in
the West's past. While acknowledging its particular local origin, the "Western" no-
tion of beauty, in its various guises and levels of application, may then serve a
communicative and heuristic function in our preliminary attempts to study aes-
thetic phenomena from a worldwide perspective. (It would of course be interesting
to see how, say, a Chinese or a Yoruba scholar would proceed in a global study that
takes *měi* or *èwa* as the starting point of the analysis, or indeed more generally, how
various intercultural examinations that are each based on a particular aesthetic con-
cept from a given tradition would lead to the development of a multifocal type of
"world aesthetics.")

My scholarly background is primarily in "anthropology," used in the sense
of the mainly Western study of a particular category of cultures outside the West.
This academic field seems to be known for its emphasis on cultural relativism, an
emphasis on the recognition that cultures should be considered on and in their
own terms, with cultures seen as the specific local outcomes of processes that are
historically particular.[8] Cultural relativism in anthropology, prominently promoted

by Franz Boas in the early twentieth century, has led to considerable epistemological attention to the Western biases involved in the study of other cultures. Theorists have stressed the culture-boundedness of basic concepts and, indeed, of the whole analytical and interpretative framework that is being employed in the Western study of these cultures.

One might expect that this critical stance would then also be adopted with regard to the culture-laden and historically framed notion of beauty. In the 1950s, when cultural relativism had become central to the anthropological paradigm, Warren d'Azevedo published one of the first systematic analyses of the study of art and aesthetics in anthropology. In it, he strongly advised against using the word *beauty* with reference to other cultures, "because it is so overlain by the philosophical and literary patina of our own civilization as to be all but useless in a cross-cultural perspective."[9] It may well come as a surprise that d'Azevedo's advice has not in effect been followed or repeated by other anthropologists.[10] This even applies to what is to date the most critical evaluation of the idea of an "anthropology of aesthetics." In their assessment, Joanne Overing and Peter Gow argue quite vehemently that the concept of aesthetics, characterized as a bourgeois and elitist Western construct, cannot be applied cross-culturally. And yet even in this critique the word *beauty* is used without question when referring to cultures outside the West. It is not even placed in quotation marks.[11]

Both Overing and Gow have carried out research in Amazonian cultures. From their observations it seems clear that these scholars indeed encountered local phenomena and views that it would be hard not to interpret in terms of beauty.[12] This would appear to be the experience of most if not all "field anthropologists"[13] and may well be regarded as a partial explanation for the fact that d'Azevedo's advice has not met with any success. One should also consider that for long the question in the Western humanities was not so much whether or not it would be appropriate to use the culturally contingent term *beauty* in interpreting particular concepts or phenomena in cultures studied by anthropologists. Rather, the question appears to have been whether or not these cultures possessed anything at all that was worthy of being compared to this notion. For, unlike so-called "Oriental" cultures, these cultures were by many—and in some circles until quite recently—considered to be "too primitive" to have "yet developed" something analogous or equivalent to "the Western concept of beauty."[14]

Beauty around the World

After d'Azevedo made his observation, several dozen empirical studies were carried out by anthropologists and art scholars interested in learning about the aesthetic preferences and criteria for beauty as found, particularly, in African, Oceanic, and Native American cultures. Many of these studies provide local terms for the idea of beauty. I will present a few examples of such terms, drawn from a variety of cultures—examples that should be considered along with such more historical cases as the ancient Egyptian word *nefer* or the classical Greek *Kulos,* and many other terms in time and space (Sanskrit and Hindi *Sundar* and so on.) I thus hope to demonstrate that "beauty" may indeed be considered a topic that is of panhuman and pancultural relevance, and hence a subject matter conceivably to be investigated from a global perspective.

While the examples that follow clearly sustain the idea that the experience of beauty is a human universal, in order to avoid misunderstanding I should add that the actual stimuli that induce this experience may vary from culture to culture. I should also acknowledge that there might, to some extent, be cultural variability in the experience itself, especially if we focus on this experience as it occurs in all its richness in a particular setting within a given cultural tradition.

Considering words for beauty worldwide, the Canadian Inuit or Eskimo use the term *takuminaktuk,* which according to Nelson Graburn means "good to look at, or beautiful." He adds that the word can be applied to pieces of sculpture or ornamented utensils, but also to "a sledge or the northern lights or any other natural or manufactured phenomenon."[15] Toward the southwest of North America, there is the example of the Navaho concept of *hozho. Hozho* can be applied in referring to physically attractive people, and it is a quality sought in weaving blankets and in creating sandpaintings. As Gary Witherspoon observes, *hozho* is also used in a more general sense to signify the desired state of being of people, their community, and indeed the universe. *Hozho* can thus be interpreted as a polysemic concept denoting also such qualities as "harmony," "well-being," and "health."[16]

If we move to the so-called Aborigines of Northeast Arnhem Land in Australia, we find that they employ the term *mareiin,* which, among other things, means "an extra quality—of being extraordinarily attractive or beautiful."[17] Turning to Melanesia, one may observe that the Trobriand use *kakapisi lula,* literally "it moves my inside," to indicate the visual appeal of humans, flowers, and sculpted objects.[18] Similar expressions are used in other Melanesian cultures—for example, also in the context of dance[19]—and the same range of stimuli may among the Murik of New Guinea evoke the comment that they are *aretogo,* "beautiful."[20]

Among the numerous examples from African cultures that I might give, I here mention only one. The Yoruba concept of *èwa* has been translated by a variety of scholars as "beauty." The quality of *èwa*, which may be a feature of a person's outward appearance, human-made visual objects, or natural phenomena, can be circumscribed in Yoruba as *ounje oju,* "food for the eye," or *oun t'oje oju ni gbese,* "something to which the eye is indebted." As with many African terms expressing the idea of visual or other sensorial forms of pleasingness, as with their equivalents in many Western and other languages, *èwa* may also be employed to refer favorably to the inner qualities or character of a person (in which case one may speak more specifically of *èwa inu,* "inner beauty," as opposed to *èwa ode,* "outer beauty").[21]

A moral dimension is also present in the case of the other non-English term mentioned in the introduction of this essay.[22] *Měi,* commonly translated as "beautiful," may be used in Chinese to refer to the physical appearance of men and women, voices and melodies, speech and poems, natural phenomena such as landscapes and flowers, food and liquor, character and behavior,[23] ideas and abstract notions such as the future or reputation, dreams, and so on.[24]

Such aesthetic terms or concepts may then form the starting point of further analyses that, for instance, investigate more thoroughly the semantic fields and domains of application of these concepts, as well as the latter's relation to other notions within a particular culture. One will then no doubt find that the semantic fields of these concepts make them differ to a lesser or greater extent from what in the first stage of analysis may be interpreted as their Western counterparts. For example, it has been observed that the Yoruba concept of *èwa,* when used with reference to artistic creations, may refer to any product or performance that is deemed appropriate or successful, whether the intention is to create something beautiful, ugly, or humorous.[25] In order to retain all the nuances of a concept's semantic field, as well as do justice to its implied relationships with other notions in a given conceptual and metaphysical system, it would thus seem advisable to preserve the original terms in our analyses, rather than employ the mere translation of "beauty." This is the point at which the Western notion of beauty could be said to have fulfilled its heuristic function. The example of *èwa* also demonstrates that, in addition to their more everyday uses, aesthetic terms may acquire a special or supplementary meaning when used with reference to particular art forms.

World Aesthetics

If one considers applying a global perspective to the study of aesthetics, the first discipline to come to mind may well be anthropology. Indeed, etymologically, *anthropology* means the study of human beings. A project that sets out to study aesthetic phenomena in human existence may then be quite appropriately called "an anthropology of aesthetics." However, the term *anthropology*, especially when used in the context of the humanities and social sciences, has become intimately related to the Western study of those cultures that the West has formerly construed as "primitive." This characterization is largely in keeping with what has been going on in anthropology as an academic field for the last one and a half centuries or so. Indeed, many Western anthropologists today appear to identify their discipline with the study of what they have often referred to in the previous two decades as "the Other" (setting up a dichotomy of "us" versus "them" that tends to emphasize cultural differences, thus largely ignoring any [underlying] commonalities). In addition, the discipline of anthropology, as a result of historical and practical factors, appears to have developed a particular approach in the study of its object, as we will see below. Since anthropology has become largely associated with a specific type of study of a particular category of so-called non-Western cultures, the label *anthropology of aesthetics* would seem rather unsuited for an approach that intends to be multidisciplinary and global in its coverage.

An alternative would be the use of the label *world aesthetics*. The project proposed in this essay deals with beauty and related phenomena, taking into account their evolutionary origin and neurophysiological basis, their sociocultural dimensions, and the ways these phenomena are conceptualized and reflected upon in various cultural traditions. Both these topics themselves and their specialized study are commonly referred to as "aesthetics." This use of the term *aesthetics* is more or less in keeping with its etymology as deriving from the Greek *aísthesis*, (sensorial) perception or awareness. However, ever since the introduction of the term *aesthetica* by Alexander Baumgarten in the middle of the eighteenth century, emphasis has been placed on "qualitative" forms of perception or awareness, especially those that are induced by what are conventionally referred to as "the arts." *Aesthetics* nowadays serves to designate the various academic fields that study such qualitative experiences, as well as the sociocultural and philosophical phenomena that can ultimately be traced to these experiences. An approach that attempts to incorporate and integrate these different fields may then conveniently retain the label *aesthetics*. In the present context *aesthetics* thus refers to a field of inquiry that

encompasses various disciplinary approaches and their attendant construal of subject matter. Considering that the term *aesthetics* has until recently been employed almost exclusively with reference to the West, the qualifier "world" should communicate the idea of a global perspective.[26] As such, *world aesthetics* may be considered an enterprise parallel to *world art studies*, to the extent that the latter aspires to achieve an understanding of *Homo artisticus (visualis)* by integrating data and insights that are provided by a variety of disciplinary approaches.[27]

Beauty as a Sociocultural Phenomenon

Cultural anthropologists today do not usually take a global point of view and are indeed frequently opposed to the very idea of a universal, comparative approach to the study of sociocultural phenomena (arguing, for example, that this level of analysis implies an unattainable supra-cultural or "God's eye" point of view, or else invoking the argument of cultural incommensurability). Still, the discipline of anthropology may provide at least a triple contribution to the project of studying aesthetics (as well as art) from a global perspective.

First, anthropology has a long history of engagement with conceptual, epistemological, and methodological issues that arise when dealing with phenomena in various cultures worldwide. It may thus provide what could be termed a *theoretical* contribution by aiding the development of well-considered frameworks from which systematically to advance global approaches in the study of aesthetic phenomena.

Second, there is a contribution in what may be called a *geo-cultural* sense, meaning that anthropology can significantly extend the range of cultures and regions on which to base our analyses. From a Euro-American perspective, at least, it is still to a large extent anthropologists who add to our knowledge of the many cultures that Westerners tend to classify as neither Western nor Eastern. With respect to data on aesthetics in these cultures, we should certainly also mention the efforts of art historians and other scholars who specialize in the study of art and aesthetics in especially African, Oceanic, Native American cultures. Since most of these scholars have substantially adopted the perspectives and methods that anthropologists have developed, I will categorize them here under the heading of "anthropology."

This brings us to the third contribution that anthropology may provide, and which concerns the particular *approach* it offers to the study of sociocultural phenomena. Within this approach I discern three hallmarks: the empirical-inductive stance, the contextual emphasis, and the intercultural comparative perspective.[28] In context of anthropology's empirical basis, in the case of aesthetics,

the adjective *empirical* usually pertains to verbal data. This means that members of a given culture are asked to put into words their aesthetic preferences and criteria and to expound on their aesthetic concepts and views (hence the importance of language, conceptual contextualization, and issues of intercultural translatability).[29] This also means that, in contrast to many philosophers of aesthetics, who tend to take a conceptual-analytic or indeed a normative stance, anthropologists are thus interested in what people actually consider beautiful, or ugly, and so on.

In their empirical research, scholars should ideally follow what may be called a cross-section approach, paying attention to the aesthetic views of all population segments that within a given society or culture may be meaningfully discerned.[30] Indeed, if we set out to investigate the aesthetic in the lives of human beings, we need to have data on as many groups of people in as many cultures as possible. Unfortunately, the application of an empirical approach to aesthetics has until now been confined almost exclusively to (a limited number of) cultures traditionally studied in anthropology. Conversely, when it comes to cultural traditions of "philosophical aesthetics," i.e., of systematic and argumentative reflections on aesthetic phenomena, our knowledge is presently limited almost exclusively to so-called Western and Oriental cultures. This double asymmetry needs to be adjusted in future research (see also below). Carefully collected empirical data on aesthetic preferences and views may then be analyzed within the larger societal and cultural settings in which they occur.

This emphasis on sociocultural contextualization—the second hallmark— is probably the most salient characteristic of the approach that anthropologists have developed. It may be argued that this contextual emphasis derives in part from the long-established anthropological practice of "fieldwork," whereby outsiders become merged into a foreign culture as a whole. Anthropologists then try to understand analytically singled-out phenomena as these are integrated in their sociocultural contexts. In the case of aesthetics, this emphasis on context may lead to analyzing the what, how, and why of the sociocultural conditioning of visual preference. Once we become aware of the sociocultural setting in which aesthetic phenomena occur, several other avenues of contextual exploration suggest themselves. These involve various questions regarding the place of beauty in the fabric and dynamics of sociocultural life, including its creation, presence, and assessment. I will briefly return to these contextual issues shortly.

The third hallmark of the anthropological approach suggested here concerns intercultural comparisons on a regional, and ultimately on a global, scale—a feature that clearly harks back to the more encompassing notion of anthropology

as the study of humanity. At least with respect to the study of art and aesthetics, however, this comparative approach has hardly been developed in anthropology (which seems due in part to an alleged lack of empirical data on the one hand, and a paradigmatic emphasis on cultural difference on the other). Intercultural comparative analyses are obviously of great importance to the study of aesthetics and art from a global perspective, allowing us to explore similarities and differences, as well as, importantly, similarities *within* differences on a global scale.

To illustrate the latter, I may briefly refer to a thesis on which I have elaborated elsewhere, and which concerns cultural relativism in visual preference.[31] Throughout the twentieth century, anthropologists have consistently argued that aesthetic preference is to a significant extent culture-bound. Yet they have been slow in trying to account for this phenomenon. Several empirical and contextual studies suggest, however, that a given community's particularistic visual preferences are informed by that community's sociocultural values or ideals. If so, then cultural relativism in aesthetics may be clarified by arguing that differing sociocultural ideals lead to differing aesthetic predilections.

In order to substantiate this thesis, I refer to visual preferences and sociocultural values in three African societies or cultures. The first of these concerns people in central Côte d'Ivoire who identify themselves as Baule. On the basis of empirical research, the art scholar Susan Vogel points out that in evaluating the visual attractiveness of people and anthropomorphic statues, the Baule prefer precisely those features that signify the communal values of this agricultural population. Thus, Baule evaluators prefer a smooth, unblemished skin, muscular calves, a long strong neck, and a youthful appearance, visual features that in Baule terms multireferentially and jointly signify such values as cleanliness, health, fertility, and the ability to work hard. On a more abstract level, both Vogel and the anthropologist Philip Ravenhill report that the most important Baule standard in evaluating visual stimuli is sɛsɛ, "moderation" or "the mean."[32] The ethnographic data concerning the Baule suggest that, similarly, the notions of restraint and conformity to the average prevail in the sociocultural value system of this egalitarian and collectivistic society.[33]

In contrast, among the Igbo of Nigeria it is individual achievement that counts as the sociocultural ideal, as described by several Igbo and non-Igbo scholars. This ideal presupposes strength and perseverance, and its attainment leads to riches, power, and prestige. The ideal of personal accomplishment would seem to motivate the Igbo aesthetic preference for *igwogo ngwogo,* or "culvilinear elaboration." For in terms of Igbo culture, as the art scholar Chike Aniakor suggests,

curvilinearity may be plausibly analyzed to refer to force and determination (as in rams' horns and young plant tendrils), while time- and money-consuming visual elaboration signifies wealth and social status.[34]

In addition to clarifying intercultural variation in aesthetic predilection, the relationship between sociocultural ideals and the evaluation of beauty also sheds light on *intra*cultural changes in visual preference. For example, the Asante of Ghana have come to display a preference for a smooth blend of stylization and naturalism in sculpture. The anthropologist Harry Silver proposes that this preference is inspired by the contemporary Asante sociocultural ideal of harmoniously merging local traditional values (signified by stylization, a visual hallmark of traditional Asante culture) and modern Western ones (signified by naturalism, which is seen as distinctive of Western culture).[35]

If the aesthetic preferences of the Baule, Igbo, and Asante were viewed in isolation from their sociocultural context, one could merely conclude that the visual predilections of these peoples are culturally relative. However, once these preferences are analyzed in their sociocultural settings, and once these analyses themselves are compared, a pattern would seem to emerge. The intercultural comparative analysis of contextualized empirical data on visual preference (that is, the application of an anthropological approach to the field of aesthetics) may thus bring out an underlying unity within the cultural diversity in aesthetic preference. In such a case, universality and cultural particularity are combined, rather than viewed as mutually exclusive.

If people would indeed regard as attractive visual stimuli that signify their sociocultural ideals, then in the wake of this observation one may suggest other contextual examinations of aesthetic phenomena. For example, it may thus be argued that aesthetic assessment appears to a significant extent to be indicative of the evaluator's ideational or value preferences. Such assessments (like the objects they refer to) could then be interpreted as metaphorical: they concisely and suggestively express something (ideational preferences) in terms of something else (visual preferences). If so, public aesthetic assessment may be theorized as a force in the processes of both maintaining and revising value systems. If particular objects of aesthetic evaluation signify prevailing sociocultural ideals, then positive aesthetic assessments of these objects could be held metaphorically to underscore the valuational status quo. Conversely, negative aesthetic evaluations (when not concerned, in the case of human products, with execution) may be held to constitute a form of ideational criticism. Indeed, due to ever-changing circumstances, a community's

value system is always to a greater or lesser extent subject to revision. Most no-
ticeably in times of pronounced shifts in value orientation, artistic objects may
tellingly signify what are proposed to be new values. Positive or negative assess-
ments of these "axiological trial balloons" could then perhaps be instrumental in
the process of ideational reorientation by thus endorsing or renouncing the valua-
tional tendencies referred to.[36]

Returning to the topic of cross-cultural commonality and variability in
visual preference, there appear to be aesthetic universals that are more straight-
forward than the pancultural mechanism suggested above. Thus, on the basis of
the available empirical evidence, it would seem that the following standards are
universally applied in the creation and evaluation of visually pleasing objects: sym-
metry and balance, clarity, smoothness, brightness, youthfulness, and novelty.[37]
To be sure, when these fundamental criteria are instantiated in terms of a given
culture, some may involve a relative dimension on the level of visual form. This
is especially clear in the case of novelty, but may also hold to some extent for a
standard such as clarity. In many cases, however, the application of a universal cri-
terion in the context of one culture leads to visual properties that can be recognized
as such and admired in any other. These properties may then be called *transcul-
tural* aesthetic universals.

In the case of novelty it is quite obvious that what counts as novel or in-
novative in one culture may not be so regarded in another. When dealing with
universal aesthetic *principles* (such as novelty), rather than panhumanly appreciated
properties (such as smoothness), one may use the term *pancultural,* or perhaps bet-
ter, *generative aesthetic universals.*[38] The term *generative aesthetic universals* may then
be employed to refer more generally to any principle (or process or mechanism)
that is operative in determining aesthetic preference in all cultures—irrespective
of whether or not the instantiation of this principle in a particular cultural con-
text entails transcultural appreciation (and irrespective, in effect, of whether this
principle is locally recognized as such or is postulated by an outside analyst).

Novelty is a clear example of a generative aesthetic universal that involves
one level of relativism—namely, on the level of form. The universal regularity we
have considered above may count as a generative aesthetic universal that in prin-
ciple involves two such levels: There may not only be relativism on the level of
forms that signify certain meanings, but also relativism concerning which mean-
ings actually count as values or ideals in a particular cultural context.

Beauty as a Response of the Human Organism

If we could establish worldwide commonalities in visual preference at several levels of analysis, we are subsequently faced with the task of having to account for them. I will here consider two lines of explanatory reasoning, which in more complex cases should in fact be combined.[39]

First, from an "experiential" perspective, one may try to explain observed similarities in aesthetic preference by pointing to shared experiences, or shared forms of enculturation, among people of various cultures. The idea of "experiential universals"[40] could then, for example, be applied in an attempt to account for the panhuman preference for a smooth skin in people and its rendition in anthropomorphic sculpture. One may then start by suggesting that humans in whatever culture come to attach positive value to the idea of health. This shared favorable assessment of health could then be called an experiential universal in the axiological realm. It would similarly seem plausible to assume that people everywhere come to associate a smooth, unblemished skin with health and hence to regard the former as a sign of the latter. We are then dealing with an experiential universal in the semiotic realm. A smooth skin would thus be able to evoke favorably assessed meaning in anyone, regardless of cultural background. According to this view, the panhuman positive response to the visual property of dermal smoothness can be explained on a semantic-valuational basis, involving developmental experiences shared by all people. (An alternative "nativist" account of the panhuman appreciation of a smooth skin, not involving cognitive mediation will be presented below.)

Although it does have its merits—in some instances and to some extent—there are several problems with this experiential approach. Thus, it would seem far more difficult to apply convincingly its line of reasoning to account for the universality of such standards as symmetry or clarity. Also, this approach would seem to undertheorize the actual outcome of the evaluative perceptual process. For how do we, in effect, explain that the positive assessment of the meaning signified by a particular stimulus ultimately involves some pleasurable feeling state? That is, why does the perception of meaning that experience has provided with attributes of favorable evaluation actually entail what may be called a positive affective response?

The same problem faces us when providing a purely experiential (or "culturalist" or "social constructivist") explanation for the observed relationship between aesthetic experience and the signification of sociocultural ideals. Visual metaphors of the local value system, one may argue, would seem to be able to succinctly and suggestively elicit a manifold of meaning that the enculturated mind of the perceiver

has come to evaluate positively. One could then suggest, as I have done elsewhere,[41] that the gratification induced by such a metaphor results from the intensified experience of a range of favorably assessed cultural meaning, cogently signified by a visual stimulus. But again, why is it that this condensed experience of positively evaluated cultural meaning ultimately involves some "emotive" dimension (rather than entails, say, a mere "cold cognitive appraisal")?

Some light may be shed on this problem by taking into consideration recent Darwinian perspectives on the workings of the human mind. This brings us to the second, "evolutionary" explanatory approach, according to which similarities among human beings may be clarified by pointing to evolved and hence shared predispositions of the human brain or mind.

The experiential account of panhuman regularities in aesthetic preference that we have considered may be regarded as a fairly rare universal application of an explanatory framework that today is often referred to as the "Standard Social Science Model." Evolutionary psychologists Leda Cosmides and John Tooby have introduced this term to refer to a paradigm for viewing the human mind and behavior that has been dominant in the social sciences and humanities throughout the twentieth century.[42] According to this "constructivist" paradigm (going back to at least the English empiricists of the seventeenth and eighteenth centuries), the mind at birth is like a *tabula rasa,* or blank slate, to be written on by experience and to be shaped or conditioned by the sociocultural environment.

In psychology the assumption of an extremely malleable human mind was characteristic of the so-called behaviorism of J. B. Watson and B. F. Skinner, who argued that an individual can be conditioned by the sociocultural environment in almost any direction. The blank slate premise has also been of paramount importance to anthropology's emphasis on cultural relativism, which in turn strengthened ideas of sociocultural conditioning in psychology (and decades later was to influence strongly the diffuse intellectual movement known as postmodernism). For instance, the work of Margaret Mead, one of Boas's students, led to the notion, among other things, that gender roles are entirely defined by culture, or that sexual jealousy is but a social construct, present in some cultures and absent in others.

To be sure, many early cultural relativists also clearly advocated the idea of "the psychic unity of mankind," thus prefiguring a basic notion of evolutionary psychology. Conversely, no evolutionary scholar doubts the influence of the sociocultural environment in the development of a human organism. Yet Darwinian or naturalistic scholars now plausibly challenge the still influential *tabula rasa* paradigm and

its concomitant views of extreme cultural determinism. In their evolutionary approaches to mind and behavior, these scholars combine data and insights from evolutionary biology, neuroscience, cognitive psychology, human ethology, anthropology, as well as such other disciplines such as economics. On this basis it is argued that, rather than a blank slate, the human brain is at birth equipped with, or will normally develop, numerous "mental modules" or "psychological programs" that predispose one to think and behave in a particular manner. Some of these functionally specialized "programs"—made up of neural circuits—are rather rigid, whereas others are more flexible or plastic in that they develop in interaction with information provided by the environment. Indeed, it is now becoming increasingly clear that environmental experiences may actually influence the expression of the underlying genes themselves (by switching them on and off), thus definitively revealing "nature versus nurture" to be a false dichotomy.[43]

The figures of speech of mental modules or psychological programs are especially associated with the discipline of evolutionary psychology.[44] Like scholars adopting related bio-evolutionary perspectives, evolutionary psychologists are concerned with applying a neo-Darwinian approach—combining Darwinian natural selection and Mendelian genetics—to the study of the human mind. They thereby attempt to account for any regularities in mental and behavioral phenomena as found in human beings (including affective or evaluative ones). Most scholars in the humanities are familiar with the basic ideas of evolutionary thinking: Naturally occuring changes in DNA sequence (which includes genes and gene expression modulators) produce variation in a population, and those variations are retained or selected that provide an organism (or better, the genetic material it carries) with an advantage in terms of survival and reproduction.[45] Some one-and-a-half centuries after Darwin, we have become used to the idea that hereditary genetic variation and natural selection may thus account for the evolution of structural and physiological properties of organisms. Now evolutionary psychologists apply this insight to the evolution and present-day workings of the one organ that has until recently been somehow exempted from such an approach—namely, the human brain, whose operations include those that we tend to refer to as the human mind.

It is argued that, throughout millions of years of evolution, the combination of random changes in genetic code and nonrandom environmental selection has slowly but relentlessly designed the way in which the brain processes information and generates behavior on that basis. Emphasis is placed on the evolution of said "modules" or "programs," each of which is seen to have been gradually

shaped to deal with recurring problems related to survival and reproduction (problems having to do with food, predators, mate choice, family and social life, and so on).[46] Importantly, many of these functionally specialized programs, or what some call "epigenetic rules," are thought to have an affective component that is involved in such processes as decision making.

Evolutionary scholars work from a broadly generalizing perspective and invoke what, at least to humanistic scholars, is an enormous time-depth. Indeed, it is argued that the species-typical features of *Homo sapiens* mainly developed at the time when humans lived as Pleistocene foragers in East Africa (where humans and their hominid predecessors have spent some 99 percent of their existence). Within this large temporal framework, evolutionary psychologists have until now paid little attention to present-day cultural differences, which are seen as relatively recent local developments. Attention is focused instead on what human beings have in common on a fundamental level. The ultimate goal is then to arrive at a formulation of what is typically human, in order to thus define "human nature."

These evolutionary ideas are now also being applied to universals in aesthetic preference. Whereas evolutionary scholars deal primarily with the "what" and "why" questions of aesthetic universals, researchers involved in neuroaesthetics add attention to the "how" questions. The neuroscientific study of aesthetic appreciation[47] is in effect only now taking off, with a growing insight into neuroanatomy and neurochemical processes (including those in the affective realm)[48] and with the arrival of brain-scanning techniques such as PET and fMRI.[49] Insights gained by these investigations should then ideally be integrated in evolutionary analyses, and vice versa.

In "evolutionary aesthetics" attention has so far focused mainly on pan-human affective responses to particular features of the human body. This emphasis on corporeal aesthetics can be understood in light of the importance that evolutionary scholars attach to mate choice, which is seen to be significantly based on bodily preferences.[50] On the basis of (cross-cultural) experiments and the ethnographic literature, evolutionary scholars suggest that several characteristics of the human body are universally considered attractive, including a symmetrical face and bodybuild, a smooth skin, and, in women, a so-called hourglass-shaped figure.[51] These preferences, it is maintained, are not only universal but also innate, meaning that over evolutionary time the human brain has developed neural circuits that predispose people to respond favorably to these visual properties. (We could then be dealing with what Edward O. Wilson has called "primary epigenetic rules,"

which process stimuli in a programmed and frequently emotion-guided manner without any significant mediation of previous experiences. "Secondary epigenetic rules" are more complex regularities in stimulus processing and do involve an organism's relevant environmental experiences.[52])

The rationale behind this nativist proposition is as follows. First, on the basis of medical research, the bodily features concerned can be considered objective indexes of such related properties as health, youth, and fertility (for example, symmetry appears indicative of developmental stability, signaling a resistance to parasites; a smooth skin counts as an index of youth and physical well-being; and a wasp-waist in women turns out to be positively collerated to health and high fecundity). It is then argued that ancestral people who, through random genetic changes, happened to acquire a preference for one of these bodily features proved on average to be more successful in reproduction than others. For these ancestors tended to choose more healthy and more fertile mates than did those who lacked this preference. Since this preference is ultimately gene-prescribed, it may be transmitted to descendants who will have an equal evolutionary edge relative to other individuals. The inborn preference for certain bodily features then gradually spreads through the population, until after many generations it becomes characteristic of the human species as a whole.

This sobering evolutionary logic is now also adopted in an attempt to account for universal preferences in landscapes,[53] panhumanly appealing themes in narrative,[54] and musical universals.[55] This logic may also be tentatively applied to elucidate the existence of universal standards or principles in the evaluation of visual artifacts.[56] In a partial explanation, one could then, for example, argue that the properties of *symmetry, balance,* and *clarity* all enhance the perceptibility of visual stimuli (both natural and artificial), something to which *smoothness* and *brightness* contribute as well. Ancestral people who, due to random changes in mental programming, became more attracted and attentive to one or more of these properties then were able to make better sense of visual stimuli in their surroundings. Since the ability to extract information from environmental clues is easily seen to be valuable in terms of survival and reproduction, the increase in this ability may be considered selectively advantageous. Future generations will then inherit the genetic material involved in developing neural circuits that entail an above-average attraction to these visibility-enhancing properties. In human-made objects created to provide visual pleasure, the amplification of these properties or qualities tends, as a result, to produce a relatively strong, agreeable sensorial effect in human beings.[57]

Similarly, in the case of *novelty*, one could suggest that individuals who, on the basis of changes in genetic code, became more sensitive to instances of novelty tended to display more exploratory behavior than others. In evolutionary terms, exploratory behavior may well be seen as instrumental in finding such essentials as water, food, and mates; in spotting dangers; in discovering escape routes; and so on—all behaviors beneficial to survival and reproduction. If an increased display of exploratory behavior (up to a certain degree) indeed provides an evolutionary edge, then people endowed with this tendency are more likely to pass on their genes. The mental program that involves a heightened attraction to novelty then spreads among the human species, together with the type of behavior it inspires.

In visual artifacts, novelty is largely a property that in an evironmentally determined manner—physical and cultural—is ascribed to form. If the above analysis makes any sense, then the example of novelty demonstrates that an evolutionary approach may also account on a panhuman basis for particular cultural or regional *differences* in visual preference. We would then be dealing with an evolved psychological mechanism that involves weighing incoming information against what is usually encountered, before a response is triggered that is itself "hard-wired." (Involving the influence of previous experiences, such a postulated regularity in stimulus processing may serve as an example of a relatively simple "secondary epigenetic rule.") In his contribution to this volume, John Onians proposes a related neuropsychological line of reasoning in order to account for regionally differing stylistic preferences, emphasizing the influence of varying visual environments in developing these preferences.[58]

One may then even go so far as to suggest an evolutionary hypothesis in view of the positive affective response that people appear to experience when confronted with visual metaphors of the local sociocultural value system.[59] (Evolutionary scholars usually apply more rigorous analyses, deriving testable hypotheses from evolutionary theories and refuting or confirming these hypotheses on the basis of empirical or experimental data. Below is an attempt to give an a posteriori evolutionary account for a regularity, arrived at in a non-evolutionary scholarly framework.)

The topic may be approached as follows. Having evolved to live in groups, human organisms recurrently face the problem of social inclusion. Social inclusion would seem to require that at given times humans display at least an elemental type of conformity to the behavioral principles or values that have been developed by the group in which they live. Indeed, individuals who do not display some minimal observance of these collective behavioral guidelines face the risk of ostracization.[60]

Especially in the context in which the mental predispositions of humans evolved over hundreds of thousands of years—that of groups of foragers or hunter-gatherers—such casting-out is likely to severely reduce an individual's prospects of survival and reproduction. Conversely, some measure of endorsement of collective values or rules may in several ways benefit a human organism and those sharing its genes. This compliance would thus seem instrumental in the organization and effectuation of various forms of cooperation, such as certain types of gathering and distributing food or warding off of danger. These forms of cooperation may then be held on average to confer advantages to the survival and reproductive success of the individual members of the group, as well as their kin.

Social inclusion and cooperation in humans may thus be regarded as recurring—and increasingly intricate—problems that are subject to selection pressure.[61] One may then speculate that selective processes, acting on the adaptive problem of social cohesion, favor people who are predisposed, in given conditions, to respond in a positive affective manner to what enculturation teaches them to be collective values. In this case, as in so many others, emotional responses would serve as economic motivators of behavior that on average proves beneficial to gene survival (or more accurately, that has proved to be so in ancestral environments).[62] If so, visual metaphors that pithily signify local sociocultural values may be able to trigger a relatively intense affective response that as such has an innate basis.[63]

To continue the speculation, one may even suggest that this hypothesized built-in capacity to experience gratification in reference to supra-personal (and supra-kin) values allows, in a rudimentary sense, for the experience of "self-transcendence" that in one form or another has been frequently mentioned as typical of "aesthetic experience." This characterization is found not only in the Western tradition of thought, but also would seem to surface in reflections provided in, for example, Indian and Chinese traditions.[64]

Beauty as an Object of Reflection

From the documented beginnings of Western philosophy onward, thinkers in the West have been concerned with pondering such topics as: the origin and nature of the arts; their classification and various functions; the skills and inspiration involved in their creation; the experience and evaluation of their qualities; and the nature of these qualities themselves. In recent decades, scholars of various cultural backgrounds have started addressing the views that have been expressed with regard to these and related questions in cultures outside the West.

Attention has until now been leveled particularly at the literate traditions of what are conventionally called Oriental cultures, with scholarly analysis mainly concerned with reflections that are expressed in various types of text. In the second half of the twentieth century, the study of the views formulated by thinkers in Indian, Chinese, and Japanese traditions vis-à-vis the arts and their qualities became known in Western academic philosophy as *comparative aesthetics* (actual comparisons between various Oriental and Western traditions, however, constitute but a minor part of these endeavors).[65]

It is only in the last fifteen years or so that the study of philosophies of art and aesthetics is developing a truly global perspective. Scholars are now taking into account the views that have been formulated by a variety of cultures in time and space, from the Aztecs to the Yoruba, from Mesopotamian cultures to the Navaho, and so on.[66] This type of research is increasingly taking place under the heading of "transcultural aesthetics." This label was launched at a conference held in Sydney in 1997, the first conference to explore the possibilities of developing a worldwide perspective on the study of thought about the arts and their qualities.[67]

Theological issues aside, once we set out examining the views on art and aesthetics in the world's various cultural traditions, a host of research topics suggests itself. Of special interest for the project of "world aesthetics" are those topics that concern the various aesthetic qualities that a given culture deems important within or outside the context of the arts.[68]

A starting point may be provided by analyses of the cardinal aesthetic terms or concepts within a particular tradition. This leads to addressing issues already hinted at above, which concern the semantic fields and contexts of application of such terms, as well as the ways they relate to other notions in a tradition's conceptual and ontological schemes. Against the background of a thorough knowledge of a culture's aesthetic vocabulary, one may then address many other questions. (The answers to such questions may of course be of interest also to scholars who focus their research on the visual arts in whatever culture in time or space.)

Investigation may thus center on the views, if any, that a particular culture has developed regarding the origin of beauty or other aesthetic qualities. For example, is beauty held to stem from a divine source, as in some prominent Western traditions, and what are the perceived consequences of such a view? Or one may ask how the creation or expression of aesthetic qualities is conceived of in a given cultural context. Is this creation considered to require the adherence to certain rules or guidelines, and if so, which rules and why? What is the role, if any, in creating

aesthetic objects or events that is ascribed to imagination, inspiration, or related phenomena? For instance, are dreams considered to play a prominent role, as among the Baule and in many other cultures? Still other queries address views on the nature of aesthetic qualities, the criteria by which their presence is judged, or how the experience of these qualities is conceived of.

One may also take a closer look at the relationships between the formulation of aesthetic views and actual aesthetic or artistic practices. For example, are the systematic views that have been developed descriptive, analytical, or explanatory in nature, or are they meant to be prescriptive? If the latter is the case, is this only a matter of thinking intended to inform practice, or does practice also inform normative thinking? Also, in a given culture, who is in fact responsible for formulating aesthetics views, as well as amending and transmitting these, and in which contexts do such processes occur?

It would indeed seem profitable to study reflections on matters aesthetic not in the isolation of the realm of thought, but with reference to the various phenomena that inspire them and to which they may pertain in a rather concrete sense. One may thus become more sensitive also to the potential sociocultural implications of thinking on aesthetic issues. From such a more contextual perspective, research may focus attention on whether in a given cultural tradition any views have been formulated, and applied, concerning the role of aesthetic qualities in such domains as education, religion, political propaganda, or even medicine. For instance, the experience of beauty is considered to be morally or spiritually uplifting, in various systems of thought the world over. Which arguments are adduced for this view and to what possible applications does it lead in, say, the field of education or religion? As to the religious role of beauty, it may also be observed that beauty is regularly held to be able to please and propitiate deities or spirits, as among the Yoruba and in various other traditions. What does this teach us about the nature of beauty as conceived in these traditions? In terms of propaganda, one may find that "aesthetics" is ascribed a role in propagating political ideology, as in Nazi Germany, the Soviet Union, and many other cases in time and space. On which assumptions concerning the impact of aesthetic objects on mind and behavior is this role based? It also happens that the presence of beauty is thought to be instrumental in healing people mentally and physically, which is the case in Navaho tradition, among others. Again, what are the premises and arguments on which such views rest, or indeed, to what a posteriori systematization of thought do they give rise?

However preliminary and incomplete the formulation of these various queries, it would seem that the emerging discipline of transcultural aesthetics (or comparative aesthetics, new style)[69] provides an appropriate, multicultural setting for pursuing questions that relate to what the human mind has produced in terms of thought about beauty and other aesthetic phenomena. The study of the accumulative reflections that have been provided by the most keenly observant and perceptive minds in the world's various cultural traditions is then likely to add considerably to our analysis and understanding of aesthetic phenomena in human existence.

Conclusion

In this essay I have tried to give some idea of what the study of aesthetics from a global and multidisciplinary perspective might amount to. In doing so, I have introduced several contemporary disciplines that aim at examining varying facets of this extensive field of study. It will be clear that these disciplines are still in their infancy, but at least various forms of scholarship are now finally taking a worldwide perspective on the study of aesthetics. The results of these endeavors should be integrated into an ever-more-comprehensive picture of *Homo aestheticus.*

In an attempt to start this process of integration (which would ideally lead from a multidisciplinary to a *trans*disciplinary approach) I have made some rather bold assertions that stand to be corrected, as in every form of scholarship. In the process, I have suggested that anthropologists and related scholars may turn to evolutionary and neuroscientific approaches in looking for explanatory models that may account for universal regularities in the aesthetic domain. Such regularities surface, for example, when comparing (contextualized) empirical data on aesthetic preference from different cultures. The cross-cultural data of anthropologists, including those that concern various forms of cultural diversity in aesthetics, may in turn provide a challenge to evolutionary scholars and neuroscientists.

When anthropologists extend their endeavors into the realm of aesthetic concepts and systematic views on matters aesthetic, their investigations grade into those that are prioritized by researchers in the field of transcultural aesthetics. The types of analysis applied by these philosophy-leaning scholars may then inform the work of anthropologists. The latter might be inspired, for instance, by the examination of reflections on aesthetic phenomena that are provided in various forms of oral or written literature. Scholars involved in transcultural aesthetics may in turn profit from anthropologists' emphasis on sociocultural contextualization, so as to produce richer analyses of thinking on aesthetic issues. They may thus take

into account the interaction between local reflections on aesthetics and the actual production and sociocultural role of artistic and aesthetic phenomena.

One may even propose a mutually beneficial relationship between research into reflections on matters aesthetic on the one hand and investigations into the biological foundations of these matters on the other. Evolutionary and neuroscientific theories may in the long run perhaps add to the clarification of recurrent characterizations that are formulated in various cultural traditions of thinking on aesthetics. In turn, the sharpened insights into aesthetics that are likely to arise from studying diverse philosophical traditions might serve a heuristic function in evolutionary and neuroscientific investigations. Studies in transcultural aesthetics could thus provide a more nuanced terminology than is presently available, which may lead evolutionary scholars and neuroscientists to formulate more nuanced research questions in addressing issues in aesthetics.

The concerted efforts of all these and related disciplines should then work toward elucidating the nature of various types of aesthetic experience (visual or otherwise), why they exist at all, and why aesthetic phenomena, in their manifold manifestations and sociocultural ramifications, have such a prominent place in human existence. By bringing these disciplines to the attention of scholars willing to consider the possibilities of examining the visual arts worldwide, it is my hope that future researchers in the field of world art studies will show an awareness of the problems addressed and the questions raised by these (integrated) disciplines. These scholars may then be motivated to contribute, each from their own specializations and vantage points, to the clarification of these issues in order to thus enhance our understanding of the aesthetic in human life.

In this essay I have tried to retain the introductory tone that characterized the original paper presented at the conference in April 2000; the literature referred to in the endnotes should provide more nuanced views. I thank John Onians for the invitation to participate in this conference, an invitation that served as an incentive to draw together several threads I have been working on for the last few years. This essay incorporates material first presented at the second international conference on "transcultural aesthetics," at the University of Bologna in October 2000, in a paper published as "Transcultural Aesthetics and the Study of Beauty," *Frontiers of Transculturality in Contemporary Aesthetics,* ed. G. Marchianò and R. Milani (Turin: Trauben, 2001), 51–70 (for a free online version, see http://www3.unibo.it/transculturality). Both the Bologna paper and this essay were written while

I was a visiting fellow of the Sainsbury Research Unit for the Arts of Africa, Oceania and the Americas, University of East Anglia, Norwich (September–December 2000). The support of the Sainsbury Research Unit is hereby gratefully acknowledged.

1. Oliver Sacks, *An Anthropologist on Mars: Seven Paradoxical Tales* (New York: Knopf, 1994). The title of this collection of essays refers to a statement by the autistic scholar Temple Grandin, who features in the book and uses the image of "an anthropologist on Mars" to describe how she frequently feels like a complete stranger in the world of human beings.

2. The few analyses available at that time are found in the context of (almost equally rare) global perspectives on the visual *arts*. Ben-Ami Scharfstein's *Of Birds, Beasts, and Other Artists: An Essay on the Universality of Art* (New York, London: New York University Press, 1988), may well be regarded as the first monograph to deal with visual art and aesthetics as truly universal phenomena, drawing on examples from a wide range of cultures, past and present. Particularly in the last chapter of his book, Scharfstein explores what is universal in art and aesthetics. In an earlier chapter he also incorporates data on non-human animals. (Scharfstein has written an updated and extended version of this study, entitled *The Hidden Unity of Art: The World's Traditions, Artists, and Aesthetic Principles*, forthcoming.) Issues of aesthetics from a panhuman perspective are also addressed in Ellen Dissanayake's *What Is Art For?* (Seattle: University of Washington Press, 1988). This is a more expressly ethological study, emphasizing the activity of "making special" as the core of "art as a behaviour" (see also her *Homo Aestheticus: Where Art Comes from and Why* [New York: The Free Press, 1992]; Dissanayake, who develops a biosocial approach, has more recently published *Art and Intimacy: How the Arts Began* [Seattle: University of Washington Press, 2000]). Richard L. Anderson's *Calliope's Sisters: A Comparative Study of Philosophies of Art* (Englewood Cliffs, N.J.: Prentice Hall, 1990) focuses on the views that various cultures in time and space have developed with regard to "the fundamental nature and value of art" (4). In analyzing these views, Anderson also pays considerable attention to conceptions of beauty or related qualities in most of the cultures considered. (A revised edition of Anderson's book was published by Prentice Hall in 2004.)

3. I use the term *aesthetic qualities* in this essay for the sake of convenience. However, I agree with George Santayana and others that we are ultimately dealing with qualitative experiences that we tend to transform into qualities of the stimulus that induces them (George Santayana, *The Sense of Beauty* [New York: Scribner, 1896]). This phenomenon is sometimes referred to in aesthetics as "projectivism" (see James W. McAllister, *Beauty and Revolution in Science* (Ithaca, N.Y.: Cornell University Press, 1996): 29.

4. For example, in an article entitled "The Stirring of Sleeping Beauty," Craig A. Lambert starts by observing the following: "In American universities, beauty has been in exile. Despite its centrality in human experience, the concept of beauty has virtually disappeared from scholarly discourse. Oddly enough, the banishment has been most complete in the humanities, home of literature, music, and

art. Critized as an elitist concept, an ethnocentric creation of white European males, beauty has been stigmatized as sexist, racist, and unfair. Attention to beauty, some say, may distract us from the world's injustices." *Harvard Magazine* 101 [Sept.–Oct. 1999]: 46; quotation from online version at http://www.harvard-magazine.com/so99/beauty.ssi; compare also Wendy Steiner, *Venus in Exile: The Rejection of Beauty in 20th-Century Art* (Chicago: The University of Chicago Press, 2001). As the title suggests, Lambert's article is in fact dedicated to the reemergence of the interest in beauty as a topic of scholarly analysis. As far as "philosophical aesthetics" is concerned, see, for example, also Bill Beckley with David Shapiro, ed., *Uncontrollable Beauty: Toward a New Aesthetics* (New York: Allworth Press, 1998); James Kirwan, *Beauty* (Manchester: University of Manchester Press, 1999); Peggy Zeglin Brand and Eleanor Heartney, eds., *Beauty Matters* (Bloomington: Indiana University Press, 2000); Arthur Danto, *The Abuse of Beauty: Aesthetics and the Concept of Art* (Chicago: Open Court Press, 2003); and Crispin Sartwell, *Six Names of Beauty* (New York: Routledge, 2004). Several recent publications dealing with beauty outside the field of (Western) philosophy are referred to below; see especially notes 51, 66.

5. John Armstrong, *The Secret Power of Beauty: Why Happiness is in the Eye of the Beholder* (London: Allen Lane, 2004), 19. See, for example, also Wolfgang Ruttkowski, "Was bedeutet 'schön' in der Ästhetik?," *Acta Humanistica et Scientifica Universitatis Sangio Kyotiensis* 19, no. 2 (1990): 215–35, and compare also Roger Scruton's introduction to the entry on "Aesthetics" in the *Encyclopedia Britannica* (online version at http://www.britannica.com).

6. From a more optimistic perspective one may observe that, if we do not actually know what we mean by "beauty," then it would at least be hard to argue, as some suggest, that particular cultures outside the West do not have anything resembling this notion. This assessment (irrespective of whether it is based on scholarly analysis, denigrating Western attitudes, or the adherence to a "politics of difference") evidently presupposes a relatively well-defined conception of "the Western notion of beauty," which presents in itself an interesting topic of investigation. Also, the indeterminateness or fuzziness of the concept (or concepts) of beauty found in Western cultures would seem to increase the possibility that we find a significant overlap with concepts used in other cultures.

7. For example, the philosopher James Kirwan prefaces his recent study on beauty with the observation that "Everyone knows what beauty is" (*Beauty*, ix). In another recent study, the psychologist Nancy Etcoff notes: "But what is beauty? As you will see, no definition can capture it entirely.... Although the *object* of beauty is debated, the experience of beauty is not" *Survival of the Prettiest. The Science of Beauty* (New York: Doubleday, 1999), 8, 9.

8. The existence of cultures as more or less discernible units (especially when looked at from an intercultural comparative perspective) has usually been tacitly assumed analytically, but this "essentialist" premise, like so many others, is now being questioned in anthropology. I will nonetheless here use the term *culture* for the sake of convenience, noting that it should be conceived as a diachronically

and synchronically flexible concept, while at the same time acknowledging internal variation.

9. Warren L. d'Azevedo, "A Structural Approach to Esthetics: Toward a Definition of Art in Anthropology," *American Anthropologist* 60, no. 4 (1958): 708.

10. Robert Plant Armstrong, however, observed some decades ago—without referring to d'Azevedo— that "To attempt to study the affecting things and events of another people by using the concepts of 'art' and 'the beautiful' would constitute a surpassing example of ethnocentrism, the exportation to an alien context of our own values, our own structures, our own grid." *The Affecting Presence: An Essay in Humanistic Anthropology* (Urbana: University of Illinois Press, 1971), 10.

11. See the contribution of Overing and Gow to the discussion introduced by James F. Weiner, "Aesthetics is a Cross-cultural Category," in *Key Debates in Anthropology*, ed. T. Ingold (New York: Routledge, 1996), 251–93. With regard to the use of the word *beauty*, I have in mind particularly Overing; as for Gow, see my note 12. One wonders, incidentally, how serious Overing and Gow take their own arguments against using the term *aesthetics*: Gow went on to publish an article ("Piro Designs: Painting as Meaningful Action in an Amazonian Lived World," *Journal of the Royal Anthropological Institute* 5, no. 2 [1999]: 229–46) that opens as follows: "What questions can be asked of a visual aesthetic system?" (229) and in which he observes: "I start with an account of the creation and aesthetics of *yonata*, 'painting with design'" (230). Overing recently coedited a book with Alan Passes called *Anthropology of Love and Anger: The Aesthetics of Conviviality in Native Amazonia* (New York: Routledge, 2001).

12. In referring to her research among the Piaroa, Overing even speaks of the "Piaroa notion of beauty" and the "Piaroa exegesis of the beautiful." A local term is not provided, but Overing observes that the Piaroa words for "beauty," "thought," and "products of work" have the same linguistic root, *a'kwa* (see Weiner, "Aesthetics is a Cross-cultural Category," 264). In his article "Piro Designs," Gow mentions the Piro terms *kigle*, translated as "beautiful," and *mugle*, "ugly" (231)—in this case "beautiful" is placed in quotation marks (as is "ugly").

13. Compare Jacques Maquet, "Art by Metamorphosis," *African Arts* 7, no. 4 (1979): 34. It may also be observed that, from what I know, and as already implied above, the use of the term *beauty* has not been criticized by any of the scholars coming from the cultures that have been traditionally studied within Western anthropology.

14. See Wilfried van Damme, *Beauty in Context: Towards an Anthropological Approach to Aesthetics* (Leiden: E. J. Brill, 1996), 27ff.

15. Nelson H. Graburn, "The Eskimos and Commercial Art," in *The Sociology of Art and Literature*, ed. M. C. Albrecht, J. H. Barnett, and M. Milton (London: Duckworth, 1982), 333. Another student of Inuit culture, George Swinton, also reports on the term *takuminaktuk*, which he similarly translates as "good to see and hence beautiful." Swinton also supplies three other Inuit terms (*pitsiark*, *maitsiak*, and *anana*), which he says are all "exclamations or expressions of visual pleasure"; "Touch

and the Real: Contemporary Inuit Aesthetics—Theory, Usage and Relevance," *Art in Society*, ed. M. Greenhalgh and V. Megaw (London: Duckworth, 1978), 81.

16. Gary Witherspoon, *Language and Art in the Navajo Universe* (Ann Arbor: University of Michigan Press, 1977).

17. Ronald M. Berndt, *Love Songs of Arnhem Land* (Chicago: University of Chicago Press, 1976), 60.

18. Ulli Beier, "Aesthetic Concepts in the Trobriand Islands," *Gigibori* 1, no. 1 (1974): 39.

19. Eric Schwimmer, "Aesthetics of the Aika," *Exploring the Visual Art of Oceania*, ed. S. M. Mead (Honolulu: University of Hawaii Press, 1979), 289.

20. Ulli Beier and Peter Aris, "Sigia: Artistic Design in Murik Lakes," *Gigibori* 3, no. 1 (1975): 22.

21. Babatunde Lawal, "Some Aspects of Yoruba Aesthetics," *British Journal of Aesthetics* 14, no. 3 (1974): 239, and "From Africa to the Americas: Art in Yoruba Religion," *Santería Aesthetics in Contemporary Latin American Art,* ed. A. Lindsay (Washington, D. C.: Smithsonian Insitution Press, 1996), 10. For more on the concept of *èwa*, see Barry Hallen, *The Good, the Bad, and the Beautiful: Discourse about Values in Yoruba Culture* (Bloomington: Indiana University Press, 2000). For other African examples, see Wilfried van Damme, *A Comparative Analysis Concerning Beauty and Ugliness in Sub-Saharan Africa* (Ghent: Rijksuniversiteit, 1987), 11ff.

22. English, Yoruba, and Chinese all have more elaborate vocabularies pertaining to pleasurable or gratifying experiences induced by external or internal stimuli; *beauty*, *èwa*, and *měi*, however, would in their respective languages seem to function as the most common and general terms in this regard.

23. "In early Confucian scriptures, the character *měi* (beautiful) was used almost synonymously with 'moral goodness' (*shan*)." Karl-Heinz Pohl, "An Intercultural Perspective on Chinese Aesthetics," in Marchiano and Milani, *Frontiers of Transculturality in Contemporary Aesthetics*, 146.

24. See Ding Guang-xun, *A New Chinese-English Dictionary* (Seattle: University of Washington Press, 1985), 693f; Robert Henry Mathews, *Mathews' Chinese-English Dictionary*, rev. American ed. (Cambridge: Harvard University Press, 1975), 619f; and J. DeFrancis, ed., *ABC Chinese-English Dictionary* (Honolulu: University of Hawaii Press/Curzon Press, 1996), 407ff.

25. Rowland Abiodun, Henry J. Drewal, and John Pemberton III, *Yoruba: Art and Aesthetics in Nigeria* (Zurich: Museum Rietberg, 1991), 13.

26. I have already intimated that according to some scholars the label *aesthetics* cannot be appropriately used outside the cultural setting in which it was coined and has since been employed, meaning that its application should be limited to something like "post-mid-eighteenth-century Western culture"; see also Gregory Elliot, "Aesthetics," *Dictionary of Cultural and Critical Theory,* ed. M. Payne (London: Blackwell, 1996), 17f. In this matter I prefer a more pragmatic stance, observing that the term *aesthetics* is nowadays used by scholars from all corners of the world. These scholars do employ the term in various senses, but their usages vary along disciplinary lines, with philosophers—unlike anthropologists, psychologists, and other scholars—preferring the interpretation of aesthetics as

referring to "the philosophy of art."

27. See John Onians, "World Art Studies and the Need for a New Natural History of Art," *Art Bulletin* 78, no. 2 (1996): 206–9. For more on the parallels as well as the differences between these two approaches, see Wilfried van Damme, "World Art Studies and World Aesthetics: Partners in Crime?," *Raising the Eyebrow: John Onians and World Art Studies*, ed. L. Golden (Oxford: Archaeopress, 2001), 309–19. I have recently employed the term *world aesthetics* in a different sense—namely, as an alternative for *transcultural aesthetics*. The latter label was introduced in 1997 at the Pacific Rim Conference in Transcultural Aesthetics, organized at the University of Sydney, to denote the emerging discipline that examines reflections on the arts and their qualities as developed by the world's various cultural traditions. I suggested that the term *transcultural aesthetics* is somewhat unfortunate as a label for the academic enterprise that, however loosely, was initiated during the Sydney conference; see my "World Philosophy, World Art Studies, World Aesthetics," *Literature and Aesthetics* 9 (1999): 181–92. I argued that the use of the adjective *transcultural* might be seen to limit the scope of this multifaceted enterprise, for it could be read to suggest that *transcultural aesthetics* deals solely with questions, however important, on the appreciation and interpretation of artistic or aesthetic phenomena across cultural boundaries in time and space. However, it seems clear that *transcultural aesthetics* may also encompass the (comparative) study of the various cultures' ways of thinking about the arts and their qualities (as well as include issues that concern the mutual influence of cultures' artistic and aesthetic systems, ultimately on a global scale). I therefore suggested that, by analogy with the emerging sister disciplines of *world philosophy* and *world art studies*, we refer to the idea of transcultural aesthetics as *world aesthetics*. The term *world aesthetics* was used by Grazia Marchianò as a synonym for *transcultural aesthetics* at the end of her paper that opened the Sydney conference; see "'Let a Hundred Flowers Bloom, Birds and Crabgrass Notwithstanding': Some Auspicious and Realistic Views on Transcultural Aesthetics," *Proceedings of the Pacific Rim Conference in Transcultural Aesthetics*, ed. E. Benitez (Sydney: University of Sydney, 1997), 5; free online version of the proceedings at http://www.arts.usyd.edu.au/arts/departs/philos/ssla/PacRim97.html. Anthony J. Palmer has also used the term *world aesthetics* in the context of his speculations on "a universal aesthetic" underlying the experience of music in, "Music as an Archetype in the 'Collective Unconscious': Implications for a World Aesthetics of Music," in "Comparative Aesthetics: Cultural Identity," ed. Sonja Servomaa, special issue, *Dialogue and Universalism* 3/4 (1997): 187–200. Considering that the proposal to refer to "transcultural aesthetics" as "world aesthetics" does not catch on (see Marchianò and Milani, *Frontiers of Transculturality in Contemporary Aesthetics*) one might withdraw the proposal and indeed suggest that we reserve the label *world aesthetics* for the global and transdisciplinary project that aims at a better understanding of *Homo aestheticus*.

28. See Van Damme, *Beauty in Context*, 2ff.

29. This procedure can only be applied in the case of living societies, which creates a methodologi-

cal problem if we are to adopt this dimension of the anthropological approach to cultures of the past. If in the latter instance we are dealing with literate traditions, one may consider examining instead whatever has remained of a culture's literary products and other writings, looking for the expression of aesthetic views herein; see, for example, Miguel Léon Portilla's observations on Aztec aesthetics, *Aztec Thought and Culture: A Study of the Ancient Nahuatl Mind* (Norman: University of Oklahoma Press, 1963), and Irene J. Winter's work on Mesopotamian cultures, "Aesthetics in Ancient Mesopotamian Art," in *Civilizations of the Ancient Near East*, ed. J. M. Sasson (New York: Scribner, 1995), 4:2569–80. In the case of living societies, analyses of the aesthetic views expressed in oral or written literature may be conceived as a supplementary methodological tool in studying a culture's aesthetic preferences. However, whether we are dealing with living societies or those of the past, we need to carefully examine the epistemic value of such analyses in view of studying aesthetics. For a preliminary discussion, see Wilfried van Damme, "African Verbal Arts and the Study of African Visual Aesthetics," in "Poetics of African Art," ed. Mineke Schipper, special issue, *Research in African Literatures* 31, no. 4 (2000): 8–20; a free online version of this article is available at http://iupjournals.org.ral/ral314. html. In view of relying on the verbal in studying aesthetics, the accuracy of people's verbalizations of mental phenomena is questioned, both by neuroscientists (for example, Joseph Ledoux, *The Emotional Brain: The Mysterious Underpinnings of Emotional Life* [New York: Simon and Schuster, 1996]) and anthropologists (for example, Jacques Maquet, *The Aesthetic Experience: An Anthropologist Looks at the Visual Arts* [New Haven: Yale University Press, 1986], and more recently, Maurice E. F. Bloch, *How We Think They Think: Anthropological Approaches to Cognition, Memory, and Literacy* [Boulder: Westview Press, 1998]). Still, in the case of aesthetics, the analysis of such verbalizations, when available, is preferred to the procedure of inferring aesthetic qualities and concepts from artistic objects per se. The dangers involved in the latter procedure—the history of cross-cultural research in aesthetics shows that these dangers are very real indeed—may be summarized as follows: First, we do not know for certain which aesthetic qualities are expressed or evoked in a given culture by the extant works of art we select to deduce these qualities. Second, even if it could somehow be plausibly assumed that we do know which qualities are at play, we are still faced with the question of exactly which of the objects' properties we should pinpoint as responsible for its aesthetic effect in the culture of origin. Third, even if an outside researcher would select the same properties as would the members of the culture in question, he or she cannot be sure about the reasons motivating the latter's reaction to these properties (see Van Damme, *Beauty in Context*, 198ff). It is thus clear that we have to be very careful in deducing aesthetic responses from objects as such. In cases where all we have are visual artifacts, at least some light may be shed on this matter (however rudimentary and tentatively) on the basis of a growing insight into the visual properties that human beings are innately predisposed to experience as attractive (see below) or those properties that tend to induce a feeling of repulsion, fear, or awe in humans; for a preliminary analysis of the latter, see Nancy E.

Aiken, *The Biological Origins of Art* (Westport, Conn.: Praeger, 1998).

30. Differences in aesthetic preferences and conceptions among these population segments, as well as the interrelations and interactions between these varying views, may then become in themselves topics of further investigation, both intraculturally and interculturally.

31. See Van Damme, *Beauty in Context*, esp. chaps. 7 and 8.

32. Susan M. Vogel, *Beauty in the Eyes of the Baule: Aesthetics and Cultural Values* (Philadelphia: Institute for the Study of Human Issues, 1980); Philip L. Ravenhill, *Baule Statuary Art: Meaning and Modernization* (Philadelphia: Institute for the Study of Human Issues, 1980).

33. For more ethnographic details, see Van Damme, *Beauty in Context*, 219f, 230ff. See, however, also Susan Vogel, *Baule: African Art, Western Eyes* (New Haven: Yale University Press, 1997).

34. See, for example, Chike Aniakor, "Igbo Aesthetics (An Introduction)," *Nigeria Magazine* 141 (1982): 3–15.

35. Harry Silver, "Beauty and the 'I' of the Beholder: Identity, Aesthetics, and Social Change among the Ashanti," *Journal of Anthropological Research* 35, no. 2 (1979): 192–207.

36. I elaborate on these and related topics in the so-called "Reflections" in *Beauty in Context*, 232ff, 258ff, 280ff, 299ff. The sociocultural significance of aesthetic assessments is also addressed by Pierre Bourdieu, *Distinction: A Social Critique of the Judgement of Taste*, trans. Richard Nice (Cambridge: Harvard University Press, 1984; orig. 1979), and Kris L. Hardin, *The Aesthetics of Action: Continuity and Change in a West African Community* (Washington, D.C.: Smithsonian University Press, 1993), and in a variety of recent studies that focus on beauty pageants in various contemporary cultures.

37. See Van Damme, *Beauty in Context*, chap. 3.

38. The use of the adjective *generative* in relation to universals I derive from Bradd Shore, who writes: "There are two significantly different kinds of human universals, which I will term *substantive* and *generative*. […] *Generative universals* are those shared human dispositions or features which underlie and produce significant human variability" ("Human Diversity and Human Nature," *Being Humans: Anthropological Universality and Particularity in Transdisciplinary Perspectives*, ed. N. Roughley (Berlin: Walter De Gruyter, 2000), 103.

39. For more on this, see Wilfried van Damme, "Universality and Cultural Particularity in Visual Aesthetics," *Being Humans*, 258–83.

40. The notion of *experiential universals* (as opposed to *innate universals*) was introduced by Aram A. Yengoyan, "Culture, Consciousness, and Problems of Translation: The Kariera System in Cross-Cultural Perspective," *Australian Aboriginal Concepts*, ed. L. R. Hiatt (Canberra: Australian Institute of Aboriginal Studies, 1978), 146–55; see Donald E. Brown, *Human Universals* (Philadelphia: Temple University Press, 1991), 47.

41. See Van Damme, *Beauty in Context*.

42. See, for example, Leda Cosmides and John Tooby, "The Psychological Foundations of Culture,"

The Adapted Mind: Evolutionary Psychology and the Generation of Culture, ed. J. H. Barkow, L. Cosmides, and J. Tooby (New York: Oxford University Press, 1992), 19–136.

43. See Matt Ridley, *Nature via Nurture: Genes, Experience, and What Makes Us Human* (New York: HarperCollins, 2003).

44. For introductory studies, see Steven Pinker, *How the Mind Works* (New York: W. W. Norton, 1997) and *The Blank Slate: The Modern Denial of Human Nature* (New York: Viking, 2002); Edward O. Wilson, *Consilience: The Unity of Knowledge* (New York: Knopf, 1998); David M. Buss, *Evolutionary Psychology: The New Science of the Mind* (Boston: Allyn & Bacon, 1999); David M. Buss, ed., *The Handbook of Evolutionary Psychology* (New York: Willey, 2005); and Leda Cosmides and John Tooby, *What is Evolutionary Psychology? Explaining the New Science of the Mind* (New Haven and London: Yale University Press, 2000).

45. In this brief account I take the liberty not to distinguish between "sexual" and "natural" selection, in effect preferring the expression "environmental selection" (natural, sexual, and sociocultural). Also, I do not consider here such other evolutionary forces as genetic drift. Indeed, and more generally, not all mental and behavioral phenomena typically found in human beings are "adaptations": some are by-products of such adaptations and others constitute what is referred to as (non-maladaptive) "noise." It should also be clear that evolutionary processes are non-directional or purposeless in the sense that they do not work towards a preset goal.

46. The fundamental "modularity" of the brain—the brain seen as made up of neural circuits specializing in processing specific types of information—is dramatically illustrated by lesions in particular areas of the brain that lead to very specific disorders. For example, vision (like language, and so on) is now known to be based on the operations of several interacting neural circuits, each of which is responsible for processing a particular component of vision, such as depth, contour, movement, color, etc., including also components involved in such specialized tasks as the recognition of human faces. Damage to one of these neural circuits results in the dysfunction of one particular component, while the others remain intact. Thus, some people are unable to perceive what humans normally experience as continuous movement, whereas others cannot recognize individual faces, and so on. The postulated mental modules or psychological programs studied in evolutionary psychology are typically of a more complex nature (involving various basic neural circuits) and are themselves in turn usually subject to higher levels of organization.

47. See V. S. Ramachandran and William Herstein, "The Science of Art: A Neurological Theory of Aesthetic Experience," in "Art and the Brain," ed. Joseph A. Goguen, special issue, *Journal of Consciousness Studies* 6, no. 6–7 (1999): 15–51; with peer commentaries, pp. 52–75. The discussion is extended in the second special issue on "Art and the Brain," *Journal of Conscious Studies* 7, no. 8–9 (2000), ed. Joseph A. Goguen. Compare also Semir Zeki, *Inner Vision: An Exploration of Art and the Brain* (Oxford: Oxford University Press, 1999); see also http://www.neuroesthetics.org. The First

International Conference on Neuroesthetics was organized at the University of California, Berkeley, in January 2002. To date, four such conferences have been held; see http://plaisir.berkeley.edu.

48. See, for example, Jaak Panksepp, *Affective Neuroscience* (New York: Oxford University Press, 1998). I thank Erik Dormaels for bringing this book to my attention and for many discussions on neuroscientific approaches to perception and affect as well as on other issues in aesthetics.

49. See, for instance, Itzhak Aharon, et al., "Beautiful Faces Have Variable Reward Value: fMRI and Behavioral Evidence," *Neuron* 32 (2001): 537–51, and Hideaki Kawabata and Semir Zeki, "Neural Correlates of Beauty," *Journal of Neurophysiology* 91 (2004): 1699–1705.

50. Mate choice is held to be based on many factors, also including smell (and pheromones) and such non-corporeal criteria as perceived kindness and, especially in female choices, reliability, and signs of status; see, for example, David M. Buss, *The Evolution of Desire: Strategies of Human Mating* (New York: Basic Books, 1994). Geoffrey Miller has recently argued that, in addition to bodily features, throughout human evolution particularly females have tended to select their mates on the basis of such mental properties as eloquence, creativity, and humor, seen as indicators of "intellectual fitness." Miller thus tries to account, among other things, for the importance that has come to be attached to the arts in human existence; see *The Mating Mind: How Sexual Choice Shaped the Evolution of Human Nature* (London: Heinemann, 2000). Incidentally, evolutionary approaches to the arts are sometimes referred to as "biopoetics"; see Brett Cooke and Frederic Turner, eds., *Biopoetics: Evolutionary Explorations in the Arts* (Lexington, Ky.: International Conference for the Unity of the Sciences, 1999). Compare also Jan Baptist Bedaux and Brett Cooke, eds., *Sociobiology and the Arts* (Amsterdam: Editions Rodopi, 1999); "Evolution, Creativity, and Aesthetics," ed. Gregory J. Feist, special issue, *Bulletin of Psychology and the Arts* 2, no. 1 (2001); "On the Origin of Fictions: Interdisciplinary Perspectives," ed. H. Porter Abbott, special issue, *Substance* 30, no. 1–2, 3/4 (2001); and notes 51, 54, 55 of this essay. A general discussion and assessment of the study of art and aesthetics from an evolutionary perspective is provided by Denis Dutton, "Aesthetics and Evolutionary Psychology," *The Oxford Handbook of Aesthetics*, ed. J. Levinson (Oxford: Oxford University Press, 2003), 693–705.

51. For a review, see Etcoff, *Survival of the Prettiest*. See also Eckart Voland and Karl Grammer, eds., *Evolutionary Aesthetics* (Berlin: Springer, 2003).

52. Wilson, *Consilience*, 151.

53. Two pioneering studies in this field are Gordon H. Orians and Judith H. Heerwagen, "Evolved Responses to Landscapes," in Barkow, Cosmides, and Tooby, *The Adapted Mind*, 555–79, and Stephen Kaplan, "Environmental Preference in a Knowledge-Seeking, Knowledge-Using Organism," in Barkow, Cosmides, and Tooby, *The Adopted Mind*, 581–98.

54. An evolutionary approach to literature is provided by Joseph Carroll, *Evolution and Literary Theory* (Columbia: University of Missouri Press, 1995) and *Literary Darwinism: Evolution, Human Nature, and Literature* (New York: Routlegde, 2004); Robert Storey, *Mimesis and the Human Animal: On the*

Biogenetic Foundations of Literary Representations (Evanston, Ill.: Northwestern University Press, 1996); and Jonathan Gottschall and David Sloan Wilson, eds., *The Literary Animal: Evolution and the Nature of Narrative* (Evanston, Ill.: Northwestern University Press, 2005). See also "Literary Biopoetics," ed. Brett Cooke, special issue, *Interdisciplinary Literary Studies* 2, no. 2 (2001); "Symposium: Evolution and Literature," ed. Nancy Easterlin, special issue, *Philosophy and Literature*, 25, no. 2 (2001); and "Darwin and Literary Theory," special issue, *Human Nature*, 14, no. 4 (2003).

55. For evolutionary and neurophysiological approaches to music and music appreciation, see, for example, Nils L. Wallin, Björn Merker, and Steven Brown, eds., *The Origins of Music* (Cambridge: MIT Press, 2000); Robert J. Zatorre and Isabelle Peretz, eds., *The Biological Foundations of Music* (New York: The New York Academy of Sciences, 2001); William Benzon, *Beethoven's Anvil: Music in Mind and Culture* (New York: Basic Books, 2002); and Steven Mithen, *The Singing Neanderthals: The Origins of Music, Language, Mind and Body* (London: Weidenfeld & Nicolson, 2005).

56. See also Van Damme, "Universality and Cultural Particularity in Visual Aesthetics," 267ff. For an alternative perspective, see Eckart Voland, "Aesthetic Preferences in the World of Artifacts— Adaptations for the Evaluation of Harvest Signals?," *Evolutionary Aesthetics*, 239–60.

57. This type of account, commencing from the results of an intercultural comparative analysis of decontextualized aesthetic standards, evidently passes over the culturally determined reasons that may additionally inform the admiration for the instantiation of a particular criterion in a given context; for an elucidation of such reasons, see Van Damme, "Universality and Cultural Particularity in Visual Aesthetics," 262ff.

58. See also John Onians, *Art Between Culture and Nature* (London: The Pindar Press, 2005).

59. See also Van Damme, "Universality and Cultural Particularity in Visual Aesthetics," 281ff.

60. On the importance of social inclusion for humans, see, for example, Buss, *Evolutionary Psychology*, 61f, referring to a study of R. F. Baumeister and M. R. Leary, "The Need to Belong: Desire for Interpersonal Attachments as Fundamental Human Motivation," *Psychological Bulletin* 111 (1995): 497–529.

61. The problem may be conceived of as increasingly intricate since it involves an ongoing evolutionary process of fine-tuning the equilibrium of an organism's loyalty toward the group and the interest in self and kin in a context of other organisms that face the same problems and develop ever-more-refined mechanisms to balance these two dimensions of existence for a social animal. Moreover, in the case of humans, the setting in which this evolution occurs shows an increased sociocultural complexity, in part precisely because of the processes just mentioned.

62. See Victor S. Johnston, *Why We Feel: The Science of Human Emotions* (Reading, Mass.: Perseus Books, 1999).

63. The first phases of this perceptual process then clearly involve conditioning by the sociocultural environment, for the enculturated mind of the perceiver is assumed to have internalized knowledge of both local values and the ways these values are in terms of the culture in question signified on the

level of visual form. However, once the perceiver has identified the meaning signified by a stimulus as presenting collective values, an epigenetic rule or inborn program may be activated that entails a positive affective response to these values, signified here in a concentrated manner.

64. Note that in discussions of aesthetic or artistic experience, the tenth-century Indian thinker Abhinavagupta and his followers used the term *vísr-anti*, "depersonalized consciousness"; see Grazia Marchianò, "The Potency of the Aesthetic: A Value to be Transculturally Rediscovered," *Frontiers of Transculturality in Contemporary Aesthetics*, 27. According to Karl-Heinz Pohl, in Chinese thought "a work of art" should, among other things, "have a poetic or self-transcending suggestive effect on the viewer or reader"; see Pohl, "An Intercultural Perspective on Chinese Aesthetics," 146. See also Van Damme, *Beauty in Context*, 15f, 17f, 166, 169f.

65. See, for example, Eliot Deutsch, *Studies in Comparative Aesthetics* (Honolulu: University of Hawaii Press, 1975), and Deutsch's entry on "Comparative Aesthetics," in *Encyclopedia of Aesthetics*, ed. M. Kelly (Oxford: Oxford University Press, 1998), 409–12; see also the many cross-references provided there, Grazia Marchianò, ed., *East and West in Aesthetics* (Pisa: Istituti Editoriali Internazionali, 1997), and Rolf Elberfeld and Günter Wohlfahrt, eds., *Komparativ Ästhetik: Künste und ästhetistische Erfahrungen zwischen Asien und Europa* (Cologne: Chora, 2000).

66. Anderson, *Calliope's Sisters*, is a pioneering comparative study in this field, encompassing art philosophical and aesthetic views as formulated not only in the West, India, and Japan, but also in Aztec culture, as well as in the oral traditions of the Inuit, Australian Aborigines, Sepik cultures in New Guinea, the Navaho, and the Yoruba and San in Africa. With respect to Mesopotamian cultures, see "Aesthetics in Ancient Mesopotamian Art." In addition, Islamic views on the arts and their qualities are discussed in José Miguel Puerta Vilchez, *Historia del pensamiento estético árabe: Al-Andalus y la estética árabe clásica* (Madrid: Akal, 1997); Doris Behrens-Abouseif, *Beauty in Arabic Culture* (Princeton: Markus Wiener, 1999); Valérie Gonzalez, *Beauty and Islam: Aesthetics in Islamic Art and Architecture* (London: I.B. Tauris, 2001); and Oliver Leaman, *Islamic Aesthetics: An Introduction* (Notre Dame, Ind.: University of Notre Dame Press, 2004). Sylvia A. Boone provides a book-length examination of beauty in an African culture in *Radiance from the Waters: Ideals of Feminine Beauty in Mende Art* (New Haven: Yale University Press, 1986); see also Barry Hallen, *The Good, the Bad, and the Beautiful* on Yoruba culture. For Melanesian cultures, see Giancarlo M. G. Scoditti's monograph on the aesthetic conceptions of Trobriand carvers, *Kitawa: A Linguistic and Aesthetic Analysis of Visual Art in Melanesia* (Berlin: Mouton De Gruyter, 1990).

67. See Benitez, *Proceedings of the Pacific Rim Conference in Transcultural Aesthetics*. Two years earlier, the XIIIth International Congress of Aesthetics (Aesthetics in Practice, Lahti, Finland, 1995) already featured many papers on various traditions other than those of the West. A selection of these papers was published in 1997 as a special issue of the journal *Dialogue and Universalism*. The XVth International Congress of Aesthetics (Aesthetics in the 21st Century, Makuhari, Japan, 2001) was the first to be or-

ganized outside the West and focused on various non-Western, especially Oriental, traditions in aesthetics. As already observed, the second conference on transcultural aesthetics took place in Bologna in 2000. A third conference was held in Sydney in 2004. The proceedings of this conference will be published on the Sydney Society for Literature and Aesthetics website (www.ssla.soc.usyd.edu.au); a selection of papers will appear in a future issue of *Literature and Aesthetics*.

68. Whatever forms the discipline of transcultural aesthetics will eventually take, it is likely to deal as much with questions relating to (philosophies of) "art" as with those concerning (philosophies of) "aesthetics"; see also Van Damme, "World Philosophy, World Art Studies, World Aesthetics." For a somewhat more detailed analysis of studying reflections on aesthetic phenomena in various cultures, including attention to the varying "philosophical status" of such reflections, see Van Damme, "Transcultural Aesthetics and the Study of Beauty," esp. 64ff.

69. See Kathleen M. Higgins, "Comparative Aesthetics," *The Oxford Handbook of Aesthetics*, 679–92.

Writing About Modernist Painting Outside Western Europe and North America

James Elkins

A long time has passed since the conference this book commemorates—too long, in the accelerated timescale of globalism, for it to be possible to reprint the paper I gave there. I argued that it was impossible to "put the world into a book," and I have said that again—with reference to the Clark panel and the other essays included here—in a review of David Summers's *Real Spaces*.[1] Meanwhile, attempts to "put the world into a book" (the phrase is John Onians's) continue, and there will be a book on the subject soon, centering on a roundtable discussion with Summers, Ladislav Kesner, Friedrich Bach, and others; the book will include thirty brief essays by art historians from twenty different countries.[2] A book on canons edited by Anna Brzyski, and another on approaches to Chinese art history edited by Jason Kuo, will also contribute to the question of what can be put into a book.[3]

So much has happened, in fact, that I am presenting here just a fragment of what I talked about in 2000—the surviving fragment, the one that still seems interesting, viable, and unpublished in English.[4]

Modernist painting broadly construed follows a trajectory from David, Manet, and Cézanne through Picasso, Expressionism, Surrealism, and Abstract Expressionism, and this trajectory is broadly shared by art historians in various countries. The uncertain path of painting after World War II forms much of the stuff of contemporary critical writing, but prior to minimalism and conceptualism, the principal works, places, and concepts continue to comprise a lingua franca in which deeper discussions of modernism take place. The enormous amount of art literature produced around the world can give the impression that modernist painting outside of the main trajectory is well studied and that it can be considered a global phenomenon. Yet this conclusion obscures a profound problem for an art historical practice that intends to look beyond Western Europe and North America.[5]

When modernist painting made outside the main trajectory, as I will call it, is introduced into contexts where the cardinal moments of modernism are taken for granted, the unfamiliar work can appear unequal for at least four reasons. First, it can seem *limited* when it is directed to a particular market that is outside the mainstreams of modernist interest, as for example with modernist marine painting

done in modernist styles. Second, modernist painting outside the trajectory can appear *uninteresting* when the pressing problems of modernism appear to be played out elsewhere, for example in the case of the Panamanian primitive and naïve artists who stand at the beginning of Panamanian modernism: their naïveté cannot appear as exemplary as, say, Rousseau's. Third, painting outside the trajectory can seem *misinformed* when it is the result of limited communication between an artistic center and a local center. An example is the short-lived phenomenon of Chilean cubism, practiced essentially by only one Chilean artist in Paris, Vicente Huidobro (1893–1948), who was primarily a poet and critic rather than a painter.[6] Fourth, such painting is often done later than similar art in the centers, so that it necessarily appears *belated,* and therefore, in the logic of modernism, of slightly but distinctly lesser value.

Judgments like these prevent histories of modernist painting from being more inclusive, unless they are also histories of the painting of individual nations—in which case they are not likely to be widely read in North America and Western Europe. Negative valuations of art outside the trajectory effectively corral the existing textbooks of modernism to a narrow field of now-canonical, if debated, works and masters, virtually all of them in North America and Western Europe.

The profusion of current art-critical writing and curatorial projects throughout the world would seem, at first, to solve this problem. There is far more documentation on modernist painting around the world than any one scholar can possibly read—and yet the material is scattered, local, and seldom linked to wider conversations about modernism. The art-critical and curatorial literature is strongly multicultural but seldom assays the link between its specialized objects of interest and worldwide issues of modernist painting.

Nor have new textbooks solved the problem. A truly even-handed multinational history of modernism would include modernist artists from countries such as Panama, Chile, Tibet, Indonesia, and Kenya. It would risk appearing willful, idiosyncratic, or misguided, because it would risk compressing the principal moments of modernism or even losing them in a sea of apparently secondary examples. Such a text would be hard to market, and in fact none has yet been produced. On the contrary, the best text on modernist painting, *Art since 1900* by Hal Foster et al., is exclusively concerned with adjustments to the main trajectory. Virtually none of the artworks mentioned in the book come from outside Western Europe and North America. (Russia and Poland are the principal, but also conventional, exceptions.)

The same obstacles can be observed in periodicals. The *Art Bulletin* and *Art History* publish relatively few articles on modernist painting outside the main

trajectory, and few articles on non-Western modernism in general. It can be difficult, from an editor's point of view, to find historical moments outside the trajectory that will be of compelling interest to scholars who work on the central problems of modernist painting. Partly that is because it is not easy to locate first-rate scholarship outside the main trajectory, although there are many exceptions; and partly it is due to the discursive structure of art history, which is built around—and for the interpretation of—works within the main trajectory. The problem is practical and structural, not merely political.

It is important to see what can be done to expand the roster of modernism. Otherwise, entire practices of modernist painting will continue to be marginalized or wholly absent from curricula outside the countries in which they were made and the art historical study of modernism will continue to be centered on just a very small fraction of the actual output of modernist painting. The purpose of this essay is to collect the approaches that are currently in use, in order to further conversation on the subject. Before I begin, I will give an example of the problems posed by "unusual" art outside the expected canons of modernism.

Introductory Case: Albert Namatjira

One of the most densely contested domains of twentieth-century painting outside of Western Europe and North America is Australian Aboriginal acrylic painting. It is a recent tradition, having begun only in 1974, but in the last quarter of the twentieth century it has grown to the point where it is a principal support of several Aboriginal communities and is represented in at least a hundred galleries worldwide.[7] At least five distinct interpretive agendas have been brought to bear on individual paintings: that of the artist and his or her relatives and community; of anthropologists interested in Aboriginal culture; of gallerists invested in the work's value in the market; of art historians concerned with the work's relation to Western art; and of curators interested in finding acceptable ways of presenting the work alongside non-Aboriginal Australian painting.[8]

In this vexed field, where the contest for interpretive power has such high political and artistic stakes, one of the most intriguing figures is the Aboriginal artist Albert Namatjira (1902–1959), who is a kind of inverted precursor of late-twentieth-century Aboriginal painting. His work is not a straightforward precedent for the later movement, because he adopted a Western watercolor style instead of transferring Aboriginal motifs and images to acrylic and canvas as the later artists did. His landscape watercolors, made mainly in the area around Alice Springs, are

strongly reminiscent of watercolors made by his teacher, the white Australian Rex Battarbee (1893–1973). The comparison is often made and as often questioned, because if Namatjira's work were to be seen simply as a version of Battarbee's, then his oeuvre would no longer be Aboriginal or represent an Aboriginal perspective. The modern history of Aboriginal painting would have begun with a case of full assimilation to the West, and Namatjira would have set Aboriginal meanings aside in the name of success: not a helpful precedent for a movement whose authenticity is its imprimatur in the art market, or for the many white Australians who work with Aboriginal communities trying to ensure that traditions are not diluted or forgotten. In the 1950s, Namatjira was celebrated, widely exhibited, and even granted Australian citizenship, so the incentive for him to adopt a Western manner was strong.[9] His work was exhibited, in Howard Morphy's words, "partly as a sign of what Aborigines were capable of achieving once 'civilized.'"[10] In 1944, Battarbee himself proposed that "Aboriginal painters could paint in the French style without any criticism," just as Namatjira managed to paint in the "European style."[11] The contrary position, articulated beginning in the 1950s, was that Namatjira's art wasn't Western but Aboriginal, and that "every brush stroke was influenced by a tribal way of thinking."[12]

By the end of the century, the reception had become considerably more complex, because the older interpretations were complicated by a growing awareness that promoting Namatjira was as much "a denial of Aboriginal art as a recognition of it" (in Morphy's words).[13] Increasingly elaborate attempts were made to demonstrate the mixed Westernness and Aboriginality of Arrernte watercolors. Some writers have stressed the particular circumstances in which Namatjira painted, suggesting he and other Arrernte Aboriginal watercolorists of the 1950s "be understood in relation to the particular circumstances of their own history and the motivations of the artists."[14] Another kind of interpretation emphasizes the topographic accuracy of Namatjira's paintings—their baked color, their stark light, their apparently uncanny fidelity to the landscape around Alice Springs, where Namatjira lived. There have also been attempts to dissect the paintings in order to distinguish Westernness and Aboriginality. In an essay in the 1992 book *The Heritage of Namatjira,* Ian Burn and Ann Stephen argue that there are particular qualities of the paintings that can be assigned to Namatjira's ethnicity, including the absence of balanced compositions, the unexpected distribution of emphases throughout the scene, the attention given to the edges, and a decorative impulse that led Namatjira to make his landscapes into collections of distinct textures.[15]

I mention these competing interpretations just to give a flavor of the suspension of ideas that characterizes the current interpretive discourse. Each of the perspectives I have mentioned leads to problems. Parsing the formal properties of the paintings, as Burn and Stephen do, assigns cultural difference to a series of incremental formal properties. For me, that is not a convincing strategy: one would hope that painting embodies thought about ethnicity in ways more interesting than imbalanced compositions. The difficulty with the first interpretation, in which Namatjira's art is seen as a product of his particular circumstances, is that it sidesteps the question of whether the art expresses something inherently Aboriginal, a question that, in many nuanced forms, comprises the central object of interest in Namajira's painting. Saying Namatjira's paintings are topographically faithful reduces them to realist documents and shrinks his culturally specific contribution to an interest in geological and botanical accuracy.

Each of the three interpretations I have sampled—topographic, anthropological, and formal—rehearses in microcosm issues that recur, in many forms, in writing about twentieth-century painting throughout the world. I will return to each of them later. What I want to emphasize here is that the literature on Namatjira cannot be exported: it remains of compelling interest in the context of Australian modernism but not outside it. The reason is not only that Aboriginal culture is a particular concern in Australia; it is also that Battarbee himself, the source of Namatjira's practice, is a minor figure even within the history of early-twentieth-century realist watercolor landscape painting. In the Australian literature, Battarbee remains largely unstudied. His practice descends from a generation of academic English watercolorists whose interest today is mainly historical or even historiographic. The early-twentieth-century English watercolor tradition, including Battarbee himself, is minor in the sense that the work does not contribute to wider practices of twentieth-century landscape painting. The particular formal properties Burn and Stephen attribute to Namatjira, including asymmetry and attention to texture, were stocks in trade of English landscape watercolor from John Sell Cotman onward. To value Namatjira's work, it is to some degree necessary to avoid placing Battarbee in the history of twentieth-century painting; otherwise his student Namatjira will be seen as the student of a painter who was himself provincial and retardataire.[16]

Does it matter that one of the first modern Aboriginal painters happened to take as his model a rearguard modernist? It does not, until—and this is the point I will be circling throughout this essay—it becomes of interest to say what place Namatjira might have in the overall history of twentieth-century painting. In that

wider arena, the work appears isolated and, in most contexts, irrelevant. This may not seem like a problem; after all, each country and region has its own history of art practices that respond to the local situation. But the coherence of modernist painting *as a whole* is compromised unless there is a way to include Namatjira in the same conversations that address modernists elsewhere. If it were judged according to the crucial works and critical concepts of modernist discourse, most of the world's production of modernist painting would be excluded. And yet what sense does the phrase "the history of modernist painting" have when it excludes so much of the world, and so much of the practice that comprises modernism? There is no easy solution to this problem. It is Sphinx in the road that has to be answered before it will be possible to imagine a truly inclusive multicultural history of twentieth-century painting.

First Answer: Describe the Artist's Relation to the (Western) Avant-garde

A common strategy in art historical scholarship is to report on times and places that can figure as avant-garde in relation to modernist painting in Western Europe and North America. Recent studies of avant-garde painting in Brazil, Czechoslovakia, Hungary, Russia, and Poland have made use of this approach. New scholarship on avant-gardes outside Western Europe and North America is promising, although there are still only a few specialists in such subjects in North American and Western European universities. In 2002, the most recent year for which I have statistics, there were no tenured art historians in North American universities who worked in southeast European modernism or South American modernism. The reasons are complex, but tied to the value accorded to what are understood as avant-garde, and therefore essential, moments in world painting practice.

The most common supplements to the main trajectory of modernism, both in terms of faculty hires and published work, are central and eastern European painting (mainly Polish and Russian Cubo-futurism and Constructivism), in part because of their strong connections with innovative moments in Western European modernism. It can seem, based on the growing interest in pan-European modernism, that the art historical study of modernist painting is expanding in such a way that it will eventually encompass modernisms throughout the world. Nevertheless, the focus on modernism's innovative moments is subject to strong limitations for two reasons, one practical and the other ideological.

In practical terms, it becomes increasingly difficult to justify the inclusion of relatively unstudied avant-gardes in the primary sequence of modernist painting.

The new examples tend increasingly to be minor and belated in comparison to events in Western Europe and North America.[17] They can even serve, indirectly, to justify work that concentrates on the Western modernist sequence at the exclusion of what are taken to be derivative movements elsewhere. There are many examples of painters who have been the subjects of scholarly studies designed to bring out the painters' avant-garde qualities and make them relevant to the Western narrative. In Bratislava in 2003, I was urged to study the work of Štefan Bartušek Prukner (born 1931). His painting is broadly expressionist, and he has tried his hand at many styles, from a Polish-style expressionism to a kind of primitivism à la Emil Nolde. The work is wild and colorful but not innovative by international standards. In a catalogue essay, Dušan Brozman compares Prukner to Jackson Pollock, saying that Prukner avoids the usual symmetries and orientations of other artists in favor of a kind of allover painting.[18] The comparison is stretched, because Prukner's painted figures observe the laws of gravity. Even the scruffy anthropomorphized insects in his *Summertime on the Sea* (1995) prance on a horizontal dance floor. The case for Prukner as an avant-garde modernist is thin, but the efficacy of the argument depends on the public it is intended to convince. For a gallerist or a collector, Brozman's argument might be helpful; but for an art historian pondering which artists to include in an undergraduate course on modernism, it probably will not be persuasive. If we take Theodor Adorno's model of the avant-garde, it would have to be said that a truly new development might not even be recognized as such, because so few people would comprehend the problems it seeks to solve or the solutions it proffers. Such an avant-garde might go unnoticed or misinterpreted, and if it were recognized it would—in theory—possess the power to displace parts of the modernist narrative that had spurred the search to begin with. In practice, neither of those things happens: the putatively innovative work is always immediately recognized, and it almost never challenges existing narratives. There is a large number of relatively unstudied modernist painters who could lay claim to being genuinely innovative. If the unclassifiable Czech painter Jan Zrzavý (1890–1977) were taken into the mainstream of modernism, he might change its terms entirely. He is odd enough, and wild enough, to stand alongside painters such as Max Ernst or (in a different sense) Salvador Dalí, or even to displace them in introductory accounts of the century. That is, perhaps unhappily, not very likely, but if it *were* to happen, Zrzavý would be an example of existing models of the avant-garde, not a genuinely new "discovery" as Adorno's theory would demand.[19]

The other limitation of scholarship that studies unfamiliar avant-garde artists is ideological. The search for relatively unknown, innovative, or radical modernist

painting is open to the objection that its point of reference necessarily remains the main sequence of modernism. How else would it be possible to know what might count as an avant-garde work or a genuinely new development? Even aside from the difficulty of recognizing a real innovation, or letting it act with full force on existing narratives of modernism, it is less than optimal for a global art historical practice to go forward by searching for concepts and qualities that are recognizably North American or European in origin. The line between legitimate extension of existing Western narratives and colonialist expansion would be hard to draw. The problems of Orientalism and projection that such work entails have been well explored.[20]

For these reasons, when I encounter promising artists who are (by Western European standards) unknown, I try to resist the temptation to re-present them to the West, or to nominate them as important discoveries. The philosophic grounds of my "discoveries," and the ideological desire that drives the "discoveries," are both suspect.

Second Answer: Acknowledge the Westernness of the Avant-garde and of Modernism

The interest accorded to avant-garde moments is not capricious, and therefore amenable to a formal solution, but built into the structure of modernism itself. In other words, the main trajectory itself, and the conversations that make it significant, impel Western scholars to pay attention to whatever can be taken as avant-garde. A good illustration of the dilemma this creates is the work of the Japanese scholar Shigemi Inaga, who has written on Japonisme and on Japan's reception of Japonisme. He has described his feelings as a student in Paris in 1987, where he saw the exhibition *Le Japon des Avant-gardes* at the Pompidou Center.[21] He recalls that he felt "awkward" for three different reasons:

> First, in the West, products (usually crafts), which are not categorized as art, are excluded from the avant-garde. Second, Western art historians assign these elements to the "Japanese tradition" so that Japanese art is disallowed from participating in modernism and the avant-garde. This can be called a consistent logical violence [*shyubi ikkan shita bouryoku-sei*]. And third, the West selects those modern Japanese arts which already have a similarity to the [Western] avant-garde, and then searches for their Japanese-ness.[22]

Inaga could not bring himself to accept this "perverse" [*tousaku*] logic in the name of "cross-cultural sociability," but neither did he want to allow himself to simply feel "pain looking at a distorted image of my home country as a faithful patriot" might. The conjunction of two impossible positions left him uncomfortable [*igogochi no warusa*]: "Who am I," he asks, "talking about this gap, and where am I located?"[23] Inaga puts the dilemma in an elaborate form, arguing that the discomfort takes two different forms, both of them compound: the awkward relation between the excitement and guilt of telling other people about one's culture, and the awkward alteration between superiority and guilt that comes from allowing oneself to interpret other cultures.

The initial cause of Inaga's discomfort is the fact that Western scholarship excludes crafts from fine art, setting in motion a logical violence that excludes modern Japanese art from the category of the avant-garde. The "violence" [*bouryokusei*] of the historical tradition that excludes Japanese craft and that "perversely" [*tousaku*] searches for Japanese-ness in those remnants of the tradition that can be considered sufficiently modern—i.e., Western—is irreparable. Modernist thinking is predicated on the distinction between art and craft, whether the craft is Western or non-Western, so it is not possible simply to right the imbalance and begin again. The only "solution," if it can be called that, is an awareness akin to Inaga's "discomfort" [*igokochi no warusa*]. I take it that Inaga's dilemma comprises a strong argument against the ongoing search for avant-gardes outside of the main modernist lineage.

A heightened awareness of the writer's dislocated and ambiguous position may be an optimal strategy for writing about modernism outside of the mainstream. It can be adapted to each scholar's viewpoint and changed as conditions change. It also has the advantage of being well attested in the literature of cultural studies, from V. S. Naipaul to Homi Bhabha. Yet it also begs the question of the relation between the standard trajectory and the material under consideration. By suspending or rejecting the judgments of modernist discourse, an approach such as Inaga's defers the "logical" clash of systems and postpones difficult questions concerning the value and place of the unfamiliar work. By the modernist logic of *Le Japon des Avant-gardes,* Japanese crafts simply cannot be valued in the way that modernist paintings are, and Japanese avant-garde paintings, in turn, are found wanting. Faced with those unacceptable conclusions, Inaga is impelled to reflect on the dilemma of choice. His work is exemplary of non-Western scholarship on Western art, but it is an open question whether meditations on the undecidability and

violence of cultural differences, and the discomfort they produce, are sufficient to analyze projects such as *Le Japon des Avant-gardes*. Discourse on cultural identity may be epiphenomenal on the clash between modernism and whatever is understood as its "Other." The "consistent logical violence" of modernist discourse consistently asks that new material be evaluated, and the longer that valuation is postponed, the more artificial and elaborate the meditations become. The impetus behind scholarship that tries to stand back from the untheorized judgments of projects such as *Le Japon des Avant-gardes* can only be driven by a belief in certain core concepts of modernism, even when it seeks to dissolve or at least complicate modernism's harsh judgments about what is not Western.

Writing about cultural dilemmas—like Inaga's meditations, like this essay—can be an optimal strategy for avoiding "logical violence," but it creates contradictions between the guiding concepts of the scholarship, which tend to be taken from the writing on the main trajectory, and the works under consideration, which would often fail if they were judged by those same criteria. Scholarship that acknowledges the Westernness of the avant-garde and of modernism must still negotiate the fact that the impetus to write about modernist painting comes primarily from the West and brings with it concepts of the avant-garde. Inaga's meditation is a pause in the search for a working answer, not—as he knows—an answer.

Third Answer: Follow the Local Critical Tradition

It may seem more appropriate to focus on the local reception of the work, rather than on the large-scale problems of its possible relations to the mainstreams of modernism. That approach presents itself as reasonable and appropriate; after all, artwork finds its meaning and significance in the context in which it is made and exhibited. Statistically speaking, few modernist paintings done outside Western Europe and North America have been noticed in print in anything more than a cursory fashion. The overwhelming majority of modernist paintings, those done by little-known artists, have minimal critical contexts, but when there is textual evidence associated with the work—a newspaper review, a catalogue essay—then the work has at least the elements of a local critical tradition. A newspaper review or a mention in an exhibition brochure are enough to provide the means for an art historian to understand how the work is understood in its own setting.

Metka Krašovec is a Slovenian painter who teaches at the Academy in Ljubljana, Slovenia. In the late 1980s, she painted neoclassical faces of women, but when I saw her work in the Galerija Equrna in January 2003, she was represented

by several surrealist landscapes.[24] One depicted a French garden, set on a height over the ocean. In the painting, two lovers stand alone next to a fountain. Beyond them is an ocean, delimited by the curve of the Earth. The picture has the stillness associated with Giorgio de Chirico's metaphysical style, a solid functional sense of illumination as in Paul Delvaux, and the hyper-realistic crystalline detail normally exemplified for the later twentieth century by Dalí. And yet, so the owner of the Equrna Gallery informed me, Krašovec does not think of herself as a descendent of any of those painters. The owner opened a copy of the *Oxford History of Western Art,* published in 2000, and turned to page 497, where Krašovec's paintings are described as "a new mannerism."[25] That English-language reference is about the only description of Krašovec's work in a language other than Slovenian, and the owner offered it as proof that a non-Slovenian observer would agree that Krašovec is not principally a surrealist. The author of that section of the *Oxford History of Western Art,* Paul Crowther, is not a historian of modern art but an aesthetician and expert on Kant. He is given to idiosyncratic aesthetic judgments, such as "the key artist in understanding the transition from modern to postmodern is Malcolm Morley."[26] (I do not know any similar claim made on Morley's behalf; he is a photorealist with an uneven reception.)[27] Crowther's appellation, "new mannerism," is only meant in the most informal fashion and does not imply that the work is not indebted to surrealism. In fact, Krašovec's work is deeply and unavoidably indebted to de Chirico in particular.

The owner also showed me the Slovenian press clippings for Krašovec's work, which avoid the word *surrealism* in favor of general references to Slovenian "feeling"—what is in other contexts referred to as *utmetnostni diakekt,* "artistic dialect." The expression was apparently first coined in the 1961 Congress of Slovenian Art History, partly as a way of describing a difference, and a national character, without spelling out what exactly the difference or character might be.[28] In the press notices of Krašovec's work, descriptions of the work imply a kind of *utmetnostni diakekt* and a non-Western genealogy, without stating it in so many words.

The strength of the local historical tradition—or in this case, the near-absence of it—is that it remains faithful to the particular historical constellation, the feel and detail, of the local scene. The successful reception of Krašovec's work in Ljubljana depends on not dwelling too much on names such as de Chirico, and also not saying too precisely what alternate influences might be. This is a common situation wherever the work itself is perceived, rightly or wrongly, to have a quality that might be damaged by too close an association with obvious forebears.

The paucity of printed materials, and the ambiguity of the operative concepts, is common in lesser-known painters. The critical notices of Krašovec's work are enough to begin a history of reception, but if I were to follow these leads in her case, I would be unable to link her paintings to the Western stories of art history: they would float free in their own elusive, evasive genealogy. The work would appear disconnected from the main trajectory of Western modernism. Such a description would preserve the work for its local context, but defer the moment when Western modernism could be brought to bear.

Fourth Answer: Disregard the Larger Context and Describe the Work Sympathetically

It may seem better to leave the local historical sense of an artist to one side and try to describe the work on its own terms. If I were to write about the historical terms according to which Krašovec's work has been understood, I still might not have an account that would make sense for a reader interested in the wider histories of art in other countries. It is dubious to insist that her practice be given a new genealogy distinct from the metaphysical style, or that she be discussed in terms of the meanings of national style in Slovenia rather than in terms of the international practices of Surrealism. So perhaps it is better to leave aside the historical settings preferred by local critics and historians and try to describe the work on its own terms.

The first-generation Slovenian impressionist Ivan Grohar (1867–1911) is a good candidate for this fourth possibility, because the historical reception of his work within Slovenia has stressed his uniqueness. He is taken as a foundation for Slovenian modernism, and so his affinities with Van Gogh or Giovanni Segantini are played down in favor of an appreciation of qualities that are uniquely his—and therefore uniquely Slovenian. His painting *The Sower* (1907) is one of dozens of paintings of the motif that were made throughout Europe beginning with the Barbizon School. It can seem that each country has its own *Sower,* who is interpreted in terms of each country's sense of its heritage. In Austria, for example, there is Albin Egger-Lienz's (1868–1926) powerful *Sower* (1908). The coincidence in dates is often remarkable; in this case, Egger-Lienz was one year younger than Grohar and painted his *Sower* one year later. In Grohar's case, the subject is associated with Slovenian work ethic: the sower is seen less as a symbol of the country's fertility than of the hard work necessary to make it fertile.

Grohar painted several canvases around the same time as the *Sower,* and another of equal importance, which hangs next to it in the Narodna Galerija in

Ljubljana, is *The Larch* (1904). A larch bisects the canvas, and beyond it is a view to a steep field. Toward the top of the frame the field gives way to forests, and there is a view of mountains beyond. The exact location of Grohar's painting has been verified by photography, and what appears to be snow on the mountains is actually characteristic whitish scree slopes. Grohar cut the canvas down, and Andrei Smrekar, director of the Narodna Galerija, tells me that Grohar also erased most of his native village in order to make the scene more modernist. He left a single farm building on the slope and some barely discernible houses on a hill at the top left. The result is not only flatter and more modern looking but also more directly about the wild country. Grohar painted his name carved in the larch, placing himself in that exact spot, and the painted carving mimics the sculpted look of his paint: both are thick, pasty, and nearly wooden. Like the *Sower*, the *Larch* is a wild subspecies of post-impressionism. The marks are dense and heavy handed, sometimes even scrappy like Adolphe Monticelli's. In places, Grohar let the raw red-brown burlap show through between patches of paint.

Grohar is the most important of a small group of seminal Slovenian post-impressionists that also includes Rihard Jakopič (1869–1943), who mounted the first modernist exhibition in 1910; Matei Sternen (1870–1949), who was apparently also influenced by Lovis Corinth; and Matija Jama (1872–1947), who was more faithful to Grohar's manner. They are understood not so much as sui generis, but as characteristically Slovenian, and for that reason the scholarship they have attracted has not made much of their debt to non-Slovenian art. Jakopič in particular played an important role in defining Slovenian art; he rethought the region's art back to the eighteenth century and was once caricatured as Moses.

What I have written in these last paragraphs may strike readers as an acceptable sketch because I have paid attention to the paintings themselves, rather than their indebtedness to non-Slovenian art. I have not said much about the local historiographic tradition, which stresses Grohar's nearly complete independence of Segantini. (One Slovenian historian told me that for Grohar, Segantini just "meant modernism.")[29] It is entirely possible to go on in this vein and write monographic treatments of artists focusing on their works. Such writing exists wherever art history is a developed discipline. By focusing on intrinsic properties of the art, it replicates the concerns of art historians who have written about Western artists. If the artist in question is Piet Mondrian or Lucian Freud, then it makes sense to pay attention to the pictures themselves and let the predecessors' work fade into the background. The Slovenian writing on Grohar does a similar thing. Yet there

is a difference: Grohar's *Sower* is not a unique painting, but one of dozens like it in many countries. A monograph on *Broadway Boogie-Woogie* or one of Freud's nude studies of Leigh Bowery might be justified in keeping rather strictly to the object itself, but a monograph on Grohar's *Sower* would not. Writing about the object itself has a significant and eventually crippling limitation: it ignores history. This fourth solution has resulted in some wonderful writing, but in comparison with art historical narratives about canonical figures, it is not history. It can be reflective, evocative, and well-informed, and it can propose links to all sorts of cultural events and ideas within the region or nation; but if it does not investigate the painting's link with the broader history of painting, such writing is not art history in a full sense. When the writing is thoroughly researched, it can be significant as local history (the third option), and when it is less well researched, it can work as an evocation of the art (the fourth option). Whatever it is, such writing is not clearly part of the larger collection of texts that are aware of one another and of the sequences of art and ideas that comprise modernism.

Fifth Answer: Write the Histories of Institutions

John Clark's *Modern Asian Art* treats about twelve countries, from the inception of modernism to contemporary art.[30] He is skeptical of the search for avant-gardes, and he presents his book as what I would call "institutional history": he is interested in the individual occasions for the making and reception of art, and in theory he is equally interested whether the work contributes to an avant-garde or not.

In his methodological introduction, Clark considers the work of the Japanese painter Yorozu Tetsugorō (1885–1927), a prominent Japanese modernist. Yorozu's painting *Nude Beauty* (1912), Clark writes, "could be interpreted… as evidence of the vain longing to be up to date at the periphery, whose position is always constructed as dystopic by its very distance from the utopian centre."[31] Yorozu's *Portrait of a Woman* (1910) would be "positioned" by the "critique of 'Orientalism,' which has now become orthodox in the Euramerican academy… as a poor and inauthentic copy." Clark calls that kind of interpretation "Orientalist" (in quotation marks, perhaps to signal that this Orientalism is an illegitimate extension of the original French Orientalism, which was directed at the Middle East), and he wants to correct it by considering the Japanese perspective. "In fact," he continues, the painting "marks the re-situation of discourse that has already been entirely assimilated": Yorozu took what he knew, and what he needed, and put it to work in a new context. It is that new context that matters—its "local discourse needs," its

goals and meanings. Clark prefers a "deliberately neutral" approach, one that "consciously stands aside from the search for what is modern or radical."[32]

A sign of this neutral attitude is that Clark considers the avant-garde in just one chapter of his book, about two-thirds of the way through, between chapters on the Salon and on nationalism. The avant-garde, he says, is really only a modernist value, and it refers to those who are "ideologically equipped to criticize earlier positions in the discourse." It names a certain position taken in regard to history: a position that demands innovation and seeks to understand previous ideas in a comprehensive sense.[33] Because it "draws its authority from origination," the avant-garde "becomes forced to absolutely privilege the new."[34] These definitions make it possible for Clark to analyze the modernism of Tokyo around 1900, in which Yorozu worked, as just a modernism among others, with an avant-garde among others—different, but potentially comparable, to avant-gardes elsewhere. "What appears derivative from a Euramerican perspective," Clark concludes, "has its quite originating avant-garde function within that Japanese context."[35]

Yorozu's works would appear to Westerners unfamiliar with Japanese modernism as close emulations, even pastiches, of Matisse, Cézanne, and other painters.[36] In avoiding that kind of description, Clark gives three arguments in favor of considering the Tokyo avant-garde, and by extension other Asian avant-gardes, independently of Western ones. He proposes that:

> The view, which sometimes appears, that avant-gardism is somehow culturally inauthentic in Asian countries because it often legitimizes itself by access to the new from outside ignores the position of the whole intellectual class, let alone the technically trained specialists in government service, whose right to speak comes from knowledge gained from imported sources or from their own residence abroad.[37]

I take it Clark means to emphasize that native voices should be heard in preference to colonialist or otherwise Western discourse, even though his sentence also implies that the "specialists" and the "intellectual class" derive their authority in proportion to how much contact they have had with the Western world. I would not argue with Clark's second reason for refusing to place Asian avant-gardes on the same scale as Western ones, which is that disputes over the value of various avant-gardes "is frequently an ideological debate about authenticity"—though I wonder which debates aren't "ideological" in that sense. Clark's third argument is

that the avant-garde is relative (it's an "open discourse"), "both to previously trans-
ferred discourses, and [to] an interstitial, cross-cultural, and transnational group
of artists who share ideas and knowledge between themselves." In new settings, the
avant-garde provides "only a context of origination not of authentication."[38] In
theory, this argument is persuasive, but in practice it is somewhat strained because
the influence of "Impressionism, Post-Impressionism, Cubism, [and] Fauvism" on
Yorozu's generation is so manifestly strong.[39] Thinking of Tokyo in the first decade
of the twentieth century, I may well become interested in its particular conditions
of production and reception. But sooner or later, I will also realize that what brings
me there in the first place is an interest in fine art, in modernism, and in the avant-
garde: and at that point it will become difficult not to return to the discourse of
newness and belatedness that informs the very ideas of modernism.

Some of Clark's book reads like a theory of all modern art, unaccountably
applied to Asia. To continue talking about Japanese avant-garde painters such as
Yorozu without mentioning the French avant-garde, it becomes necessary to stop
talking about the painting's forms, technique, color, and subject in favor of its con-
ditions of production and reception. Clark's book sometimes reads as if it was
sociological investigation into the conditions of production and reception. But surely
it is not necessary to subscribe to high modernist aesthetics to want to register the
fact that art *is* value—not least, in this case, because of the values Yorozu himself
put on Matisse or Van Gogh. It is possible to go on for ten or twenty pages de-
scribing the artists in the Tokyo School of Fine Arts without mentioning the ways
their sense of the avant-garde came from Paris, but at some point the description
will begin to sound counterintuitive. Why spend time on Tokyo School of Fine Arts,
a regional avant-garde, unless the avant-garde *itself* is an important subject? Given
that a Western interest in the avant-garde is a necessary ingredient in Clark's proj-
ect, how long can it make sense to continue speaking as if the Japanese situation in
1912 was just as interesting an avant-garde as the one in Paris in the 1880s?

Because this is a crucial point in a range of current scholarship, I want to
dwell on it a little longer. *Modern Asian Art* includes a great deal of interesting in-
formation about the level of awareness of the West that obtained at the Tokyo
School of Fine Arts. Contact between Paris and the Tokyo School of Fine Arts was
exceptionally close in the first two decades of the twentieth century. The Futurist
Manifesto had been translated in 1909, and Yorozu's teacher, the modernist painter
Kuroda Seiki (1866–1924), mentioned in 1912 that he had just been sent a recent
Futurist exhibition catalogue. In March 1914 there was an exhibition of *Der Sturm*

prints, and Albert Gleizes and Jean Metzinger's *Du cubisme* (1912) was translated into Japanese in 1915, just two years after the English translation. These facts contribute to the sense that Yorozu and Kuroda were well in control of the reception of the Western avant-garde, and therefore that they should be evaluated by different criteria rather than being considered as belated post-impressionists. *Nude Beauty* was, Clark says, a "deliberately provocative display of recently received post-impressionist mannerisms."[40] What matters for its appreciation is the contemporaneous Japanese sense of certain French modernism, and the economic, political, and strategic reasons why elements of French practice were adopted.

The devaluation of non-Western avant-gardes, Clark says, stems from "an ideological debate about authority" and ignores "the relativising function of the avant-garde." For example, the appearance of *Der Sturm* prints in Tokyo in 1914 "should be seen as the functioning of the avant-garde as a transcultural group in communicating among themselves."[41] Japanese artists such as Yorozu and Kuroda were not derivative because they were "actors in an international movement where cultural origin provided only a context of origination not of authentication."[42] The phenomenon of the avant-garde, together with its concept of originality, should be seen as an ideology shared by many cultures. Even the concept of originality might be relative, because it might be different from one place to another.[43]

The problem I want to point to here does not have to do with Clark's history, which is detailed and apposite. It has to do with an effect of reading: after a while, such accounts become counterintuitive. I can read with interest about Yorozu and Koruda for fifteen or twenty pages, but after that it becomes increasingly difficult for me to remain convinced by their responses to Van Gogh and the Nabis. Yorozu's and Koruda's paintings clearly depend on simplified or impoverished versions of Van Gogh, and as much as I may want to undermine that judgment, it returns insistently. It becomes increasingly difficult for me to sustain interest in Yorozu's or Koruda's paintings as independent works, comprehensible and viable without their Western references. The work looks derivative, and the art scene in Tokyo looks conservative. And that derivativeness and conservatism refuse to be subordinated to my concurrent interest in the economics, the self-reflexivity, and the unique particularities of the Tokyo art scene in those years. Clark might say that such an opinion is just a repetition of Western Orientalist prejudices, and that it is a consequence of the thrall of the ideology of Western avant-gardism, whose interpretive agenda is traditionally insensitive to new contexts. But I wonder if the Western perspective is so easy to discount. The art practice at the Tokyo School of

Fine Arts is certainly specific to its time and place, and I agree that it constitutes an avant-garde that is different from the one in Paris in those years. But the ideological and cultural differences are not enough to prevent the work from being seen as derivative, and that will be true not only for Western observers unused to the work, but for anyone whose understanding of twentieth-century painting comes from Western modernism. I may prefer Yorozu's *Nude Beauty* to a painting by Van Gogh, but that does not erase Yorozu's dependence on Van Gogh. I may not care about the *direction* of influence: if Yorozu influenced Van Gogh, instead of the other way around, I would not particularly care—but that does not stop me from experiencing the direction of influence as part of the work's character. I may even devalue the very notion of dependence as a Western construction, but that does not prevent me from experiencing Yorozu's painting as dependent.

Clark wants to change the terms of the conversation in modernist art history so that works like *Nude Beauty* will not be devalued, but there is a severe obstacle in the way of that entirely admirable goal: the very structure of art history and modernism. There is no sense to modernism without the privileging of innovation and of the avant-garde: the terms cannot be subtracted away without dismantling the very idea of modernism. Clark would like to rewrite the concept of the avant-garde so it can be sensitive to differing cultural contexts, but that cannot be done by claiming that originality is relative, or that new contexts rewrite the notion of what is innovative. The avant-garde is like a vital organ of modernism: it cannot be removed without destroying the concept itself and the interest that accrues to studying its products. It seems to me that if *Modern Asian Art* were to succeed in excising or relativising the avant-garde, it would no longer be called *Modern Asian Art,* because there would no longer be any sense in writing about modernism. Or, to put this another way, if Clark's strategies were effective, then art historians would be equally interested in avant-garde practices wherever they have occurred, whether they were in Tokyo in 1912 or Samoa in 1990. (American Samoa had one of the more belated modernist moments in world art.) In fact, art historians remain interested in the times and places where innovation—the avant-garde—was strongest. Art historians are not normally interested in avant-gardes because they are economically and ideologically unique in each case; they are interested because the work itself seems original.

It enriches art history to be asked to reconsider Western values and to think about concepts such as belatedness as the conceptually narrow concerns of a naïve Western historiography. I find a great deal of interest in Clark's discussions of par-

ticular avant-gardes, and it is especially significant that after reading a postcolonial account, a run-of-the-mill Western text may well seem unreflective. Yet I cannot see how to *effectively* rethink concepts such as originality and innovation, or to redefine ideas such as dependence and influence, or to relativise ideas like the avant-garde. It is not enough to stress local historical situations, because that only defers the moment when it is necessary to come to terms with the fact that the work is dependent on Western models.

If I subtract away concepts like "belated" and "dependent" and try to refine the avant-garde as an "international movement," then I end up with a maimed concept of modernism. The full game of art history is more challenging. It requires me to be sensitive to the unique characteristics of the Tokyo School of Fine Art around 1900, and it certainly asks me to be understanding and sympathetic with paintings like *Nude Beauty,* but it also requires me constantly to remember that Yorozu's paintings cannot compete with Van Gogh's. In theory, in a utopian world where there are multiple narratives of art history, Yorozu's painting could certainly be understood to be just as interesting as Van Gogh's. But that world does not yet exist, and the proof is very simple: Clark's *Modern Asian Art* is a work of Western art history, shot through with Western postcolonial theory, Western protocols for the writing and research of art history, Western interpretive methods, and a very Western concern with modernism. To imagine otherwise is invigorating but unpersuasive.

Sixth Answer: Define the Work *per negationem*

I showed an outline version of these first five solutions to the Slovenian scholar Tomaž Brejc, who teaches art history and theory at the Academy in Ljubljana. He proposed a sixth answer, taking as an example the Slovenian painter Rihard Jakopič. How, Brejc asked me, should I write about this painter, who is one of the seminal figures of Slovenian modernism? Take, for example, *Memories* (1912) in the Narodna Galerija, which hangs a room away from Grohar's *Larch* and *Sower*. The painting is certainly indebted to intimist work, but it is not mistakable for a Édouard Vuillard. In a broad sense, it is impressionist, and that is the way Jakopič is usually identified in Slovenian art criticism (and, for that matter, on the 100 Tolar banknote issued in 1992). Yet Jakopič is not an impressionist in the way that Monet is, or even Sisley. Nor is he very close to the German or Hungarian impressionists.

Brejc has written a book on Slovenian modernism, and he told me he has wrestled a long time with this problem. In the end, he favors specifying the artist by saying what he is not. This definition *per negationem,* as he calls it, has the virtue

of being very faithful to whatever the painting at hand actually is. *Memories* is not Vuillard, Monet, or early Emil Nolde, or early Karl Schmidt-Rottluff, or any number of others. Jakopič was never a Fauve, even though he used complementary contrasts in his painting. Something in *Memories* builds from the Slovenian reception of Paul Signac, and later there was also the influence of Vasily Kandinsky. It is possible to work through the possible antecedents and say, in each case, what Jakopič was not.

I am impressed by Brejc's application of this method, which seems to me ideally sensitive to the often unnameable differences between painters and their prototypes. Brejc's book, unfortunately not translated from the Slovenian, could be exemplary in that regard. Yet I also wonder if the definition *per negationem* is not compelled to depend, at every point, on existing Western descriptions. Without the existing literature on the Fauves, for example, it would not be possible to make sense of the claim that Jakopič took the color theory but not the painters' other concerns. Brejc's *via negativa* is promising, but I do not think it can be a model for the description of non-Western work.

Seventh Answer: Adjust the Stress

Several times, in discussing this problem with friends and colleagues, it has been suggested to me that the answer is not so much theoretical as a question of emphasis. Adjust the stress on Western painters, people say, and the problem will eventually be meliorated or solved. If the plurality of art historians in all countries spent more time on lesser-known artists, then finally the burden of art history's emphasis would shift and the margins would become a new center. In effect, my friends have told me that the problem is only a question of the privilege that has historically been given to canonical Western modernists, and that the next generations of art historians can solve it passively, as it were, simply by refusing to contribute to the growing mass of scholarship on the major figures.

One different way of paying attention would be to give up the metaphor of the family tree of modernism, where the sturdy trunk is Western European and North American modernism. The metaphor of rhizomes, made popular by Gilles Deleuze, might be a substitute. Rhizomes, according to Deleuze, proliferate in all directions, so that there is no preferred direction or central node. Deleuze's metaphor is not quite accurate because rhizomes are offshoots of root processes, so no matter how tangled they are, they are all linked to a large central plant. Still, the many modernist practices that flourished throughout the world in the first half of

the twentieth century could be pictured as rhizomes, distantly or indirectly connected to the massive central core of modernism in Western Europe.

A better model might be mycelia, the vegetative bodies of fungi, because they are truly without a center: they branch and divide through the soil with no pattern whatsoever, and they grow from spores that might be scattered anywhere. A mycelial model of modernism would let each local center be as important as every other center, and there would be no central body—no equivalent, in this model, of a mushroom.

It is worth considering options like these seriously. A rhizomatic model, in which a cloud of tiny randomly oriented shoots surrounds a central stalk, is a fairly good way of picturing the situation in the first three decades of the twentieth century. It reflects the fact that artists on the margins did not always imagine their relation to the center as if they were a branches of a tree, but in more complicated ways. It also does justice to the fact that artists in the center—for example, Picasso working in Paris in the 1910s—knew of the existence of many modernisms but did not have a clear understanding of any. From his perspective, the many offshoots of modern art must have appeared as a halo or cloud of minor interests. The difference in *weight* is also well modelled by the rhizome theory: a massive and compact art scene in the West and a widely dispersed but lightweight system of interrelated art scenes elsewhere. The mycelium model, on the other hand, does away with the center in the name of equality and posits a world filled with labyrinthine connections to equally weighted centers. It models the situation within some regions, but it is not an accurate model when it comes to the influence of the West.

There would be many more models, as many as there are ways of paying attention to different art practices. I mention the rhizome and mycelial models because they capture two major alternatives. All such options, I think, are ultimately unrealistic. It is utopian, I think, to say that the problem of the overbearing influence of the West can be mitigated by paying more attention to the margins. The overwhelming influence of the center, or centers, was a historical fact over much of the twentieth century, and in order to overcome it, more will be required than just shifting the emphasis. Even if art historians decided, on a worldwide basis, to stop writing about Picasso and Matisse, their presence in art historical discourse would still inform the accounts of other artists. That is the root-level problem that is not solved by paying attention differently.

I have often found myself fascinated by artists I discover for the first time, and as I study them, their works become richer and loom in my imagination. I was introduced to Fujita Tsuguharu (1886–1968) by John Clark's account; he was an

artist with very divided loyalties, and his works seem to reflect that fact. He graduated from the Tokyo School of Fine Arts in 1910, and went to Paris; he was back in Japan during the Sino-Japanese War in 1938, working as a war artist; during the war in the Pacific he was back in Paris; and even though he was barred from exibiting there after the war, he eventually became a citizen in 1955. Clark makes some sensitive observations on Fujita's dour graduation self-portrait of 1910, wondering if his "domineering downward-looking stance" might mean he already had begun to "disown" his culture. Clark wonders about the white background in a self-portrait done in Paris in 1926: is this "the past turned to nothing, or is it the nothingness of the past that the (Parisian) world he inhabits cannot recognise except in the elaborate play of brushwork"?[44] Often Tsuguharu seems to avoid the question, making popular and middle-brow decorative pictures for the Parisian and Japanese art markets. But those markets fluctuated over the years, and his own sense of them was apparently just as variable. It is seldom clear, in Fujita's works, where his alliances and affinities lie, and that makes his work a good subject for a study of identity and its relation to painted signs. It makes him grow in my imagination, until he seems a better indicator of those ideas than any French artist living in Paris in those same years. And yet I know that behind those questions, making them possible, are the expectations and norms against which Fujita measures himself: the 1910 self-portrait is a species of late Western academic painting, and its hauteur works in that context; the 1926 painting is a light concoction of Paul Klee, Raoul Dufy, and Matisse, and its virtuoso line and airy white emptiness are expressive on account of those particular precedents. In other words, paying attention differently is rewarding and historically specific, but it defers the question of wider connections.

Eighth Answer: Just Give Up

What to do? Some kinds of painting are especially far removed from the discourses of modernism, for example the debased landscapes offered to tourists on Montmartre or paintings of jungles and coral reefs on the walls of shopping malls. Such work probably cannot be well described in the language of modernism or serious art history. It needs to be appreciated differently—"on its own terms," as people say—and the whole project of historical writing should probably be set to one side. It could be argued that such work is not only a major component of the sum total of modernist painting but the majority of all painting done in the last century.

 An interesting place to think about this is the Leopold Museum in Vienna. Because it is the result of Rudolf Leopold's personal sense of Austrian modernism,

and because the display space is extensive, it raises interesting questions about what can, what might be, and what should not be recuperated for the history of twentieth-century painting. The collection includes major painters who are essential in any account of modernism, among them Gustav Klimt, Egon Schiele, Oskar Kokoschka, and Lovis Corinth. The collection also includes work by followers, who figure in accounts of Austrian modernism: for example Kolo Moser (1868–1918), a more decoratively minded member of the Secession, and Anton Kolig (1886–1950), a member of the movement called Carinthian Kolorismus. But among them Leopold has hung painters whose contribution to European, and even Austrian, modernism is dubious. In winter 2003 Gustav Hessing (1909–1981) was prominently displayed, but his loose adaptations of cubism are unconvincing, and his long career only seems to make that point over and over again. Josef Dobrowski (1889–1964) is represented by several dark, overwrought adaptations of Breughel, a painter whose work has long been an important presence in the Vienna Kunsthistorisches Museum. But Dobrowski's paintings, even as a record of the historical reception of Breughel, are not very interesting. Another such artist is Leopold Blauensteiner (1880–1947); he was an extremely literal-minded pointillist who preferred his dots in neat rows as if they had been painted with an inked comb.

In one room Leopold has hung a series of flower paintings: one by Egge Sturm-Skrila (1894–1943); another by Anton Faistauer (1887–1930); and a third by Kolig, which shows evidence Kolig was looking at Matisse. The pictures are modernist, but also in parts indifferent to modernism, as if they are answers to the question, "If you like flowers, and you are a modernist in Austria in the 1930s, how can you paint?" Together with Schiele, Faistauer and Kolig comprised the short-lived Neukunstgruppe, and that is enough to ensure their presence in art history. Sturm-Skrila is a more obscure painter. The canvases in the Leopold Museum are grouped, however, as flower paintings, making the difference less visible. They are each lovely. They have a particular solidity that I take as an echo of Gustave Courbet, an important progenitor for Expressionism. They also share a rich crimson that is typical of the decade in much central European modernist painting; it occurs again in the Carinthian Kolorismus painters. Kolig taught in the Vienna Academy along with Josef Dobrowsky, who also painted flowers, and one of their students was Karl Josef Gunsam (1900–1972), who also painted modernist flower arrangements. But if I go on like this, I am only distracting myself. These paintings do not belong in history; they belong to the private moments I have on my way from one historical encounter to another. These paintings take themselves out of history: they are a

hiatus from thinking about Vienna, and about Austria's contribution to modernism, and I imagine that may have been Leopold's intention.

The private enjoyment of flower paintings is not at all a poor thing. Anyone who loves painting knows that it very often works by producing just such incommunicable feelings that seem detached from historical meaning. I forget myself in front of Sturm-Skrila's mediocre bouquet, and then I remember myself in the next gallery. That lull in cognitive intensity, that aesthetic encounter, that lapse into subjective space—call it whatever you like—is utterly central to what some modernist painting is about. I do not want to parody it here, devalue it, or criticize it at all. But it is not relevant to the problem at hand, which is the production of historical meaning. If I give up trying to write an historical account of Yorozu, Grohar, and the others, then my task does not necessarily become simpler: I am still faced with the challenge of trying to put my personal reaction into words. But my task is different, and it no longer has to do with the problems I am pursuing.

An insidious and tremendously difficult question lurks here. It makes sense *not* to consider Sturm-Skrila, Faistauer, Kolig, Dobrowsky, and Gunsam in terms of the history of modernism, to exclude them from the essential canons of the history of art. Their flower paintings are simply not necessary for a serious consideration of modernism. It would be artificial to try to find a place for their flower paintings in a history of twentieth-century painting; if I did so, I would be misusing the paintings and misunderstanding their intended public. But there is a problem: if I exclude those paintings, where do I stop? Can I then say flower painting as a whole is not part of twentieth-century painting? On what grounds? Aren't there ambitious and important flower paintings by Matisse, Picasso, Bonnard, and even Lucian Freud? Weren't the Pop appropriations by Andy Warhol, Tom Wesselman, and Wayne Thiebaud made possible by the earlier history of modernist still lifes? And shouldn't we doubt any attempt to exclude flower paintings, because after all their low value is a leftover from the Baroque hierarchies of genres? Once I begin to exclude certain paintings and types of paintings, there is no way to know how to stop. If a single painting can be somehow granted exemption from being considered historically, then all paintings can be. My simple judgment that Sturm-Skrila is not appropriate for a historical account raises questions that are lodged deep within the discipline.

Conclusion

There is no simple solution to the problem of writing art historical accounts of the world's painting. We should take heart from that, because if there were a single answer, it would mean there are no significant differences between paintings made in different regions or countries and that all modernist painting is a massive worldwide project, something akin to modern physics, and therefore suitable to a single explanatory model. Happily, that is not true. But the lack of a single answer should also be regarded as a serious challenge. If we do not continue to work on this problem, paintings made in smaller countries, in marginal places, in neglected regions, will be lost to the international dialogue on art history. Their voices will grow even fainter, even harder to hear, and the trumpeting of the Picassos and Pollocks will get stronger each year.

1. *Art Bulletin* 86, no. 2 (2004): 373–80.

2. *Is Art History Global?,* James Elkins, ed., vol. 3, *The Art Seminar* (New York: Routledge, forthcoming).

3. The former is forthcoming from Duke University Press; the latter will record a conference in College Park, Maryland, held in November 2005.

4. A related version has appeared in Slovakian: "Ako je mozné písat' o svetovom umení?" ["How Is It Possible to Write About the World's Art?"], *Ars* [Bratislava] 2 (2003): 75–91, with an English summary provided by the editors. The text was adapted from a lecture given at the National Centre for the Performing Arts at the Mohile Parikh Centre in Mumbai, India, and at the Sanskriti Foundation in Delhi, in November 2003.

5. This paragraph is adapted from my *Master Narratives and Their Discontents,* with an introduction by Anna Arnar, vol. 1, *Theories of Modernism and Postmodernism in the Visual Arts* (New York: Routledge, 2005), which explores justifications of some of its claims.

6. See Milan Ivelic and Gaspar Galaz, *Chile: Art actual* (Valparaiso, Chile: Ediciones Universitarias de Valparaiso, 1988), 27–60; also Milan Ivelic, ed., *1900–1950: Modelo y representación* (Santiago de Chile: Museo Nacional de Bellas Artes, 2000). I thank Milan Ivelic, director of the National Gallery in Santiago de Chile, for information on Huidobro.

7. This figure is an estimate extrapolated from the number of galleries in Melbourne in 2003 (over twenty) and the number in Alice Springs in 1998 (thirty-three). For the latter figure, see Howard Morphy, *Aboriginal Art* (London: Phaidon, 1998).

8. I thank Nigel Lendon, Howard Morphy, and Charles Green for advice on this section.

9. The citizenship resulted only in increased hardship.

10. Morphy, *Aboriginal Art,* 22.

11. Quoted in Morphy, *Aboriginal Art,* 272.

12. "When Albert started exhibiting some critics labeled him as a copyist. They said he was mimicking a western style. What they were trying to say was that his works were un-Aboriginal. This statement has no credibility. The critics were blinded by their western ideals. What they couldn't realize was that behind these works was an Aboriginal mind, every brush stroke was influenced by a tribal way of thinking." Christopher Hunter, "The Critics," The Hermannsburg School, http://www.hermannsburgschool.com/index.html (accessed 25 July 2003).

13. Morphy, *Aboriginal Art,* 22.

14. Morphy, *Aboriginal Art,* 272.

15. Ian Burn and Ann Stephen, "Namatjira's White Mask: A Political Interpretation," in *The Heritage of Namatjira,* ed. Jane Hardy, Vincent Megaw, and Ruth Megaw (Port Melbourne: William Heinemann, 1992), 249–82.

16. For more on the modernist uses of Australian landscape watercolors, see Graham Coulter-Smith's *The Postmodern Art of Imants Tillers: Appropriate en abyme, 1971–2001* (London: Paul Holberton Publishing, 2002). Tillers's works, unlike Namatjira's, have an unambiguous and readily identifiable take on their originals.

17. This is the case, for example, with those moments in Steven Mansbach's *Modern Art in Eastern Europe* (Cambridge: Cambridge University Press, 1998) that are concerned with the disclosure of significantly avant-garde moments in Eastern European painting. This is, however, only one of three concerns of Mansbach's book. For a discussion, see my review in *Art Bulletin,* 82, no. 4 (2000): 781–85.

18. Dušan Brozman, [untitled essay] in *Štefan Bartušek Prukner* (Banská Bystrica: Statna Galeria, 1996), 13.

19. Karel Srp and Jana Orlíková, *Jan Zrzavý* (Prague: Academia, 2003). I thank Karel Srp and Vojtech Lahoda for sending me a copy of this beautiful book.

20. Among many other texts on Orientalism, see the sensitive account in Hollis Clayson, *Paris in Despair: Art and Everyday Life Under Seige (1870–71)* (Chicago: University of Chicago Press, 2002).

21. *Le Japon des Avant-gardes* (Tokyo: Kokusai Kōryū Kikin, 1988) was on view from 1986 to 1987.

22. Shigemi Inaga, "La peinture moderne en Occident et son extérieur," in *The Orient of Painting* (Nagoya, Japan: Nagoyadaigaku syuppankai, 1999), 2–3. I thank Hiromi, a graduate student, for preparing a translation and answering my questions about specific words.

23. Ibid.

24. For the older work, see http://yellow3.eunet.si/yellowpage/netgalle/kraswork.html.

25. Paul Crowther, "Postmodernism," in *Oxford History of Western Art,* ed. Martin Kemp (New York: Oxford University Press, 2000), 497. Crowther's books include *Critical Aesthetics and Postmodernism*

(New York: Oxford University Press, 1993).

26. Crowther, *Critical Aesthetics,* 159, 187.

27. For samples of Morley's work, see http://www.artcyclopedia.com/artists/morley_malcolm.html (accessed December 2005).

28. I thank Nadja Zgonik for this information.

29. I thank Andrei Smrekar for this information.

30. John Clark, *Modern Asian Art* (Honolulu: University of Hawaii Press, 1998).

31. Ibid., 17.

32. Ibid.

33. Ibid., 219.

34. Ibid., 222.

35. Ibid., 225.

36. For samples of Yorozu's work, see http://www.pref.iwate.jp/~hp0922/engyorozu.htm (accessed December 2005).

37. Clark, *Modern Asian Art,* 225.

38. Ibid., 225.

39. Ellen Conant, "Japan," *Grove Dictionary of Art,* www.groveart.com (accessed March 2003).

40. Clark, *Modern Asian Art,* 217.

41. Ibid., 225

42. Ibid.

43. "The avant-garde becomes forced to absolutely privilege the new when it draws its authority from originality," Clark writes. Clark, *Modern Asian Art,* 222. But how could any avant-garde be understood apart from a privileging of originality?

44. Ibid., 231.

World Art History and the Rise of Western Modernism, or, Goodbye to the Visual Arts

David Summers

This essay was originally written some six years ago, and during these six years, the problems I meant to address in this essay and the book it compresses have only become more acute. According to the old idealist art history, it was possible, on the basis of the expressive character of forms, to generalize about the "worldviews," "aesthetics," or "spirits" of periods and peoples. Such inferences are no longer useful or even defensible, and if that is so, how is it possible sympathetically to address and articulate the art of different world cultures? To be sure, there are powerful reasons current for *not* addressing cultural differences as in any way substantial, and, if we think of historical cultures as ideologies or as consumeristic "lifestyles," the contact— and especially the conflict—of cultures may be easily traced to the economic disparity of groups involved, and, having done that, the question becomes how best to right the disparities. In these terms, the "root causes" of conflict cannot be cultural.

The degree to which cultures are themselves sources of conflict is very difficult to specify. Certainly history is rich in apparent examples of cultural conflict. Without oversimplifying these issues and their solutions, it will be helpful, proceeding from the premise that absolute generalization about cultures is never admissible, to think about cultures themselves in different ways.

As is well known, evolutionary biology had a powerful impact on nineteenth-century thinking in general, and the generally anthropological idea of culture (as opposed to *Kultur* as *Bildung,* which seems no longer to be on the table) is no exception. If the biological analogy is carried out, cultures are adaptive responses of human groups as groups, which grow up together with groups themselves, then develop in more or less consistent ways. (It was the developmental dimension of culture that had the most disastrous consequences, since "evolution" could be easily translated into progress, leaving the "primitive" and the "undeveloped" behind, at the same time tending to put the modern and "developed" beyond critical reach.) If cultures do in fact crystallize as the formation of human groups, and do so in similar ways, the specific forms taken in relative isolation are by no means the same, nor do groups have the same opportunities for interaction with other groups. Now, "worlds" shaped in isolation are no longer isolated, and the problems resulting from these new conditions must be addressed.

I think that the presumed universalizability of modern Western *homo economicus* is reductive relative to the variety of world cultures, and I think that a fully humane world would be one in which "development" and "modernization" are achieved in relation to human needs and in accommodation with more or less local traditions. Cultures are not simply sets of beliefs, they are patterns of collective behavior, often of immemorial antiquity. In the terms I am offering, art simply *is* context, and cultures are the social spaces groups have shaped and that in turn have shaped the members of groups. The art of all historical cultures has in its turn been shaped to human scale, and if cultures are sources, not just of difference, but of friction and violence, it is also possible for members of cultures to comprehend one another as inhabiting alternative human possibilities and histories.

When I first presented these ideas at the Clark Conference in Williamstown, I described a book manuscript I was completing entitled *The Defect of Distance: World Art History and the Rise of Western Modernism;* the book was published, in 2003, by Phaidon Press (with a change in title I will explain later).[1] Consequently, this essay is the double expression, or second compression, of a long argument that began to take shape in my mind decades ago around problems internal to what might be called the classical theoretical literature of the history of art. From the time I began to study the history of art, I was puzzled by the inadequacy of the descriptive language I was taught—formal or "visual" analysis—to account for things as manifest as space and light in painting, or size and scale in sculpture, which is not even to mention the problems posed by architecture. As what came to be called "contextual" art history took shape on a number of fronts through the late 1960s and 1970s, my own sense that there were difficulties at the theoretical base of the history of art took on much broader dimensions, as it became more and more obvious that connections could not be drawn between the results of formal analysis, the "internal" art history it supported, and the kinds of issues with which art historians were increasingly concerned. One also began to hear in reaction to this new state of affairs that art historical inquiry was drifting away from "works of art themselves." As I saw the problem, the discipline of art history stood in need of a different method of description, without, however, returning to formalism.

Consensus about the objects and procedures of a discipline, of course, is not necessarily desirable. In its formalist days, the history of art was remarkably confident about its theoretical foundations, which went largely unexamined, not least because of the exaggerated authority of formalism in avant-garde painting. If the advent of iconography, which is "external" to formal structure, and therefore

contextual, raised problems, such problems of "form and content" could be solved in favor of form by arguing that it was precisely in great works of art—those worthy of study—that a unity of form and content had been achieved. To be sure, the theoretical unsettledness of the history of art over the last two or three decades has interjected new terms, themes, and possibilities for interpretation. However, for reasons I will explain shortly, although I certainly adjusted the arguments of *Real Spaces* to new theoretical developments over the years, I never felt it was necessary to give up the project upon which I had embarked. From the standpoint of this project, it was difficult to take either a "left" or "right" position in theoretical controversies. The defense or simple rejection of formalism, or the shrinking of art history to its essential archaeological, archival, and philological components, presented no more attractive alternatives than reduction of art history to the analysis of its own past and present literature, however indispensable historiographic awareness might be. This is not to mention the endless acknowledgment of the political-to-psychoanalytic "situatedness" of the historian in interpretation. If situations must be acknowledged as part of an appropriate professional humility, awareness of them should not be disenabling, and, in general, none of these alternatives allows the consideration of what seem to me to be the obvious and important issues raised by what we call "art." In such shifting disciplinary historical circumstances, it seemed to me possible to ask a more radical question: must it continue to be assumed that art (as we have come to understand it as the result of a lengthy and culturally specific history) is essentially "formal" or "visual?" It should go without saying that this assumption is very recent in the European intellectual tradition itself[2] and that its universal application is a dubious, highly debatable projection. The best outcome of art history's disciplinary questioning might in fact be debate about the definition of art itself, from the specific standpoint of what we have come to understand about art's own histories.

As I worked through a series of related questions—substitution, bilateral symmetry, and "conceptual" images, for example—I found myself frequently crossing the boundaries of art-historical fields, and, rather than turning back, I became convinced that the "fields" of Western art history are themselves major impediments to the understanding of the tradition to which they all belong. Despite misgivings I might have had about such trespasses at the beginning, I began to see more clearly an art history able to address many traditions of art, and to bring the strands of their various accomplishments into significant relations of similarity and difference. As I have said, it became clear to me that art *is* context, and moreover

that all contexts—and therefore all art—are formed in one or another way to human physical presence.

When it first began to occur to me how this project could be done, widespread professional lip service was paid to the idea that a more comprehensive art history was highly desirable, even imperative, and complaints are still to be heard about the difficulty of "getting to non-Western art" in introductory courses, even when, or especially when, art of other traditions is included in all of the textbooks. In other words, even though the populations of American universities have changed markedly in the last thirty years, it seems impossible not to keep telling undergraduates about Antonio del Pollaiuolo's *Nude Men Fighting,* or Agostino Carracci, or Thomas Gainsborough, whatever these new students' backgrounds might be. During the same years, any attempt in the direction of comprehensiveness came to be complicated by suspicions of "intellectual imperialism," and nowadays any project of reach sufficient to include the word "world" in its title raises immediate skepticism. I have not ignored these suspicions, nor am I unaware of the theoretical and political issues underlying them, but I have never been persuaded that these risks outweighed the possible benefits of the enterprise. It is of course impossible to escape the fact that the art history we learn, practice, and teach has grown up, and continues to develop, in the European intellectual tradition, and we cannot jump out of our intellectual skins or run away from our intellectual shadows; but it is not necessary therefore to conclude that, because historical writing has served obviously imperialistic purposes in the past, this whole tradition should—even if it could—be abandoned, or worse yet, that we cannot or should not make historical inferences at all. History remains fundamental to our self and group understandings, and to our mutual understandings, and cannot be ignored. A chastened historical writing can serve better and more responsible purposes, thus to provide a base for much broader conversation. At the beginning of the twenty-first century it has come down to this: The history of art as it stands is a *de facto* world art history, whether we admit it or not, and it is a deeply flawed, partial, and inadequate one.

It should be added that in the years I worked on *Real Spaces,* museums by and large rose to the demand to which I also meant to respond, including in their exhibition schedules what was not so long ago marginal and even "ethnographic" art. It has been possible, for example, to see major exhibitions of Olmec art with excellent scholarly catalogues, and if the context of precious aesthetic object presentation in a modern national museum is very different from the contexts of the uses for which Olmec status and ritual objects were made, these exhibitions have

helped make us aware of those first contexts and have continued to do positive cultural work. No corresponding theoretical structure has been devised for such presentations by academic art history, which—however progressive it might be in other terms—has to my mind remained parochial and derivative.

To state what I have said a little differently, I think that a fully realized contextual art history (in the terms in which I understand the word "contextual") would be a better art history, not simply because it would raise questions with which we ought to be engaged but because it would provide possibilities for more adequate description, explanation, and understanding of what we call "art." In the years I worked at these problems, what I had seen as the spreading theoretical void at the center of the history of art was filled in other ways, most of them adapted from some variant of post-Saussurian linguistics. I have argued elsewhere that the universalization of the linguistic sign underlying these developments is far from self-evidently necessary.[3] The especially influential post-structuralist variant of this theory linked the over-generalized principle of the arbitrariness of the sign to some version of Freudian (or other unconscious) explanation for our assumption that signs refer, or for our desire that they might do so. If such premises make sense as an episode in ongoing Western epistemological controversy, their own historicity is certain, and they provide little assistance in the attempt to understand, for example, Maya art and architecture; they are as reductive as any of the other ideas I have avoided. I am therefore not convinced that "the expansion of the concept of text is strategically decisive," nor am I persuaded by the warning that denial of this decisive expansion "is really either a gross misunderstanding or a political strategy designed to limit deconstruction to matters of language."[4] According to this argument, "deconstruction" as a "strategy" for institutional critique is short-circuited if the principle of the arbitrariness of the sign is deuniversalized. I cannot see why this must be so, and such critique might in fact be very usefully supplemented by considering categories beyond those afforded by the analogy to language. If all Western ideas are ethnocentric, those provided by this linguisticism are no less so, and no less defined by the perennial disputes of Western representationalism.

In terms of general semiotic categories, I have argued that indexical inference should be placed alongside symbolic interpretation based on the interpretation of language. One of my purposes has been to show that art should be acknowledged to have its own irreducible kinds of meaning, not that it should in its turn become the paradigm for all interpretation. When indexicality is taken seriously, fundamental issues begin to arise that must be ignored altogether, if "signification"

is assumed to be no different in all cases from symbolization. The denial of *any* semiotic universalization provides access to the particularity of art of all kinds.

A few very general principles guided my project. I remain convinced by E. H. Gombrich's rejection of the Romantic historiographic tradition he called "Hegelian," which in both its idealist and materialist versions involves universal, progressive, and reductive narratives.[5] Like my teacher George Kubler, I assumed a very broad definition of "art"—art is basically what people make at both the individual and social levels of their activities—and adapted Kubler's idea of "shapes of time," according to which any artifact is made up of traditional series in more or less complex combinations.[6] This conception of art-historical time precludes the possibility of any historicist totalization and makes describable the realization of purposes within and among traditions, thus opening the possibility for any number of art-historical narratives. Analysis of artifacts into series requires interpretation of members of the series themselves, and then interpretative synthesis of individual works on the part of the art historian, but this individual and professional component is not fatally "subjective" and, quite to the contrary, provides the solid basis for further positive discussion.[7] Shapes of time also leave to one side the question of quality. This does not mean that there are not works of quality, but rather that such works are neither self-explanatory nor the sole subject of art's history. On the contrary, it is the specific shapes of the histories out of which the best works arise that we must also learn to value.

Etymologies appear fairly frequently in *Real Spaces,* and these are necessarily in languages with which I am familiar. These etymologies serve two purposes. First, they are intended to refresh usage by making clear the differences between words we use and their likely origins. We think of a word like "profane" differently if we know that it was formed of elements meaning something like "outside a sacred precinct," or "periphery" and "circumference" differently if we know that they refer to "carrying around." The omnipresent modern word "sex" has little to do with its origins and was first related to words like "seclude," "seduce," or "segregate"; it was that on the basis of which some were set apart from others. All of these terms harbor what I have called *real spatial metaphors,* which point to real social spatial activities and divisions. The etymologies are meant to reveal a basic and important dimension of language, and to invite others who know the many languages relevant to the world's art to dig for similar roots. There is a kind of wager involved in this, and my strong hunch is that they will find many other real spatial metaphors, some similar to, but others only partially similar to, or different from, those I have presented.

What I am proposing is a "post-formalist art history," and, as the title of this essay suggests, I have rejected the whole idea of the "visual arts," located as it is in the long history of Western representationalism. Late in this history, and at the beginnings of modern formalism, Immanuel Kant wrote in his *Critique of Judgment* that we apprehend things aesthetically by "confining attention to the formal peculiarities of our representation or general state of representational activity."[8] In other words, in aesthetic experience, and so in art, we may reflectively examine the activity of our free potential to realize the world as such. Once this preconceptual formative activity had been defined, first as fundamental to the project of transcendental idealism, it underwent vast expansion in the nineteenth century, providing the basis for the formulation of collective "spirits," "worldviews," or "visions," which, of course, could always be defined with the same totality physiologically and materialistically, their idealist origins notwithstanding. Such essentialist ideas, if most fully developed in the nineteenth and twentieth centuries, rather than disappearing, have persisted in the art historical language of style, which merges easily with more vernacular categorization and stereotyping by ethnicity, class, gender, nationality, region, and decade. We might, for example, quickly surmise the "worldview" of a white, middle-class, American male who grew up in the Pacific Northwest in the 1950s.

According to the post-formalist alternative I am offering, we do not radically imagine our world, nor does "art" show us all the ways in which we have done that. Instead I have proceeded from the generally phenomenological assumption that we human beings have always found ourselves already in the world under certain *conditions* that in important respects, and to varying degrees, have been determined by those who went before us. This world, and these conditions, among which are the terms of our embodiment and community, are never encountered in themselves but rather in one or another cultural historical form. Although it may be possible to imagine unrecoverable encounters with the world, in which our most distant ancestors reacted in characteristic ways to given conditions, we cannot reenact those encounters. It is better to say that our various distant ancestors responded in various ways to given conditions, by doing so establishing the bases for subsequent traditions. At our places in one or another of these traditions, we inevitably take up the world as *second nature,* as habit, in the accustomed forms in which it has been left for us by those who came before. In these terms, a central task of art-historical interpretations becomes that of trying to understand how our own second nature might have been established quite otherwise, as so many others have been.

In my arguments, isolation provides an important explanation for differences in artifactual styles, much as (but not just as) it also helps to explain differences in languages. There is no reason that Neolithic knappers on different continents should have made arrowheads in the same way. Once the *de facto* choice has been made to do so in one way or another, however, that choice may assume *authority:* that is, it may become part of the "way things are done," or the "way we do things" for a group of people. The continuity of styles of making might thus be explained by such social and historical processes as instruction, group identification, and differentiation within groups, rather than by the collective "wills" or "spirits" of earlier art history. In the contemporary world, of course, few places are isolated, and, on the contrary, contiguity and interaction are the rule. Styles are still deeply rooted in mores, however, and the modernity we associate with cultural contiguity is still continually negotiated in these terms.

Fig. 1. Rembrandt Harmensz. van Rijn (Dutch, 1606–1669), *Landscape with a Farmstead ("Winter Landscape")*, c. 1648–50. Ink and wash on antique laid paper, 2 ⅝ × 6 ¼ in. (6.6 × 15.8 cm). Courtesy of the Fogg Art Museum, Harvard University Art Museums, Cambridge, Massachusetts. Bequest of Charles A. Loeser

Post-formalist art history replaces the "visual arts" with the "*spatial arts*," the former having been relegated to the modern Western history of representationalism. Given this change, there is a further distinction between *real space* and *virtual space*. *Real space* is the space we share with other people and things, and in these terms, *sculpture* is the art of *personal space,* fundamentally significant relative to the conditions of our own physicality. Sculpture is significant as bigger or smaller than we are, more or less permanent than we are, portable, possessable, approachable, or none of these. Still in the category of *real space, architecture* is the art of *social space,* defined by boundaries and inclusions, by division, exclusions, and hierarchy, and by accommodation to culturally specific activities. *Virtual space* is space represented in two dimensions (as opposed to constructed in three dimensions) in, for example, paintings, drawings, and prints. Rembrandt's drawing of a snowy landscape (fig. 1) is merely a bit of paper with a few signature-like marks, but it is hard for us not to see space, light, and even weather when we look at it. This is an example of virtuality from a familiar and highly developed tradition, but it is important to stress that, in principle, real and virtual spatial alternatives are available everywhere. Any practicable objects

may be used substitutively, for example, and all surfaces may be developed as virtual space for images placed upon them. Either option may be articulated for different social purposes, and may therefore be more or less developed in one or another tradition.

Given the distinction between real and virtual space, the deeper of the two principles is real space. (This is why the book was finally given the title it has.) Real space is the deeper principle because all virtual spaces must have *formats,* which are culturally specific and always integral with the shaping of social spaces. Polyptychs, canvases, screens, and scrolls are examples of culturally specific formats, and even Rembrandt's little drawing does not escape this rule. Drawing and even paper itself have complex factural, technical, and social—real spatial—histories in European art after its introduction from China through Islam.

I will return to these spatial categories shortly, after examining the principle of *facture. Facture* is the evidence in a work of its having been made, and it is insistence on this principle that makes the fundamental interpretative change from quasi-symbolic interpretation based on the analogy of texts to *indexical inference.*[9] Art historians are perhaps most accustomed to thinking of art in terms of *autographic facture,* of which figure 1 is a fine example. Much art-historical attention has been given to problems of sorting out individual "hands" or "styles," but the principle of facture means much more than that. Rembrandt's drawing is not only a snowy landscape, nor is it only significant as a record of his evidently having touched it in idiosyncratic ways. Again, the drawing is a highly complex and determined historical format, and both paper and the artistic processes for which paper is necessary have significant histories, as do the possession, exchange, and collection they make possible. To take another familiar example, Vincent van Gogh did not simply express himself about a subject by marking the surface of a canvas, and he also did not make his own paints, brushes, linen, or stretchers. Explanation of how all those things came to his hands as possibilities in just the way they did must involve broader culturally specific questions of technology, industry, and commerce, before the questions of personal expression or the art market even arise. The same principle of facture holds at the embracing scale of social space. Stonehenge may or may not be an elaborate observatory, and it may or may not have been used for one or another purpose, but it does tell us unambiguously that stone was quarried (that is, cut squared) and transported, and that more or less specialized and collective labor was necessary in order for the site to have been made and remade, from which we may infer certain general kinds of social arrangements. Obviously, traditions of art are

very different in these terms, but, just as obviously, the activities that result in what we call "art" are inevitably inextricably woven into one or another social order.

If facture records larger social purposes and enterprises, this means that the appearance of artifacts should be explained art-historically by their fit to specific circumstances of making and by their accommodation to the purposes enacted in larger social spaces. That is, artifacts are integral with their *first spaces of use.* Works are of course turned to new purposes, as for example when polyptychs are displayed in museums, but these later placements do not explain their having been made in the way they were and have other kinds of art-historical interest.

Facture has other fundamentally important meanings. *Refined* and *elaborated facture,* like materials considered intrinsically valuable or powerful, articulate distinctions among persons, places, objects, and activities. The Olmec celt in figure 2 was made of hard green stone, rare and potent, with long-forgotten energies, painstakingly worked to the highest possible finish. Both material and facture reserved this implement for extraordinary use by a small number of people. The refinement and elaboration of artifacts lead directly to the issue of *ornament.* Just as there has been a perennial resistance to the use of images in worship in the Western tradition, with intermittent episodes of iconoclasm, so there has also been a deep, uninterrupted distrust of ornament in Western criticism from Classical Antiquity to the present. We are still inclined to think of ornament as superfluous (relative to function) or superficial (relative to content). This attitude, however, represents only one strand in the Western tradition itself and obscures or conceals the absolute importance of ornament for the definition and distinction of persons, artifacts, and places in major traditions, including our own. In a very real sense, and especially in ceremony, the queen is not who she is without her regalia, and countless such examples might be given. Decoration, after all, is the active form of decorum, and we hide that from ourselves when we dismiss ornament as merely secondary or ancillary relative to deeper form or substance, or mark it off as merely "visual," "aesthetic," or "abstract."

Fig. 2. Olmec jade celt, c. 900 B.C.E. Diopside-jadeite, 11 ½ × 3 ⅝ in. (28.3 × 9 cm). Dumbarton Oaks Research Library and Collections, Washington, D.C.

Finally, facture raises the issue of the *notional,* which places art at the very foundation of characteristically human order. When we smooth a surface (as in fig. 2), there is an *implicit limit* to our activity. This limit is perfect smoothness, which

is ultimately the *notional limit* of *planarity.* When we weave textiles, there is likewise a notional uniformity implicit in both the process and the result. I have followed Meyer Schapiro's lead in arguing that the plane is a human invention and that the significance of this invention is the creation of abilities, arising only from the application of human skills, *to think and act in terms of pure relations.*[10] This is ultimately part of the heritage from our hominid ancestors and provides a floor from which human artifactual, imaginative, and conceptual activity of innumerable kinds has arisen and continues to arise.

The second chapter of *Real Spaces* treats *places,* the definition and divisions of social spaces. The modern Western world is contrasted with everything else, including the pre-modern Western world, as effectively placeless. Technology, that is, prediction and control based on the channeling of energy from natural resources, the electric world of communication and exchange, all imply the interchangeability and even fungibility of places. These modern Western circumstances are very different from the aggregate world of places from which Western modernity emerged and with which it continues to interact in many new and unpredictable ways. Traditional worlds have been defined by qualifications of place, by centers, boundaries, paths, and significant alignments, and in social groups from small to large these qualifications have been associated with collective identity and continuity. These general definitions typically provide the basis for social distinctions (as, for example, by gender) and hierarchy (for example, by lineage). To be sure, there are many such arrangements in the world, but their bases are no more comprehensible in the terms of Western modernity than the premises of Western modernity are in theirs. This opposition sets up what are to my mind some of the most important problems raised by the arguments of *Real Spaces.* If centers and boundaries entail origin and continuity, and thus both inclusion and exclusion, that is, if they create the possibility of group definition and unity, but also distinguish that group from others, then they set the conditions for culturally specific activities but also for the many conflicts of which we are all aware. On the other hand, the negation of centers and boundaries by the qualitative de-differentiation of space seems to threaten the very real spatial existence—at base, the real possibilities of enactment—of historical traditions. This is an abstract phrasing of familiar issues. We might consider the difference between the same shrine as the destination of tourism and as the destination of pilgrimage, or the difference between the same burial ground as the object of archaeological investigation and as the place of the spirits of the dead.

On a more positive side, considered in real spatial terms, all traditions—with the exception of Western modernity—have been shaped to human scale, and the task for the history of art is the reclamation and presentation of human scale and correlative place in an increasingly unified world, which in its own terms must actively seek scale and place.

Before leaving the subject of places, I will illustrate the kind of general cultural contrast its categories make possible with the example of *alignment*. As the word "orientation" itself tells us, we in the West have been inclined for a long time to give priority to the direction east. Christian churches, for example, have their altars in the east whenever possible. (Saint Peter's reverses that, but is still oriented.) In China, however, the favored alignments have for millennia been north to south. In the ancient Near East, alignments of important buildings were typically intercardinal, in India they are cardinal and intercardinal, and in China, India, and ancient America the center has been a direction. In ancient America alignments are astronomical. And of course all mosques, and all praying Muslims, acknowledge Mecca. This is not to say that Christian churches cannot be aligned in any direction (although the altar remains the liturgical "east") or that Chinese buildings cannot be aligned to the east. It *is* to make the claim, however, that alignment is a fundamental category of social spatial meaning, a claim borne out by the long monumental traditions in which the choice of one or another alignment not only persists once made, but becomes inseparable from the construction of the right order of ritual and rule.

This leads to the topic of chapter 3, "The Appropriation of the Center," which is a history of kingship, arguing that kings identified themselves, or came to be identified, with the center as a principle of collective origin and continuity. Divine kingship spreads from Sumer and Egypt to East and West, beginning a tradition that ends with the French Revolution, when the king was decapitated and the great royal shrine of Saint Denis despoiled. This literal decentering, or uncentering, signals the end of the millennial economic and political orders based on agriculture and is a defining act for the modern Western period (which begins, however, as the final chapter explains, in the late Middle Ages with the rise of technology and the rationalization of space, time, and force).

The premise of chapter 4, "Images," finally allows me to explain the main title of the book before it became *Real Spaces*. For many years it was called *The Defect of Distance*, a phrase taken from a Counter-Reformation writer, Gabriele Paleotti, who in his *Discourse on Images* explained that people make images in order to remedy "the defect of distance."[11] That is, the gods are in heaven, the dead

occupy some other reality, the sacred stories happened in the past, and so we make images in order that what we desire to see and address may be part of the spaces and times of our lives. Paleotti's is a poetic and deeply incisive way of saying that all images are substitutive, which serves to bring traditions of image making into view as real spatial modalities of substitution.

 Substitutes—and here I began from E. H. Gombrich's "Meditations on a Hobby Horse"—are most effective and significant in their spaces of use,[12] which links them to the places of chapter 2. In principle, any object, whether or not it *resembles* what it represents, may serve as an image in a real spatial context in which it may be regarded and treated as such. This raises the subject of *real metaphor,*[13] intended once again to make a fundamental distinction between images and words. "Metaphor" is from a Greek word meaning "to carry over." When we call a word a metaphor, then, we are speaking figuratively; that is, we are speaking as if we were moving something from one place to another when we are actually putting a word in place of another word. A *real metaphor* is something moved into place in order to be treated as if it were something else, and it is argued that this is an irreducible act of substitution. Given a substitutive base, three-dimensional images are classified as *icons* and *effigies.* Icons are combinations of powerful materials and resemblant elements; they are closely related to *masks,* which animate the inwardness implicit in the appearance of a substitutive object. Effigies are images that take shape and authority from actual contact with their subject, like a life or death mask. Rather like religious relics, effigies have been especially significant in Western art and practice, from Roman *imagines* to photography. Veronica's veil actually touched the face of Jesus; Saint Luke actually saw the Virgin and Child when he painted them. Images, like relics, may be approached, displayed, and seen (or access to them may be restricted, and they may be hidden from view).[14]

 Photographs, whatever else they may be, are fundamentally indexical, and, although they have the values of effigies, are two- rather than three-dimensional. They thus raise the issue of *images on surfaces.* Surfaces provide the conditions for *virtual spaces,* but they may also be smoothed, implying the limit of *planarity,* the subject of chapter 4. As stated above, the plane is historical, and more specifically, certainly arose from the artifactual as a major consequence of the evolutionary emergence of the *notional* to be traced first in hominid tools. That is, *possible relations* emerged together with, and *only* together with, the making of actual relations. The tool-like size and shape of the so-called *Venus* in figure 3 is significant in terms of the personal spatial values of manipulability and portability, and it was no doubt

also significant that the image was present and could be manipulated in use; in the present terms, however, the figure represents the transfer of the *notional* relation of *bilateral symmetry* from tools to the schematic description of the female body.

Surfaces able to be treated as notional planes presented a new condition for an open number of culturally specific *formats* and have provided the basis for the operations we associate with civilization, from city building itself to writing and tabulation. Surfaces able to be treated as planes assumed social spatial scale in the Neolithic period, a development accompanied by the rise of *hierarchical planar order,* to be seen in an interculturally broad *decorum* of images. In these images, relative wholeness in the plane, centrality, relative size, equality, and relative position in the plane are constitutive. Hierarchical planar images state an optimal, quasi-substitutive presence by the fullest possible identification with the plane (usually frontality) and also state relations among images with maximal clarity in the same planar terms. Of the countless examples from many traditions that might be given, the polyptych in figure 4 displays the Virgin and Child frontally, centrally, and as relatively larger, on a larger panel. Seated, the Virgin is the same height as the flanking figures and would thus be taller than they were she to stand. She is enthroned and elevated, with a cloth of honor behind, robe, and halo. That is, she is distinguished by material and facture. God the Father is central above her, Christ as Man of Sorrows is in the predella panel on the same central axis below. Relative to the central figure of the Virgin, the archangels Gabriel and Michael are symmetrically paired, the profile Gabriel suggesting a narrative element, addressing the Virgin as if in an Annunciation. Peter and Paul are similarly paired, not so much as shapes, but, as they frequently are, as iconographic equals. Left and right relative to a central image are often significant in Christian art—most emphatically in Last Judgments—and Peter may be higher between equals than Paul. In the predella panels the significance of the central images' left and right is perhaps clearer. As in a Crucifixion, the Virgin is to Christ's right, Saint John the Evangelist to his left. Consistent with that, the frontal bust of Saint John the Baptist points upward to the central group, whereas the corresponding three-quarter bust of Mary Magdalene opposite him seems to be another narrative figure,

a participant in the grief of those more immediate to the central dead Christ. With appropriate adjustments, the same order might be seen in images of the Buddha and attendants. Such planar decorum—the altarpiece would seem very different if the Virgin were off to one side, or Mary Magdalene were at the top—governs hierarchical images in many variations and inflections in Western art until modern times, when, like other modalities of hierarchy, its use became marginal.

Planarity is also the underlying condition for all operations involving *measure,* which in turn yields more notional *ratio* and *proportion.* Since the use of any specific unit of measure is arbitrary, the establishment of any system is a prerogative of rule, as the double meaning of the word "ruler" in English might suggest. The allotment of land depends on its division, and rulers established, guaranteed, and enforced weights, measure, and currency in many long traditions. Accordingly, local measures and weights were eliminated and literally globalized (a process not yet complete) after the French Revolution as part of the more general separation from the millennial political order based upon agriculture.

Fig. 4. Giotto and followers, *Bologna Polyptych,* 1330–35. Tempera on panel, 35 7/8 × 103 7/8 in. (91 × 340 cm). Pinacoteca Nazionale di Bologna

The two- and three-dimensional development of measure and ratio is the *grid,* and the gridding of the world has proceeded more or less without interruption since the late Western Middle Ages, and in fact advances apace to a finer and finer measure.

As stated earlier, the conditional bases for substitution (real metaphor) and placing images on surfaces are universal, and, within local limitations—walls or paper are not available in all circumstances—one option or another may be taken up at any time for whatever purposes. When an image is put on a surface, we may or may not see what is *not* image as a virtual place, but if we do, then this *virtuality,* the subject of chapter 6, may be articulated in a number of ways. Virtuality is rooted in our capacity to see three dimensions in two, and, since virtual space is always *represented* space, images and relations in virtual space cannot be equivalent to the real space shared with the *observer,* who has now become more properly a viewer. Only the supporting format is real spatial. A virtual space is another place and time in relation to the space and time of the observer, and *is thus essentially narrative.*

Fig. 5. Fragment of the Stele of Urnammu, Ur, Iraq, 3rd dynasty (c. 2112–2095 B.C.E.), originally about 10 × 5 ft. (3 × 1.5 m). University of Pennsylvania Museum of Archaeology and Anthropology, Philadelphia

With the advent of planar formats, the *framing* of virtual space emerges as an issue. Planar formats for virtual spaces make possible a *ground line,* developable in the virtual dimension as a *ground plane,* thus introducing planarity into the virtual dimension. This happens independently in many places but is highly developed in Egyptian art, thus to form the beginnings of Western *metric naturalism.* In the fragmentary libation scene from Ur in figure 5, the ground line is treated as if it were a plane perpendicular to the planar surface of the relief itself, a virtual planar surface able to accommodate the three-dimensional forms of the figures in the virtual dimension. The

now-halved king stands before the god "on" a ground line. This "on-ness" implies that the line is the edge of a virtual plane upon which the king's three-dimensional feet are placed. The elevation of the god's throne is stated by two lines parallel to the ground line "on" which the square throne is a virtual cube, and the god's left foot slightly overlaps his right. This implicit plane may be developed by successive planes of overlapping figures.

The ground plane implicit in the ground line becomes explicit—comes into actual view—as an *optical plane* in Greek *skenographia* in the second half of the fifth century B.C.E. The ground plane is represented as a quantity under a *visual angle,* the primary analytic device of Greek optics. Greek *skenographia* became the geometric forerunner of Italian Renaissance metric *perspective* (from *perspectiva,* the medieval Latin term for "optics"). The least-surviving element of ancient *skenographia* is to be seen—among thousands of examples—in the optical ground plane upon which the figures stand in figure 4, a late Medieval version of the "stage" of space characteristic of Western art.[15]

The theory of vision of the late tenth- and eleventh-century Ibn al-Haytham, called Alhazen by his Latin translators, was crucial for the later Western history of optics. Alhazen's demonstrations were for the first time based on a theory of light, making it possible to fit the classical visual angle into the whole visible world, thus to provide a schematic account of ongoing vision.[16] It was on the basis of Alhazen's optics that the optical plane, newly defined as a grid, could be developed by Filippo Brunelleschi, Leon Battista Alberti, and others, as the metric, three-dimensional order of Italian Renaissance one-point perspective, which translated the grid, and thus ratio, into the virtual dimension. The impulse to this spatial representation was partly theatrical and rhetorical, but the construction also implied that the whole visible world was subject to uniform measure and ratio.

Part of the project of *Real Spaces* was the intellectual historical clarification of the assumptions about art that we take to everything we call "art," and so the seventh and final chapter addresses the embracing questions of the emergence of Western modernity and its relation to previous art histories, including the history of the West itself. The rise of technology and its supporting assumptions is essential. The first of these is *metaopticality,* the universal coordinate matrix (the notional three-dimensional grid) implied by the universal geometry of light. The counterpart of metaopticality is *force,* which is defined as acting through metric space. In this new context, mind is a *counterforce,* and the individual as *subject* comes into view as the unique locus of reaction to external force.[17] It is within the very general scheme of

metric space, force, and counterforce that fundamental modern ideas, including ideas about art, have taken shape. In the modern West, with the rise and triumph of the epistemological principles of natural science, the classical assumption that mind through sight apprehends essential *form* is replaced with the idea that mind in some way or another articulates the experience of a subject, so that the idea of "form" assumes entirely new meanings. (In these circumstances, by the way, the framing of virtual spaces becomes a crucial issue, and the traditions of virtuality, highly developed in other terms in Chinese and Japanese painting, for which framing had been fundamental from the start, began to nourish European art.) Sublimity, romanticism, symbolism and abstraction, impressionism and expressionism, caricature and the unconscious, photography and naturalism, realism, cubism, futurism, construction, and performance may be variously explained in these terms. (Dada may be considered a demystification of the idea of art, yielding many new ideas of what it means to make art, as well as a disillusionment with technology.)

To return finally to some of the arguments with which I began, it is metaoptical space that is uniform, indifferent to place, and without scale. It must be stressed that this space of Western modernity, rather than being the "true" representation of space, is a pragmatic space, a framework for prediction and control, essential to a set of new conditions for converting given nature to human desires and purposes. Realization of these desires and purposes is in large part good, the fulfillment of ancient dreams; but it is by no means unmixed, and it also yields unintended social spaces and social consequences. Individual freedom of transportation, for example, has actually come to mean hundreds of millions of automobiles, endlessly expanding systems of highways, congestion, and atmospheric degradation; everyday individual consumption has made the landfill a major form of collective architecture, which is not to mention the disposal of toxic wastes. *Real Spaces* ends with the argument that all art should be studied for what it teaches us in endless variations on its constitutive and conditional themes of human scale in the making of artifacts, places, and images, a task crucially important at a time of unprecedented cultural interaction. If we accept the metaphor of culture as biological, then modernization may be said to diminish diversity, much as it has meant the death of languages and the extinction of animal species. What we call "cultures," however, are more complex than their definition by this metaphor and may be deeply understood as human communities of observance, rooted in often millennial second nature. It may be hoped that the contact of continuous cultures will mean ongoing negotiation and accommodation. These negotiations and accom-

modations will be best conducted on the basis of humane mutual understanding, to which the history of art has much to contribute.

It has not been possible to rewrite this essay, which might have taken the form of "further thoughts," or of a response to reviews. I will end, however, by stressing my simplest intentions in writing *Real Spaces*. Such a book requires a certain amount of tedious theoretical clearing and foundation laying, but the book is so long in order to demonstrate the possible practice, and to invite others to the practice, of an intercultural art history.

1. David Summers, *Real Spaces: World Art History and the Rise of Western Modernism* (London: Phaidon, 2003). I would like once again to thank my editor at Phaidon, Bernard Dod.

2. Paul Oskar Kristeller, "The Modern System of the Arts," in *Renaissance Thought II: Papers on Humanism and the Arts* (New York: Harper, 1965), 163–227.

3. David Summers, "Conditions and Convention: On the Disanalogy of Art and Language," *The Language of Art History,* ed. Ivan Gaskell and Salim Kemal (Cambridge: Cambridge University Press, 1991), 181–212.

4. Peter Brunette and David Wills, "The Spatial Arts: An Interview with Jacques Derrida," in *Deconstruction and the Visual Arts: Art, Media, Architecture,* ed. Peter Brunette and David Wills (Cambridge: Cambridge University Press, 1994), 15.

5. Ernst Hans Gombrich, "In Search of Cultural History," in *Ideals and Idols: Essays on Values in History and in Art* (London: Phaidon, 1979), 24–59; and David Summers, "E. H. Gombrich and the Tradition of Hegel," *A Companion to Art Theory,* ed. Paul Smith and Carolyn Wilde (London: Blackwells, 2002).

6. George Kubler, *The Shape of Time: Remarks on the History of Things* (New Haven: Yale University Press, 1962).

7. David Summers, "'Form,' Nineteenth-Century Metaphysics, and the Problem of Art Historical Description," *Critical Inquiry* 15 (1989): 372–406. This essay has also been included in badly truncated form in a collection more concerned with problems than with solutions (Donald Preziosi, ed., *The Art of Art History: A Critical Anthology,* [Oxford: Oxford University Press, 1998], 127–42) and should be read in its original version.

8. Immanuel Kant, *The Critique of Judgment,* trans. James Creed Meredith (Oxford: Oxford University Press, 1952), 151; and David Summers, "Why Did Kant Call Taste a Common Sense?" in *Eighteenth-Century Aesthetics and the Reconstruction of Art,* ed. Paul Mattick, Jr. (Cambridge: Cambridge University Press, 1993) 120–51.

9. Summers, "'Form,'" passim.

10. Meyer Schapiro, "On Some Problems in the Semiotics of Visual Art: Field and Vehicle in Image-Signs," in *Theory and Philosophy of Art: Style, Artist, Society* (New York: George Braziller, 1994), 1–32.

11. Gabriele Paleotti, *Discorso intorno alle imagini sacre e profane* (Bologna, 1582) in *Trattati d'arte del Cinquecento fra Manierismo e Controriforma,* vol. 2 (Bari: Laterza, 1960), 141.

12. Ernst Gombrich, "Meditations on a Hobby Horse, or the Roots of Artistic Form," in *Meditations on a Hobby Horse and Other Essays on the Theory of Art* (London: Phaidon, 1963), 1–11.

13. David Summers, "Real Metaphor: Towards a Redefinition of the 'Conceptual' Image," in *Visual Theory: Painting and Interpretation,* ed. Norman Bryson, Michael Ann Holly, and Keith Moxey (New York: Icon Editions, 1991), 231–59.

14. David Freedberg, *The Power of Images: Studies in the History and Theory of Response* (Chicago: The University of Chicago Press, 1989); and Hans Belting, *Likeness and Presence: A History of the Image Before the Era of Art,* trans. E. Jephcott (Chicago: The University of Chicago Press, 1994).

15. David Summers, "The Heritage of Agatharcus: On Illusionism and Theatre in European Painting," in *Art and the Beholder in Early Modern Europe,* ed. T. Frangenberg, forthcoming.

16. On Alhazen, see David C. Lindberg, *Theories of Vision from Al-Kindi to Kepler* (Chicago: The University of Chicago Press; 1981), 58–86; and David Summers, *The Judgment of Sense: Renaissance Naturalism and the Rise of Aesthetics* (Cambridge: Cambridge University Press, 1987), 151–81; and for a translation of the original Arabic text (as opposed to its medieval Latin translation), see A. I. Sabra, ed. and trans., *The Optics of Ibn Al-Haytham: Books I-III In Direct Vision* (London: The Warburg Institute, 1989).

17. David Summers, "Cogito Embodied: Force and Counterforce in Rene Descartes's *Les Passions de l'ame,*" in *Representing the Passions: Histories, Bodies, Visions,* ed. R. Meyer (Los Angeles: Getty Research Institute, 2003), 13–36.

A Brief Natural History of Art

John Onians

This essay may be too tight for comfort, revealing more of what makes us human than the reader would like me to show. It may indeed be quite shocking to some that I am going to take off the nice clothes of culture in which we like to dress works of art and expose something of the extent to which they should be understood as the products of nature. For, what I am going to discuss is the natural basis of artistic activity, that is, its basis first of all in our own nature and then in the nature of our relationship to our environment, which is why I call it a natural history of art.

This natural history, while indebted to a strong tradition that runs from Aristotle to my teacher, E. H. Gombrich, and Michael Baxandall, adopts a perspective which is both more down to earth than theirs and more Olympian. It treats human beings as animals, but in order to do so it takes a super-human viewpoint, looking down on the full range of artistic activity, trying to imagine why it is unique to our own species, *Homo sapiens sapiens,* which, by around 35,000 years ago, had replaced all earlier human types. The question I start with is: Why has just one of the many different creatures who live on earth spent so much time and energy doing something others did not, that is marking, coloring, shaping, constructing, and using different materials in different ways in different places?[1] Looking down on humanity in this way, it is clear that the answer must be rooted in modern man's difference from other animals (including our own ancestors, from the hominids to the Neanderthals) and, since that difference is rooted in genetics, it is to our genetically defined nature that we must turn. Of course, all our nature is involved in the making of and response to art, but one element has a particularly important role in supporting these extraordinary behaviors, and that is the brain, or more specifically the brain's neural linkages between the eye and the hand. It is thus on an acknowledgement of the importance of these linkages that the brief history I am about to present depends.

However, before sketching this story I want to stress something we easily forget in our celebration of human culture: that the genetically determined make-up that distinguishes *Homo sapiens sapiens,* and that has allowed us to develop increasingly complex behaviors over the last 35,000 years, developed over the previous several million years as the result of a continuous process of natural selection.

Our complete physiology, including our neurophysiology and the abilities and inclinations it supports, is the product of millions of years of selection. Ever since the first life-forms emerged four billion years ago, all their descendents, including those who were to be our ancestors, have been subjected to a process by which those members of a species who were better equipped to survive in the environment in which they happened to find themselves were more likely to transmit their genetic material. The overwhelming majority of that genetic material was always inherited from previous generations, but new elements were always arising as a result of random mutation. When such a mutation gave an individual an advantage, it was liable to be passed on to his or her offspring and, as each new generation inherited the same advantage, the genetic material and the trait or traits it coded for were liable to become more prevalent within the breeding population.

It was this process that resulted first in the emergence in Africa over a hundred thousand years ago of a new slender type of *Homo sapiens* with a much-enlarged brain and then, in that type's expansion out of Africa, to displace all existing other types as *Homo sapiens sapiens*. Whatever the abilities and inclinations that were selected for during the emergence of *Homo sapiens sapiens*, they had nothing directly to do with all the activities, such as art making, with which that creature subsequently became associated. The configuration of the brain that supports the complex behaviors that developed after 35,000 B.C.E. must have been selected for other reasons. Whatever we use the linkages between the eye and the hand for nowadays, whether it is making art or using a computer, they must have originally become established in the species because they helped our ancestors to perform much more basic functions, such as finding food or a mate, making friends, bringing up children, and avoiding being killed and eaten. It is thus likely that all that was selected for in the first place was a set of improvements in the ability to visually discriminate between phenomena and to react to them appropriately. It was only in specific circumstances that the neural linkages that secured these abilities also supported the emergence of such secondary behaviors as those involved in art making. The primary need might be to reach out quickly for or reject a desired or detested object or person, the secondary behavior might be to reach for or reject anything, whatever its material, that looked sufficiently like that object or person to elicit such a response. To put it another way, the ultimate reason for an individual reaching for something, touching it, and consequently marking or reconfiguring it might only be that it matched visual preferences—or aversions—already established in his or her brain and provoked the motor actions with which those preferences and aversions were associated.

Such preferences and aversions might be either inborn, as is the preference for other members of our species, or they might be acquired by visual experience after birth, as are the preferences for readily available forms of food. Neither type of preference or aversion has been taken seriously by art historians, although, as I will argue, understanding them can help us greatly in dealing with some of the most familiar phenomena in the history of art. Nor is understanding them as difficult as it sounds. All we need is a basic understanding of our neurobiology, that is, of the nature of our neural networks, and of our neuropsychology, that is, of the behaviors with which that neurobiology is associated. The activities of collecting and making objects are two of the best examples of behaviors that can be understood in this way.

To illustrate this we can begin our brief history of art long before the emergence of *Homo sapiens sapiens,* when some of the most basic elements in our neuropsychology are manifest in the collecting activities of a hominid ancestor.

Fig. I. Pebble, from Makapansgat, collected two million years ago. Reproduced from *South African Journal of Science* 70, no. 6 (June 1974): cover

One of the first objects to reveal the emergent visual preferences and associated motor inclinations of our primate ancestors is a pebble found at the site of Makapansgat in South Africa, an area occupied by hominids around three million years ago (fig. 1).[2] The excavators who found this rounded stone in a habitation area noted that it must have been brought there from a riverbed a few miles away. They also suggested that it had been picked up and removed in this way because it looked so much like a human face and this can now be explained in terms of neuropsychology. One of the most important properties of the brain selected for by evolution is its positive emotional and motor reaction to a baby's face.[3] The original reason for the establishment of such a reaction is that those of our ancestors in whom the tendency to look at and pick up a baby was so strong as to be instinctive were more likely to successfully rear young and so transmit the genetic material that gave them the propensity in the first place. Such a tendency could indeed have led an individual hominid to pick up and take home the pebble, whose reddish color, as well as whose form, may have made it irresistible.

Equally neuropsychologically understandable are the aesthetic preferences noticed by Kenneth Oakley in the inhabitants of Britain two hundred thousand

Fig. 2. Acheulian hand axe, from Swanscombe, made two hundred thousand years ago. Reproduced from Michel Lorblanchet, *La naissance de l'art: Genèse de l'art préhistorique* (Paris: Errance, 1999), 90

Fig. 3. Fossilized coral, from Swanscombe, collected two hundred thousand years ago. Reproduced from K. P. Oakley, "Emergence of Higher Thought 3.0–0.2 Ma B.P.," *Philosophical Transactions of the Royal Society of London, Series B* 292, no. 1057 (May 1981): 210

years ago.[4] What fascinated Oakley was that a flint axe had been so formed that a fossil sea urchin, or so-called shepherd's crown, lay at its center, its anus carefully positioned on the tool's axis (fig. 2). Since a positive response to any configuration manifesting one of the principal traits of the human face, that is axial symmetry, was another trait selected for in humans because it favors survival, it is hardly surprising that this tendency influenced the manipulations of the early toolmaker. That it subsequently affected many later makers and designers is well understood, being demonstrated by the predominance of axial symmetry in human artifacts right up to today.

Another equally fundamental visual preference almost certainly lies behind our Neanderthal ancestor's careful collection of another stone, this time a fossil coral, also noted by Oakley, whose special value was demonstrated by its having been removed 120 miles from the only site in England with comparable fossils (fig. 3). Since the regular patterning that distinguishes this object from almost all other stones is one of the principal diagnostic attributes of organic and so potentially food-yielding life, being an attribute of everything from corals to honeycombs to foliage to nut cases to fish scales, it is likely that here, too, we are observing the operation of a preference that had been selected for by evolution. As in the case of the hand axe, the preference concerned is one with great importance for the future history of art, being that which lies behind almost all of what we later call ornament. For what characterizes all ornament, whether it is more explicitly organic or more geometrical, is that it has the specific property of repetition, which in nature is usually the result of growth and so a trait that typically distinguishes the organic and thus potentially edible from the inorganic and mineral. The preference for repetitive ornament, like the preference for axial symmetry, has been selected for by nature and will always remain a genetically determined element of our neuropsychology.

But what of the first true works of art in the conventional sense, that is those objects or surfaces whose appearance has been radically changed by marking

and coloring? This earliest art, which appears after 35,000 B.C.E., can be broken down into four categories, each of which can be seen as relating to an inborn neuropsychological predisposition, that is the inclination to give a particular type of object visual, and often tactile, attention.

This is perhaps most obvious in the case of the category of female genitalia (fig. 4). For, it is indeed obvious that, at least among males, evolution would necessarily have selected for an interest in such configurations. Males who had an inborn tendency to look at and touch female genitalia would always have been more likely to survive than those who did not, with the result that that reaction must have been as strong in our ancestors as it is today. Nowadays the strength of this reaction accounts for a vast industry of top-shelf magazines. Thirty thousand years ago such magazines were not available, but a male who saw something sufficiently resembling a vulva to attract his touch might naturally, like the modern purchaser of an illustrated magazine, have found himself reaching out for it. In doing so he might have touched it in such a way as to alter its appearance, increasing both the resemblance and the associated pleasure, until he had created an ancient equivalent to the modern photographic image.[5]

Fig. 4. Vulva, from Abri Cellier, Dordogne, Aurignacian c. 30,000 B.C.E. Reproduced from Paul G. Baum and Jean Vertut, *Images of the Ice Age* (London: Windward, 1988), fig. 54

Another category of the earliest art, three-dimensional representations of the whole female body, might be explained in a similar way, but since pleasure in the whole female body, and especially in the breasts, must have been selected for in both males and females because it favors survival in childhood, there is no need to see such figures as exclusively the product of linkages unique to the male brain. Women are perhaps as likely to have been involved in the making of and response to such images as men.

Neuropsychology may help us to explain not only the emergence of these categories of art but also their differential distribution within the area of their production in Europe. As I have argued elsewhere, the reasons why the genitalia are found almost exclusively in the far west of Europe, in southwest France, and the whole figures in larger numbers to the east in a belt from Germany to Russia may well be that these very different environments encouraged equally different emotional climates.[6] The relaxed enjoyment of genitalia would thus have been much

easier in the relatively safe and temperate area close to the Atlantic coast than in the colder and more savage continental hinterland, where the whole female form would have responded to the more desperate need for security and warmth.

Certainly a similar difference in normal emotional context would explain why there is a parallel differential distribution in the two other principal categories of early art, prey animals and predators. Again it is food animals that are predominant in the western coastal areas and more dangerous species such as predatory felines in the more exposed east (fig. 5). If emotions were a prime provocation to the manipulations of the earliest image-makers, then we can easily understand that a comparatively safe environment could have left those to the west more free to enjoy the sight of configurations that resembled food objects, while to the east fear of the dangerous might have had the most influence on the visual imagination and the hand it governed.

Fig. 5. Hunting scene, Cueva Remigia, Spain, Mesolithic, 10,000–3,000 B.C.E. Reproduced from Stuart Piggott, *Ancient Europe: From the Beginnings of Agriculture to Classical Antiquity* (Edinburgh: Edinburgh University Press, 1965), fig. 5

Within a natural history of art the principles of neuropsychology can as profitably be applied to the solution of problems of style as to those of subject. Scholars have, for example, long fretted over the fact that the art of the Paleolithic period in general, and even the earliest art, is remarkable for its naturalism. Given that all accounts of artistic development, from Pliny to Gombrich, assume a laborious progressive improvement in representational ability, such early representational excellence presents a real problem. Yet these writers all assume that art was best understood as part of culture, the product of training and a constructive social framework. If, instead, we see art as more the product of nature, it becomes much easier to understand this early naturalism. The reason why members of the species *Homo sapiens sapiens,* and especially the first members to reach Europe, reached out to lumps of stone and clay and touched cave walls was not that they were taught to. Rather, they were probably more influenced by new neural linkages between their visual and the motor systems. Living in what was, from west to east, a less hospitable climate than that to the south, where they came from, their neural networks were so

activated that, imagining they saw in the slimy, stained, and shadowed surfaces the females of their own species and the other large animals that absorbed their attention in the outside world, they spontaneously reached out for them. Once we recognize this possibility, it is easy to understand how the touching that such neural stimulus provoked might have first led to the initiating of a process of coloring and molding and that this process might not have stopped until the image had enough in common with a real woman or animal to meet the emotional need of its maker, that is, in our terms, until it was quite naturalistic.

Scholars have been equally surprised that, in contrast with the art of the Upper Paleolithic, that of the Mesolithic, Neolithic, and Bronze Age periods is much less naturalistic and more schematic. Their assumption has been that this later art would share in the progress demonstrated by the same peoples' superior tools, allowing them to move from schematism to naturalism. Today, however, we can draw on some of the most recent and most interesting discoveries of the neurobiologists and infer that the improvement in tool technology is likely to have had exactly the opposite effect.

One of the most remarkable discoveries of neuroscientists is that the outer cortex of the brain, unlike the lower areas concerned with the more basic survival needs discussed above, is extraordinarily plastic, the structure of its networks being critically determined by environmental exposure. This means, as Keiji Tanaka and others have shown, that if we see more of a particular shape we will get better at discriminations in that area and will acquire a preference for looking at configurations with the same traits.[7] The implications of this discovery for the history of the art of the period between the Mesolithic period and the Bronze Age are enormous. The new, more refined, and more complex tools became so vital for food-gathering that they would have acquired the mental importance previously only possessed by food itself. They thus now attracted so much visual attention that they created a whole new set of neurobiologically driven visual preferences. The more vital for survival and prosperity the new tools and weapons became, with fine flint blades, bows and arrows, spears, fishhooks, and needles, being joined by sickles, swords, musical instruments, horse trappings, and chariots, the more such tools would have replaced women and large animals as the most important focus of attention. This would have reinforced the neural networks involved in their perception and given rise to new visual preferences. Neural networks adapted for the perception and manipulation of the soft, rounded forms of large animals would have been increasingly replaced by ones adapted to the enjoyment of tools and weapons, objects characterized instead

Fig. 6. Entrance to the tomb of Mereruka, near Sakkara, 6th dynasty. Reproduced from *Encyclopedia of World Art* (New York: McGraw Hill, 1959–c.1983), vol. 4, plate 336

by such attributes as straightness, hardness, and slenderness, and this would have led to a natural rise in the preference for configurations sharing those properties. The predominance of such neurally determined visual preferences would explain why the imagery that emerges from the new, increasingly tool-dependent ecology shares the thin hard outlines characteristic of such tools. This is particularly obvious in portrayals of the human figure itself, and since so many scenes now show human figures, who by the use of such tools would have come to be conscious of the instrumental properties of their own limbs, it is natural that they would have represented tools and limbs in the same way (fig. 6).

The art of third-millenium B.C.E. Mesopotamia and Egypt is only the latest to manifest such properties, but now a further environmentally conditioned restructuring of neural networks takes place. For the first time in their history, human beings' control of tools—and the use of each other as tools—enabled them to manage food production artificially and in so doing actually reshape the landscape. The systematic irrigation of the Nile Valley and the construction of extensive networks of roads and canals framing cultivated areas brought about a substantial transformation of physical geography. Exposure to the new rectangular configurations that were increasingly vital for human well-being, whether these were buildings or plantations of trees or fields of grain, would have led to the formation of totally new types of neural networks in the brains of those exposed to them. As a result, the populations of these areas would have acquired new sets of visual preferences, and these are clearly manifest in Egyptian art. For the first time we find strong ground lines, rectangular masses of vegetation, rows of trees, and herds of animals. What we see is not just people, artifacts, plants, and animals all lined up, as they would have been in a well-administered society that depended on an efficient and irrigation-based agriculture. Each individual object and each overall composition participate in the property of rectangularity. What everyone now desired to see was rows of those things, on which their welfare depended, arranged in rectangular patterns, and all types of art, from wall paintings to temple colonnades, reflect the way these desires influenced the movements of pen, brush, and chisel (fig. 7).

Such preferences did not survive the transfer of the same technologies of painting, sculpture, and architecture to Greece. In the very different ecology of narrow, rocky valleys and small, rocky islands, rival communities became preoccupied with the defense and expansion of their territories, and fighting became more essential for survival than irrigation. Warfare became endemic, and in this situation it was not the general environment that absorbed people's attention, but

Fig. 7. Ionic capital from Temple of Artemis, Ephesus, mid-sixth century B.C.E., British Museum. Reproduced from William Bell Dinsmoor, *The Architecture of Ancient Greece: An Account of Its Historic Development* (New York: W. W. Norton and Co., 1975), plate 30

two particular configurations, those of the objects they at once most feared and desired: the best military formation, the phalanx, and the most effective naval vessel, the trireme.[8] Such absorption in two specific configurations ensured that new and extraordinarily precise neurophysiologically based preferences emerged. The Doric temples of the gods who protected the cities of mainland Greece and their colonies, where war or the preparations for war were a constant necessity, now acquired the desirable properties not of an orchard or well-sown field but of a well-drilled military formation. Columns were transformed under the chisel and given flutes separated by sharp arrises that gave the eye the same pleasure as would a well-made spear or sword blade. Capitals and entablature became as sharp, angular, and hard as body armor. The Ionic temple, on the other hand, which first developed on the island of Samos, then the maritime queen of the Aegean and which was subsequently adopted by most cities who depended on the sea for protection and prosperity, instead acquired properties transferred from ships. The organic leaf forms developed on capitals in the agricultural East turned into stiff bolster-like shapes resembling rolled-up sails bound by ropes, and the equally organic eastern column base hardened even more until it resembled the pulleys and rope-grooved capstans that must have been the greatest source of pleasure and pride to the citizens of maritime states. The distinctive properties of neural networks adapted by evolution to ensure that visual and manual attention was given to the most vital food sources meant now that sculptors unconsciously gave to blocks of stone the attributes of equally vital artifacts. The degree to which the different visual experiences of land-based and sea-based communities brought into existence configurations that precisely matched the preferences shaped by their different experiences demonstrates the extent to which it is possible, if one can reconstruct a community's distinctive visual priorities, also to develop explanations for the distinctiveness of its artistic production.

A similar principle drawn from neuropsychology can be used as the basis for the explanation of another distinctive feature of Greek artistic production: linear perspective. The area of the brain concerned is that mapped by D. H. Hubel and T. N. Wiesel over thirty years ago.[9] What they showed was that one part of the

visual cortex consists of banks of neurons, each adapted to respond to a line of a different orientation (fig. 8). What has been discovered since is that, the more any of these banks of neurons are exposed to the particular line to which they are designed to respond, the more the connections between them will improve in a process that gives the brain's owner a growing preference for looking at them. In other words, our visual preferences for linear configurations vary according to the linear properties of the environment in which we grow up, and such a mechanism probably already explains aspects of Egyptian art. Now, however, it can be used to explain the emergence of what amounts to a whole new system of representation. While in all earlier agricultural and architectural environments there might have been numerous lines of different orientation in a person's visual field, in Greece not only for the first time does the number of lines of different orientation increase dramatically, they also appear increasingly in contexts in which they converge. The reason for this is that the Greeks created a new type of architectural environment, becoming the first people to build stone walls, whose masonry was characterized by courses separated by clear horizontal lines. As the Greeks walked along and between such walls, they would have experienced a repeated exposure to lines of varying orientation that would have increasingly tended to reconfigure their neural networks (fig. 9). The people living in Greece during the period from the sixth to the second centuries B.C.E.—precisely the period in which perspective developed—would thus have acquired banks of neurons in this area of the brain that were ever-better connected and so gave their owners an ever-greater preference for viewing configurations employing linear convergence. The consequence of this would have been that individuals making drawings or paintings would have manifested an increasing, neuropsychologically driven tendency to employ such convergences in their products. As a result, by the second century B.C.E., what we call linear perspective naturally came into existence. Viewed in this way, linear perspective was in many ways less a product of culture than of

Fig. 8. Layer IV of visual cortex showing neurons that react to lines of different orientation. Reproduced from Richard L. Gregory, ed., *The Oxford Companion to the Mind* (Oxford: Oxford University Press, 1987), 802

nature, an almost neurobiologically predictable result of the Greek fondness for coursed masonry.

This does not mean that neurobiology was on its own responsible for its development. Many other factors contributed to its emergence, such as the Greek interest in geometry and optical naturalism. I would, however, argue that the increase in coursed masonry was at least a necessary condition for its appearance. This view can be to some extent confirmed by asking when that necessary condition occurred again. Readers will be able to check the history of the world's architecture for themselves, as I have done. The results of my inquiry are simple. Coursed masonry is extremely rare. Dying out in the Roman period, unknown in China and India, and rare in pre-Columbian America, it only reappears on a large

Fig. 9. Street in Florence

scale in one place at one time, that is in Florence in the fourteenth century. It does so as a consequence of a particular circumstance, the Florentine desire to challenge the German emperor's claim for dominion over them. Frederick II had sought to assert his authority in Italy by using coursed masonry imitated from Roman fortifications in buildings that represented his authority. In response to this, the Florentines set out to make their own claim to a Roman inheritance by using such masonry, first in their own main government building, the Palazzo Vecchio, begun in 1296, and then in innumerable other buildings lining the rectangular spaces and streets of the rapidly expanding city. The progressive accumulation of such masonry within the visual field of fourteenth-century Florentines would, as in ancient Greece fifteen hundred years earlier, have slowly transformed the banks of neurons in successive generations of the city's inhabitants, increasing the tendency for them to prefer configurations with convergent lines. Filippo Brunelleschi, born in the city in 1378, would have been only one of those who experienced this transformation, but in his case, combined with his other experiences and activities, it allowed him to recognize and then formulate the rules of what we call linear perspective. The desirability of other artists applying the device was obvious. Since those who were in the market for artworks had undergone a similar neuropsycho-

logical development, they, too, naturally preferred works with those properties, which is why perspective became such a distinguishing feature of Florentine art.

A further test of the degree of importance of the relationship between environmental exposure and neuropsychology is to see whether there is any correlation between the living environments and the visual preferences of other individual Renaissance artists besides Brunelleschi. An appropriate artist to whom we can apply the test is Masaccio, the first painter to adopt the system, and if we look for his hometown we find that he was born and brought up in San Giovanni in Valdarno, the largest grid-plan town in the Florentine dominions. Exposure to this environment, which would have been rich in converging lines, would at least have prepared Masaccio neuropsychologically to respond sympathetically both to the Florentine environment generally and to Brunelleschi's perspective in particular. It is also revealing that in one of the first works to employ systematic perspective, *Saint Peter Healing the Sick with His Shadow,* coursed masonry figures prominently in the background (fig. 10).

There is not room in this brief essay to discuss the application of this proposed natural history to the rest of the world's art. All that I have presented here is a limited series of examples of the influence of particular biological mechanisms. What should emerge, however, is that one advantage of such an approach is that it allows similar questions to be asked about different peoples living at different times. Essentially the argument is

Fig. 10. Masaccio (Italian, 1401–1428), *Saint Peter Healing the Sick with His Shadow,* 1426–27. Fresco, 7 ft. 6 ½ in. × 5 ft. 7 ¾ in. (230 × 162 cm). Brancacci Chapel, Santa Maria del Carmine, Florence

that, if we can reconstruct critical elements in someone's emotional life and environmental experience, we may also reconstruct sufficient components of their neurobiological history to allow us to understand the formation of their uncon-

scious visual preferences. The approach can be applied on a variety of scales, from the individual to the group. It can also be used to shed light on the preferences of consumers as well as of producers. As presented here, it is still a very primitive tool, but fortunately, as science advances, it will provide an increasingly wide range of insights into the rules governing the formation of neural networks and the behaviors with which those rules are associated. The fact that most of what is proposed here is based on knowledge acquired only in the last decade gives a sense of how rapidly our understanding is likely to develop in the future. Having said that, it is also worth pointing out that since so much of the understanding that stems from this approach is close to common sense, at one level it is not really new at all.

Finally, I cannot resist the temptation to turn the weapon I have been developing on myself. What of the personal neural history that led me to discard so much of the culture in which I had been so carefully clad? How might a future historiographer, applying a similar neuropsychological approach not just to art, but to art history, explain my own advocacy of this particular approach? Perhaps he or she might note that already in the early 1960s, the coincidence of the abandonment of empire, the Profumo affair, and the publication of *Lady Chatterly's Lover*, together with the recent liberation of my own hormones, might have first made me aware of the nature that my education had been trying to suppress. He or she might then note how Margaret Thatcher's subsequent celebration of the emotional drive of the individual could have encouraged me to trade on that awareness. It would also not be difficult to observe that I was not alone and that artists living in Britain at the period I developed these ideas in the early 1990s had felt similar inclinations to respond to biological instincts linking them with the artists of the caves, seeing female genitalia in a kebab, as does Sarah Lucas, or the breast in a pile of elephant dung, as does Chris Ofili and, for that matter, like Damien Hirst, making images of predators and food animals. A "natural" historiographer reflecting on the relation between works of art and their historians might thus conclude that what is proposed here is the art historical equivalent of recent British art. Artists and art historians would thus share similar neural networks. If this is so, then such a natural historiography would confirm the key tenets of this natural history of art.

1. Other important attempts at exploring the biological basis of artistic activity are Desmond Morris, *The Biology of Art* (London: Faber, 1962); Ellen Dissenayake, *Homo Aestheticus: Where Art Comes From and Why* (Seattle: University of Washington Press, 1992) and other works; and Nancy E. Aiken, *The Biological Origins of Art* (Westport, Conn.: Praeger, 1998).

2. Raymond A. Dart, "The Waterworn Pebble of Many Faces from Makapansgat," *South African Journal of Science* 70 (1974): 167ff.

3. Irenaeus Eibl-Eibesfeldt, "The Biological Foundation of Aesthetics," in *Beauty and the Brain,* ed. Ingo Rentschler, Barbara Herzberger, and David Epstein (Basel: Birkhäuser Verlag, 1988), 29–68.

4. Kenneth P. Oakley, "Emergence of Higher Thought 3.0–0.2 Ma B.P.," *Philosophical Transactions of the Royal Society of London,* Series B 292, no 1057 (May 1981): 210.

5. See Desmond Collins and John Onians, "The Origins of Art," *Art History* 1 (1978): 1–25.

6. John Onians, "The Biological and Geographical Bases of Cultural Borders: The Case of the Earliest European Prehistoric Art," in *Borders in Art: Revisiting Kunstgeographie,* ed. Katarzyna Murawska-Muthesius (Warsaw: Institute of Art, 2000), 27–33.

7. Keiji Tanaka, "Neuronal Mechanisms of Object Recognition," *Science* 262, no. 5134 (1993): 685–88.

8. See John Onians, "Greek Temple and Greek Brain," in *Body and Building: Essays on the Changing Relation of Body and Architecture,* ed. George Dodds and Robert Tavernor (Cambridge: MIT Press, 2002), 44–63.

9. D. H. Hubel and T. N. Wiesel, "Receptive Fields of Cells in Striate Cortex of Very Young, Visually Inexperienced Kittens," *Journal of Neuropsychology* 26 (1963): 994–1002; and H. V. B. Hirsch and D. N. Spinelli, "Modification of the Distribution of Receptive Field Orientation in Cats by Selective Visual Exposure During Development," *Experimental Brain Research* 13 (1971): 509–27.

Contributors

Cao Yiqiang is Professor of Art History and Director of the Department of Art History at the National Academy of Art in Hangzhou and Professor of Historiography in Art at Nanjing Normal University, People's Republic of China. His current research focuses on the hidden links in the visual dialogues between the Euro-American world and China.

Rita Eder is Professor of Art History and a Research Fellow at the Instituto de Investigaciones Estéticas at the National University of Mexico. She is currently Director of the Graduate Art History Program at UNAM. In 2006 she co-organized an exhibition entitled *Art of the 1930s: Argentina, Mexico and Spain* and authored its catalogue.

James Elkins is the E. C. Chadbourne Chair in the Department of Art History, Theory, and Criticism at the School of the Art Institute of Chicago and Head of History of Art at the University College Cork, Ireland. His most recent books include *Master Narratives and Their Discontents, What Happened to Art Criticism?, On the Strange Place of Religion in Contemporary Art,* and *Visual Studies: A Skeptical Introduction.*

Arlene K. Fleming is a cultural resources specialist, currently working on the relationship of cultural heritage to social and economic development. She advises the World Bank and other organizations on safeguarding cultural heritage sites during development projects through the processes of environmental and cultural assessment.

Derek Gillman is President and the Edna S. Tuttleman Director of the Pennsylvania Academy of the Fine Arts, Philadelphia. His research interests are Chinese art and the relationship between culture and political philosophy. His book *The Idea of Cultural Heritage* will be published by the Institute of Art and Law in 2006.

Jyotindra Jain is Professor of History of Indian Art at the School of Arts and Aesthetics, Jawaharlal Nehru University in New Delhi. His current research focuses on Indian popular visual culture and representation, on which he has recently organized an exhibition and is presently editing a book, to be published shortly.

Cecelia F. Klein is Professor of Art History at the University of California, Los Angeles, where she teaches Pre-Columbian and Early Colonial Latin American art history. Her research focuses on the complex relationships among Aztec religion, politics, and art before, during, and following the Spanish Conquest.

Yves Le Fur, former curator at the Musée National des Arts d'Afrique et d'Océanie in Paris, organized the presentation of the Oceanic collection for the permanent exhibition of the new Musée du Quai Branly in Paris. He is now co-director of the museum, responsible for the permanent collections. Among other works, he has published *La mort n'en saura rien: Reliques d'Europe et d'Océanie.*

Dominic Marner is Assistant Professor of Art History at the University of Guelph, Canada, where he teaches courses on medieval art and architecture and museology. He is currently writing a book on the late-twelfth-century scriptorium at Durham.

Anitra Nettleton is ad hominem Professor in the Wits School of Arts, University of the Witwatersrand. She teaches historical and modern African art and aspects of European art history. Her research focuses on the interface between historical traditions and modernity in African art in Southern Africa. She is currently completing a book on African headrests.

John Onians is Director of the World Art Research Programme at the University of East Anglia, Norwich. He was editor of the *Atlas of World Art,* which was published in 2004, and he is currently working on a book entitled *Neuroarthistory,* an account of the history of art founded in the latest neuroscience.

Edmund P. Pillsbury is Managing Director of Fine and Decorative Arts at Heritage Galleries, Dallas, as well as Research Professor at the University of Texas at Dallas. His role as one of America's foremost museum professionals includes tenure at the Yale Center for British Art (Director, 1976–1980) and the Kimbell Art Museum, Fort Worth (Director, 1980–1998).

Michael Rinehart was Chief Librarian of the Sterling and Francine Clark Art Institute Library from its foundation in 1966 to 1986, Assistant Director and Lecturer in the Williams College Graduate Program in Art History, and founding director of RILA (International Repertory of the History of Art), later known as BHA (Bibliography of the History of Art). He retired in 2000.

David Summers is William R. Kenan, Jr., Professor of the History of Art at the University of Virginia. He is the author of *Michelangelo and the Language of Art; The Judgment of Sense: Renaissance Naturalism and the Rise of Aesthetics;* and *Real Spaces: World Art History and the Rise of Western Modernism.*

Wilfried van Damme is Lecturer in World Art Studies at Leiden University, Netherlands, and Visiting Professor of African Art at the University of Ghent, Belgium. He is currently editing, with Kitty Zijlmans, a volume provisionally titled *World Art Studies: Exploring Concepts and Approaches.*

Georges S. Zouain is the owner of GAIA-heritage, a company specializing in the economics and management of heritage sites and museums in several countries. He also lectures on economics and management of heritage in European universities. Prior to creating GAIA-heritage, he was Deputy Director of the World Heritage Centre of UNESCO.

Photography Credits

Permission to reproduce illustrations is provided by courtesy of the owners as listed in the captions. Additional photography credits are as follows:

Archivo Fotográfico, IIE-UNAM, digitization by Adriana Roldán Roucas, 2005 (pp. 121, 122 top, 123 top [photos by Pedro Cuevas, 1993], 127 [photo by Pedro Ángeles Jiménez, 1996]), 123 bottom [photo by Gerardo Vázquez Miranda, 2002], 122 bottom [photo by Eumelia Hernández Vázquez, 2002]); Courtesy Crafts Museum, New Delhi, photo by Jyotindra Jain (pp. 13, 14); Dumbarton Oaks Research Library and Collections, Washington, D.C. (p. 224); © President and Fellows of Harvard College, Harvard University, photo by Photographic Services (p. 222); Courtesy *inSite* (pp. 133 [photo by Phillip Sholtz Rittermann], 134, 135 [photos by Alfredo de Stéfano]); Courtesy Dominic Marner (pp. 70–74, 76–78); All rights reserved, The Metropolitan Museum of Art, New York (pp. i, iii, 1, 57, 149,); © The Museum of Modern Art / Licensed by SCALA / Art Resource, NY / © 2006 Artists Rights Society (ARS), New York / SOMAAP, Mexico City (p. 129); © Naturhistorisches Museum, Vienna, photo by Alice Schumacher (p. 228); Courtesy John Onians (pp. 237–40, 242, 244–47); University of Pennsylvania Museum, Philadelphia (Neg. # 54-140070) (p. 230); Soprintendenza beni artistici e storici, Bologna (p. 229)

Clark Studies in the Visual Arts

The Two Art Histories: The Museum and the University (2002)
Edited by Charles W. Haxthausen

With essays by Dawn Ades, Andreas Beyer, Richard R. Brettell, Stephen Deuchar, Sybille Ebert-Schifferer, Ivan Gaskell, Eckhard Gillen, Richard Kendall, John House, Patricia Mainardi, Griselda Pollock, Mark Rosenthal, Barbara Maria Stafford, Gary Tinterow, William H. Truettner, and Michael F. Zimmermann, and an afterword by Richard Brilliant

Art History, Aesthetics, Visual Studies (2002)
Edited by Michael Ann Holly and Keith Moxey

With essays by David Carrier, Philip Fisher, Hal Foster, Ivan Gaskell, Jonathan Gilmore, Thomas DaCosta Kaufmann, Michael Kelly, Karen Lang, Stephen Melville, Kobena Mercer, Nicholas Mirzoeff, W. J. T. Mitchell, Griselda Pollock, Irene J. Winter, and Janet Wolff

The Art Historian: National Traditions and Institutional Practices (2003)
Edited by Michael F. Zimmermann

With essays by Mieke Bal, Stephen Bann, Horst Bredekamp, H. Perry Chapman, Georges Didi-Huberman, Eric Fernie, Françoise Forster-Hahn, Carlo Ginzburg, Charles W. Haxthausen, Karen Michels, Willibald Sauerländer, Alain Schnapp, and Michael F. Zimmermann

Anthropologies of Art (2005)
Edited by Mariët Westermann

With essays by Hans Belting, Janet Catherine Berlo, Suzanne Preston Blier, Steve Bourget, Sarah Brett-Smith, Shelly Errington, David Freedberg, Anna Grimshaw, Jonathan Hay, Howard Morphy, Ikem Stanley Okoye, Francesco Pellizzi, and Ruth B. Phillips

The Lure of the Object (2006)
Edited by Stephen Melville

With essays by Emily Apter, George Baker, Malcolm Baker, John Brewer, Martha Buskirk, Margaret Iversen, Ewa Lajer-Burcharth, Karen Lang, Mark A. Meadow, Helen Molesworth, Marcia Pointon, Christian Scheidemann, Edward J. Sullivan, and Martha Ward